ABANDONED
CASTLES

ABANDONED CASTLES

KIERON CONNOLLY

amber
BOOKS

Published by
Amber Books Ltd
74–77 White Lion Street
London
N1 9PF
United Kingdom
www.amberbooks.co.uk
Appstore: itunes.com/apps/amberbooksltd
Facebook: www.facebook.com/amberbooks
Twitter: @amberbooks

ISBN: 978-1-78274-522-8

Project Editor: Michael Spilling
Designers: Keren Harragan and Mark Batley
Picture Research: Terry Forshaw

Printed in China

Contents

Introduction

Most castles weren't built just once, but were modified and expanded as the centuries passed and defensive needs changed. Over time, a Norman keep might have been joined by new storeys, towers, surrounding walls, moats, gates and drawbridges. Consequently, castles don't usually tell us about a single moment in the past but about many different times. They offer us layers of history – and sometimes mystery, too.

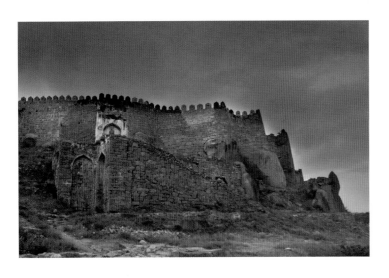

Where they have been left to ruin, that glimpse into the past remains at first ragged and exposed. But by looking closely at them we can spot the different materials used, the changing architectural styles, and the need for ever stronger defences – until they themselves became obsolete.

Today, while the nobles and kings who ordered their building are long gone, the castles have proved their strength by not falling into complete ruin. So from the Ancient Greeks to the Crusades, and from the Hundred Years' War to the American Civil War, we celebrate the stories of more than a hundred castles, forts and citadels.

ABOVE:
The 16th-century complex at Golconda in Andhra Pradesh, India, contained a citadel, mosques, temples and four forts, but within 150 years it had fallen into ruin.
OPPOSITE:
Built in the 14th century, O'Brien's Castle, Ireland, was important in policing Galway Bay's shipping channels, but in 1652 it was made unusable by the forces of Oliver Cromwell.

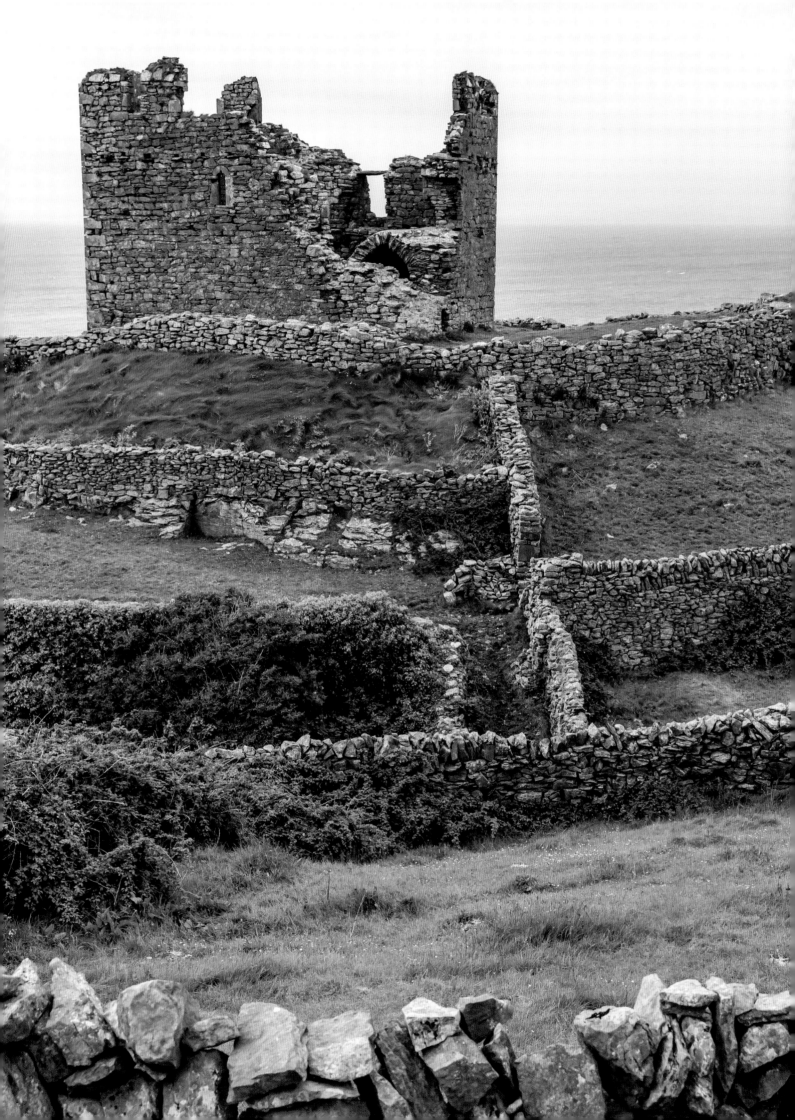

Ancient Times to the Dark Ages

Ranging across more than a thousand years from the 6th century BCE to the 5th century CE, the forts featured in these pages include examples from Ancient Greece, the Roman Empire, ancient Israel, the Mesopotamian civilizations and Byzantium. They include Iron Age English settlements, Greek coastal forts built to defend against the Carthaginians, and historically prominent places such as Persepolis, Masada and Hadrian's Wall.

One of the later entries in this chapter, the Theodosian Walls of Constantinople, were first built in the 5th century CE, but its forts and fortifications did not necessarily pass into history with the coming of the so-called Dark Ages. The Theodosian Walls protected Constantinople for another thousand years, not being breached until the city fell to the Ottoman Turks after a siege in 1453. And even then, the Ottomans restored the walls and kept them in repair for the first centuries of their rule.

So it is with many of the entries in this book: what was built by one power to defend against an enemy may well have been later used by that enemy against a new foe. The names changed, states rose and fell, but the forts remained.

And today it is the ruins of the forts that can tell us much about those lost worlds.

OPPOSITE:
Eleutherae, Attica, Greece
More than 2,000 years after its construction and more than 1,800 years since it was abandoned, parts of Eleutherae are still standing. One of the best-preserved fortresses of Ancient Greece, Eleutherae dates from 370–360 BCE. When first constructed, the walls averaged 2.6m (8ft 6in) thick and reached 860m (2,822ft) around the fortress.

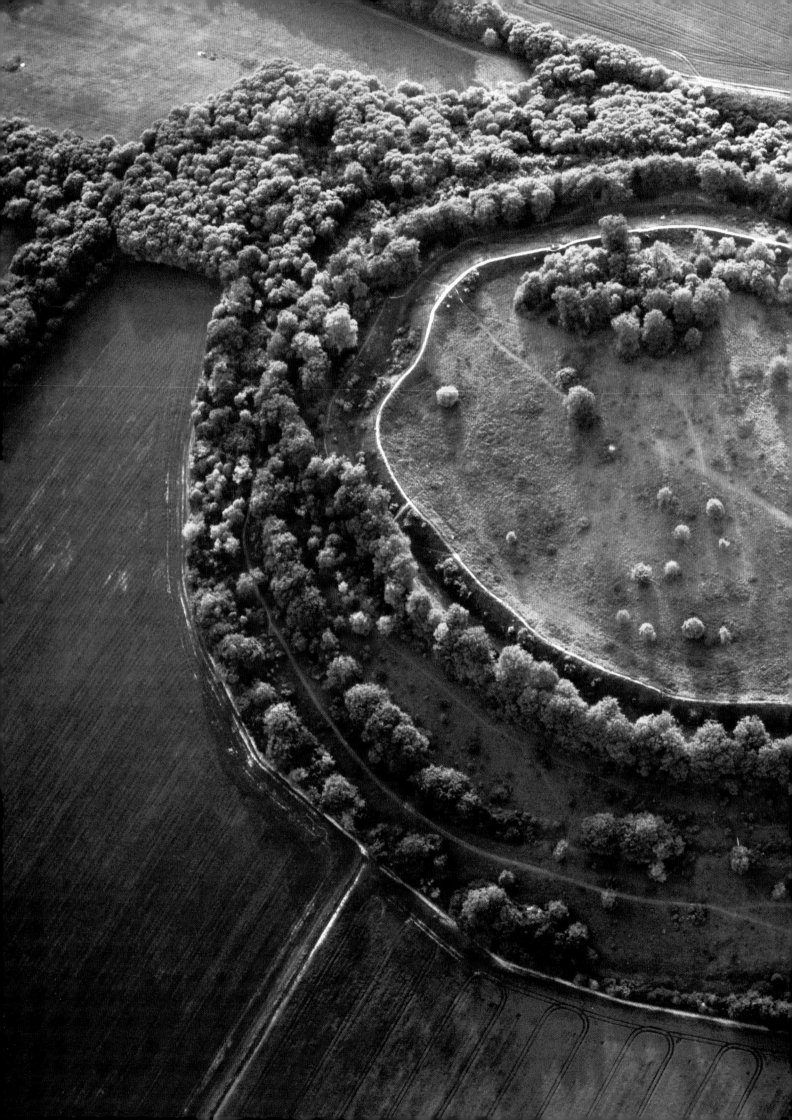

Danebury, Hampshire, England
An Iron Age hill fort, Danebury was built around 500 BCE and was occupied until around 100 BCE. In constructing the fort, a circular ditch was cut into the ground, and the chalk rubble from it, along with local clay soil, used to build ramparts. The fort was subsequently remodelled and expanded several times. Hill forts ceased to be used in Britain around 100 BCE and within 100 years Danebury only remained as a farm.

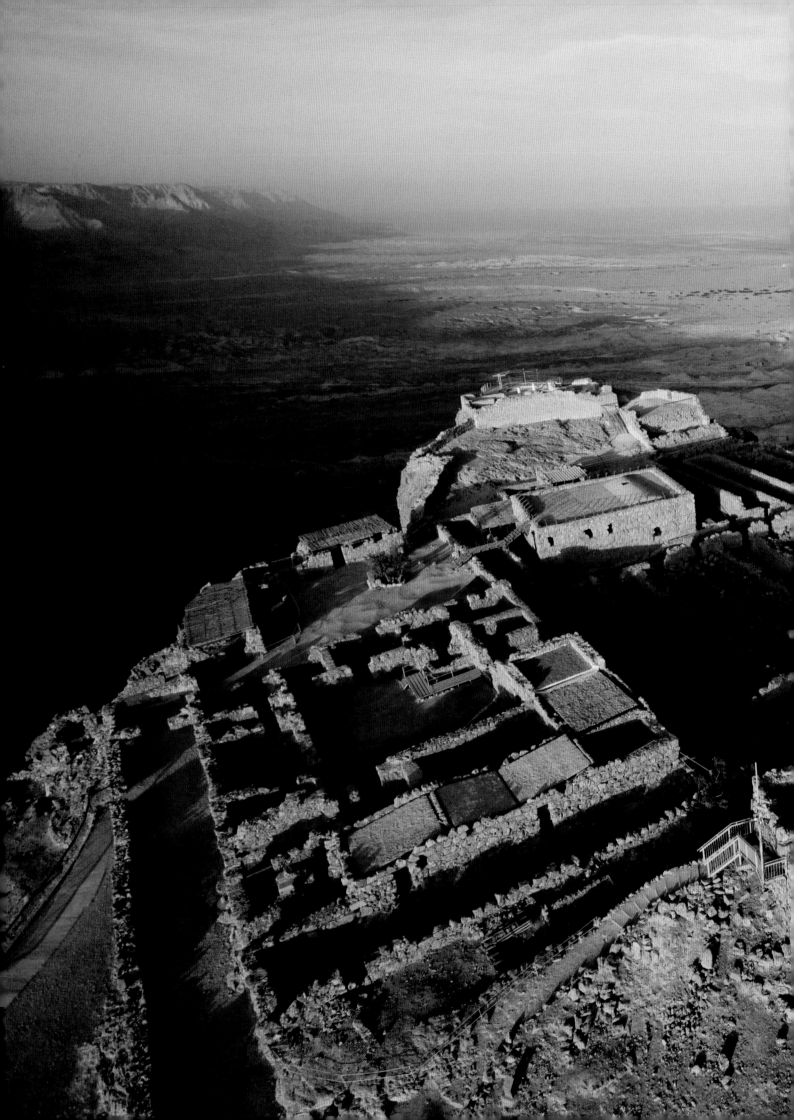

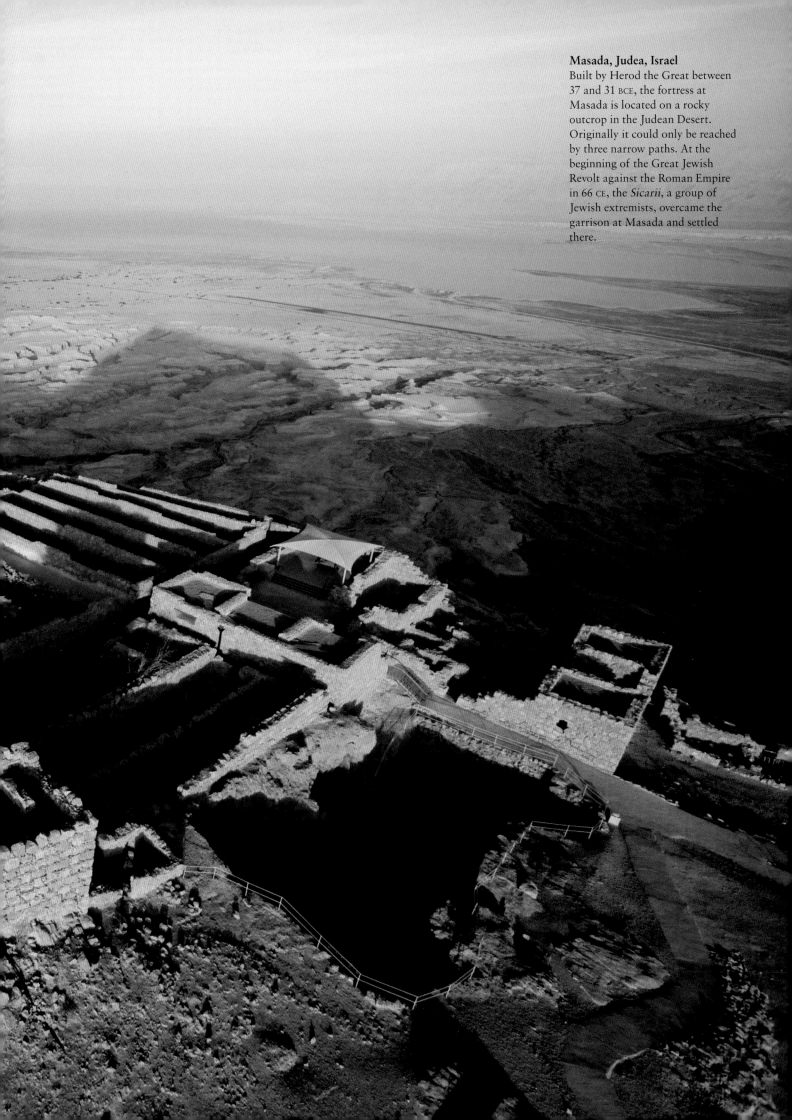

Masada, Judea, Israel
Built by Herod the Great between 37 and 31 BCE, the fortress at Masada is located on a rocky outcrop in the Judean Desert. Originally it could only be reached by three narrow paths. At the beginning of the Great Jewish Revolt against the Roman Empire in 66 CE, the *Sicarii*, a group of Jewish extremists, overcame the garrison at Masada and settled there.

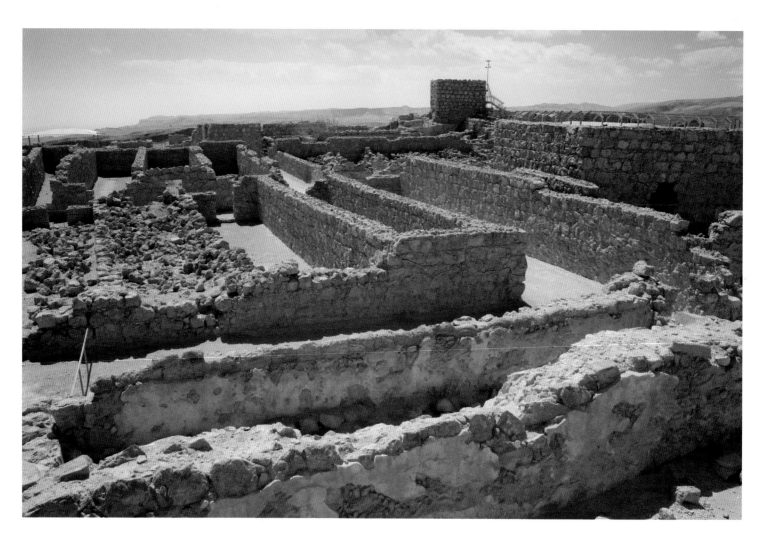

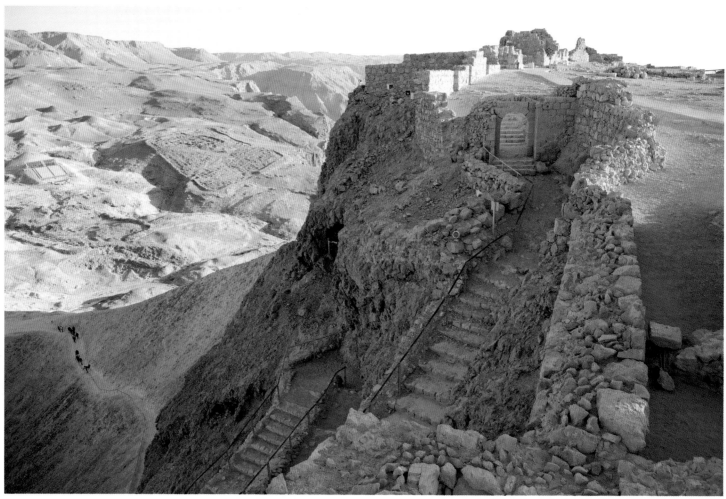

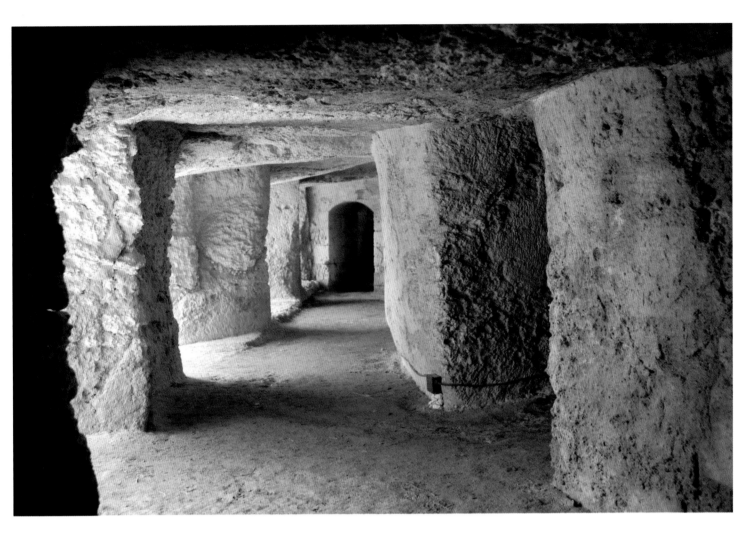

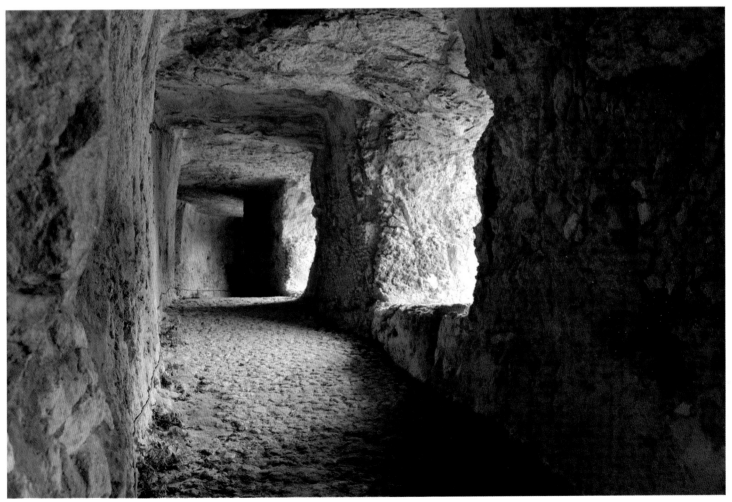

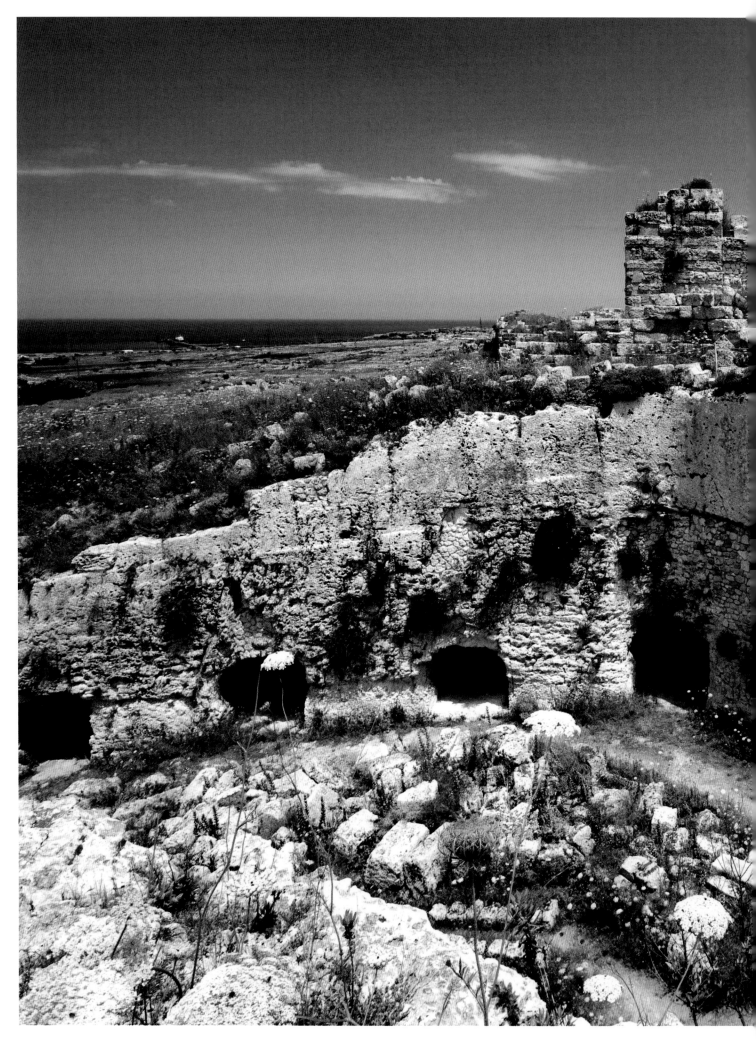

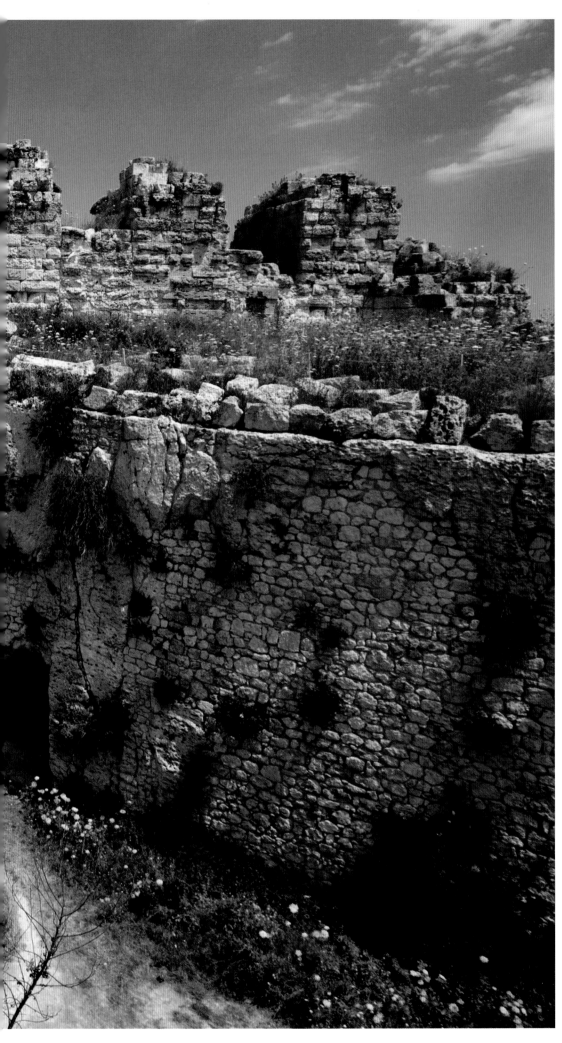

PREVIOUS PAGES:

TOP AND BOTTOM LEFT:

Masada, Judea, Israel

The *Sicarii* at Masada were joined by other Jews who had fled Roman persecution in Jerusalem. Then, in 72 CE, the Roman army besieged the fortress and over the course of three months built a ramp from which they launched an assault. We only have historian Flavius Josephus's account to rely on, but, according to him, the Romans found that all 960 inhabitants of Masada – with the exception of two women hidden in a cistern – had committed mass suicide rather than surrender.

TOP AND BOTTOM RIGHT:

Euryalus, near Syracuse, Sicily, Italy

First built between 402 and 397 BCE by the Greeks during a lull in the conflict with the Carthaginians, the fortress at Euryalus is part of Dionysius I's 27-km (16.7-mile) walls around the port of Syracuse. The numerous underground passages allowed troops to be moved around the site unseen by outsiders, enabling them to surprise attackers.

LEFT:

Euryalus, near Syracuse, Sicily, Italy

Euryalus's high position meant that it served as a look-out point for spotting enemy ships and therefore a base from which to send cavalry to prevent a landing. Despite many attempts, the castle was not taken until Syracuse fell to the Romans in 212 BCE. Even then, the Romans did not expect to be able to conquer the castle, the captain of the Greek garrison at Euryalus only giving in after other quarters of the city had either surrendered or been captured.

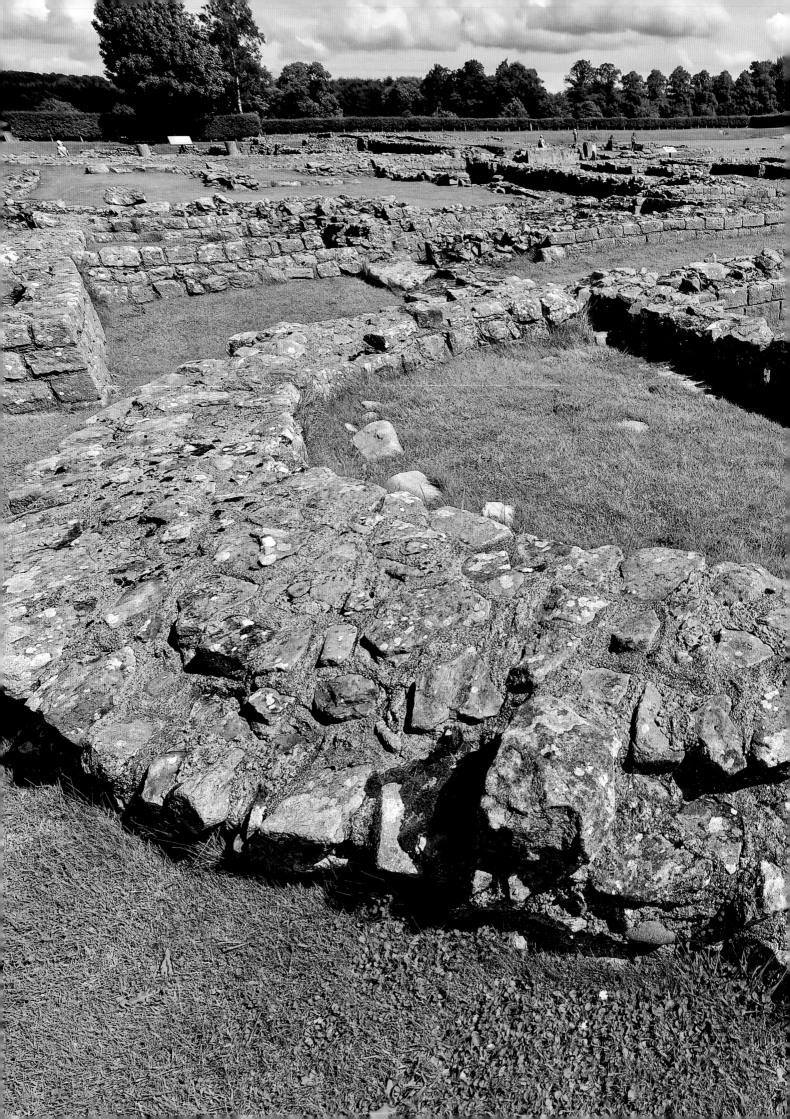

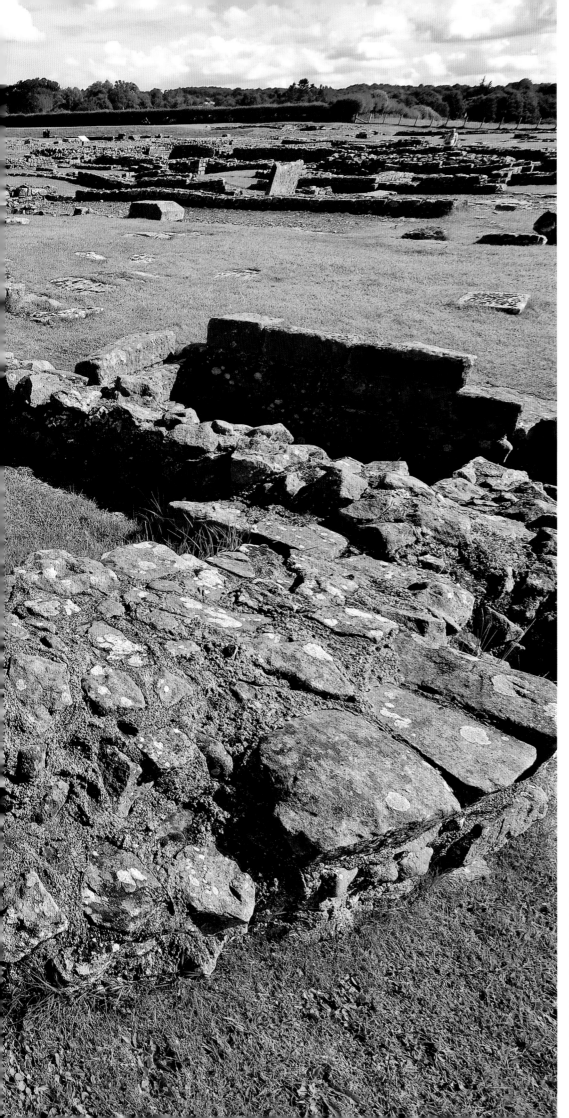

Coria, Northumberland, England
Coria was a fort first built in 84 CE when the Romans were pushing through northern England into Scotland. In 122 CE, the Romans began to build Hadrian's Wall, which would stretch 117km (73 miles) across the width of northern England, and for a time marked the northern extremity of the Roman Empire. Coria, just 4km (2.5 miles) south of the wall, became one of its supporting forts.

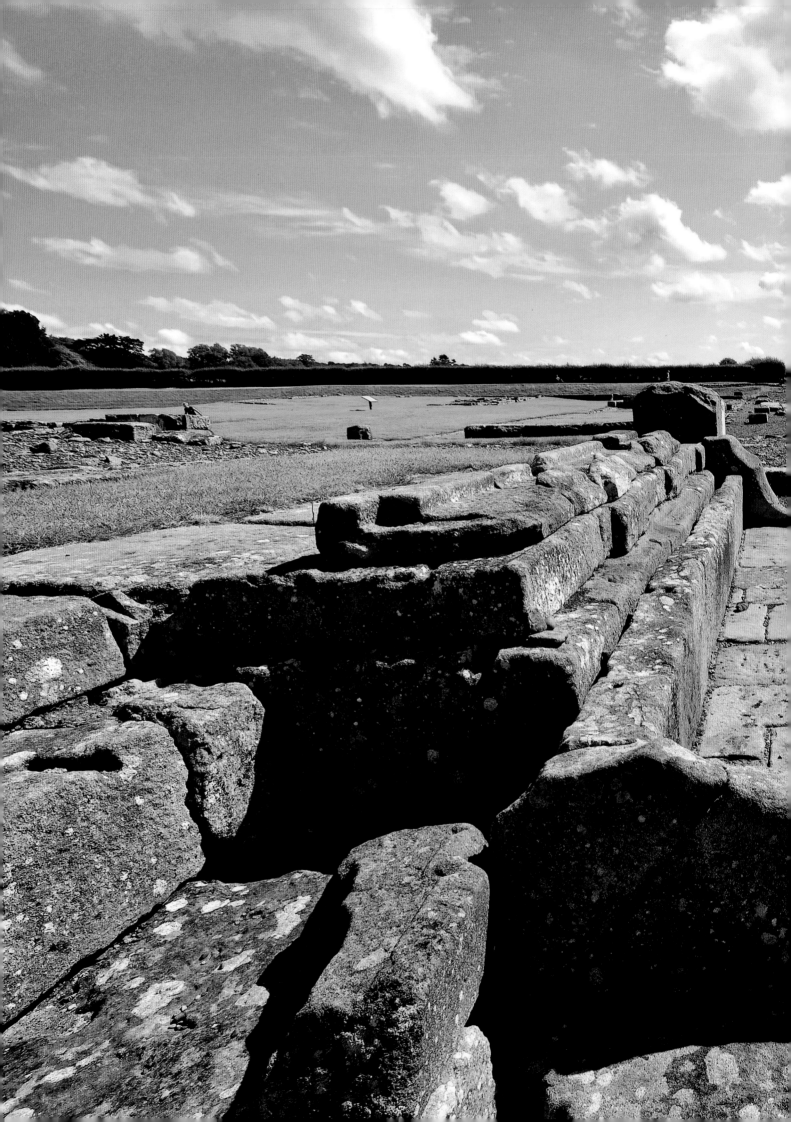

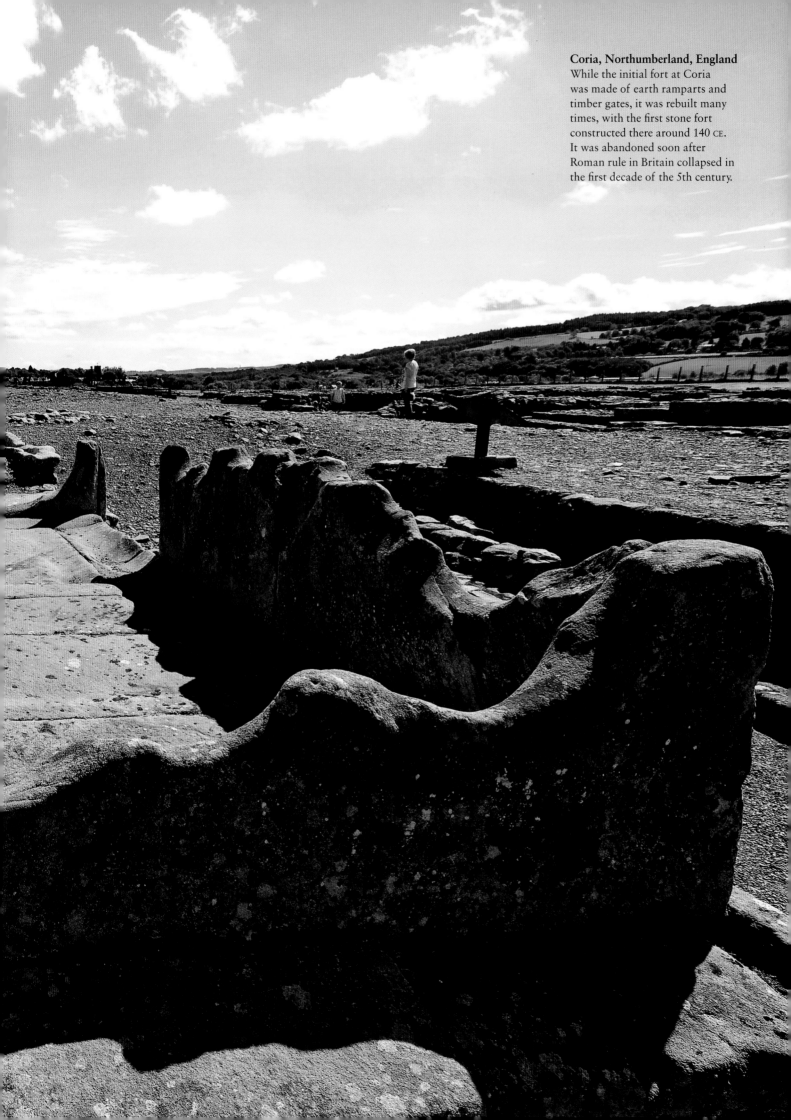

Coria, Northumberland, England
While the initial fort at Coria was made of earth ramparts and timber gates, it was rebuilt many times, with the first stone fort constructed there around 140 CE. It was abandoned soon after Roman rule in Britain collapsed in the first decade of the 5th century.

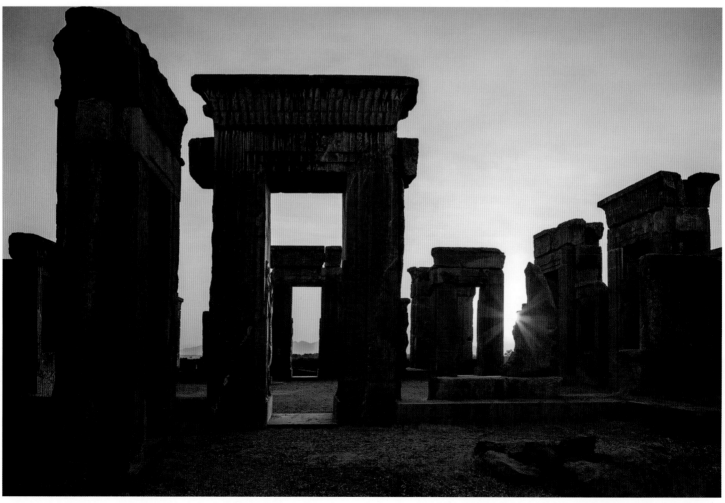

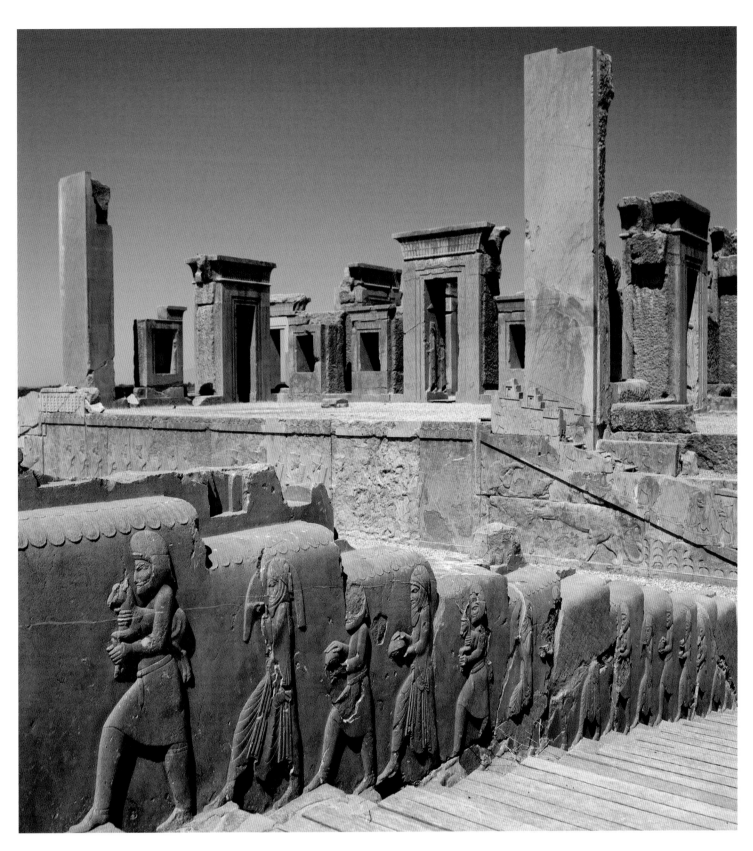

OPPOSITE TOP:

Qal'at al-Bahrain, Bahrain
Qal'at al-Bahrain (Bahrain Fort) dates from the 6th century CE, though excavations have shown that settlements existed on the site from as early as 2300 BCE, when the port was the capital of the Dilmun Civilization. In the ancient world, it held a central place in Mesopotamian trade routes.

OPPOSITE BOTTOM:

Darius's Palace, Persepolis, Iran
The ceremonial capital of the Achaemenid Empire (ca. 550–330 BCE), Persepolis's earliest remains date back to 515 BCE, during the reign of Darius I (522–486 BCE). Persepolis fell in 330 BCE to Alexander the Great's Macedonian forces, who looted the city before setting it on fire.

ABOVE:

Darius's Palace, Persepolis, Iran
Twelve columns supported the roof of the central hall of Darius's palace – also known as the *Tachara* (the Winter Palace). Reliefs on the three stairways show servants carrying animals and food in covered dishes. While the palace's mud-block walls have disintegrated, the grey stone door and window frames have survived.

OVERLEAF:

Circular Tower, Coastal Fortress, Qal'at al-Bahrain, Bahrain
Archaeologists have determined that the fortress was not built before the 3rd century CE and was largely abandoned at the end of the 5th century. For a time it became active again in the 13th century, when trade with China reached Bahrain. The following century it fell into ruin.

23

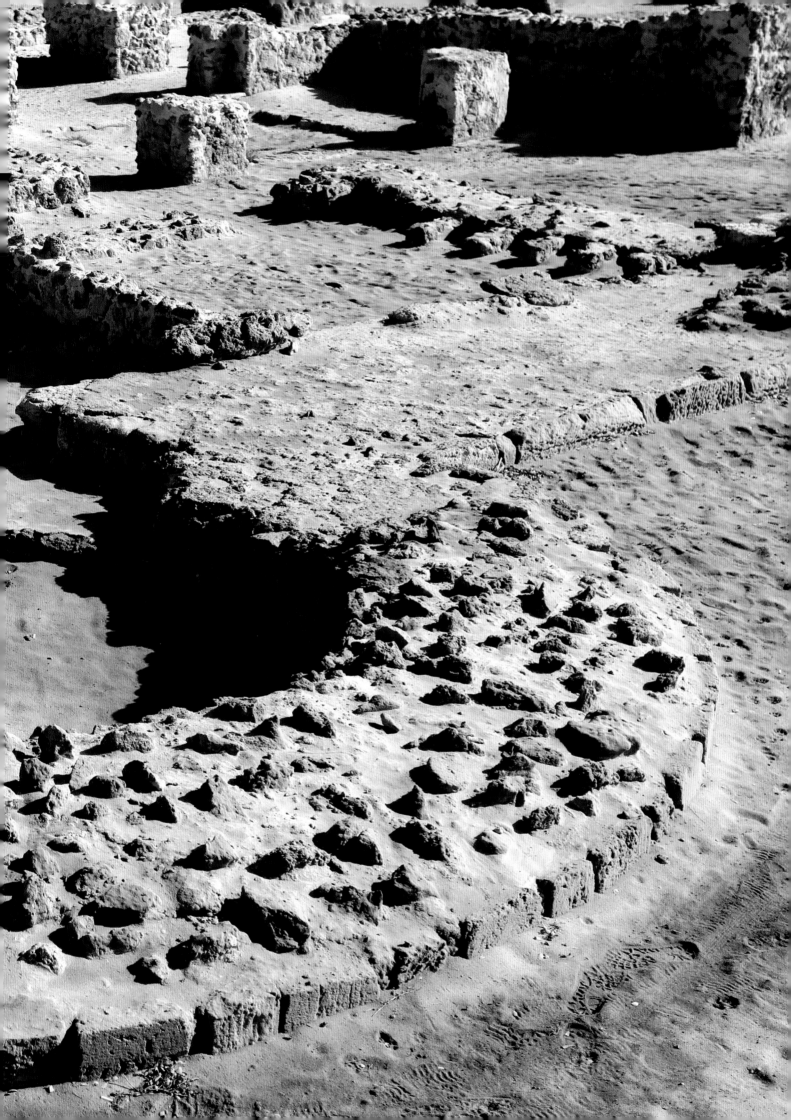

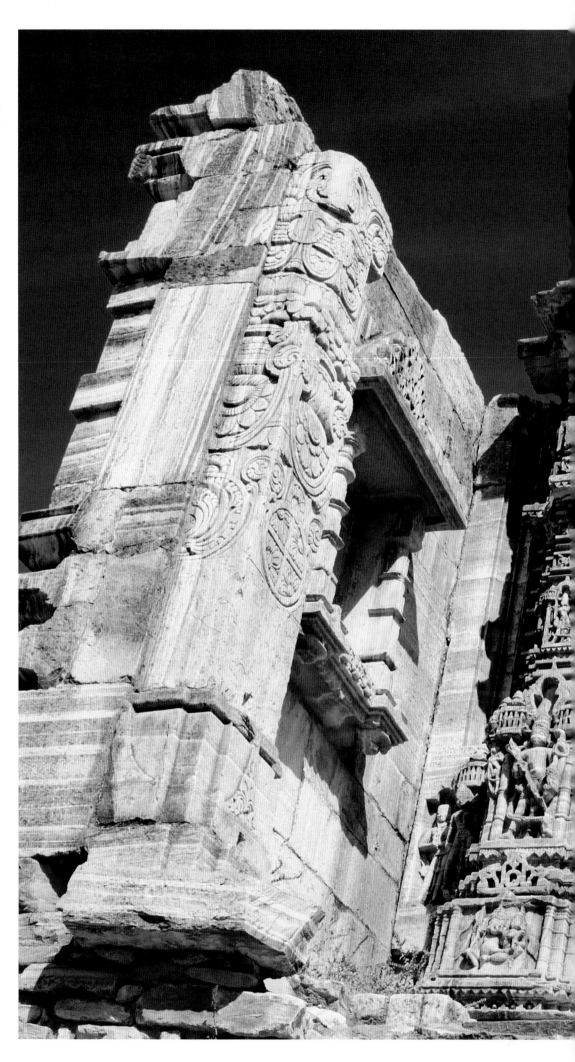

RIGHT:

Chittorgarh, Rajasthan, India
One of the largest forts in India,
Chittorgarh sits on a high ridge.
First occupied by the Mewar
kingdom in the 7th century CE, the
sprawling site now houses palaces,
gates and commemorative towers
built up to the 16th century.
Rising in the background of this
photograph is Chittorgarh's Vijay
Stambha, a victory monument
erected by the Mewar king Rana
Kumbha in 1448 to commemorate
his victory over the combined
armies of Malwa and Gujarat.
Its walls are covered in sculptures
depicting scenes from Hindu
mythology.

OVERLEAF:

Maiden Castle, Dorset, England
First built around 600 BCE, the
Iron Age hill fort at Maiden was
expanded to reach 19 hectares
(47 acres) in around 450 BCE,
making it the largest hill fort in
Britain and, possibly, in Europe.
Defences consisted of a series
of ditches and ramparts. It was
abandoned by the end of the 1st
century CE, although in the 4th
century a Romano-Celtic temple
was built on the eastern half.

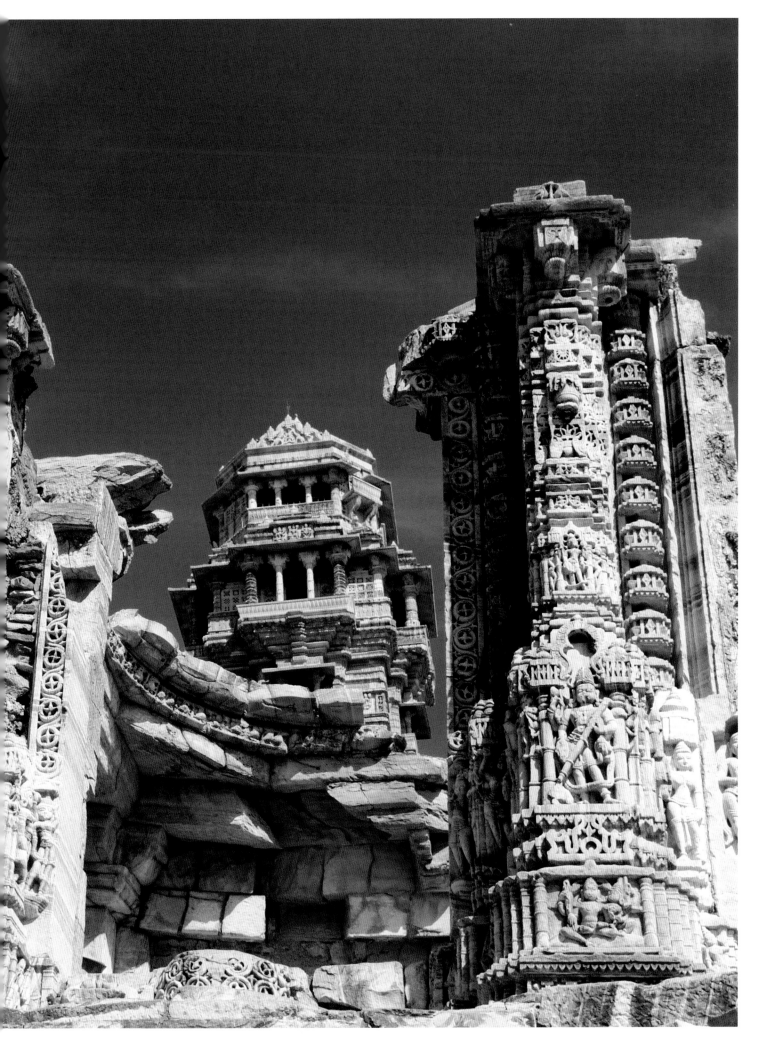

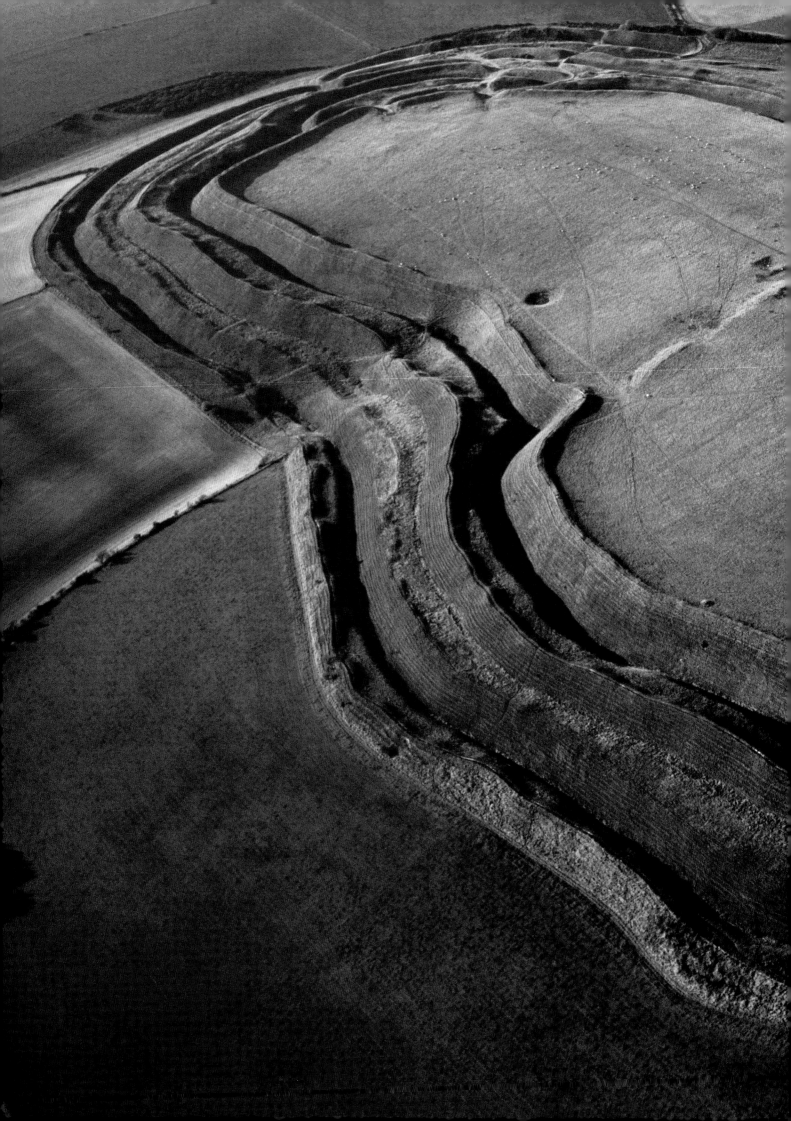

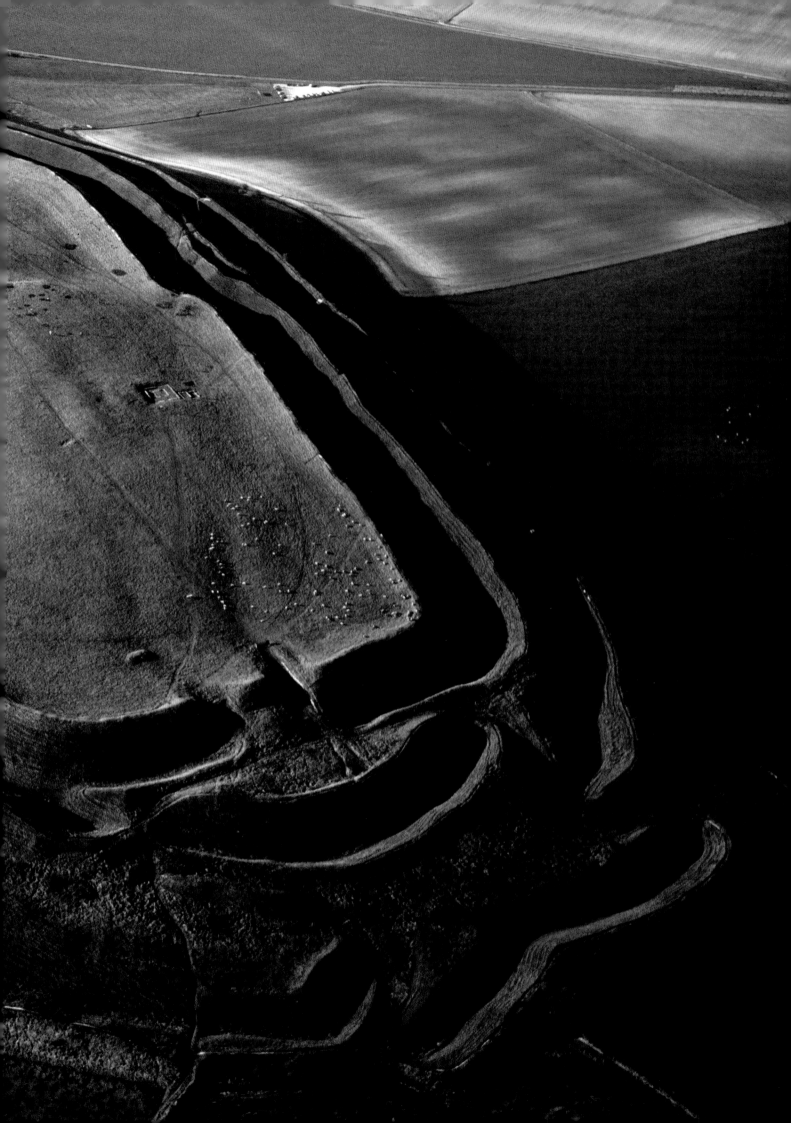

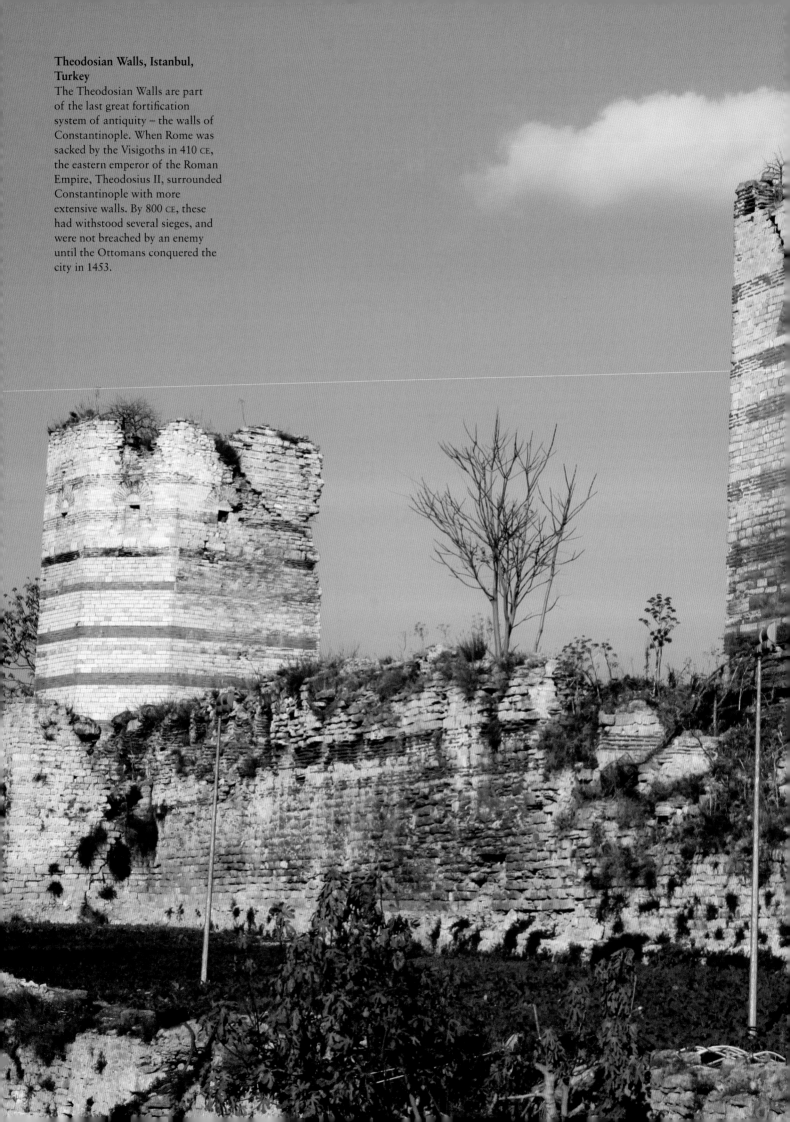

Theodosian Walls, Istanbul, Turkey

The Theodosian Walls are part of the last great fortification system of antiquity – the walls of Constantinople. When Rome was sacked by the Visigoths in 410 CE, the eastern emperor of the Roman Empire, Theodosius II, surrounded Constantinople with more extensive walls. By 800 CE, these had withstood several sieges, and were not breached by an enemy until the Ottomans conquered the city in 1453.

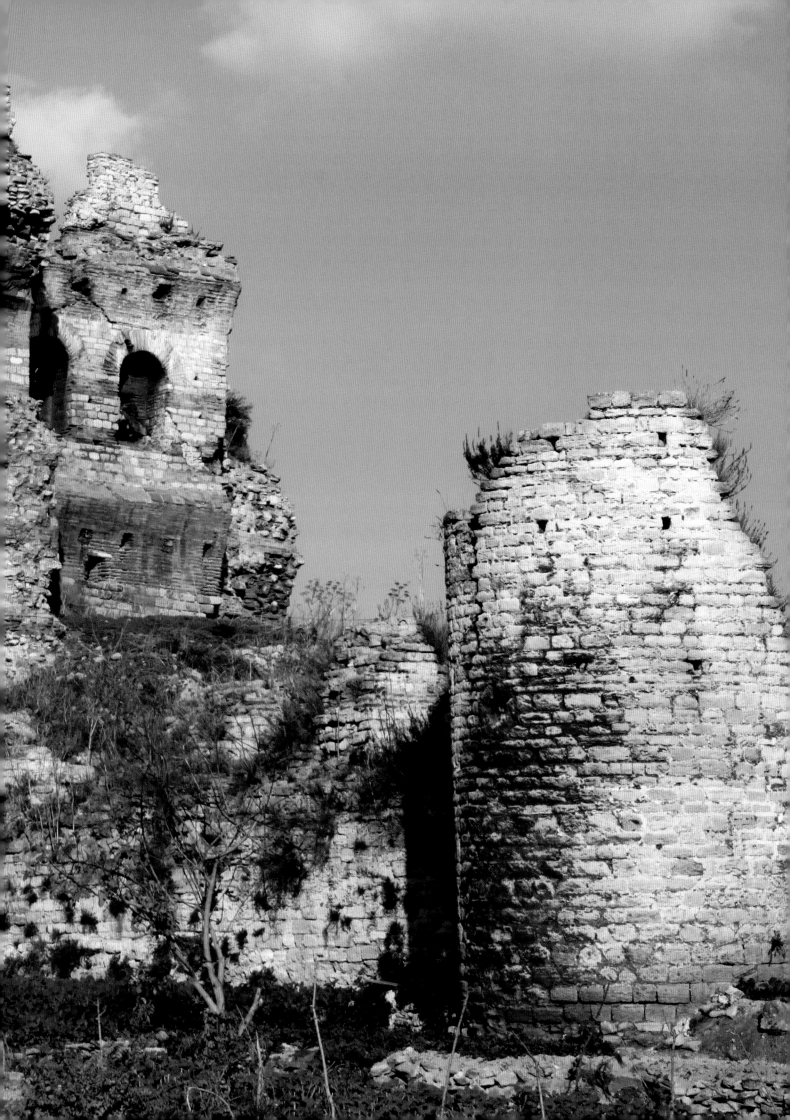

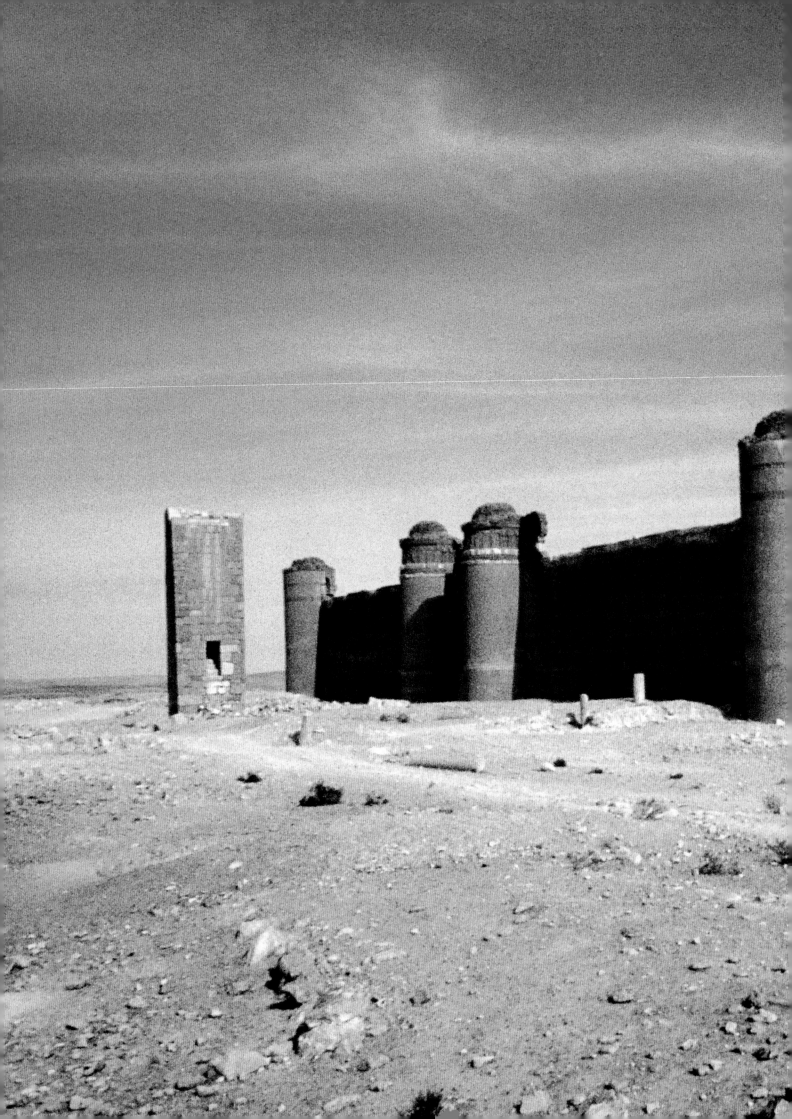

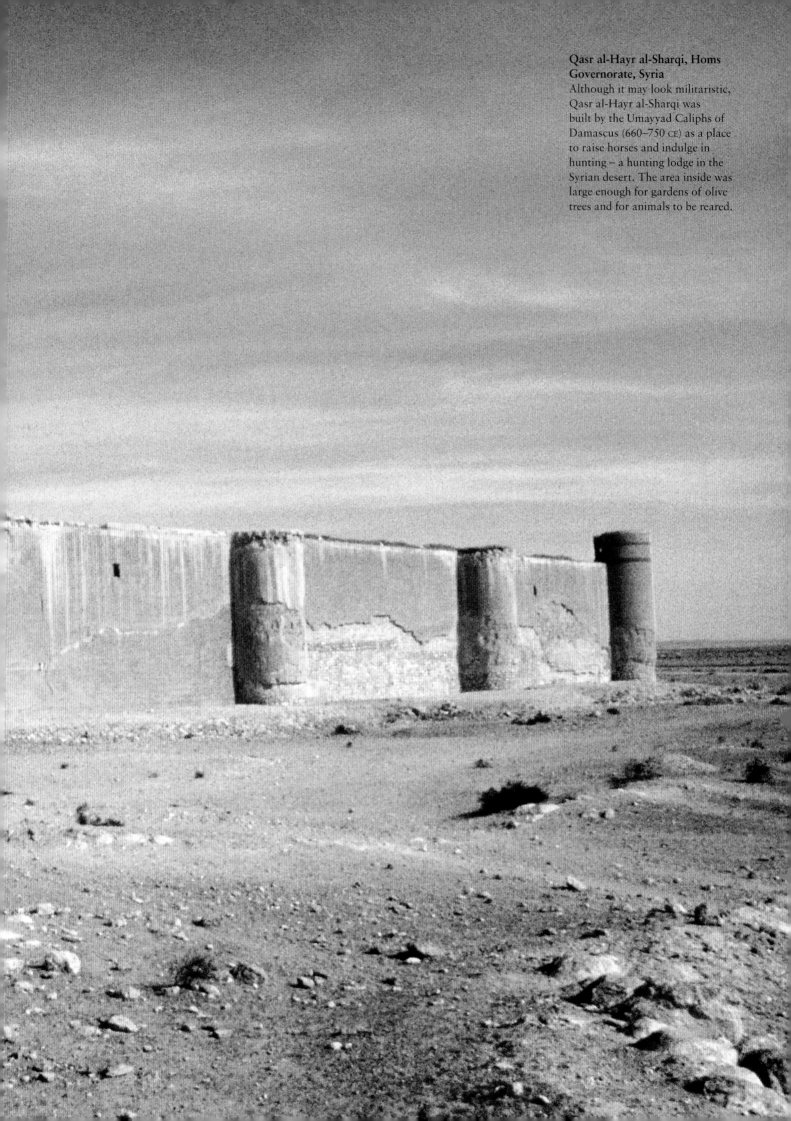

Qasr al-Hayr al-Sharqi, Homs Governorate, Syria
Although it may look militaristic, Qasr al-Hayr al-Sharqi was built by the Umayyad Caliphs of Damascus (660–750 CE) as a place to raise horses and indulge in hunting – a hunting lodge in the Syrian desert. The area inside was large enough for gardens of olive trees and for animals to be reared.

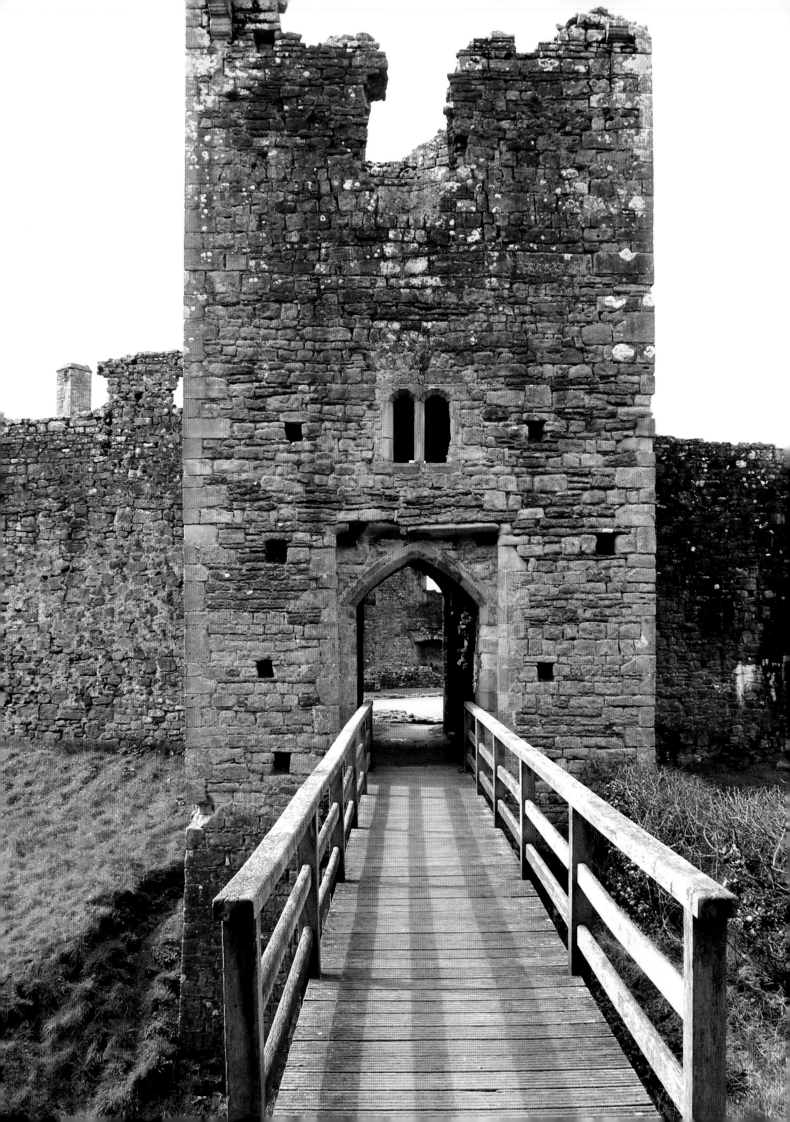

Early Medieval Period

The number of castles in Europe increased sharply from the 10th century. To give one example, in Provence in southern France in 950 CE, there were 12 castles, by the year 1000 there were 30, and 30 years later there were more than 100. And, as earth and timber castles gave way to stone ones, more have survived to the present day.

Early medieval castles, at their simplest, consisted of a basic rectangular keep, or donjon – from which we derive the English word dungeon. But, as castle building advanced through the Middle Ages, the buildings gained the characteristics by which we know them. By 1200 many featured high walls, towers and moats.

The castles in these pages range from those captured by the Christians from the Muslims in Spain to those taken by the Muslims from Crusaders in the Middle East, and from Indian forts to Richard the Lionheart's magnificent Château Gaillard in Normandy.

Today, most of these castles may be abandoned and largely ruined for centuries, but they have not all been consigned to history. Beaufort Castle is a 12th-century crusader fortress in Lebanon, but in the 1970s it was occupied by the Palestinian Liberation Organization (PLO) and shelled by Israeli forces before they captured it. Strategically situated and robustly built, some of these buildings have served a purpose in the modern world.

OPPOSITE AND OVERLEAF:
Coity Castle, Glamorgan, Wales
A stone keep was first built at Coity by the Normans in the 12th century. This was reworked and expanded throughout the 14th–16th centuries. In a dispute over succession in 1412, William Garnage and Sir Gilbert Denys led armed men to besiege Coity and oust Lady Joan Verney from it. In response, Henry IV authorized the local authorities to end the siege, and Garnage and Denys found themselves imprisoned in the Tower of London. However, after the king's death the following year, the two were released and, in time, Garnage's claim on the castle proved successful.

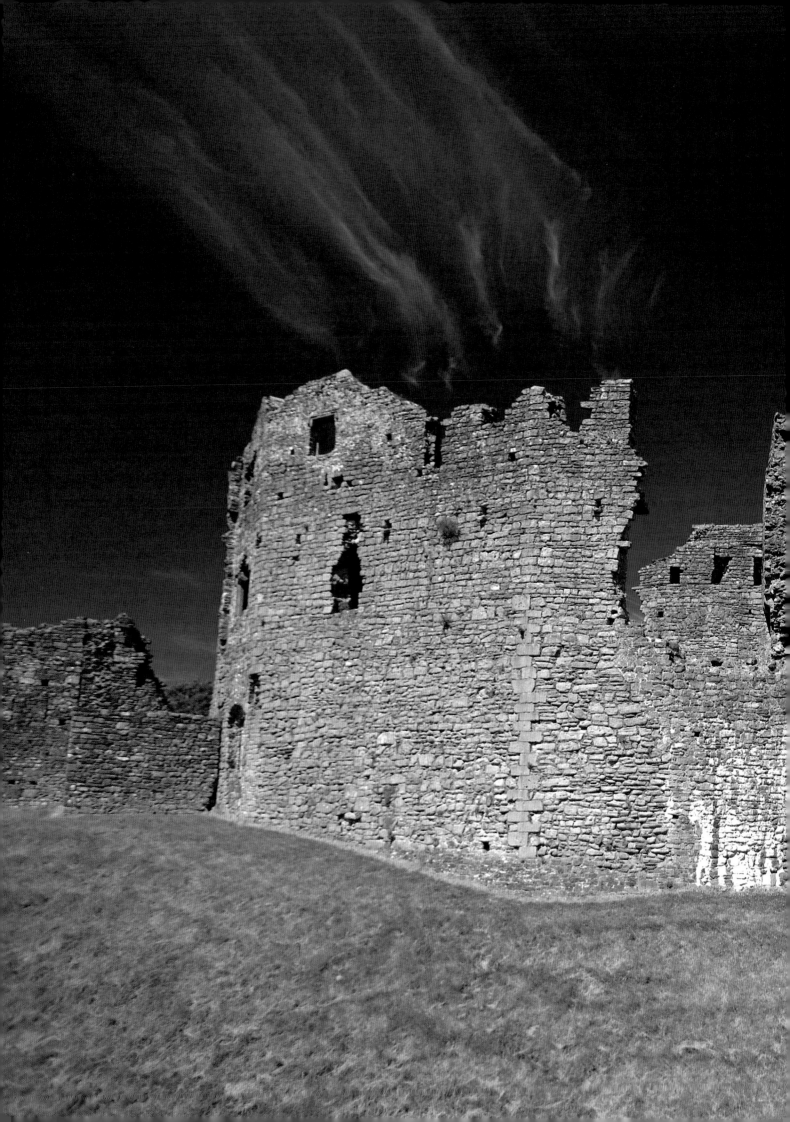

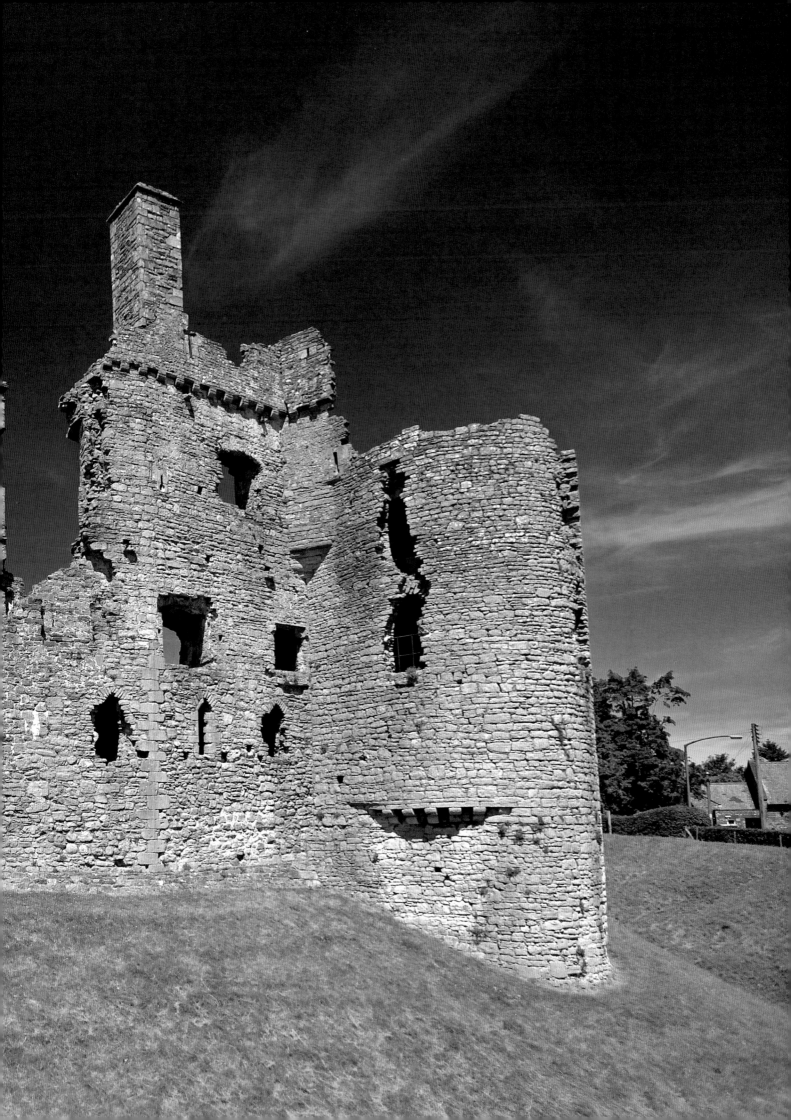

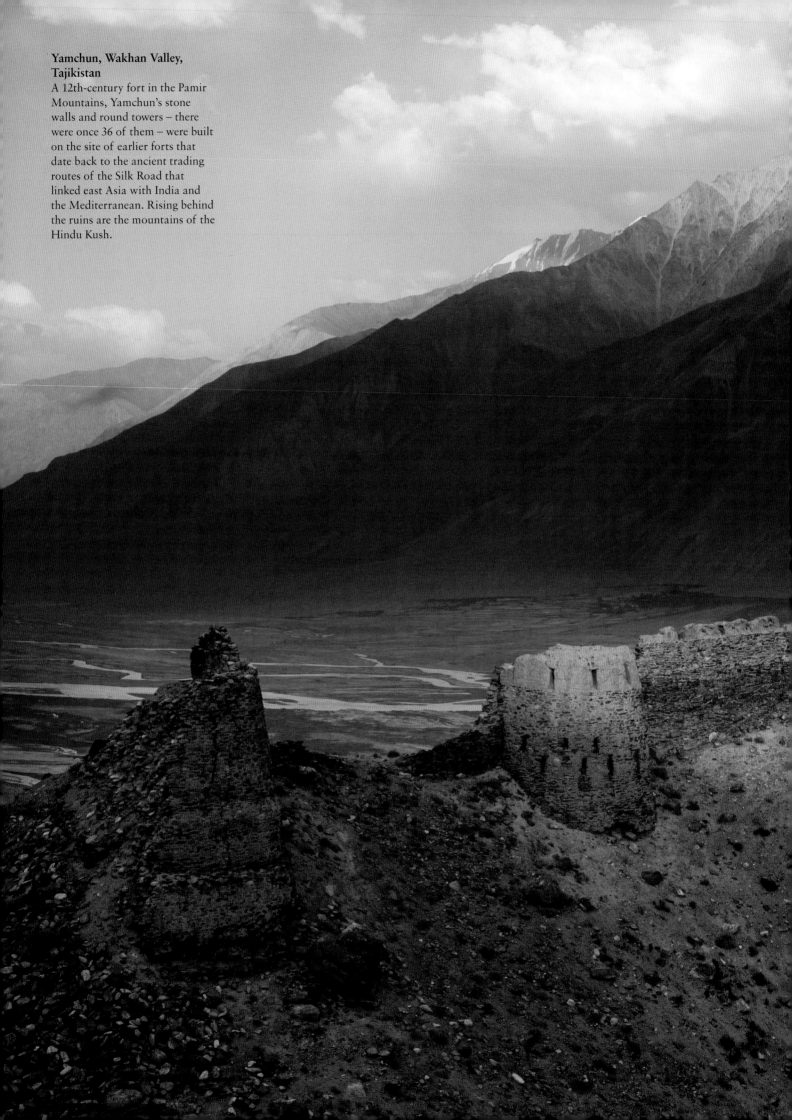

Yamchun, Wakhan Valley, Tajikistan
A 12th-century fort in the Pamir Mountains, Yamchun's stone walls and round towers – there were once 36 of them – were built on the site of earlier forts that date back to the ancient trading routes of the Silk Road that linked east Asia with India and the Mediterranean. Rising behind the ruins are the mountains of the Hindu Kush.

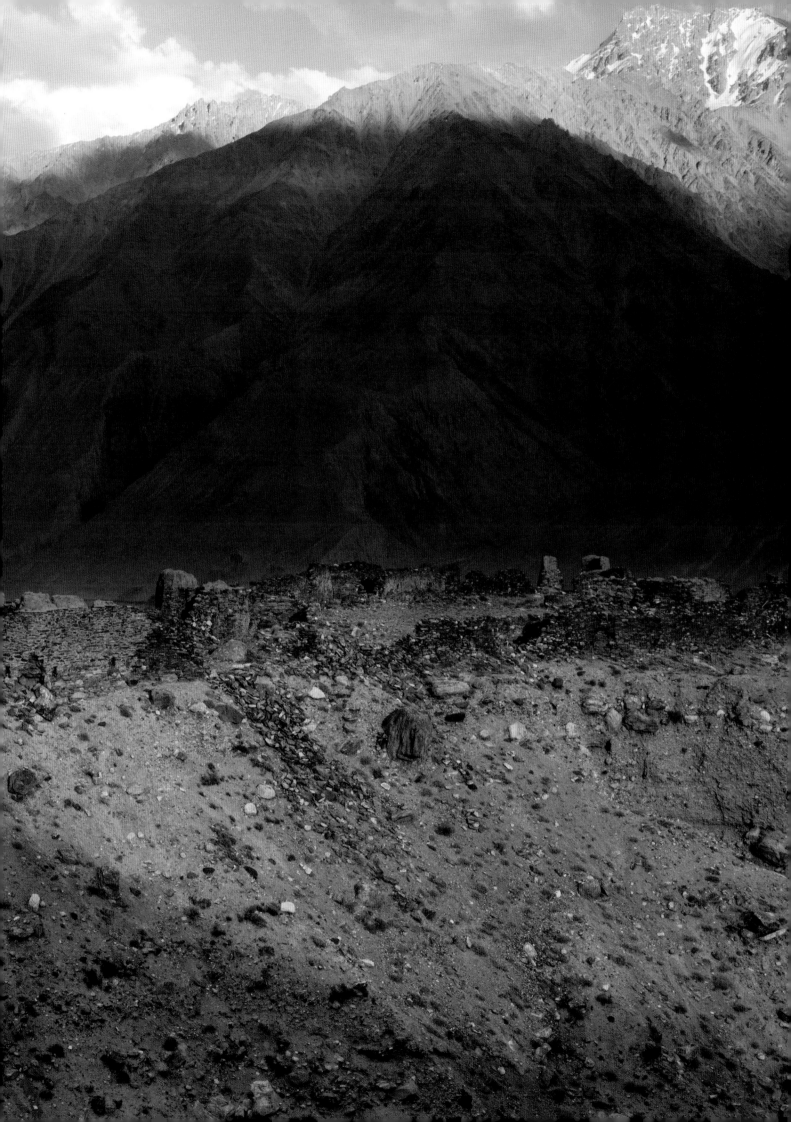

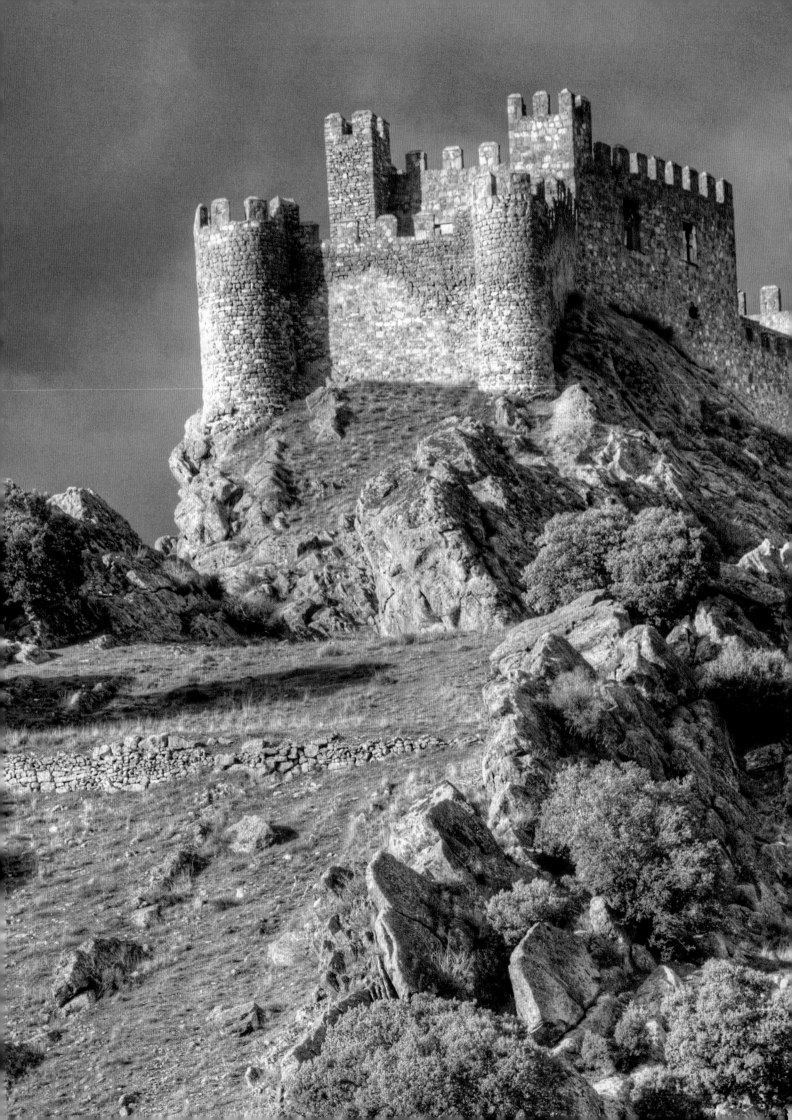

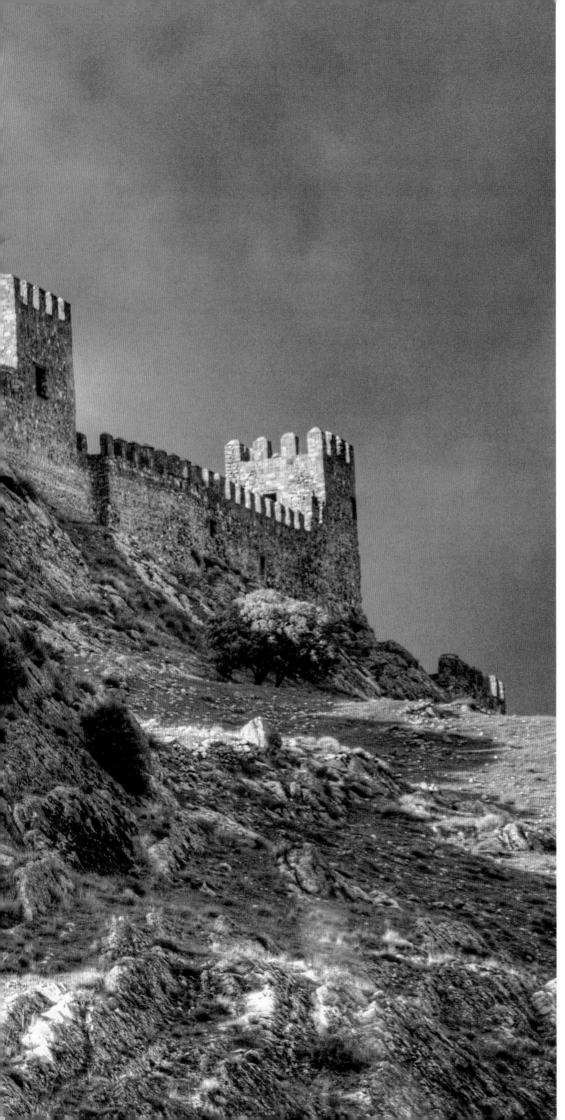

Riba de Santiuste, Guadalajara, Spain
Built by Muslim rulers in the 9th century when most of Spain was under Islamic occupation, Riba de Santiuste was a defence both against other Spanish Muslim kingdoms and Christians to the north. Reinforcements and extensions were made in the 12th and 13th centuries after the territory had been reconquered by Christians.

Riba de Santiuste, Guadalajara, Spain
In the mid-15th century, Riba de Santiuste was taken from the Castilians by the Navarrese, before a five-month siege restored it to the Castilians. In 1811 the castle was made unusable by French invaders so that it couldn't serve as a refuge for guerrilla forces during the Napoleonic Wars.

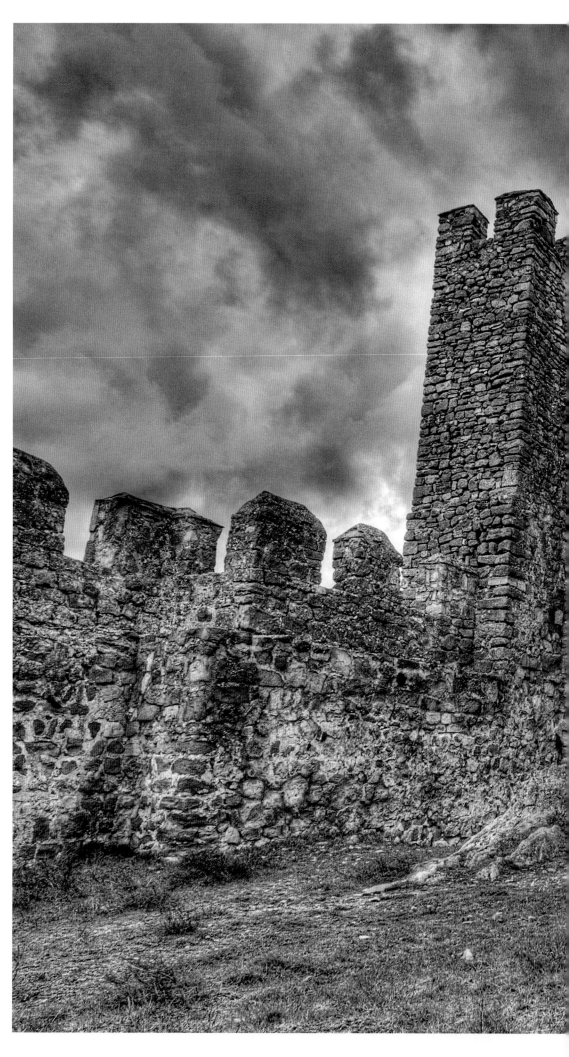

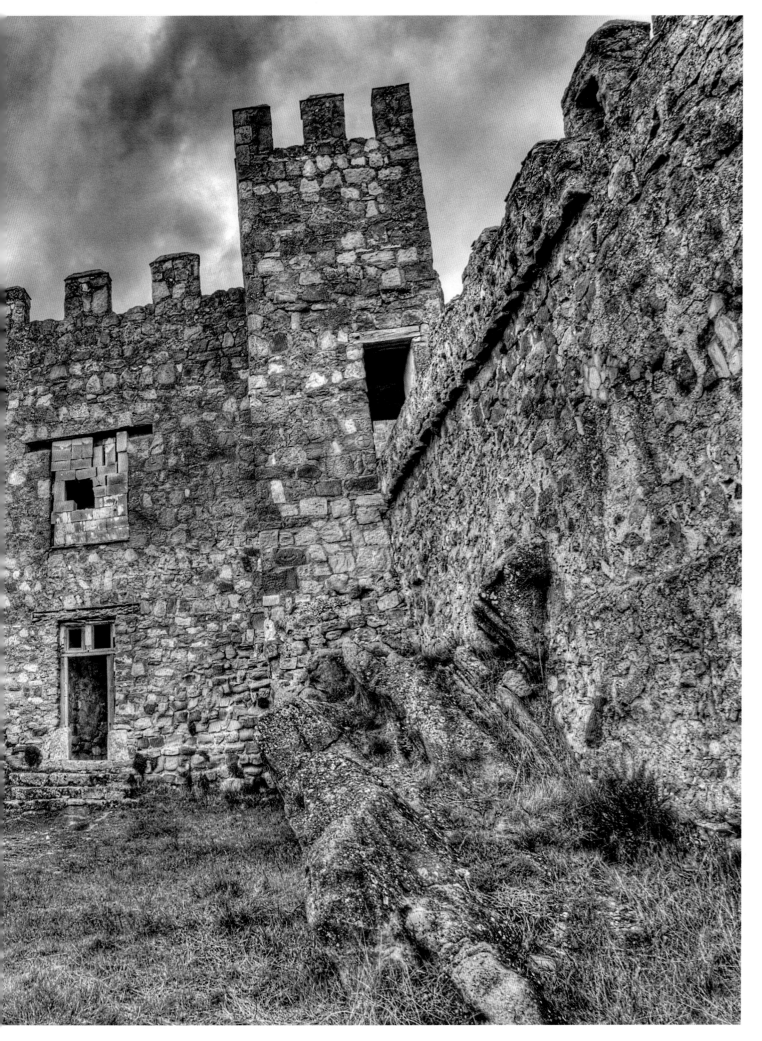

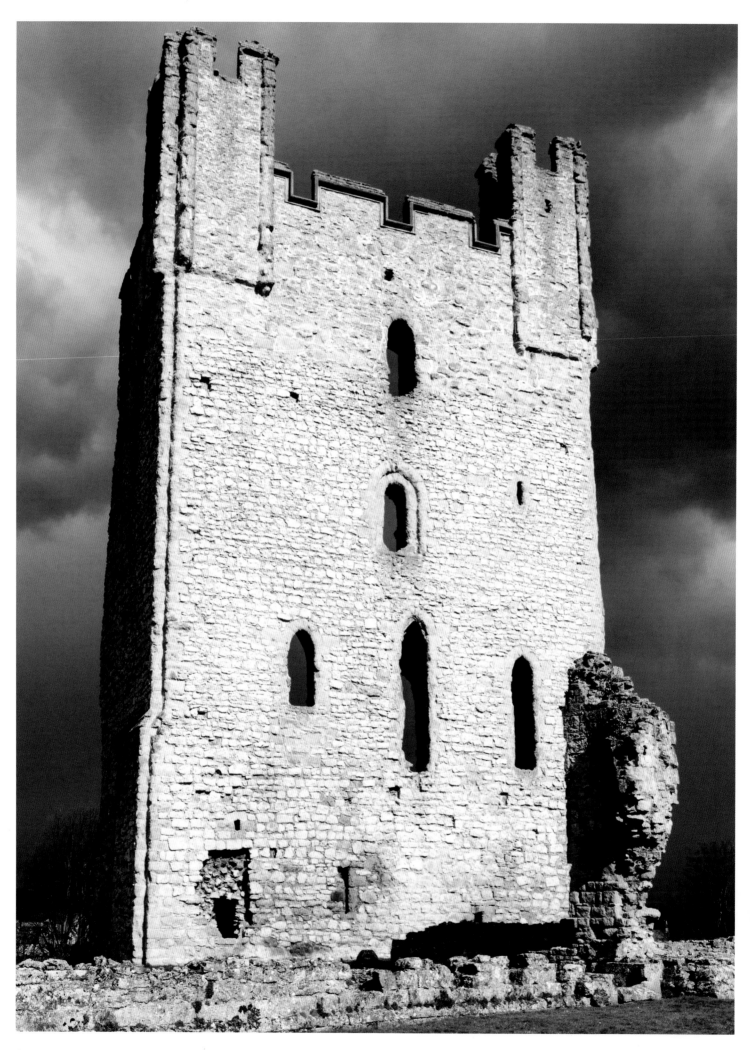

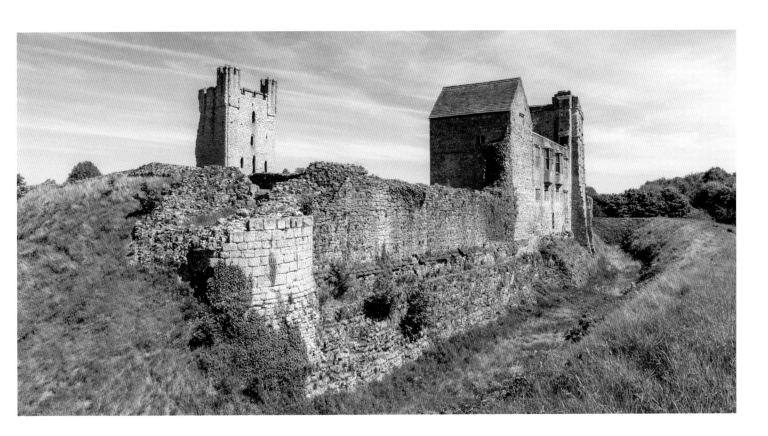

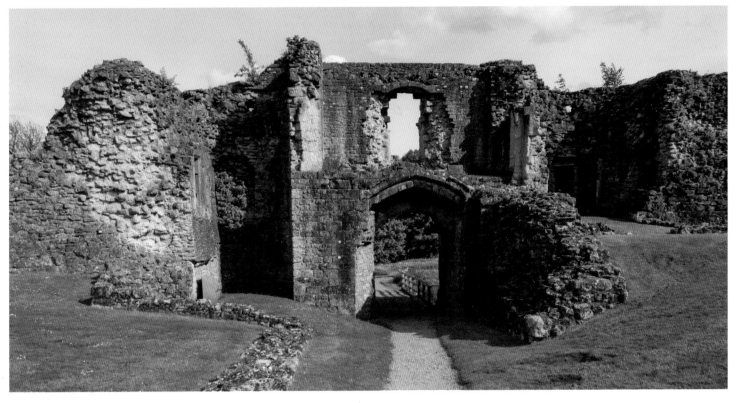

Helmsley Castle, North Yorkshire, England

The first stone castle at Helmsley was begun in 1186, before being expanded the following century. Having been knighted on the eve of the Civil War by Charles I, Royalist Jordan Crosland was besieged at Helmsley for three months before being forced to surrender to Parliamentarian Thomas Fairfax. Under Parliament's orders, the castle was made unusable, with walls, gates and parts of the East Tower destroyed. In the early 18th century, the owner commissioned a new house to be built nearby and left the castle to fall into ruin.

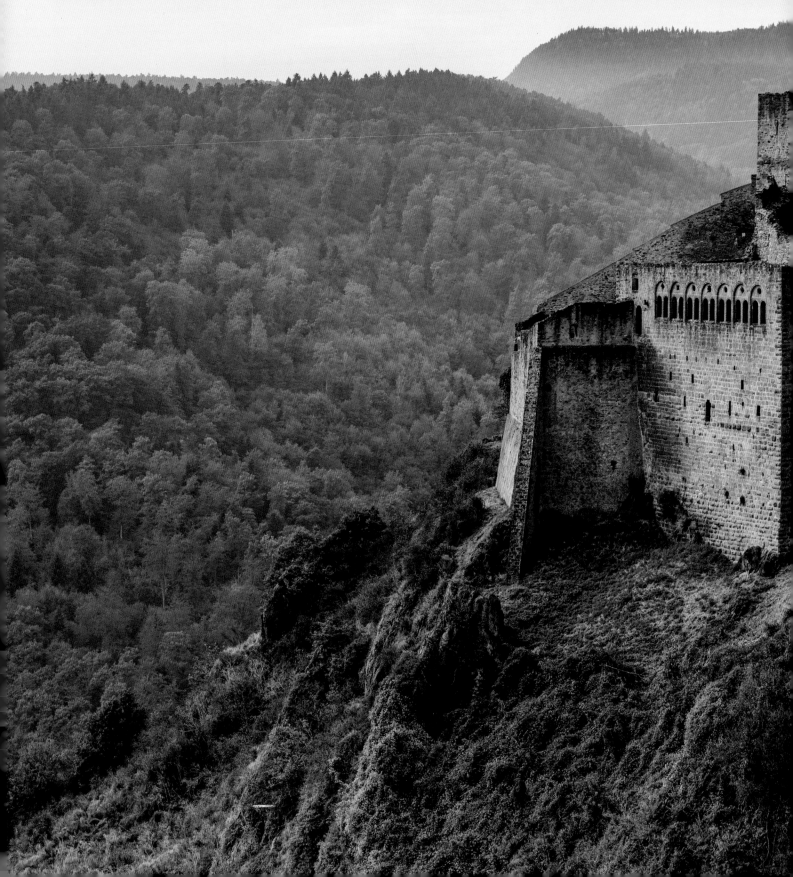

Château de Saint-Ulrich, Haut-Rhin, France

At an altitude of 528m (1732ft), Château de Saint-Ulrich is one of three castles that overlook the town of Ribeauvillé in the far east of France. First built in the 11th century and expanded over the following centuries, the château was home to the lords of Ribeaupierre until the 16th century, when the family moved to a nearby mansion.

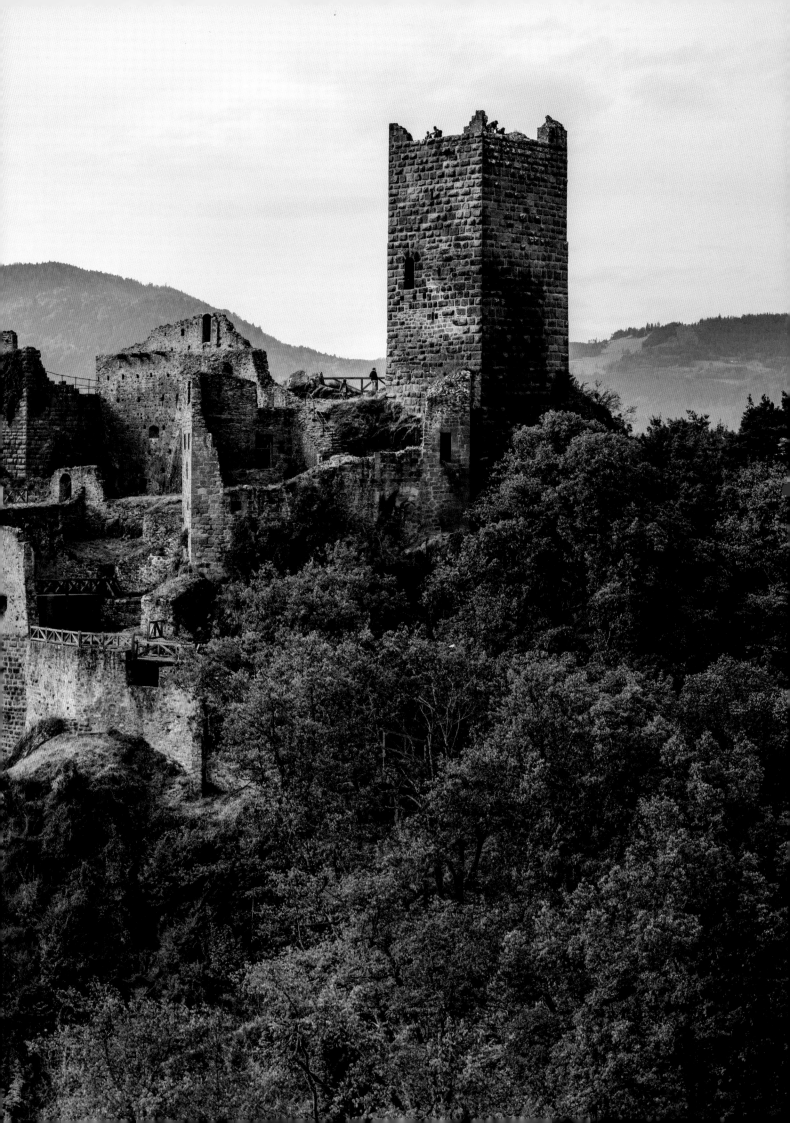

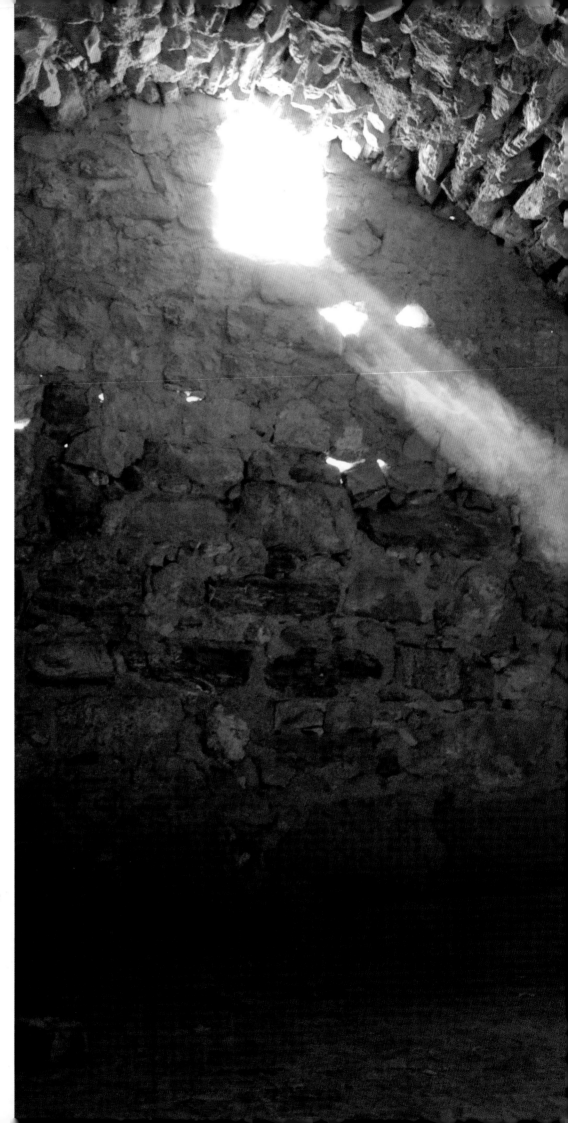

RIGHT AND TOP LEFT OVERLEAF:

Crac des Chevaliers, Homs Governorate, Syria

Built by the crusader Knights Hospitaller in the 1140s, Crac des Chevaliers was lost in 1271 after a 36-day siege by the Mamluk sultan Baibars. Although it may appear to be a typically robust crusader castle, the external fortifications we see today were developed after Muslim rulers had taken the castle from the Hospitallers.

OVERLEAF:

BOTTOM LEFT:

Beaufort Castle, Nabatieh Governorate, Lebanon

Beaufort Castle also fell to Baibars in the 13th century. By the mid-19th century, war and an earthquake had left the castle in ruins. But a medieval castle can still have a function in the modern world: in 1976, the Palestinian Liberation Organization (PLO) occupied the castle, making it a target for Israeli shells before the Israeli army captured it in 1982.

TOP RIGHT:

Spis Castle, Kosice, Slovakia

Spis is one of the largest castle sites in Europe. First built in the Romanesque style in the 12th century, Gothic additions were later made and the castle was completely reconstructed in the 15th century. Abandoned in the 1700s, the castle burned down later that century.

BOTTOM RIGHT:

Araburg Castle, Lower Austria, Austria

Araburg, which dates from the 12th century, served as a place of refuge when besieged by the Turks in 1529 and again in 1683 – a siege that resulted in the destruction of most of the castle.

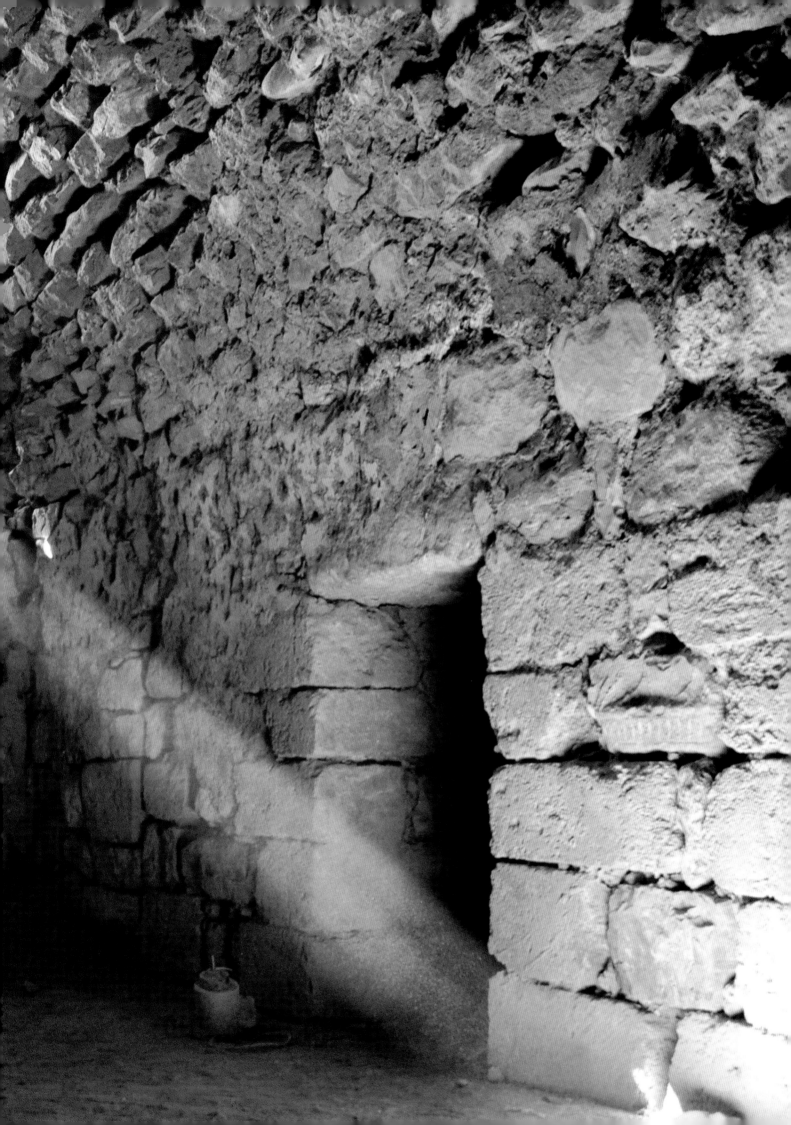

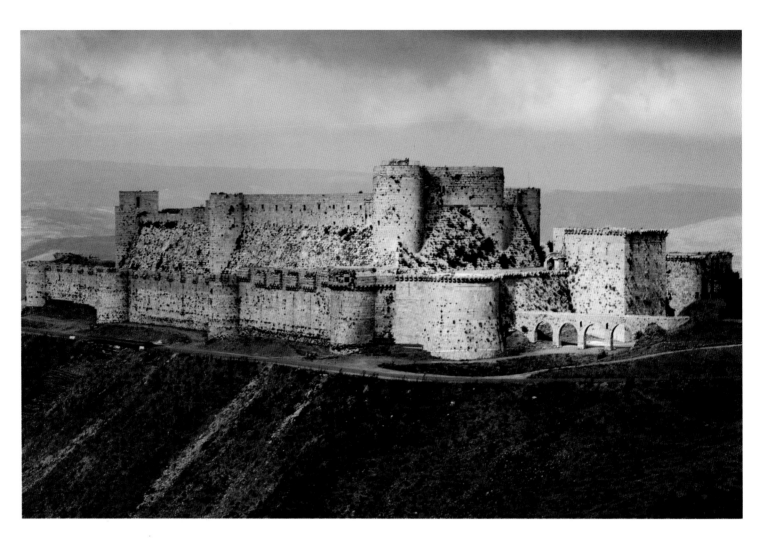

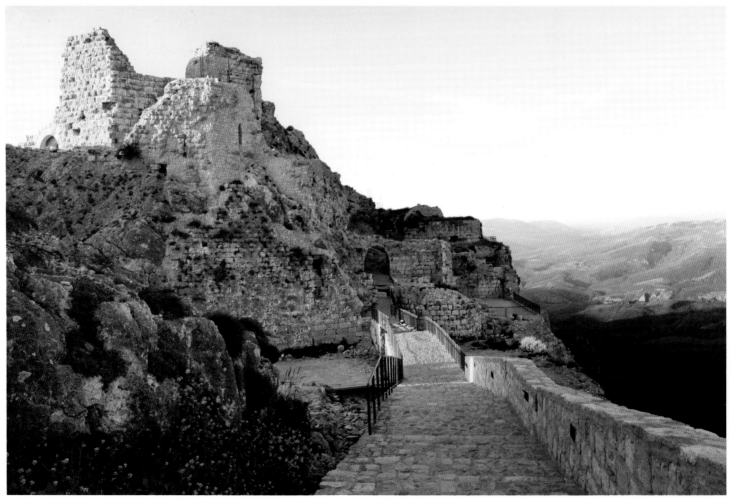

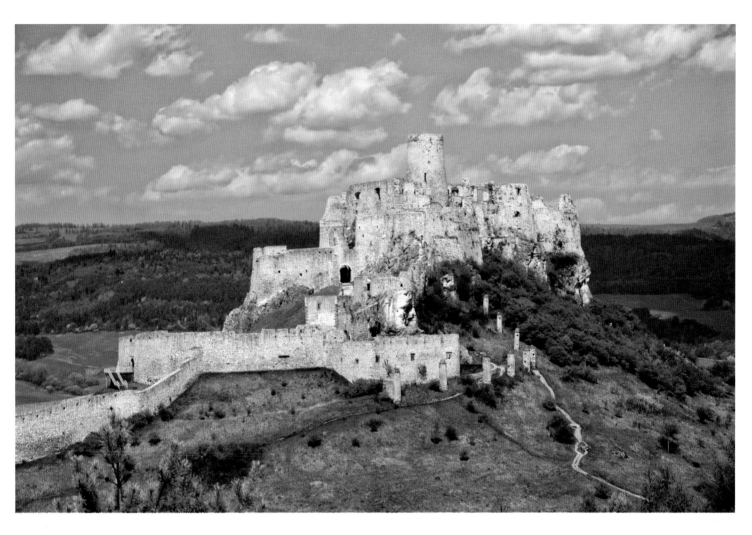

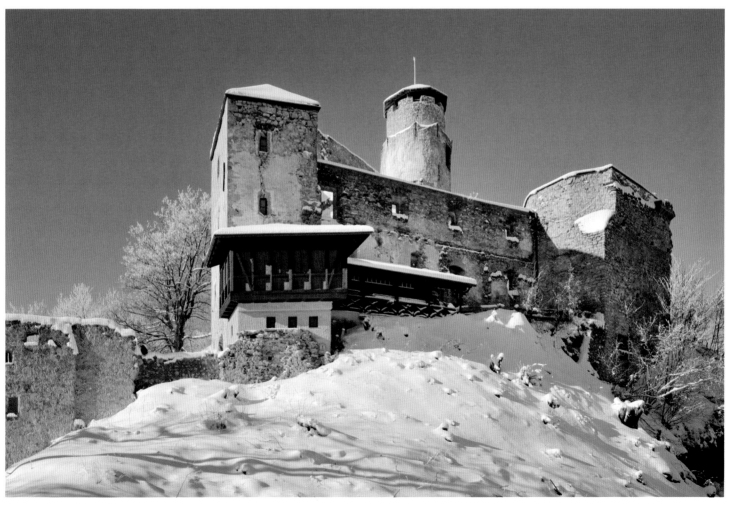

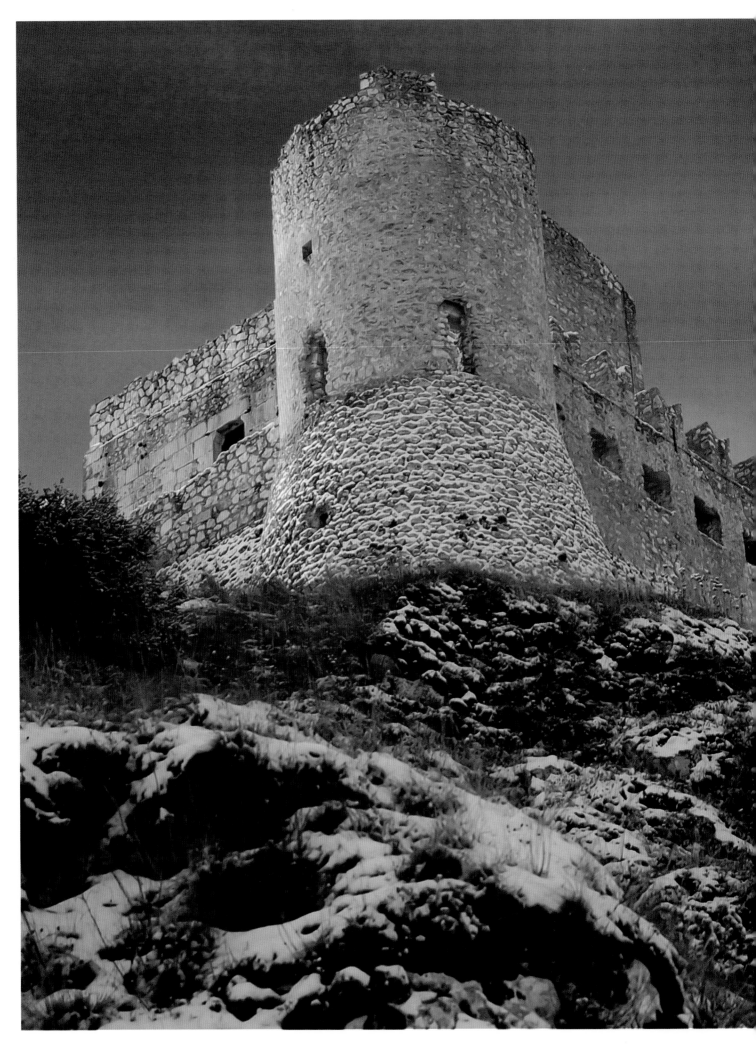

Rocca Calascio, Abruzzo, Italy
The highest fortress in the Apennines, Calascio began as a watchtower in the 10th century, before a courtyard, four cylindrical towers and an inner tower were built in the 13th century. Never tested in battle, the fortress was ruined by an earthquake in 1461.

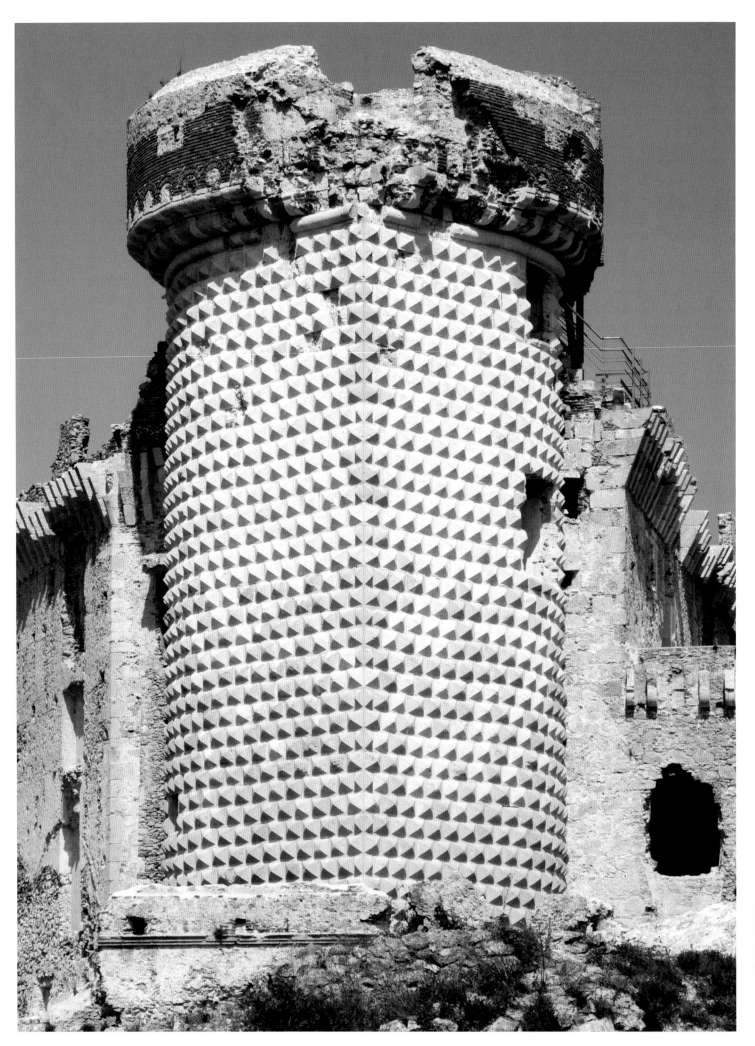

OPPOSITE AND ABOVE:

Govone, Savona, Liguria, Italy
A fortress and later an imperial
residence, Govone was built by
either Henry I Del Carretto or
his son in the late 12th century.
The defensive Diamond Tower,
with its distinctive ashlar surface,
was added in around 1490. The
Spanish gained control of the
castle in 1602, but, having taken
Govone in 1714, the Genoese blew
it up.

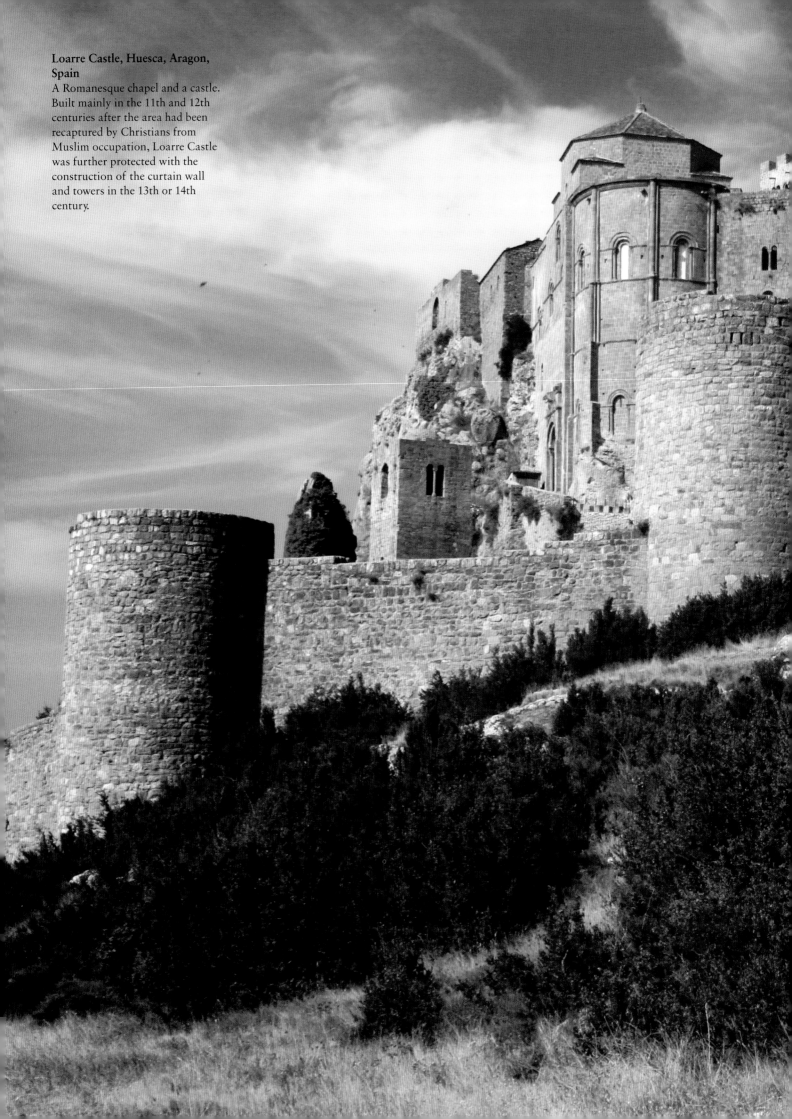

Loarre Castle, Huesca, Aragon, Spain
A Romanesque chapel and a castle. Built mainly in the 11th and 12th centuries after the area had been recaptured by Christians from Muslim occupation, Loarre Castle was further protected with the construction of the curtain wall and towers in the 13th or 14th century.

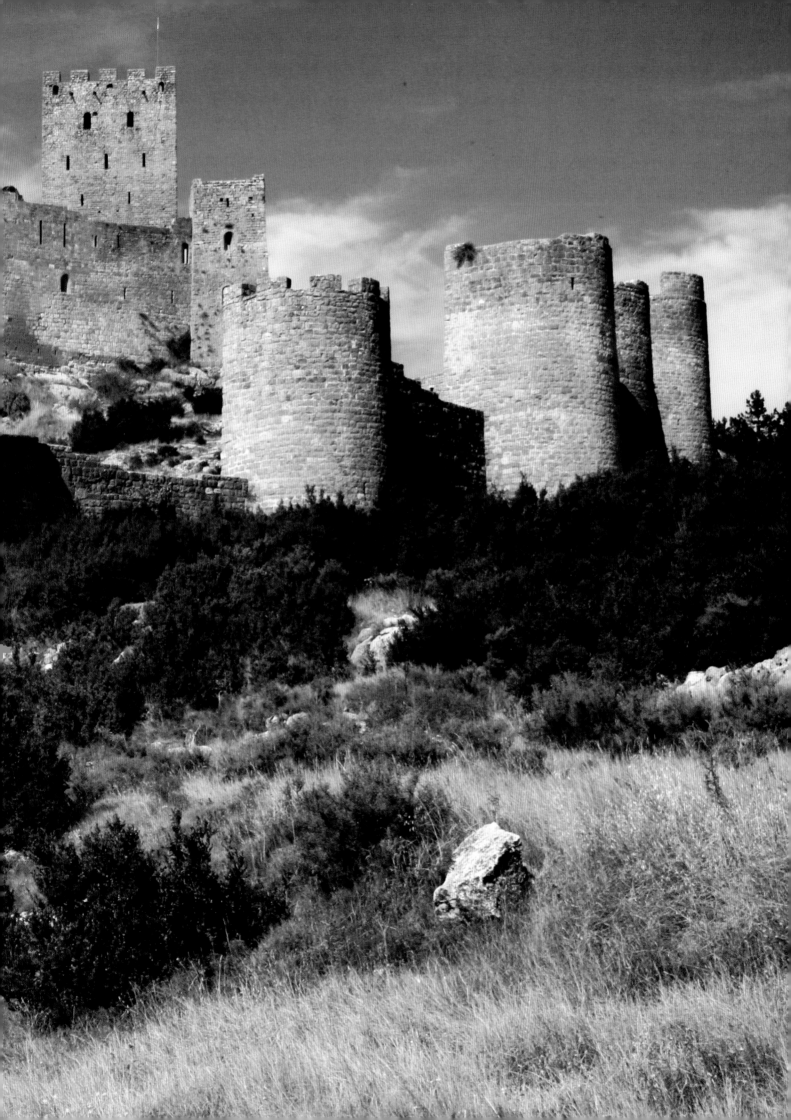

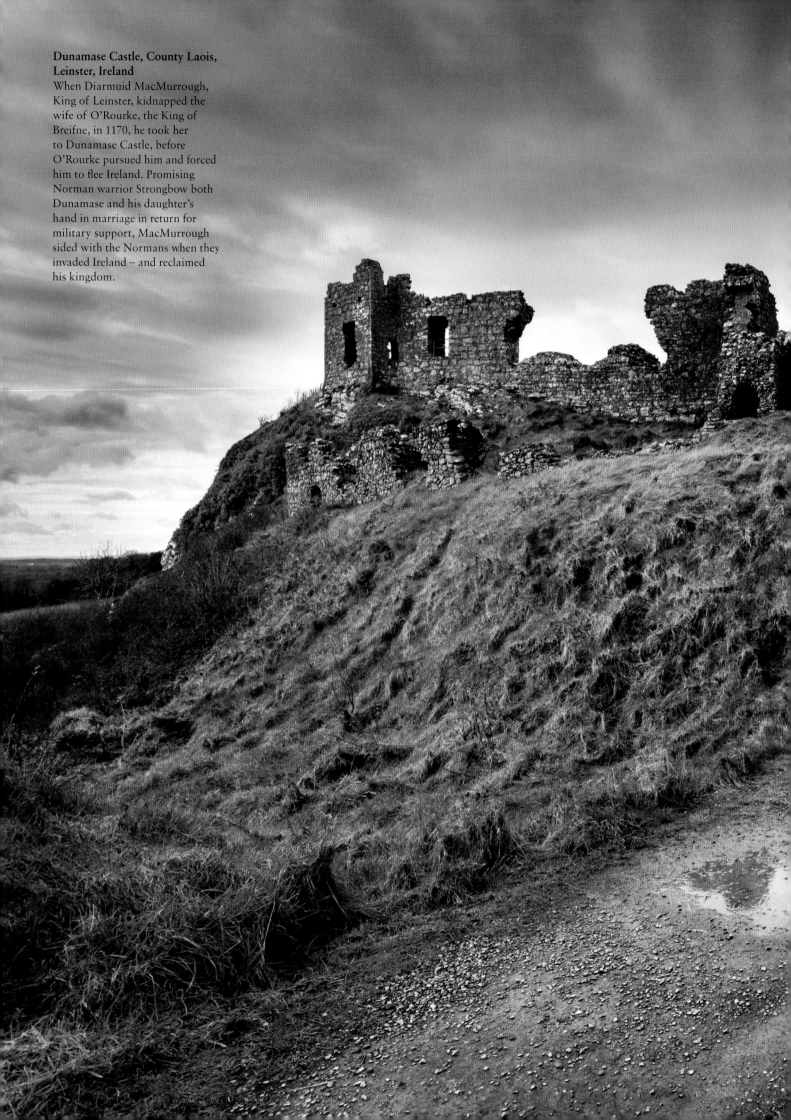

Dunamase Castle, County Laois, Leinster, Ireland
When Diarmuid MacMurrough, King of Leinster, kidnapped the wife of O'Rourke, the King of Breifne, in 1170, he took her to Dunamase Castle, before O'Rourke pursued him and forced him to flee Ireland. Promising Norman warrior Strongbow both Dunamase and his daughter's hand in marriage in return for military support, MacMurrough sided with the Normans when they invaded Ireland – and reclaimed his kingdom.

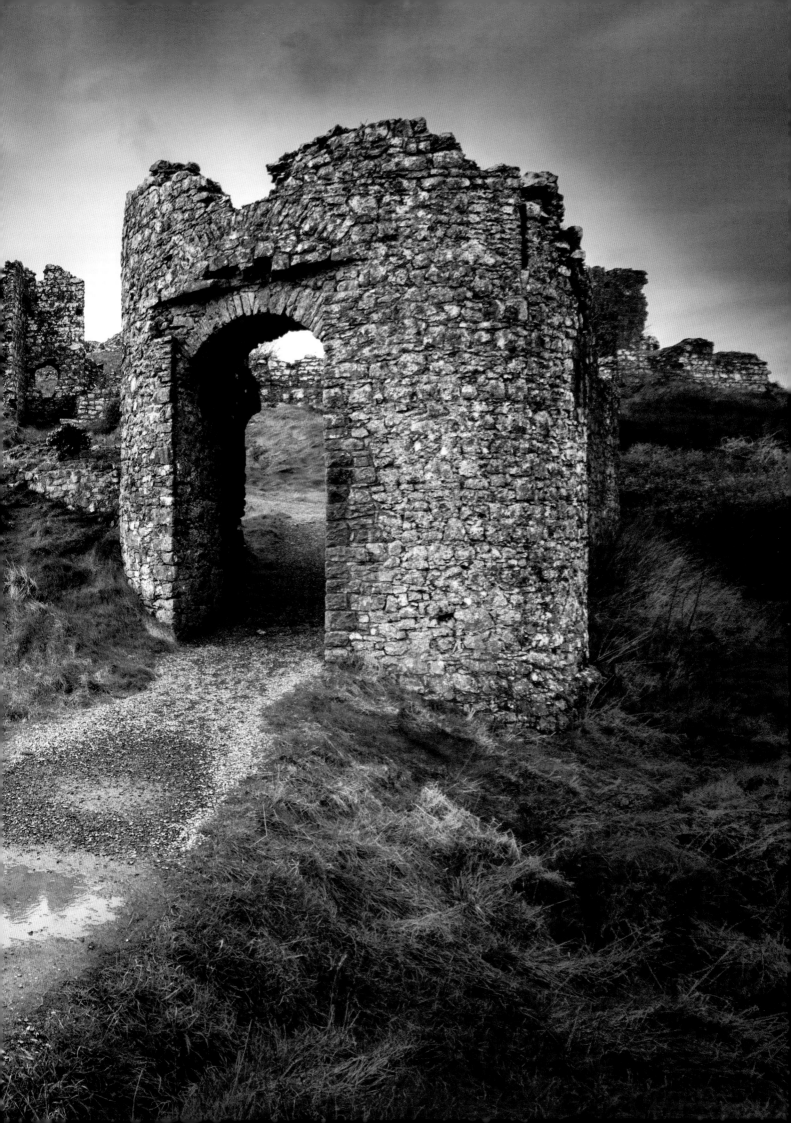

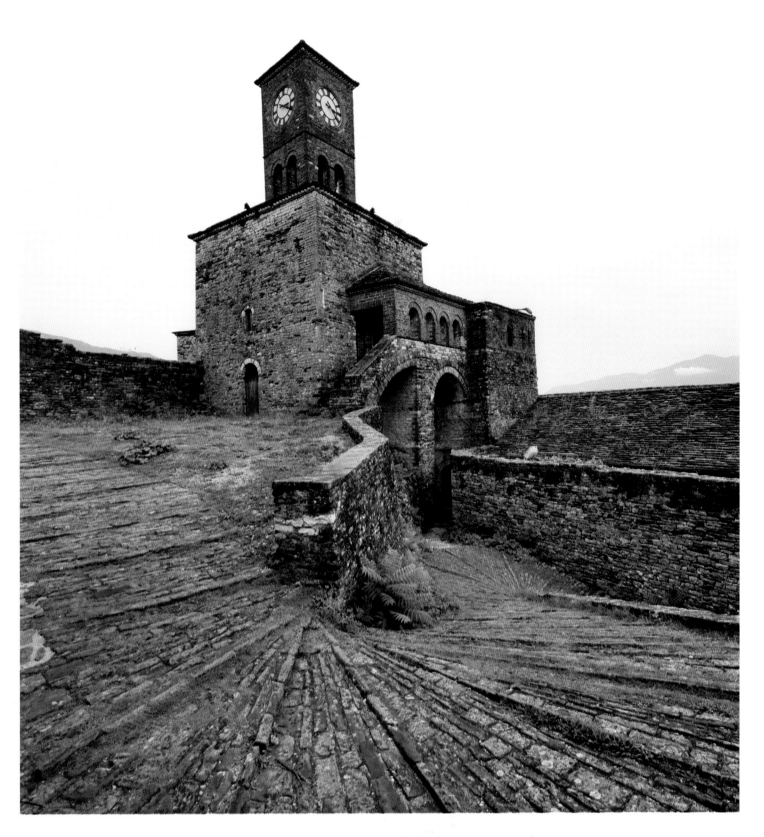

OPPOSITE:

Drachenfels, Rhineland-Palatinate, Germany
Known locally as the *Backenzahn* ('molar tooth'), the tower at Drachenfels dates from the 12th century. Cut out of sandstone rocks on a 368-metre (1,207-ft) high ridge, the castle was besieged and partly destroyed in 1335 in a conflict with the city of Strasbourg after the lords of Drachenfels had been accused of being robber barons.

ABOVE:

Clock Tower, Gjirokastër Fortress, Gjirokastër, Albania
Overlooking the Ottoman town of Gjirokastër and holding a strategically important place along the Drin River Valley, a citadel has existed on the site of Gjirokastër Fortress since the 12th century. Additions were made as recently as 1932, when King Zog expanded the castle prison.

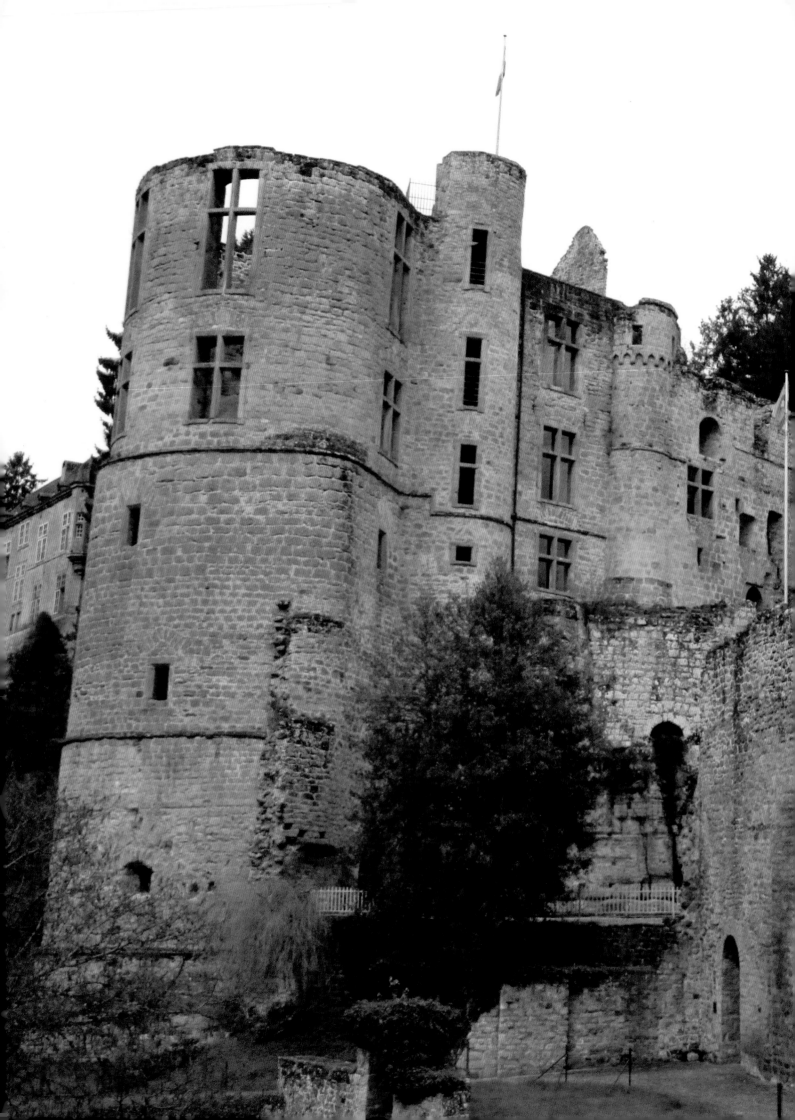

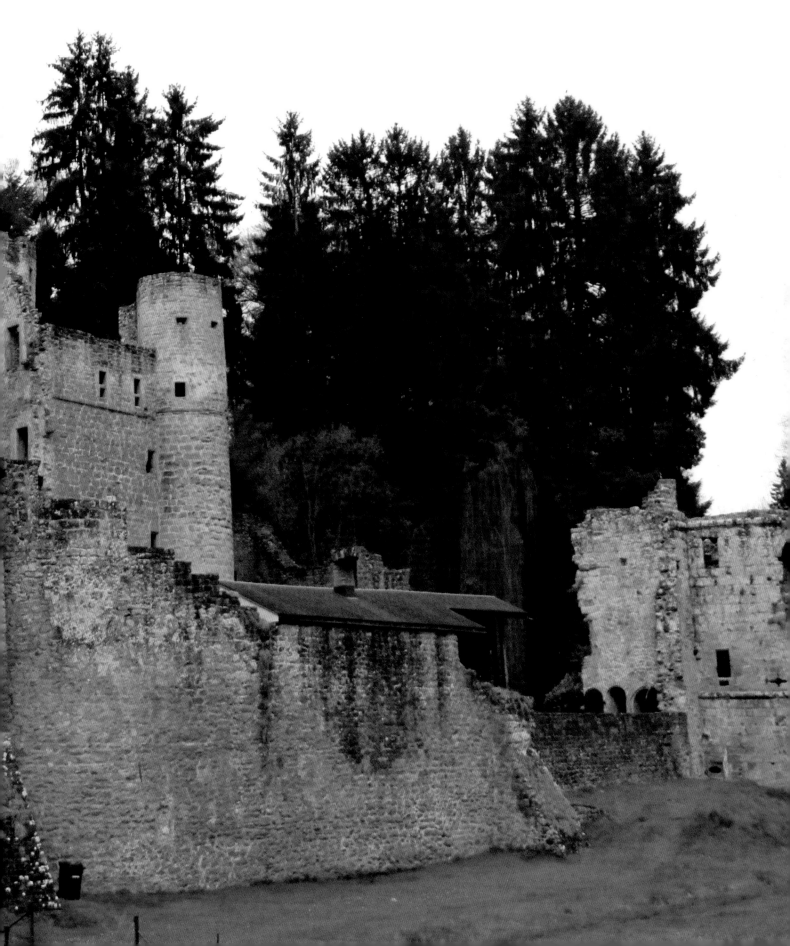

Beaufort Castle, Luxembourg
Built in stages between the 11th and 17th centuries, Beaufort Castle was abandoned in the late 18th century and later used as a quarry. The cross-framed Renaissance windows were added in the 16th century.

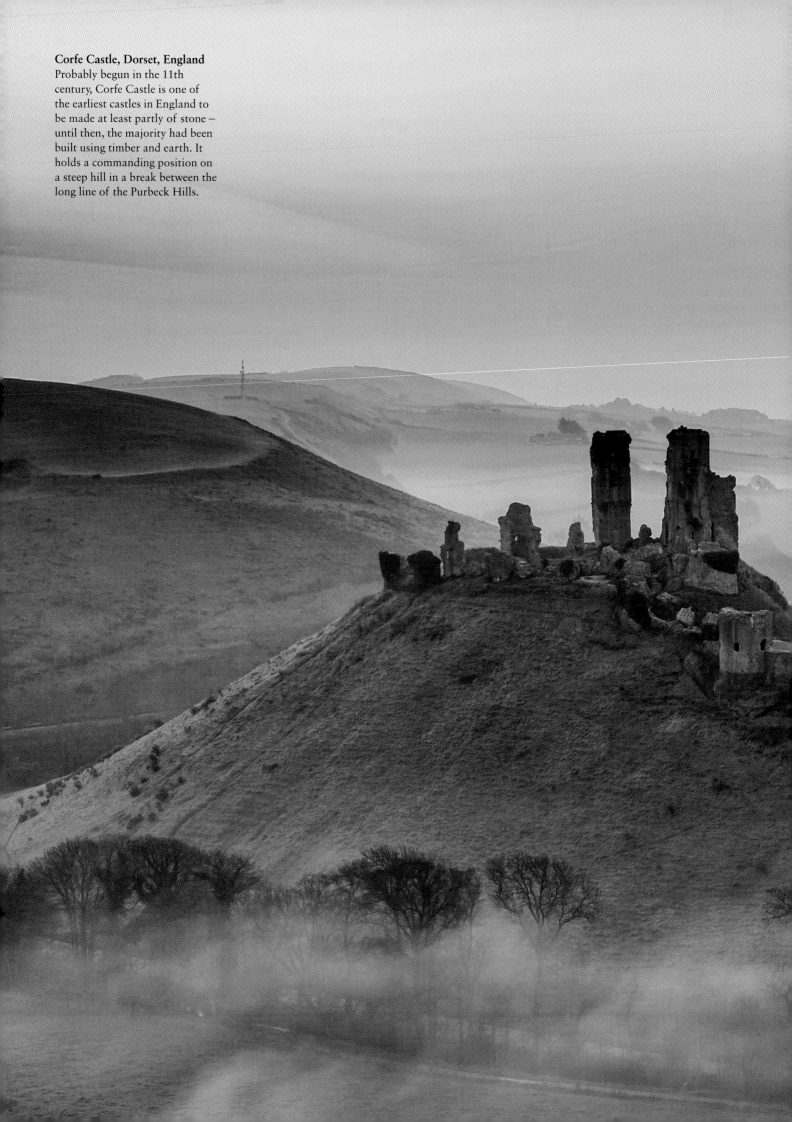

Corfe Castle, Dorset, England
Probably begun in the 11th
century, Corfe Castle is one of
the earliest castles in England to
be made at least partly of stone –
until then, the majority had been
built using timber and earth. It
holds a commanding position on
a steep hill in a break between the
long line of the Purbeck Hills.

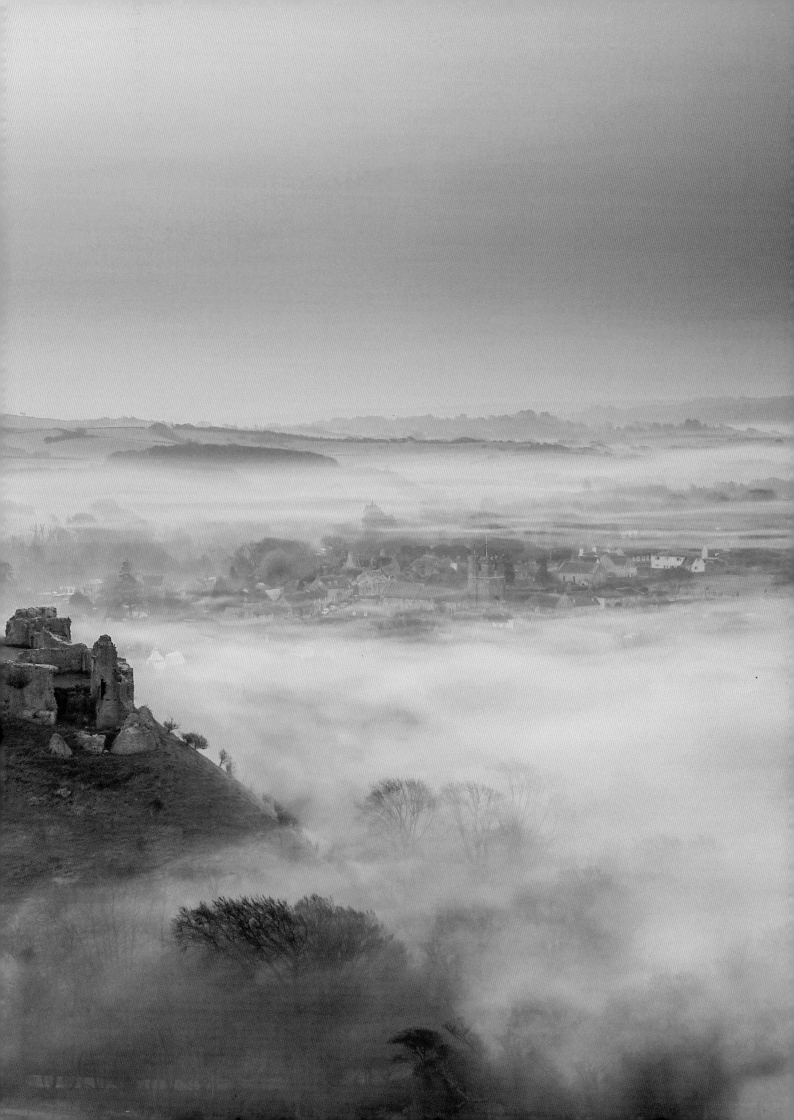

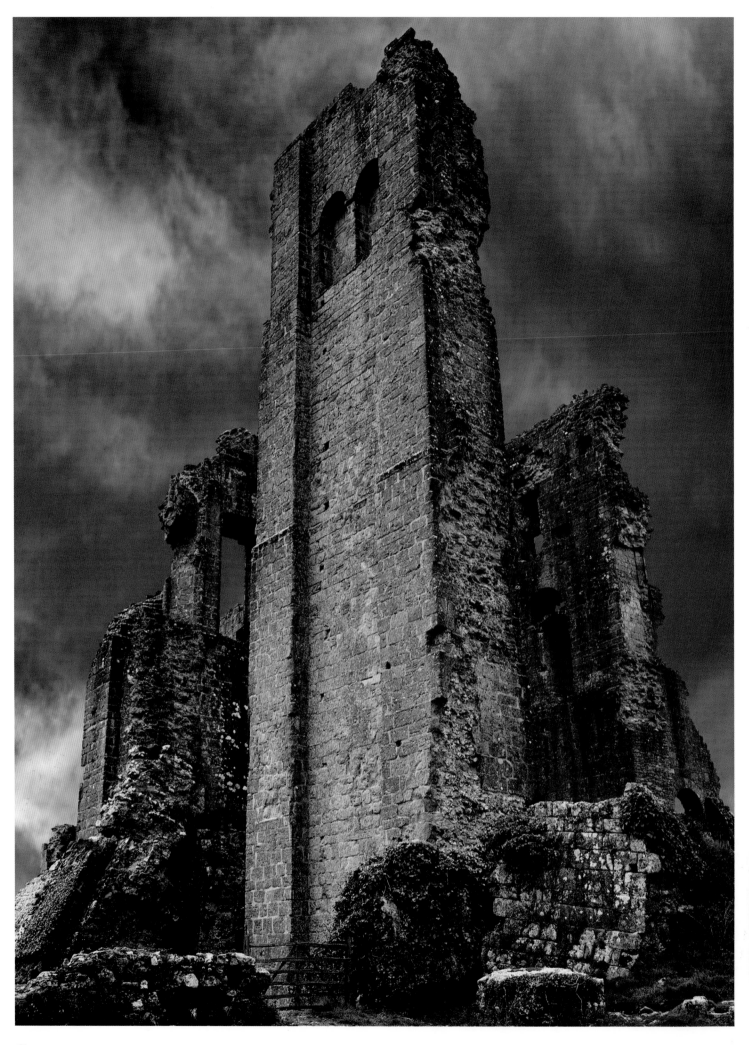

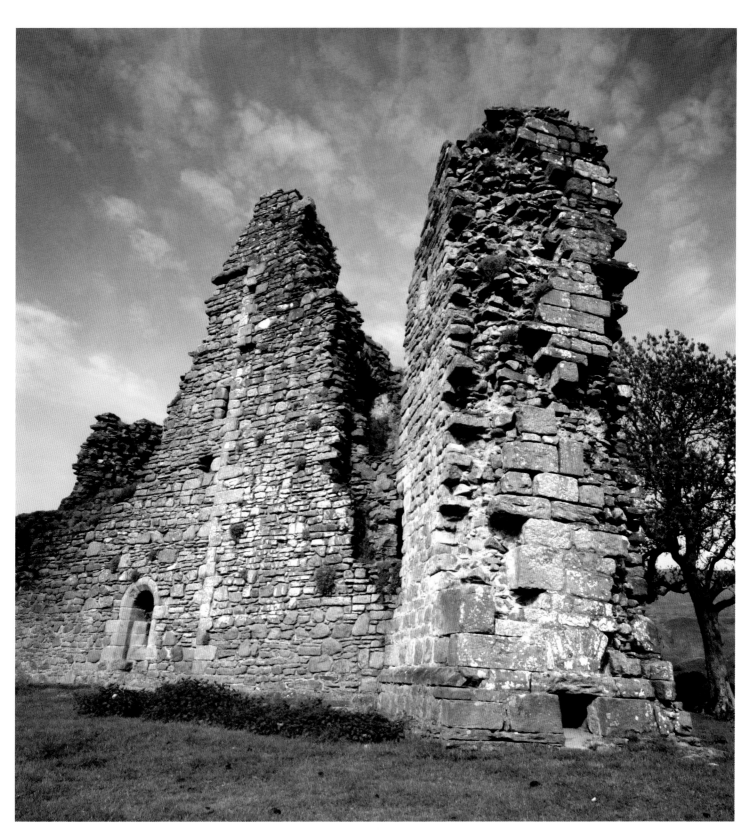

Corfe Castle, Dorset, England
Corfe Castle was besieged twice by Parliamentarians during the Civil War. On the second occasion, in 1645, one of the defending officers colluded with the enemy, managing to smuggle 100 Parliamentarians into the grounds disguised as Royalists. The Parliamentarians then attacked from both outside and in, defeating the king's men. Parliament later ordered that the castle be made unusable.

Pendragon Castle, Cumbria, England
Built in the 12th century, Pendragon Castle was expanded two centuries later. Attacked by Scottish raiding parties in 1541, it was left uninhabitable until rebuilt in 1660. But at the end of the 17th century, a new owner had no use for the castle and stripped the lead from the roof, leaving it to ruin.

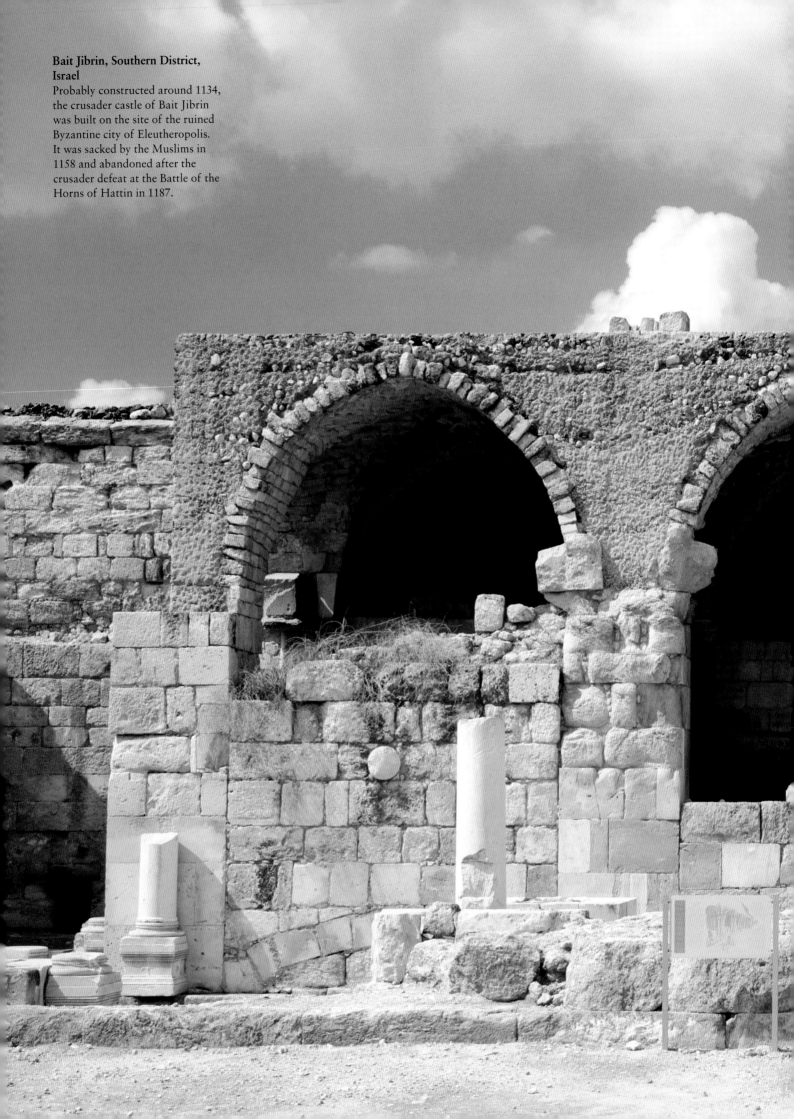

Bait Jibrin, Southern District, Israel
Probably constructed around 1134, the crusader castle of Bait Jibrin was built on the site of the ruined Byzantine city of Eleutheropolis. It was sacked by the Muslims in 1158 and abandoned after the crusader defeat at the Battle of the Horns of Hattin in 1187.

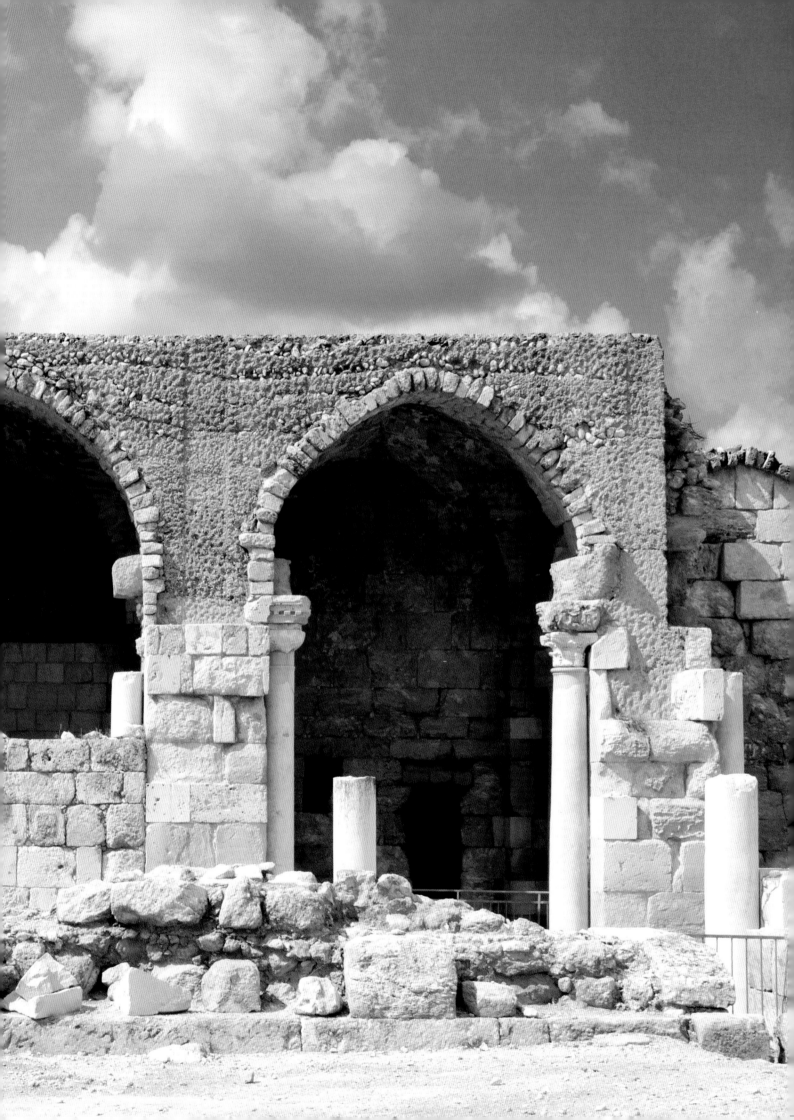

RIGHT:

Château de Brésis, Gard, France

The Château de Brésis was built in the 12th century on the site of a former Roman villa. Its position allowed the control of traffic along and across the River Cèze. Abandoned after the French Revolution, the château fell into ruin in the 19th century.

OVERLEAF:

Belvoir Fortress, Northern District, Israel

Perched 500 metres (1,600ft) high on the western slopes of the Jordan River Valley, the crusader fortress at Belvoir controlled access from the north into the Kingdom of Jerusalem. Begun by the Knights Hospitaller in 1168, the fortress is shaped like a Roman *castra* (a military camp), with a rectangular inner enclosure, corner towers and a large gatehouse in the middle of one wall.

Belvoir withstood attack from the Muslims in 1180, and in 1182 the Battle of Belvoir Fortress was fought nearby between King Baldwin IV of Jerusalem and Saladin, sultan of Egypt and Syria. Following Saladin's victory over the crusaders at the Horns of Hattin in 1187, Belvoir was besieged for 18 months, before the defenders finally surrendered in 1189.

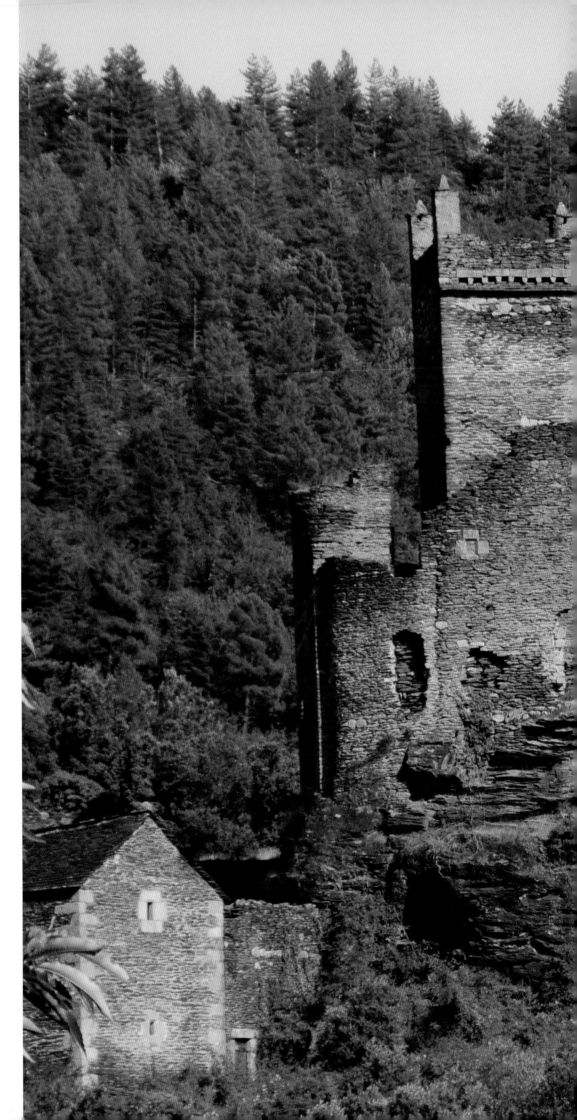

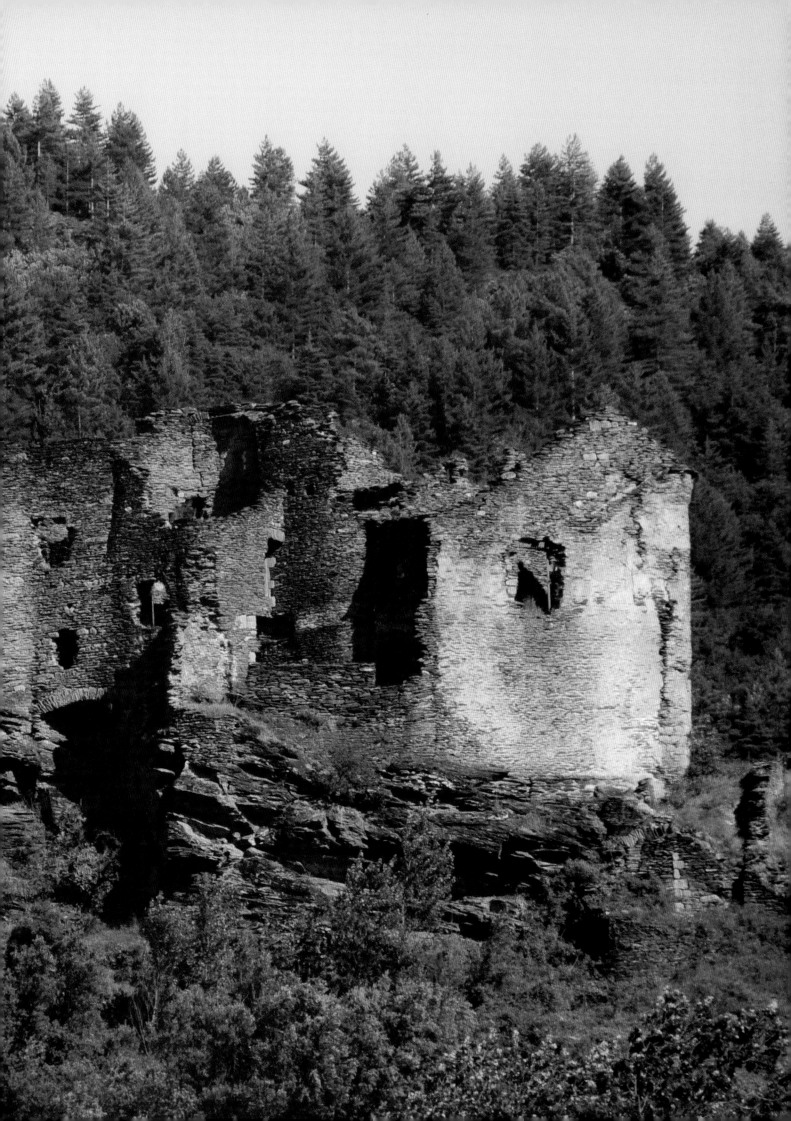

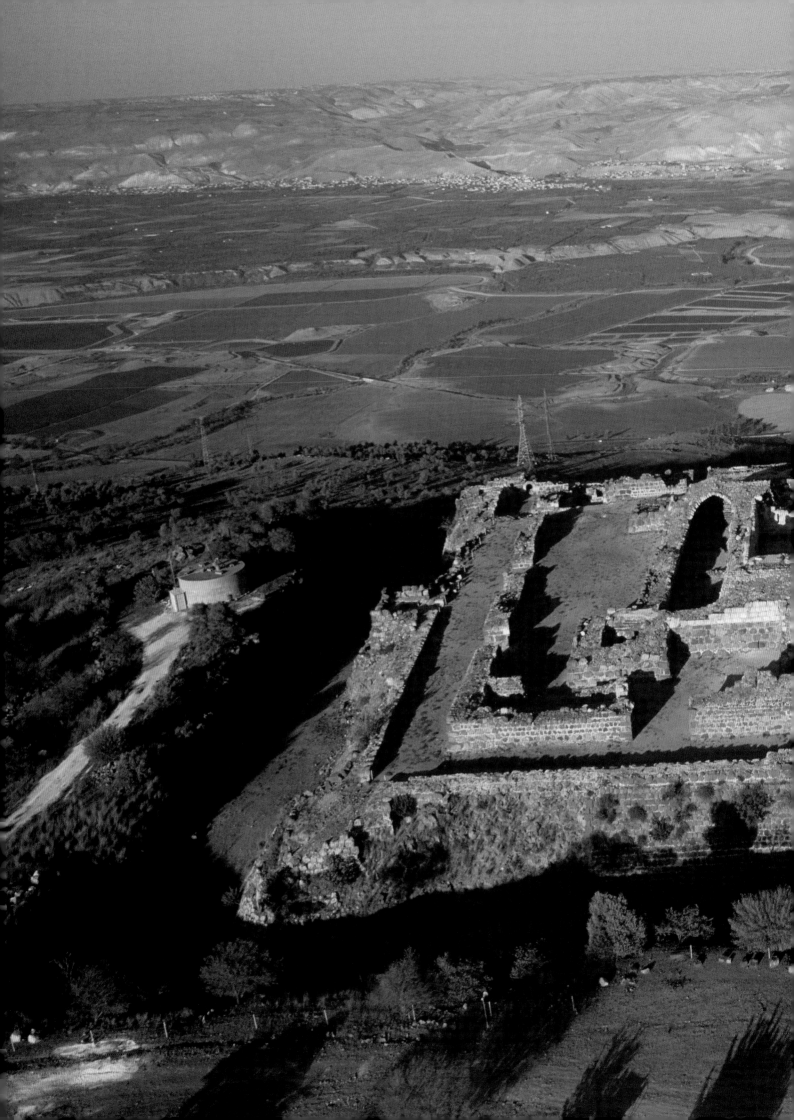

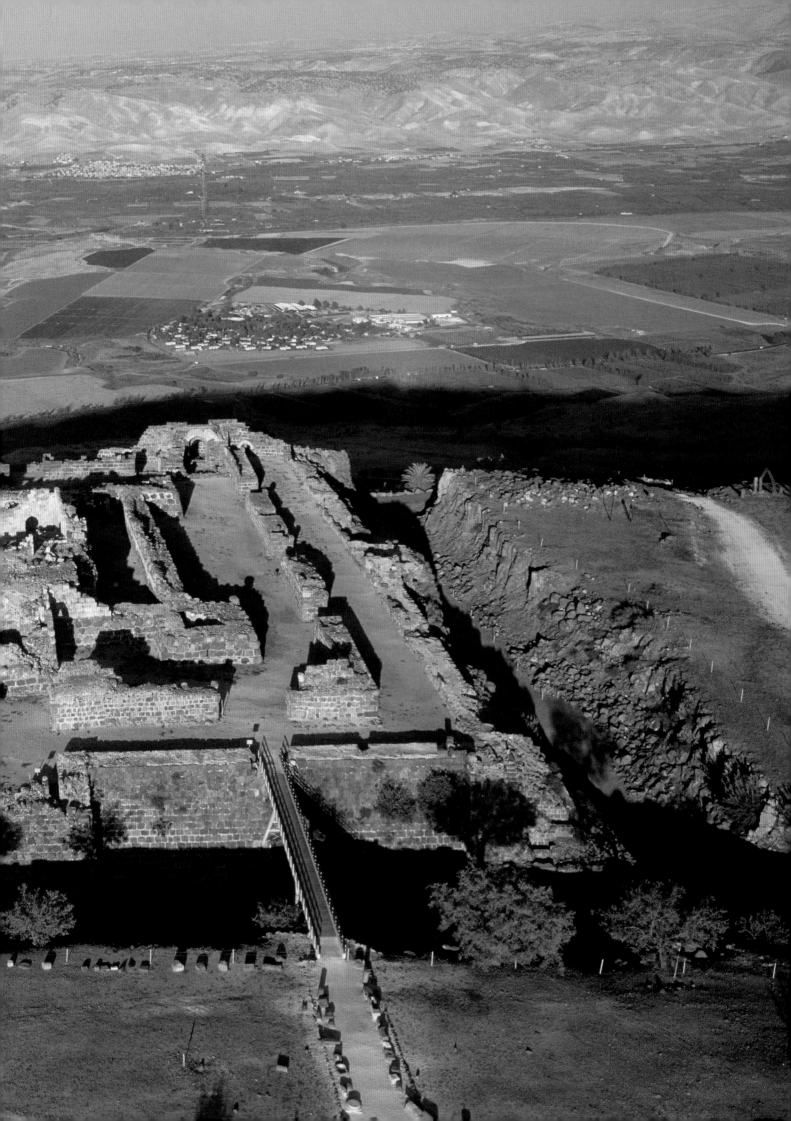

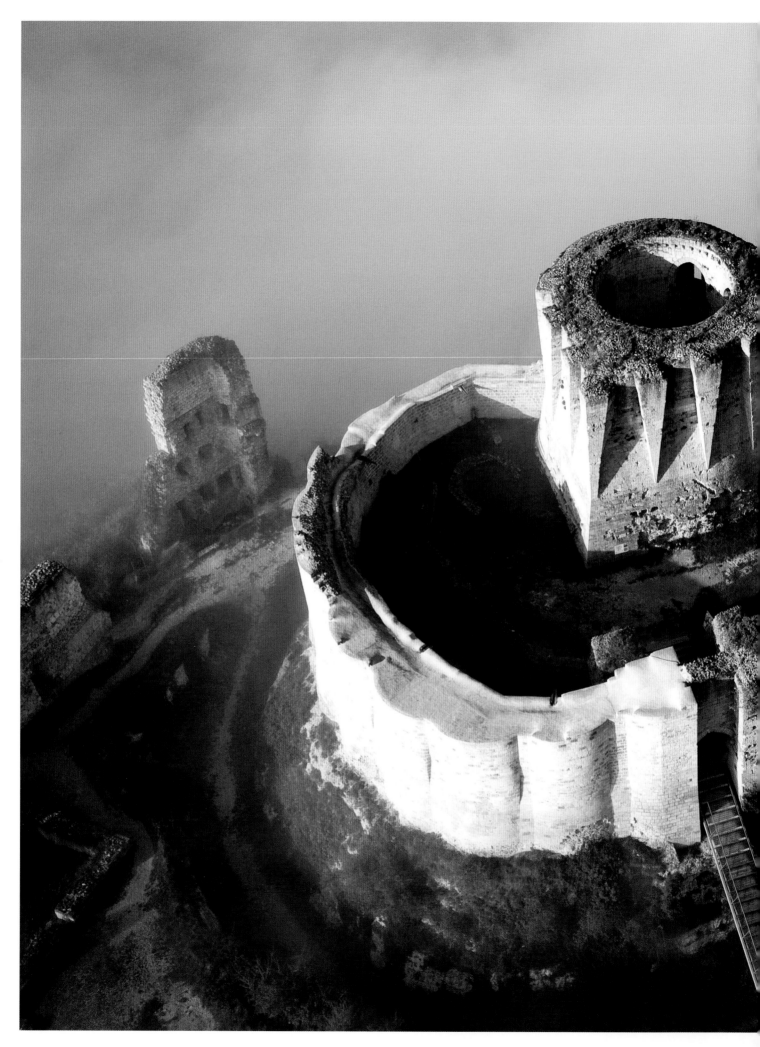

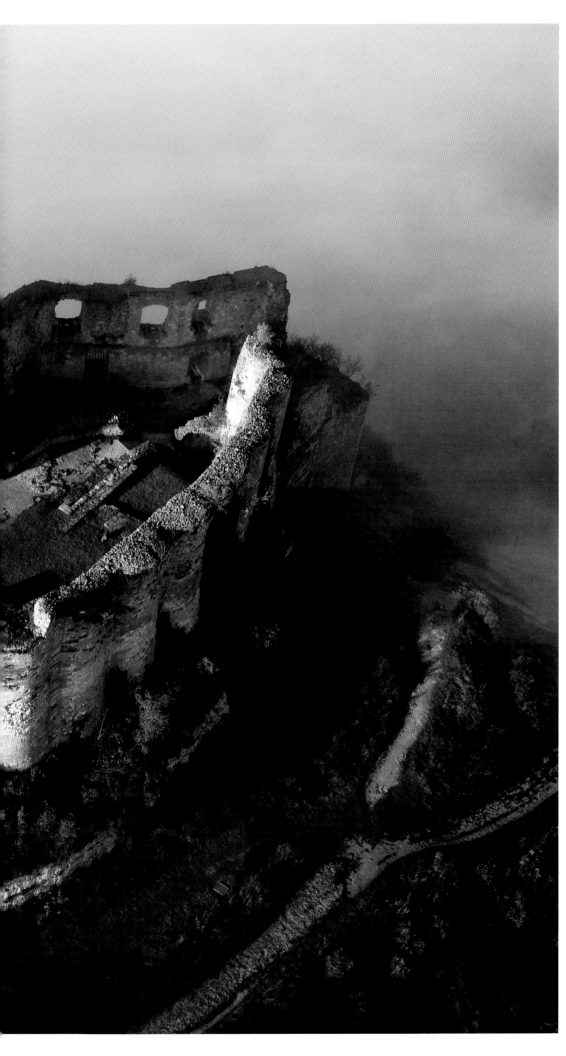

Château Gaillard, Eure, Normandy, France

Dominating a spur on the River Seine, Château Gaillard was built between 1196 and 1198 on the orders of Richard Lionheart, who was both King Richard I of England and the Duke of Normandy. Situated as close as possible to the border between Richard's Normandy and the territories of the king of France, the castle was supposed to be impregnable – 'Were its walls made of butter, they would still stand,' Richard is reputed to have said.

However, during a long siege in 1204, French forces loyal to Philip II gained access through a latrine chute and lowered the drawbridge, allowing the castle to be captured. With Château Gaillard no longer an obstacle, Philip annexed Normandy.

By the late 16th century the castle was a ruin and on the orders of King Henri IV it was largely demolished.

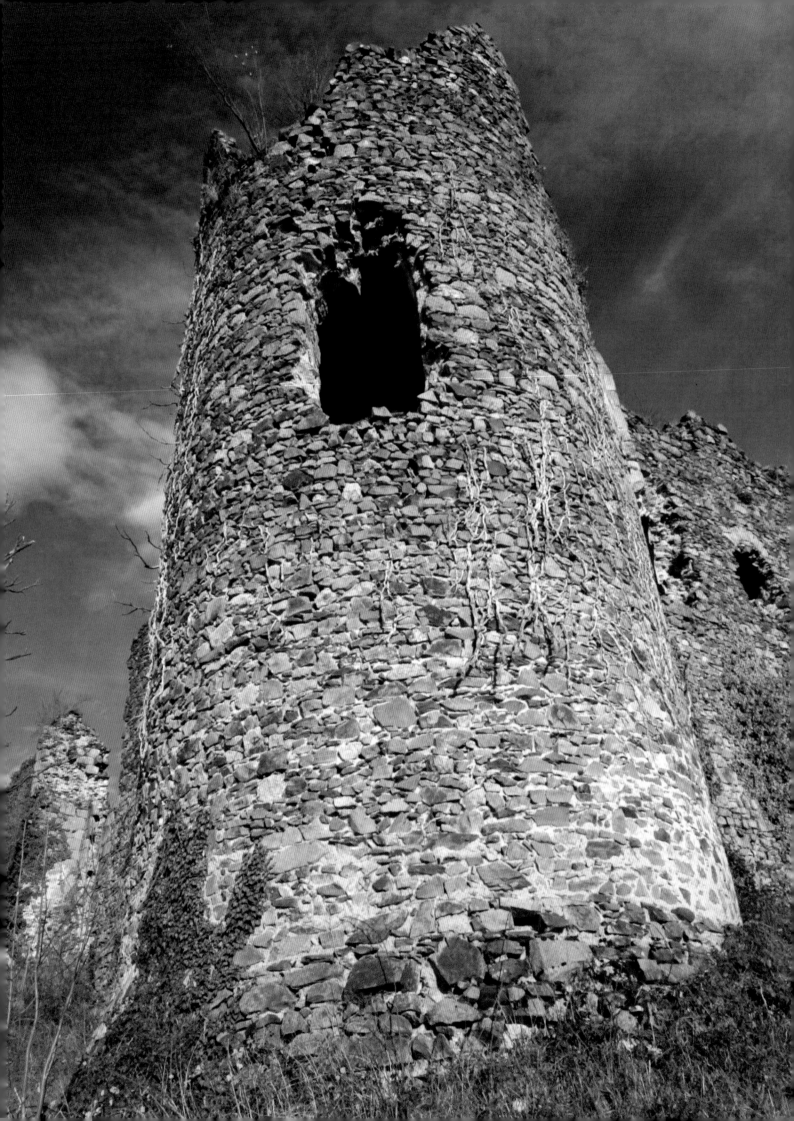

Late Medieval Period

Just as stone castles superseded those made of timber and earth, by the early 13th century, polygonal castles were supplanting rectangular ones. From a building with protruding towers, archers could fire arrows into the flank of a force attacking the castle walls, rather than being limited to facing their foe head on.

Arrow slits began to appear in walls in the late 13th century, but by the 1320s castle builders had to contend with a new threat – gunpowder. In response to cannon fire, walls were made thicker and new castles were often built with round towers, as these were more likely to deflect a cannon ball.

Many were also adapted to allow cannons to be fired from them.

In these pages, we find castles originally built during the Middle Ages to defend the local nobility in territorial disputes, still in use hundreds of years later in larger, more broad-ranging conflicts, such as the Thirty Years' War (1618–48) or the English Civil War (1642–51).

The late medieval period saw the greatest numbers of castles built. But by the 16th century, construction of such vast buildings waned, as, despite all efforts to strengthen them, their walls proved unable to withstand attack from ever more powerful cannons.

OPPOSITE:

Château de Montgilbert, near Vichy, Allier, France
Built during the 13th century with towers and arrow slits, Château de Montgilbert was expanded in the 15th century to adapt to the age of gunpowder. Artillery batteries housing cannon were constructed, as was a bastion – a projecting part of the castle wall to allow defensive fire in several directions. By the time of the French Revolution, the castle had been abandoned.

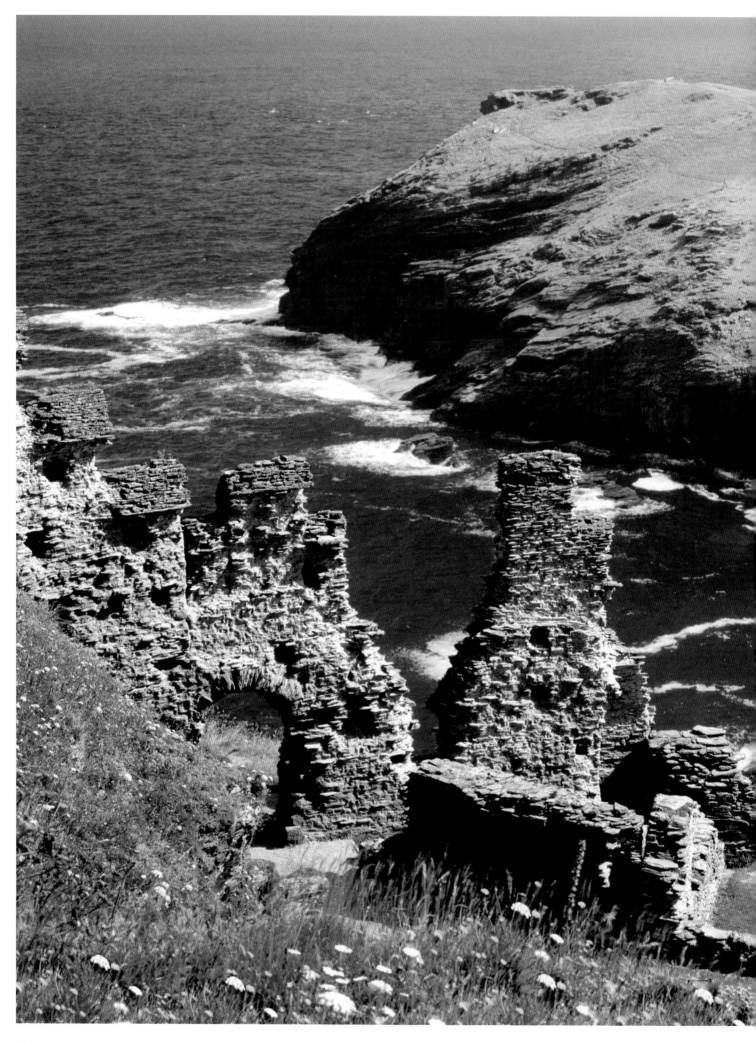

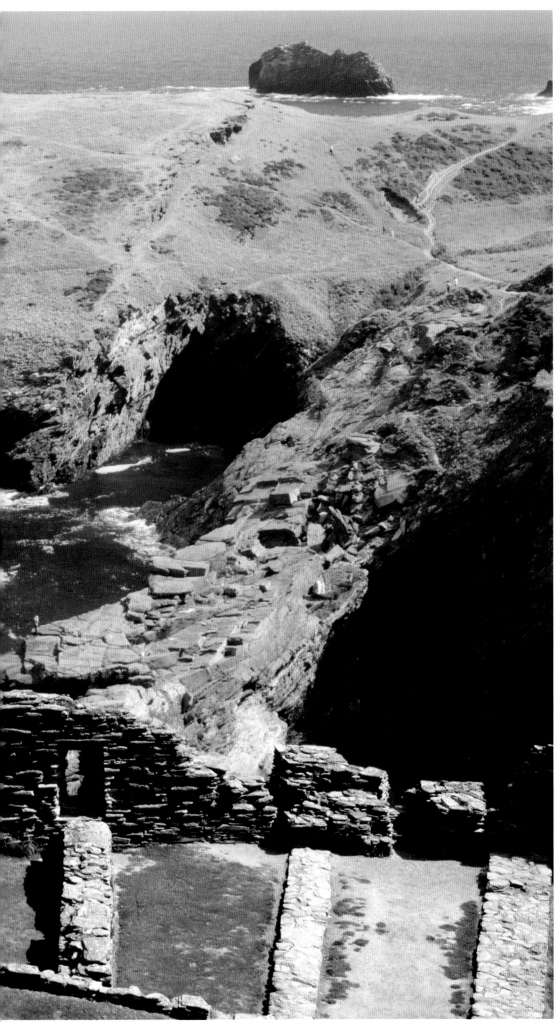

Tintagel, Cornwall, England
Although built by Richard, 1st Earl of Cornwall, in 1233, Tintagel Castle was designed to appear as if it bore the gravity of coming from an earlier era. Its location, too, carried great meaning: not only was the site a traditional location for Cornish kings but it was even believed to be associated with the legendary King Arthur. Within a century, however, Tintagel had fallen into ruin.

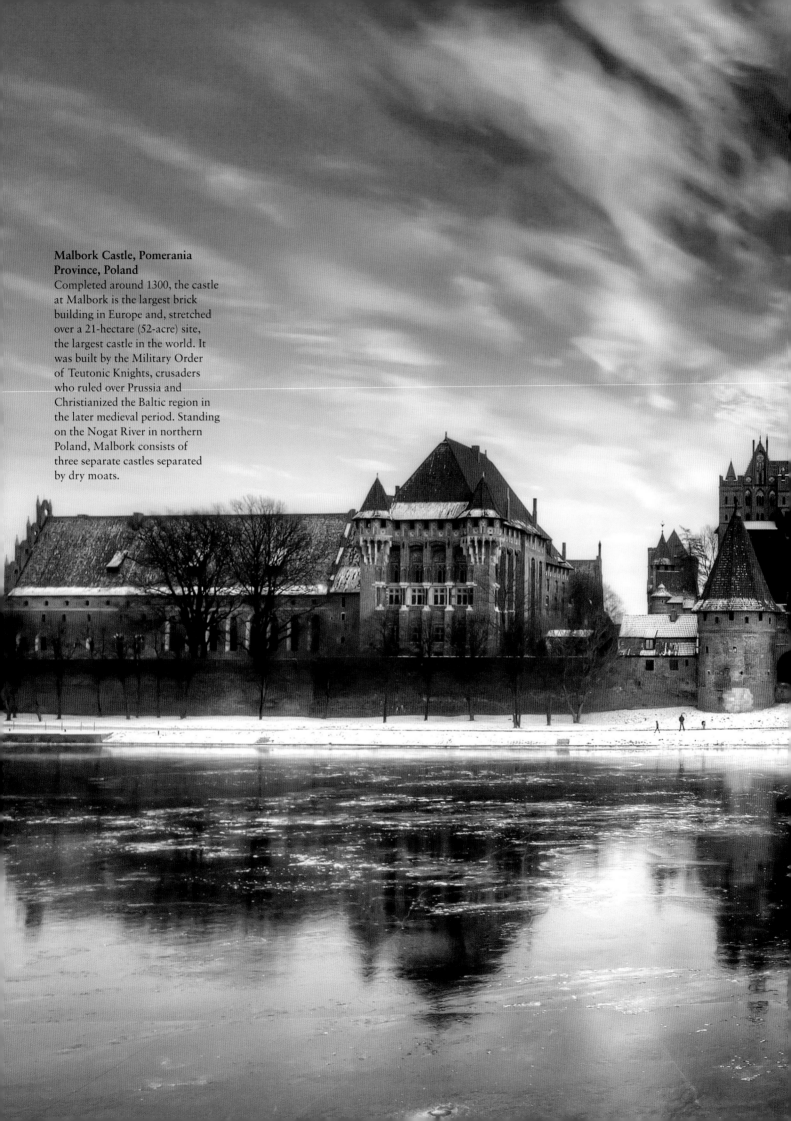

Malbork Castle, Pomerania Province, Poland
Completed around 1300, the castle at Malbork is the largest brick building in Europe and, stretched over a 21-hectare (52-acre) site, the largest castle in the world. It was built by the Military Order of Teutonic Knights, crusaders who ruled over Prussia and Christianized the Baltic region in the later medieval period. Standing on the Nogat River in northern Poland, Malbork consists of three separate castles separated by dry moats.

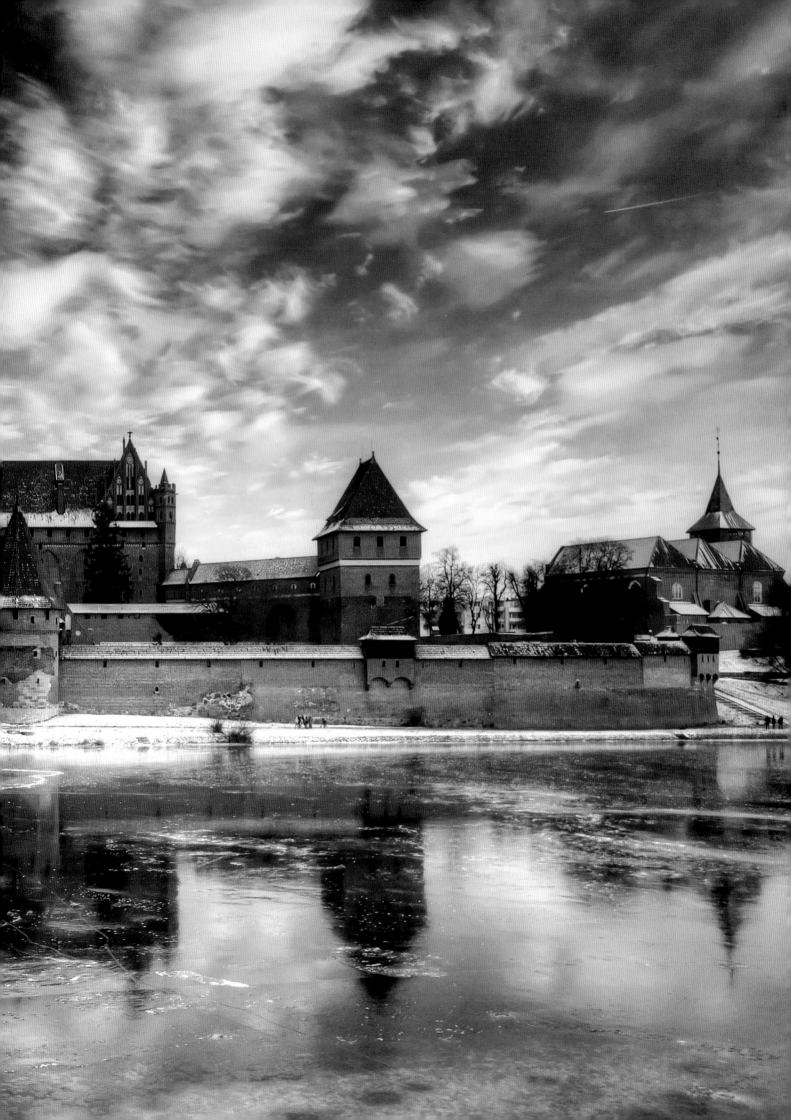

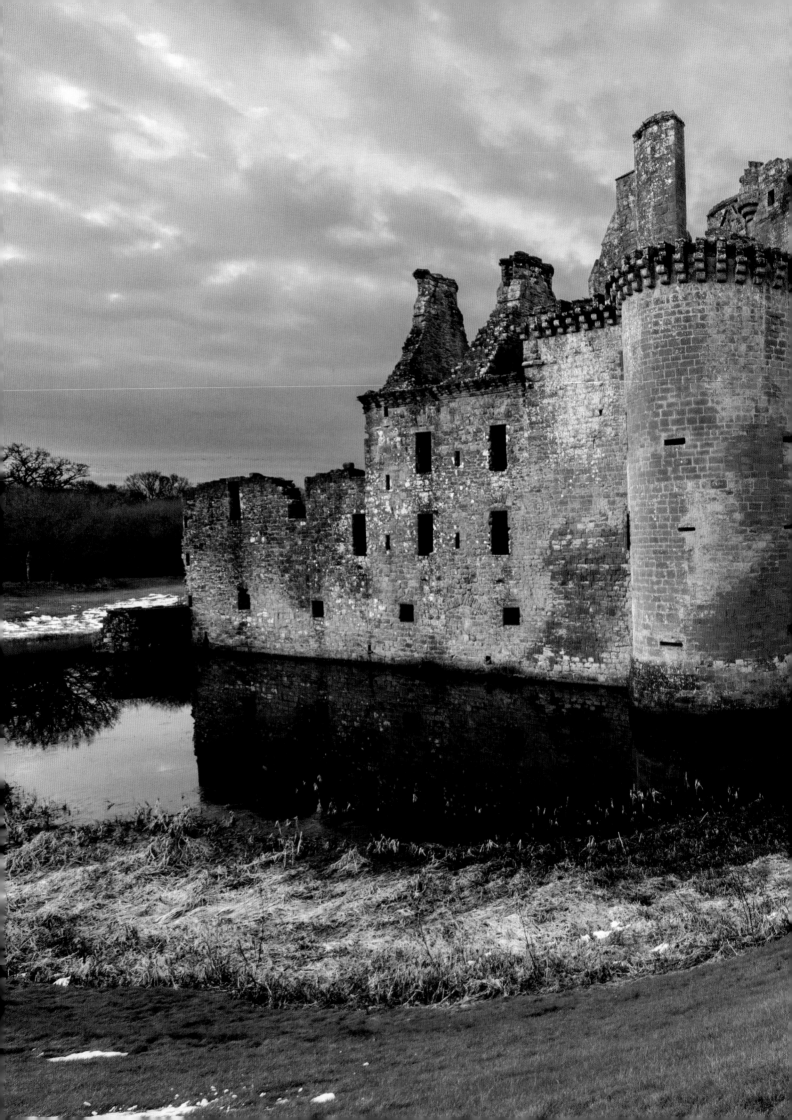

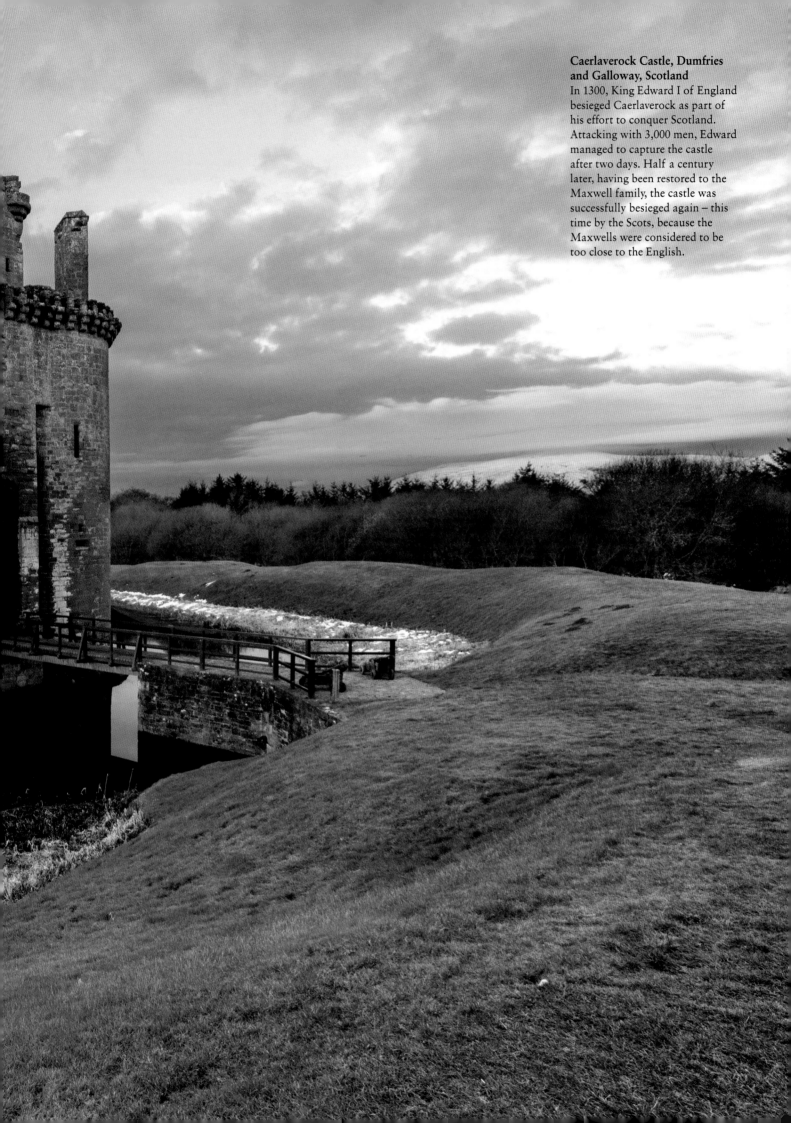

Caerlaverock Castle, Dumfries and Galloway, Scotland
In 1300, King Edward I of England besieged Caerlaverock as part of his effort to conquer Scotland. Attacking with 3,000 men, Edward managed to capture the castle after two days. Half a century later, having been restored to the Maxwell family, the castle was successfully besieged again – this time by the Scots, because the Maxwells were considered to be too close to the English.

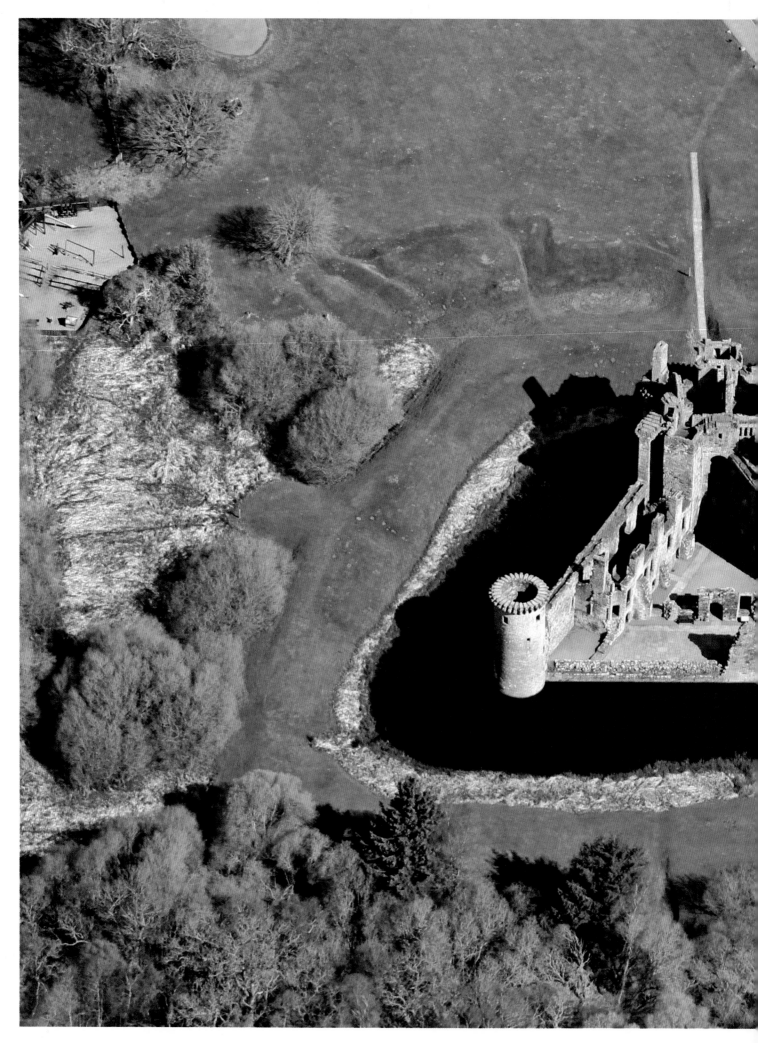

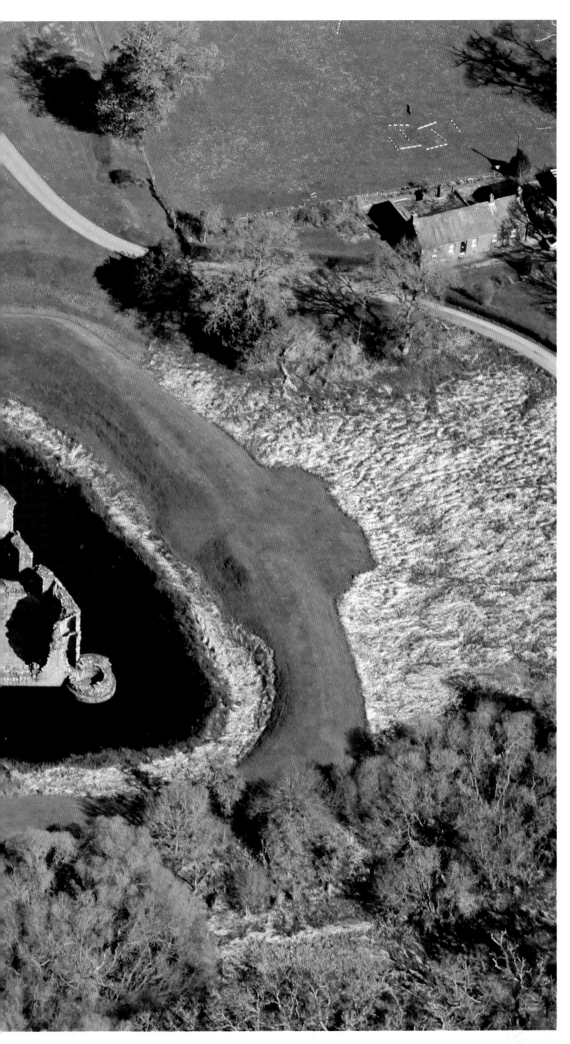

LEFT:

Caerlaverock Castle, Dumfries and Galloway, Scotland
Situated in the Scottish–English borderlands, 13th century Caerlaverock is Britain's only triangular castle. Although solidly defensive, it is not known why a triangular design was chosen, or why no other British castle was built in that shape.

OVERLEAF:

Caerlaverock Castle, Dumfries and Galloway, Scotland
When the Maxwell family sided with King Charles I during the English Civil War, Caerlaverock was besieged for the final time. For 13 weeks in 1640 the Maxwells held out, before being overwhelmed by the Parliamentarians. After that, the Parliamentarians made Caerlaverock unfit for defence and it fell into ruin.

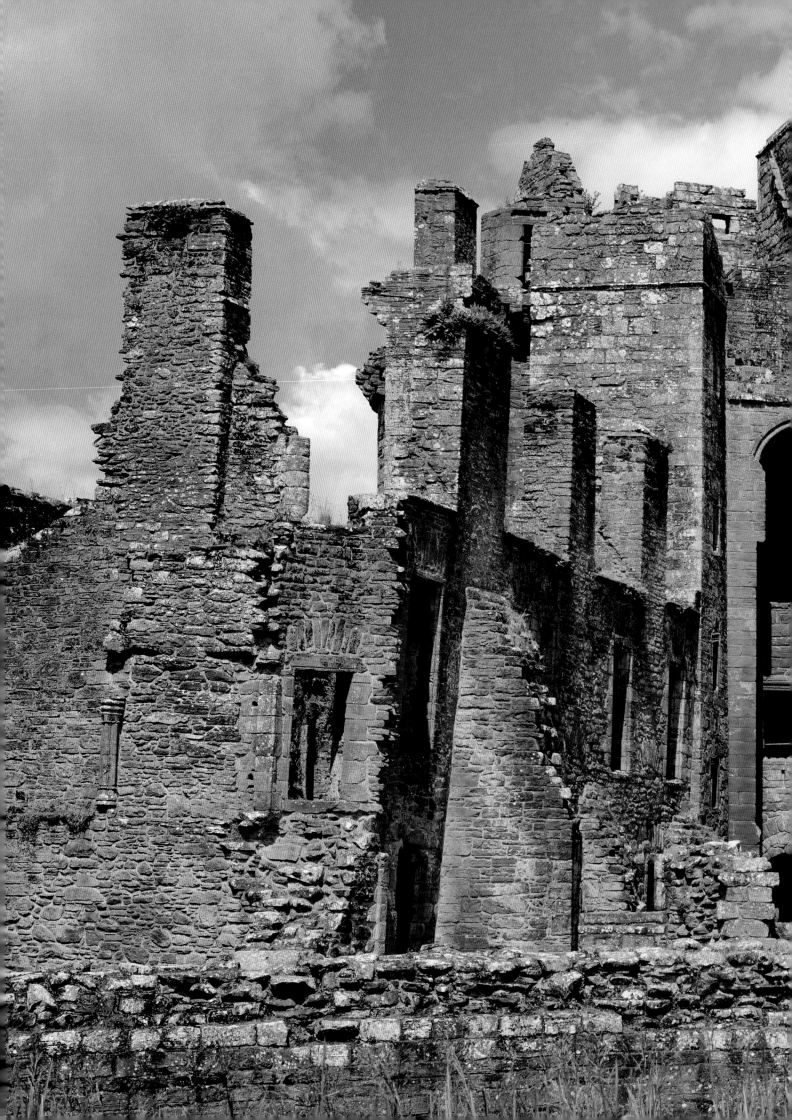

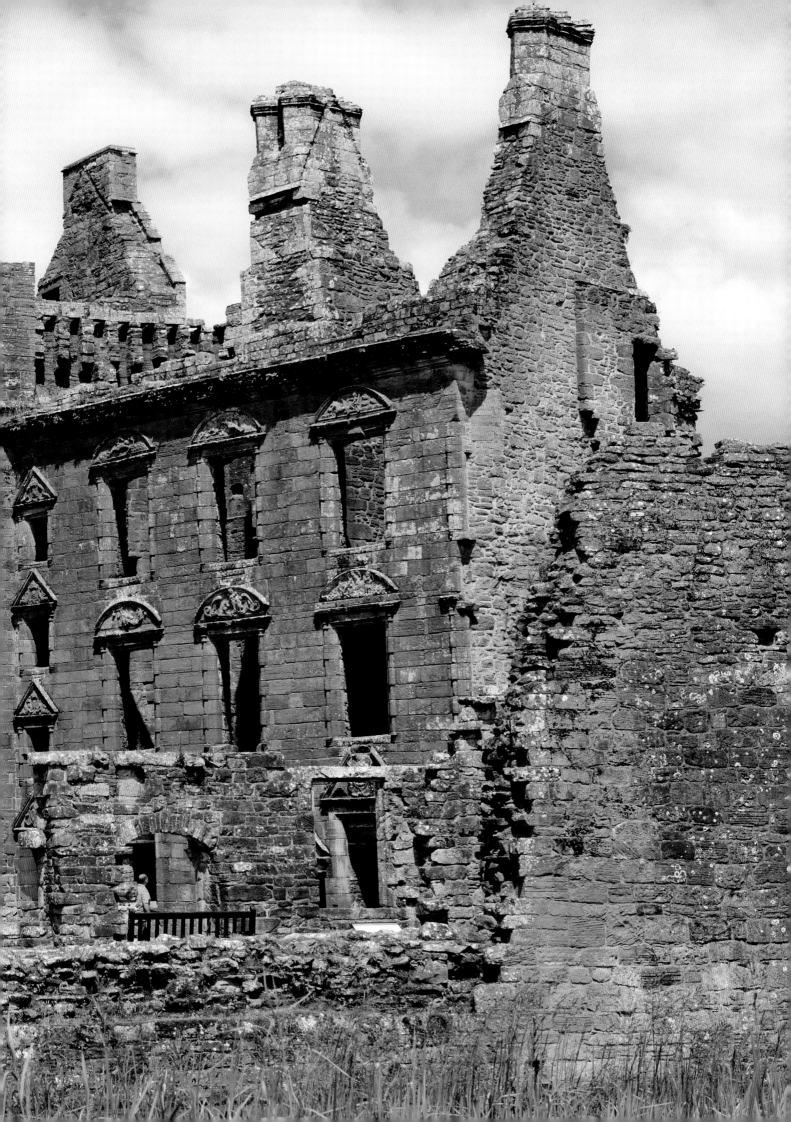

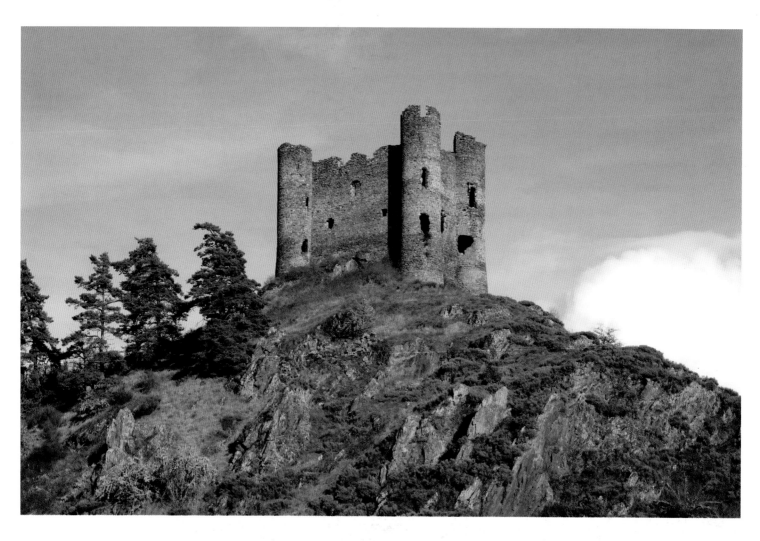

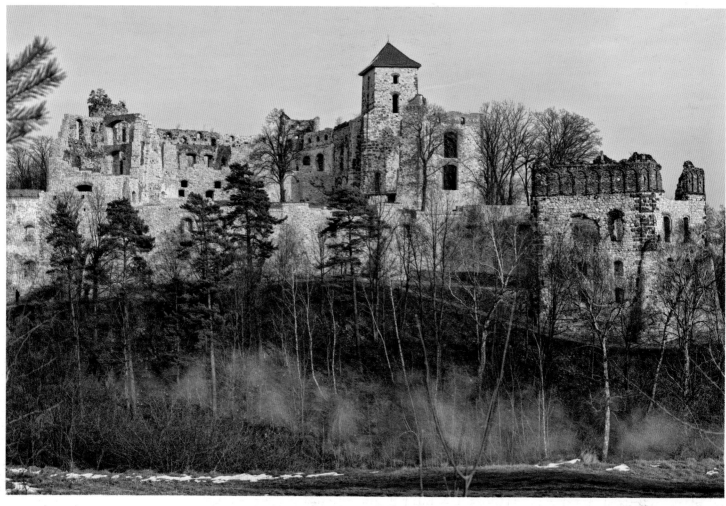

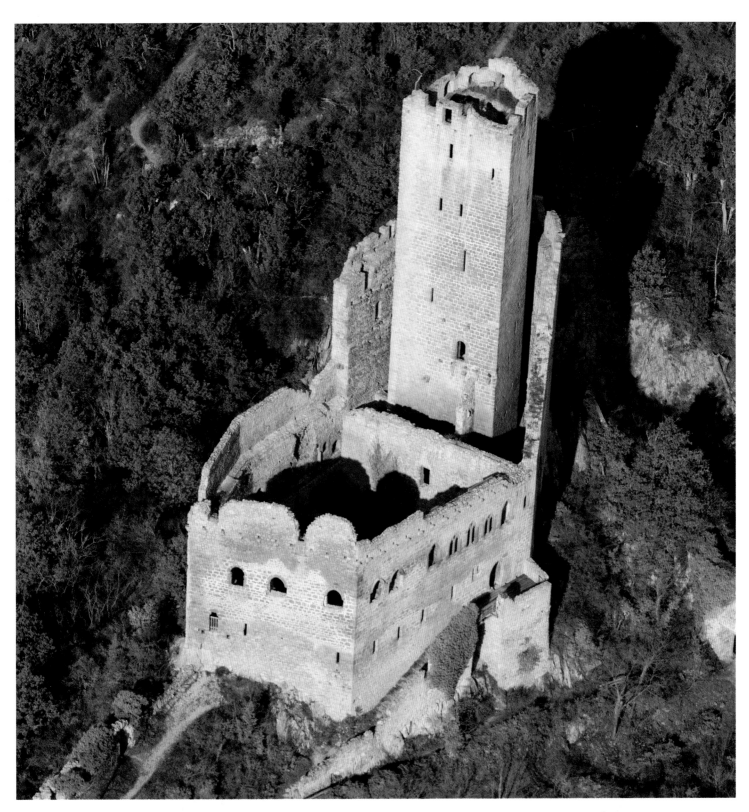

Château d'Alleuze, Cantal, Auvergne, France
Why did the villagers of Saint-Flour burn down Château d'Alleuze in 1405? Because for seven years it had been occupied by Bernard de Garlan, a noble siding with the English during the Hundred Years' War, and he had spent his time terrorizing the area. Alas, the castle's new owner made them rebuild the 13th-century castle just as it had been.

Teczyn, Kraków-Czestochowa Upland, Poland
Dating from the early 14th century, Teczyn Castle reached its greatest extent in the early 17th century before being conquered by Swedish-Brandenburgian forces in 1656. The victorious army butchered everyone inside and set the castle on fire.

Château de l'Ortenbourg, Alsace, France
Situated on a high, rocky outcrop, Château de l'Ortenbourg was built out of white granite in the 13th century. The tall keep is unusual in that it is pentagonal rather than square shape. Having changed hands several times over the centuries, the château was burned by the Swedes in 1633 during the Thirty Years' War.

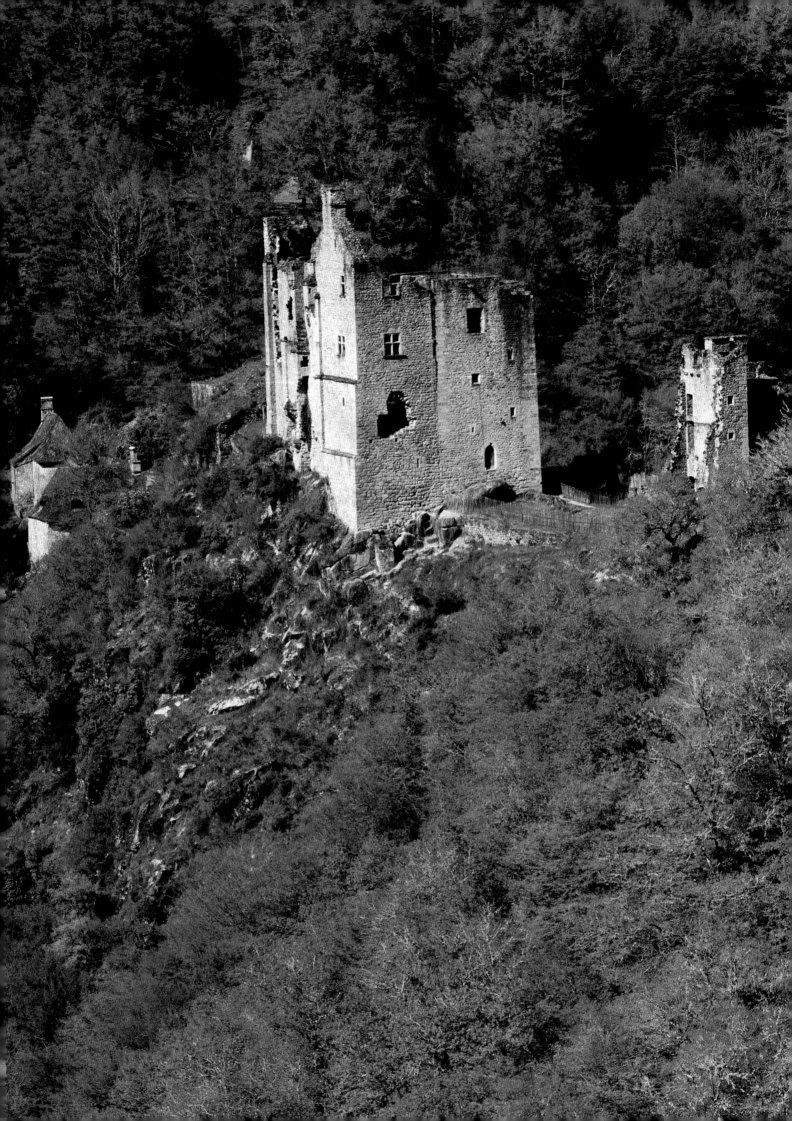

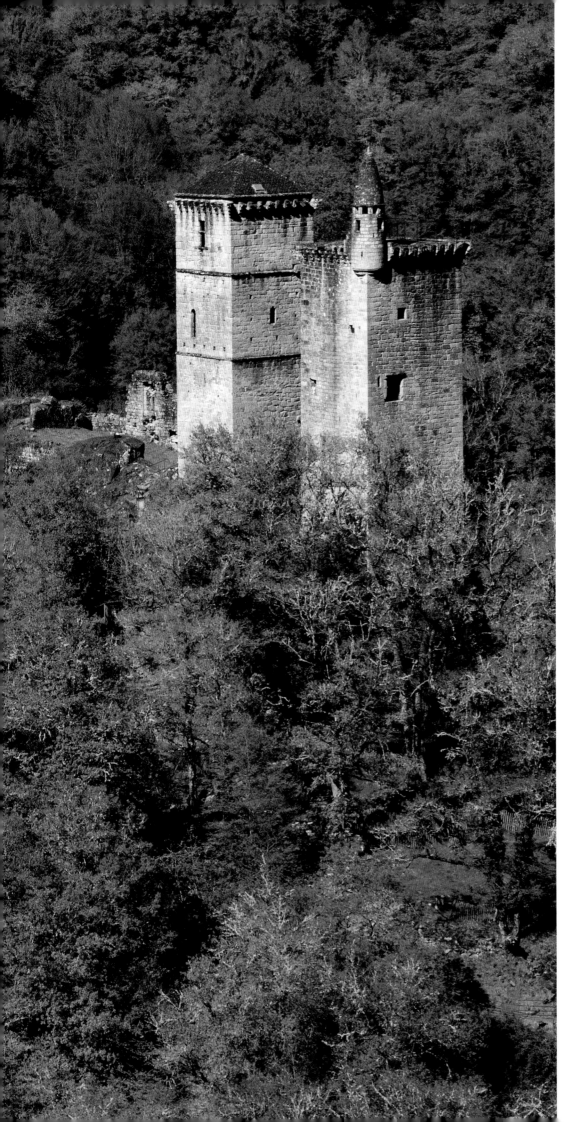

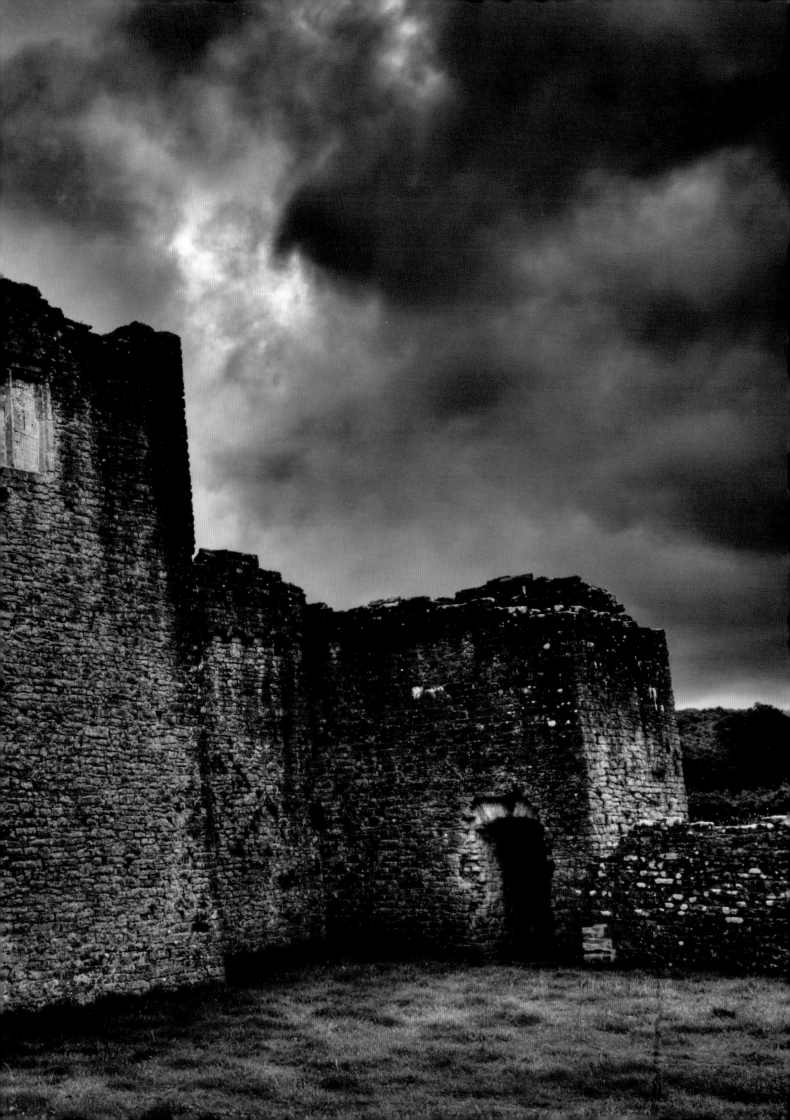

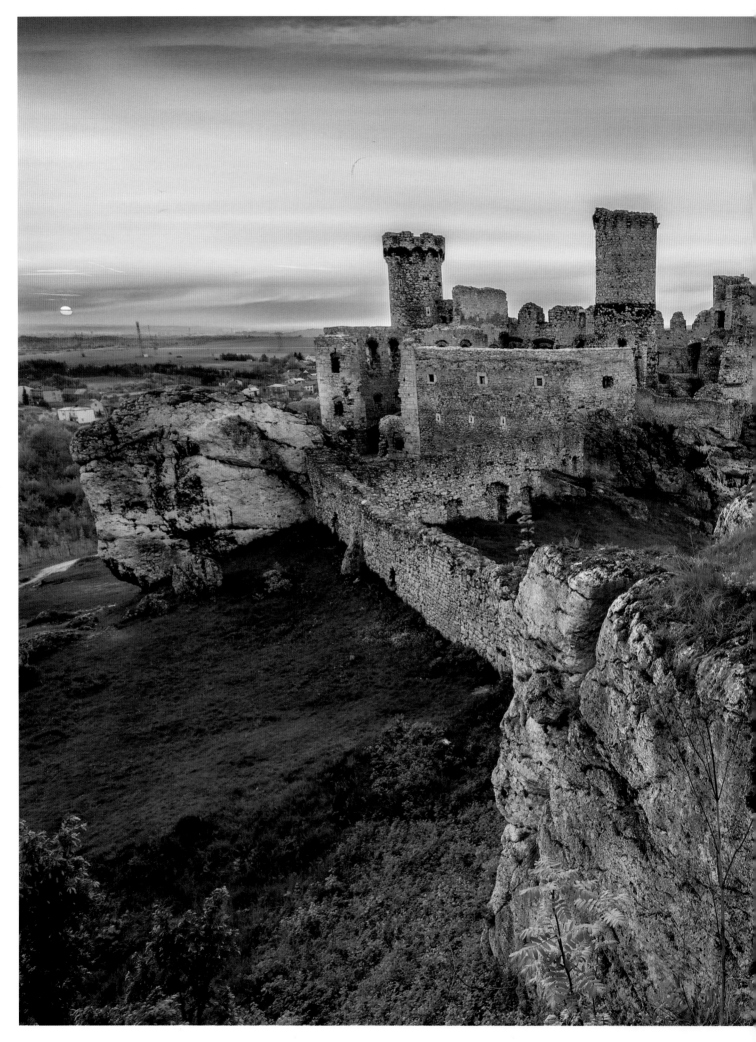

LEFT:

Ogrodzieniec, Kraków-Czestochowa Upland, Poland
Ogrodzieniec stands on the border between the provinces of Lesser Poland and Silesia. In 1587, it was captured by Maximilian III of Austria during the War of Polish Succession. An earlier wooden castle on the same ground had been destroyed in 1241 during the Mongol invasion of Poland.

OVERLEAF:

LEFT:

Ogrodzieniec, Kraków-Czestochowa Upland, Poland
Dug into the limestone rocks of the highest hill in the Kraków-Czestochowa Upland, a Gothic castle at Ogrodzieniec was built in the mid-14th century, before being replaced 200 years later by the Renaissance building that remains today. Severely damaged in a fire lit by Swedish troops in 1702, the castle subsequently fell into ruin.

TOP RIGHT:

Rabi Castle, Bohemia, Czech Republic
In terms of area, 14th-century Rabi is the largest castle in the Czech Republic. In rebellion against the Roman Catholic Church, the Hussites conquered the castle twice, in 1420 and 1421. The castle was devastated during the Thirty Years' War (1618–48).

BOTTOM RIGHT:

Dunnottar Castle, Stonehaven, Aberdeenshire, Scotland
Perched on a headland jutting into the North Sea, Dunnottar Castle is best known as the place where the Scottish crown jewels – the Honours of Scotland – were hidden when Oliver Cromwell invaded Scotland in 1650. The oldest buildings date from the 14th century.

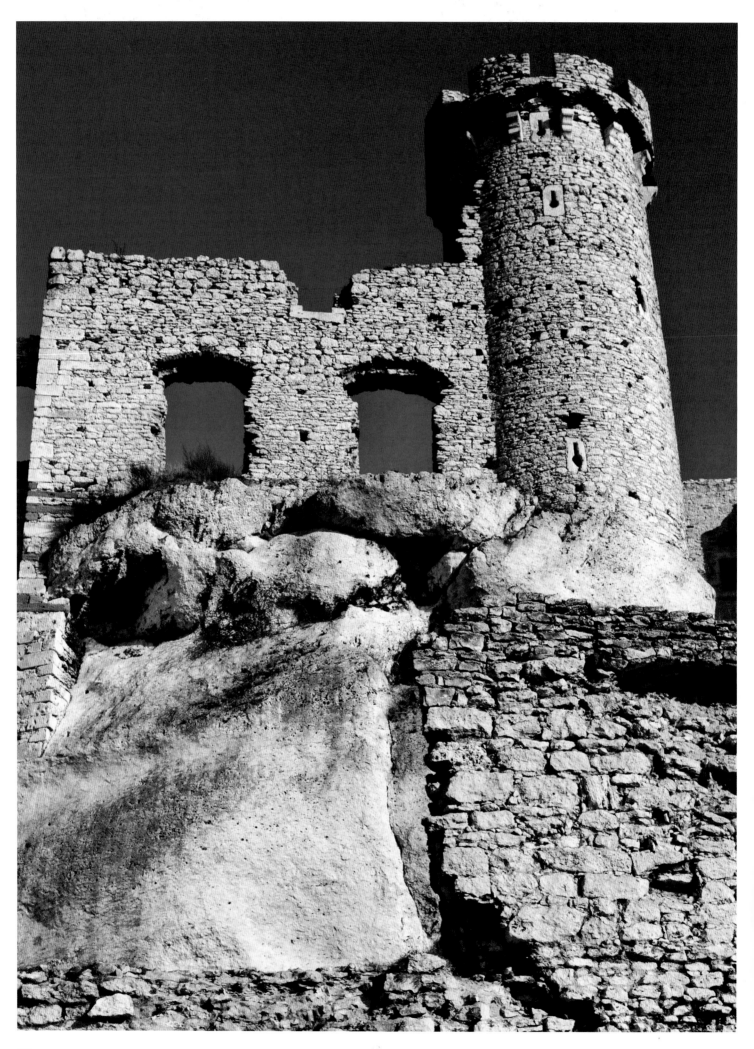

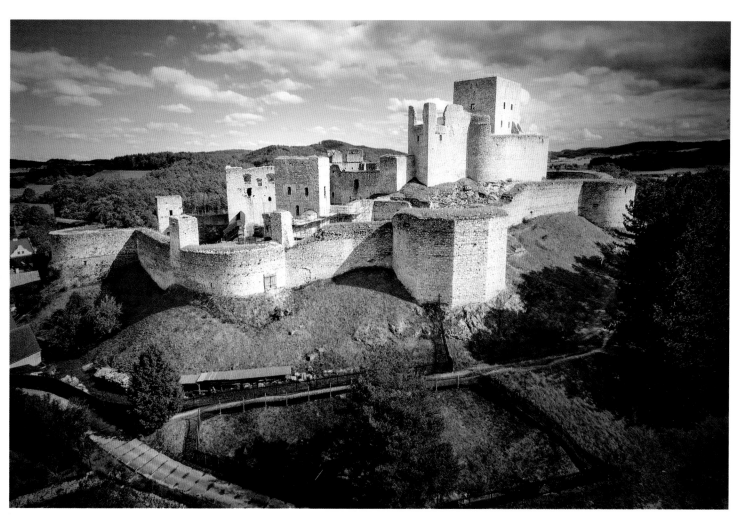

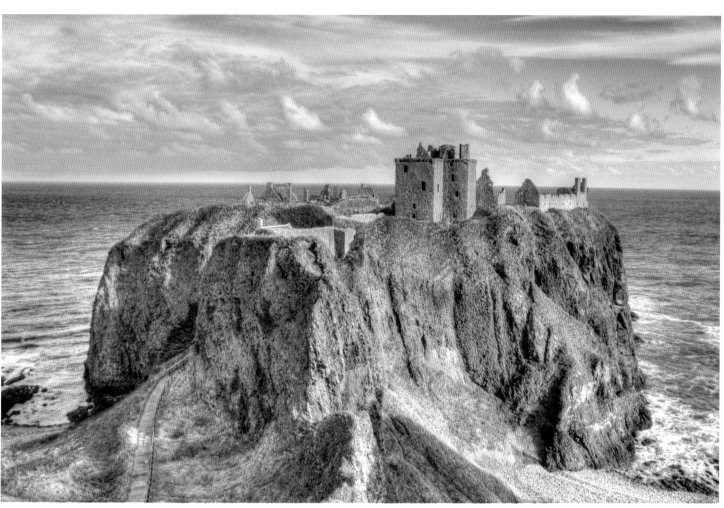

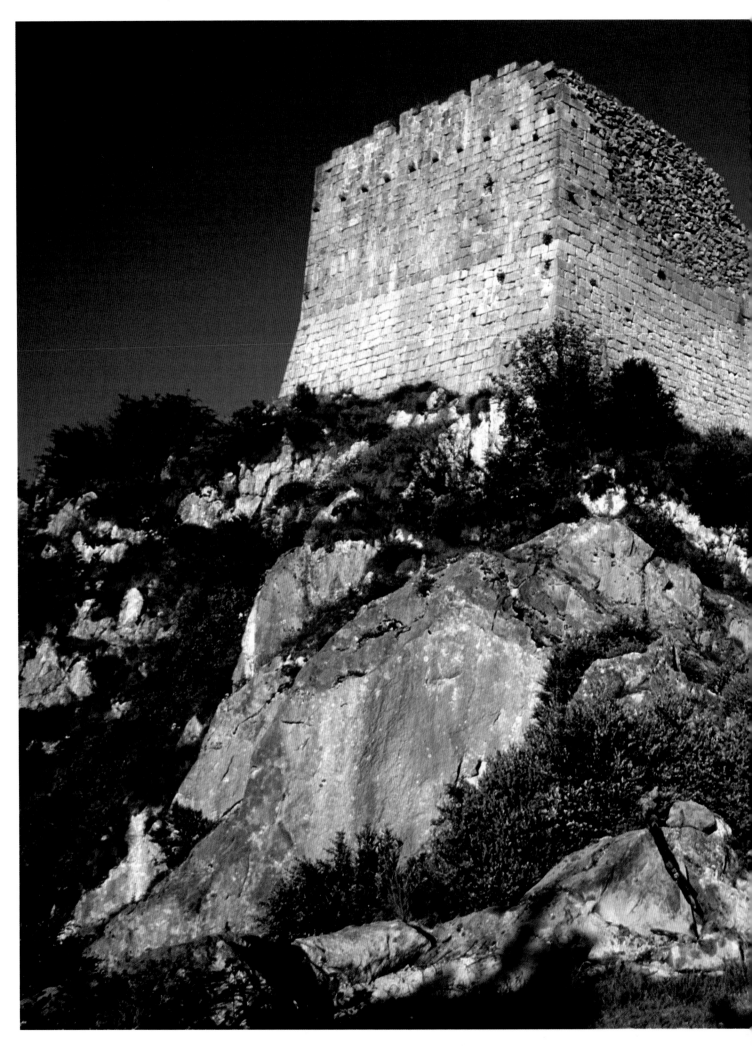

Château de Montségur, Ariège, Occitanie, France

This is a 17th century fortress built on the site of the earlier Cathar castle. The Cathars were a sect in southern France who believed in both a good God, who created the spiritual world, and an evil one, who created all physical matter. Regarded as heretics by Rome, they had already been the target of the Albigensian Crusade (1209–29) when, in the 1230s, Montségur became their stronghold. But when in 1242 two members of the Inquisition were murdered there, 10,000 French troops were sent to eliminate the sect.

Although there were only 100 fighters and 190 Cathar *Perfecti* – male and female pacifist monks – they managed to survive a nine-month siege, before agreeing to surrender. Those who renounced their Cathar faith were free to leave; the rest would be burned as heretics. But rather than the numbers of *Perfecti* dwindling when faced with execution, at least 20 defenders of Montségur joined the devout. In March 1244, more than 200 Cathars left the castle and willingly mounted the funeral pyres. The castle was subsequently destroyed. Although Catharism had not completely been eradicated, it had lost its focal point.

Carew Castle, Pembrokeshire, Wales
Built around 1270 on the site of earlier fortifications, Carew Castle was expanded during the Tudor period and refortified by Royalists during the English Civil War (1642–51). It changed hands three times during the conflict before the Parliamentarians pulled down the south wall, leaving it indefensible to either side. By the late 17th century, the castle had been abandoned.

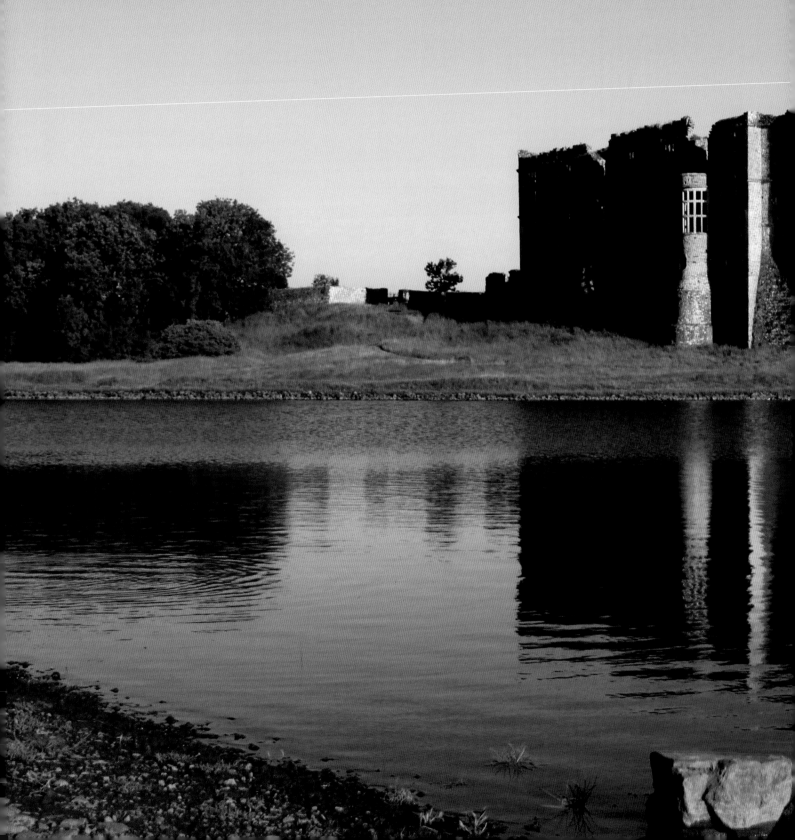

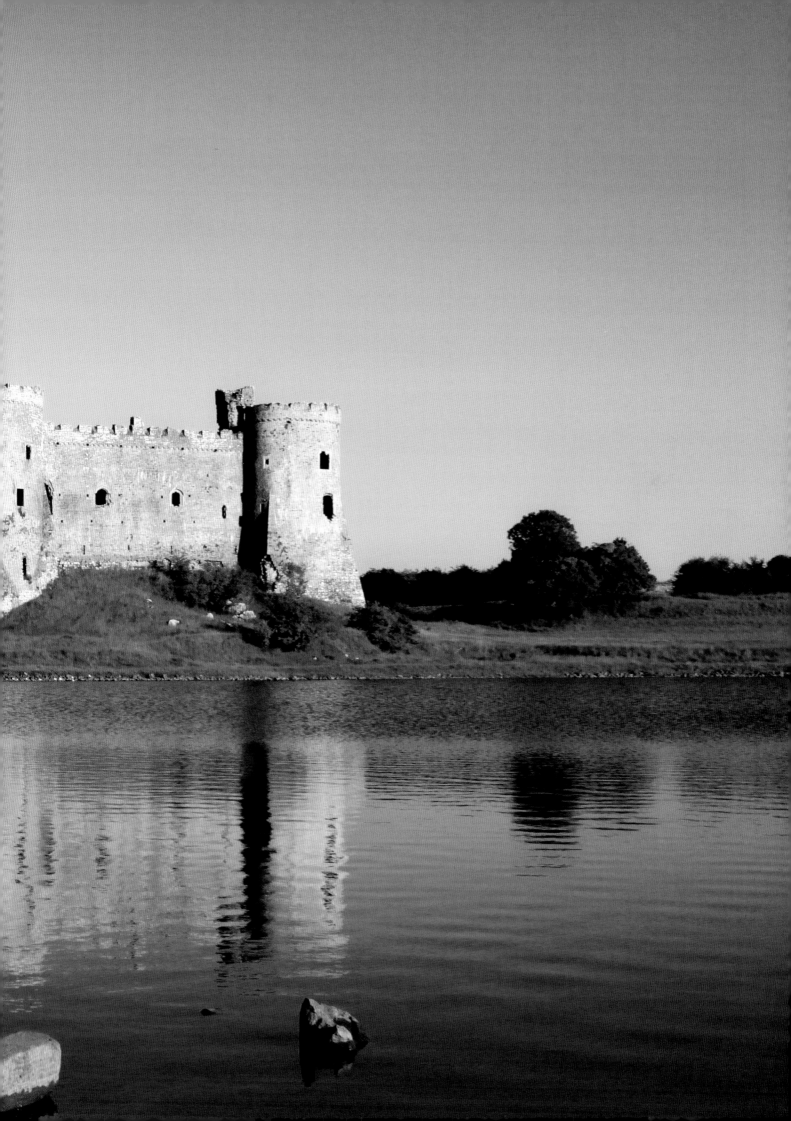

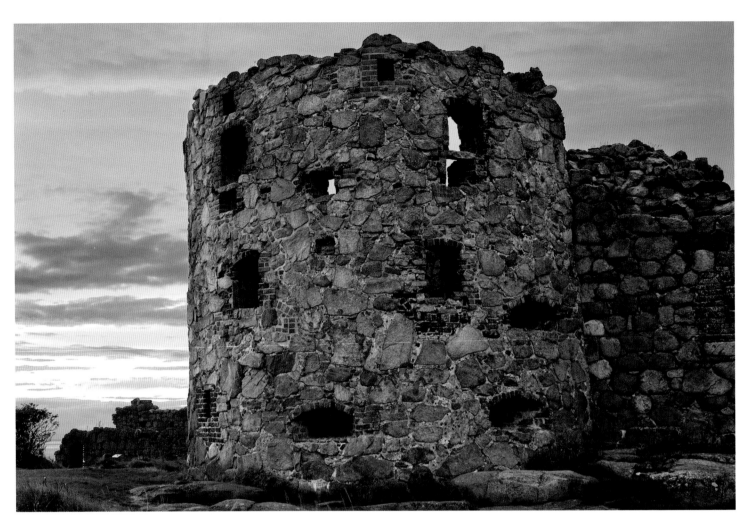

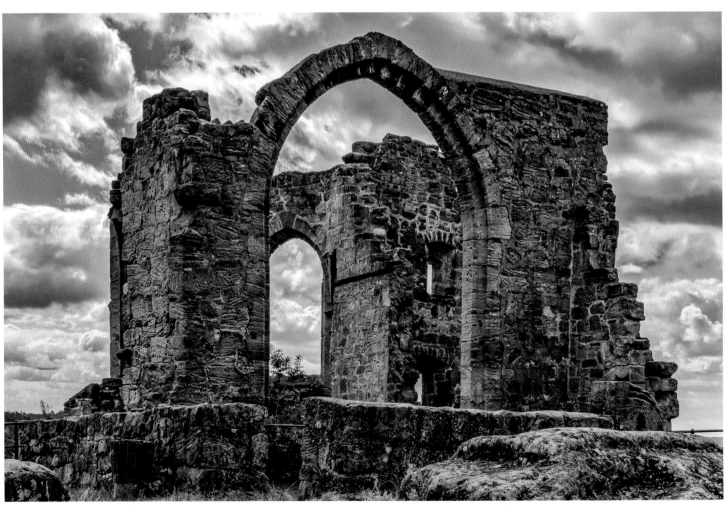

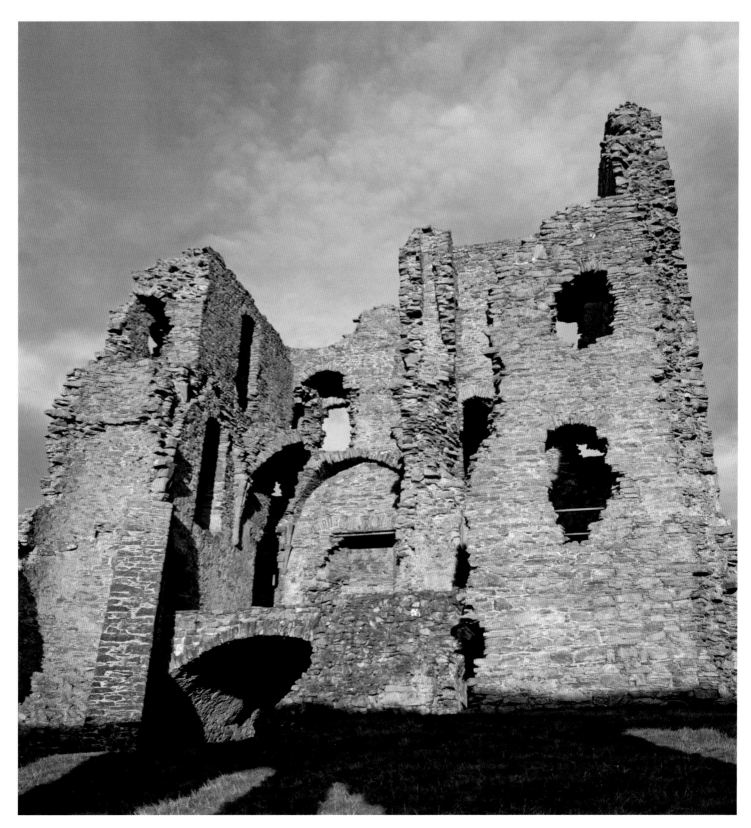

OPPOSITE TOP:

Hammershus, Bornholm, Denmark

Scandinavia's largest medieval fortification, 13th century Hammershus, on the isolated island of Bornholm, proved to be a refuge for the archbishops of Lund (now in Sweden) in their disputes with the Danish monarchy. Conquered repeatedly by the Danish crown in the 13th–14th centuries, it was later used as a prison.

OPPOSITE BOTTOM:

Altenstein, Bavaria, Germany

Altenstein was the seat of the lords of Stein zu Altenstein from the early 13th century. By 1300, eight branches of the family were living within the castle in a system of joint inheritance. When the Steins moved to a new palace in 1703, Altenstein was allowed to fall into ruin.

ABOVE:

Auchindoun Castle, Moray, Scotland

What remains of Auchindoun was built in the mid-15th century. It passed through the hands of several clans but by 1725 was derelict, its masonry later being used in local farm buildings. Surrounding Auchindoun are defensive ditches dating back to the Iron Age, when a hill fort existed on the site.

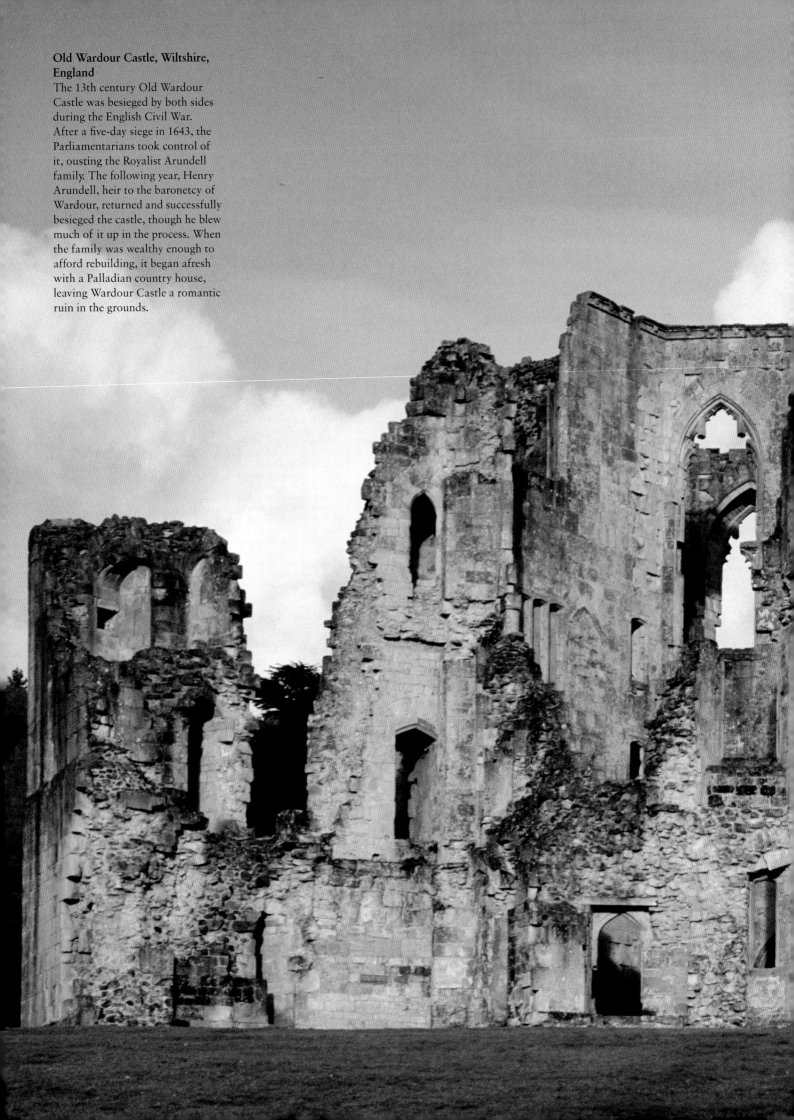

Old Wardour Castle, Wiltshire, England
The 13th century Old Wardour Castle was besieged by both sides during the English Civil War. After a five-day siege in 1643, the Parliamentarians took control of it, ousting the Royalist Arundell family. The following year, Henry Arundell, heir to the baronetcy of Wardour, returned and successfully besieged the castle, though he blew much of it up in the process. When the family was wealthy enough to afford rebuilding, it began afresh with a Palladian country house, leaving Wardour Castle a romantic ruin in the grounds.

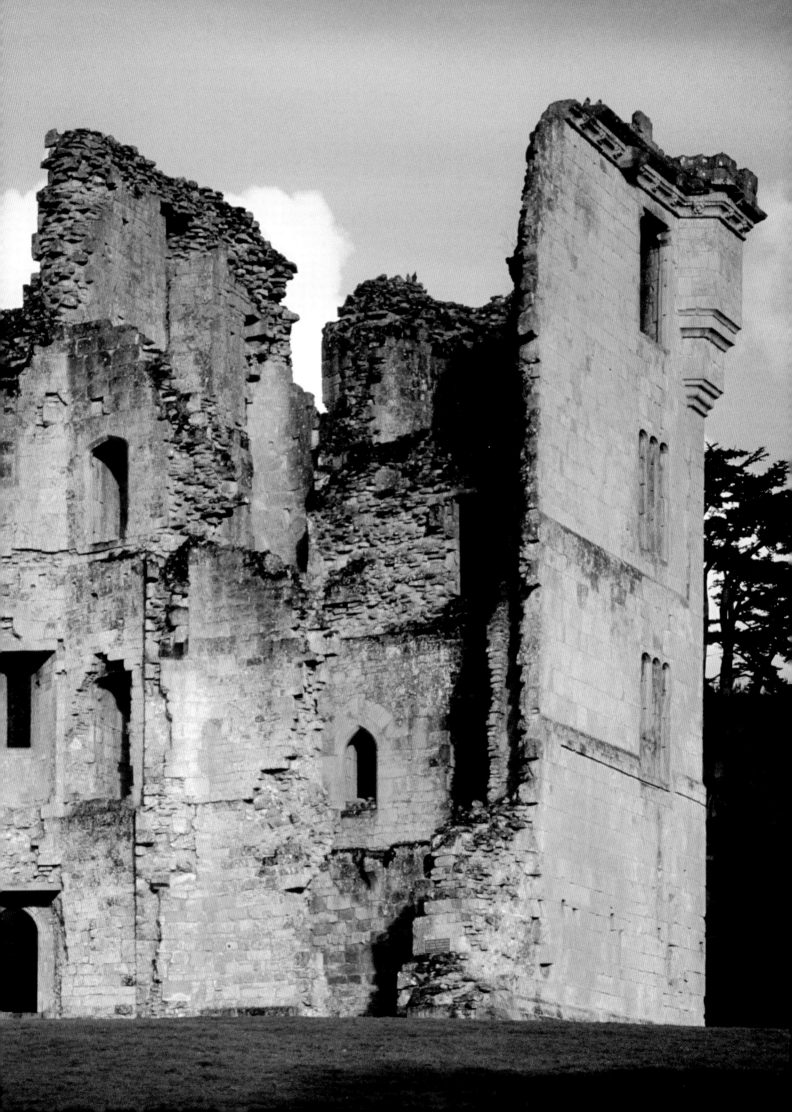

Nakijin Castle, Okinawa, Japan
Built in the 14th century, the limestone castle at Nakijin later became part of the independent Ryukyu Kingdom, rulers of Japan's southern Ryukyu Islands from the 15th to the 19th century. In 1609, the Japanese feudal Domain of Satsuma invaded and set the castle on fire.

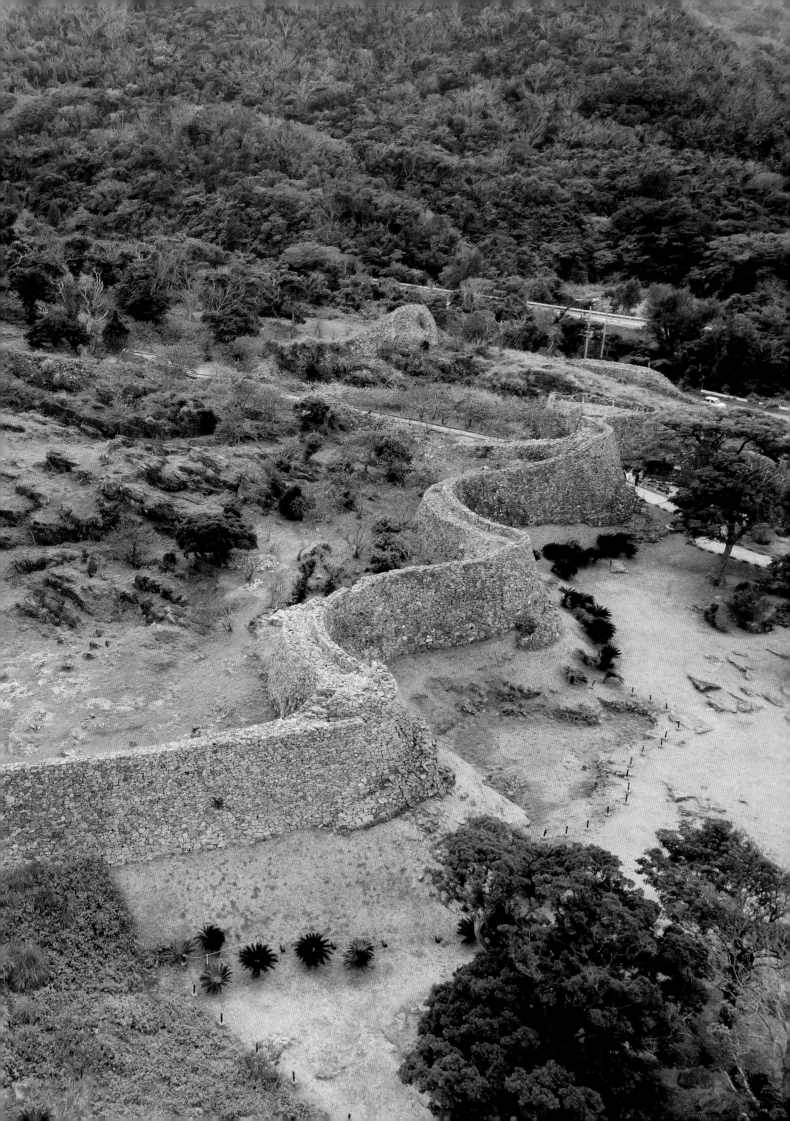

RIGHT AND OVERLEAF LEFT:

Château de Quéribus, Aude, France

Sometimes regarded as the final Cathar stronghold after Château de Montségur was captured in 1244, Quéribus itself was targeted 11 years later. Before the French army arrived, however, the remaining Cathars managed to slip away. Dating from the 11th century, it was one of the frontier castles between France and Spain, losing importance in 1659 when the border was moved further south. In recent years, it has been reconstructed.

OVERLEAF:

RIGHT TOP AND BOTTOM:

Frangocastello, Chania Prefecture, Crete, Greece

Frangocastello is a nickname that stuck. Built by the Venetians in 1371–74 to impose order on the rebellious region, deter pirates and protect Venetian nobles settled there, the still remote fortress was named Castle of St. Nikitas after a local church. But contemptuous of the foreign presence, the locals dubbed it Frangocastello – 'Castle of the Franks'.

In 1828, Cretans attempting to overthrow Ottoman rule re-occupied Frangocastello, but Ottoman Mustafa Naili Pasha managed to regain the castle and crush the rebellion. After blowing up parts of the castle to make it unusable, 40 years later in the Cretan Revolt, he would find that he needed to rebuild Frangocastello to control the island.

108

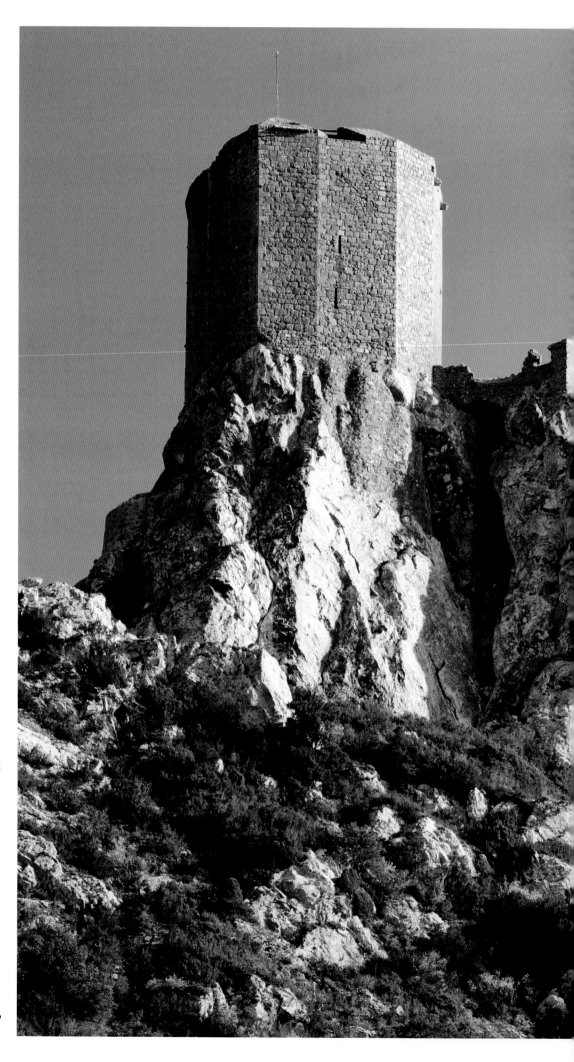

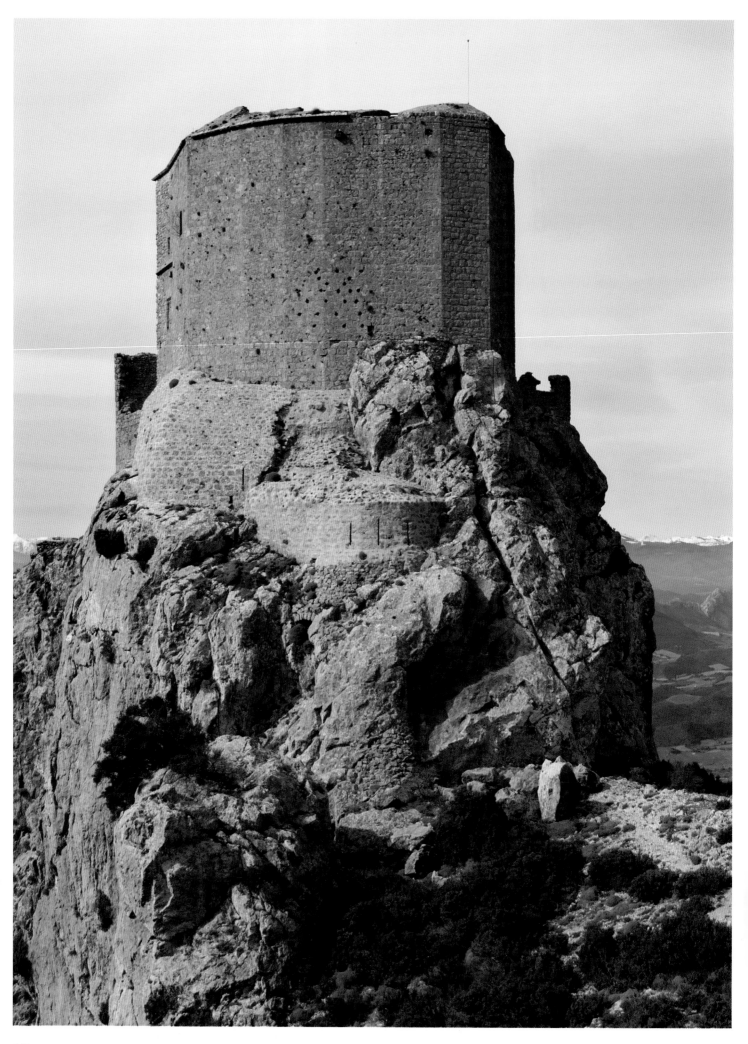

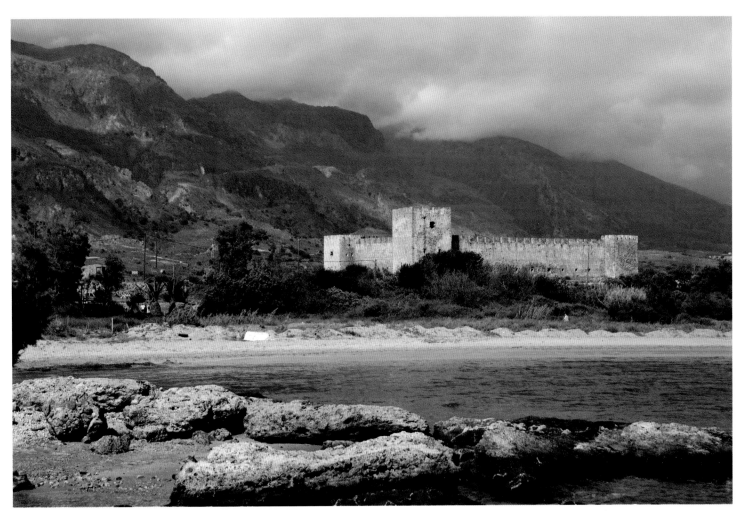

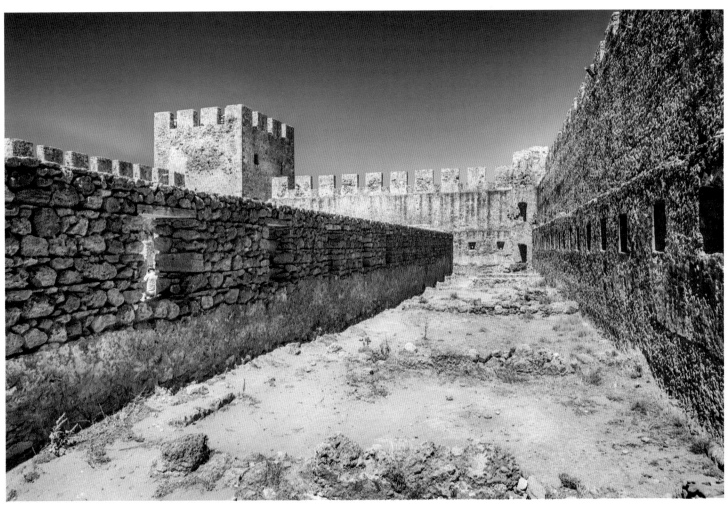

LEFT:

Tamagusuku, Okinawa, Japan
When Okinawa was part of the
Ryukyu Kingdom, there were more
than 200 castles on the island, with
Tamagusuku the oldest. It was
built on a limestone hill in the 13th
century and later expanded. Once
a sacred grove, it is now largely
overgrown with just a wall and the
archway remaining.

OVERLEAF:

Olsztyn, Silesia, Poland
Built into the limestone crags
in Poland's Jura hills, Olsztyn
Castle was largely constructed in
the 14th century on the orders of
King Casimir the Great to protect
western Lesser Poland against the
Czechs. In 1655 it was captured by
the Swedes, after which time, with
its defences now obsolete, it was
abandoned.

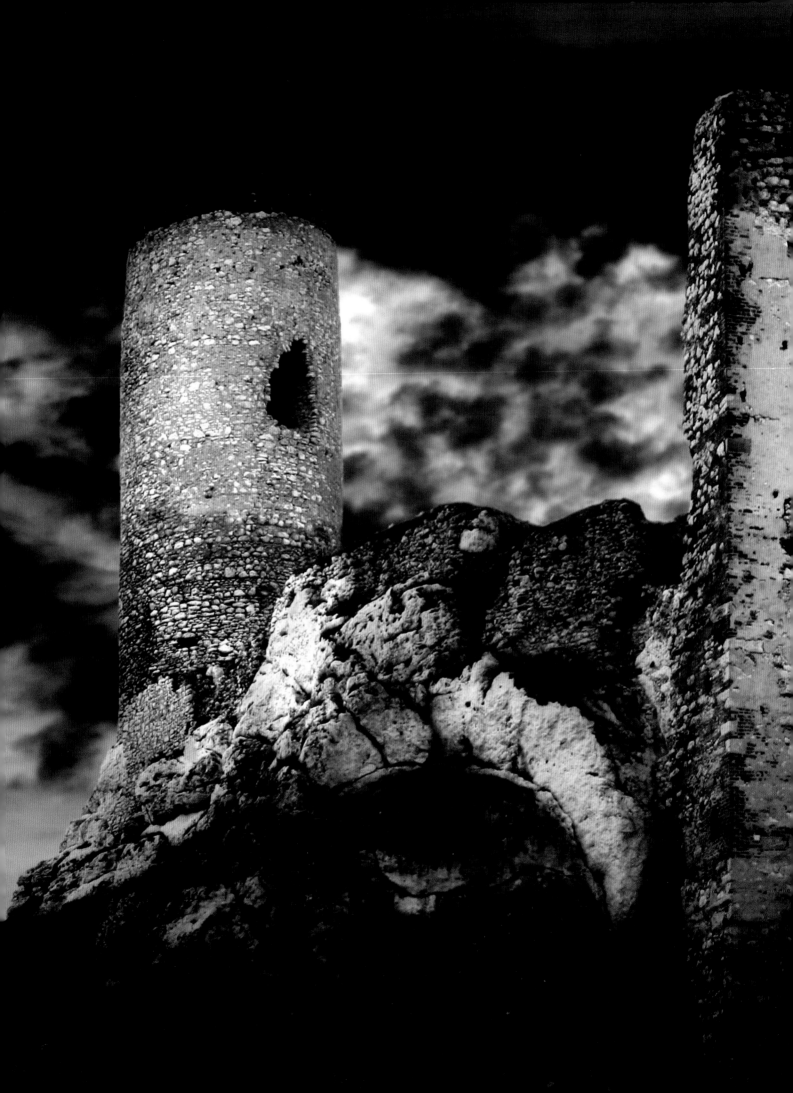

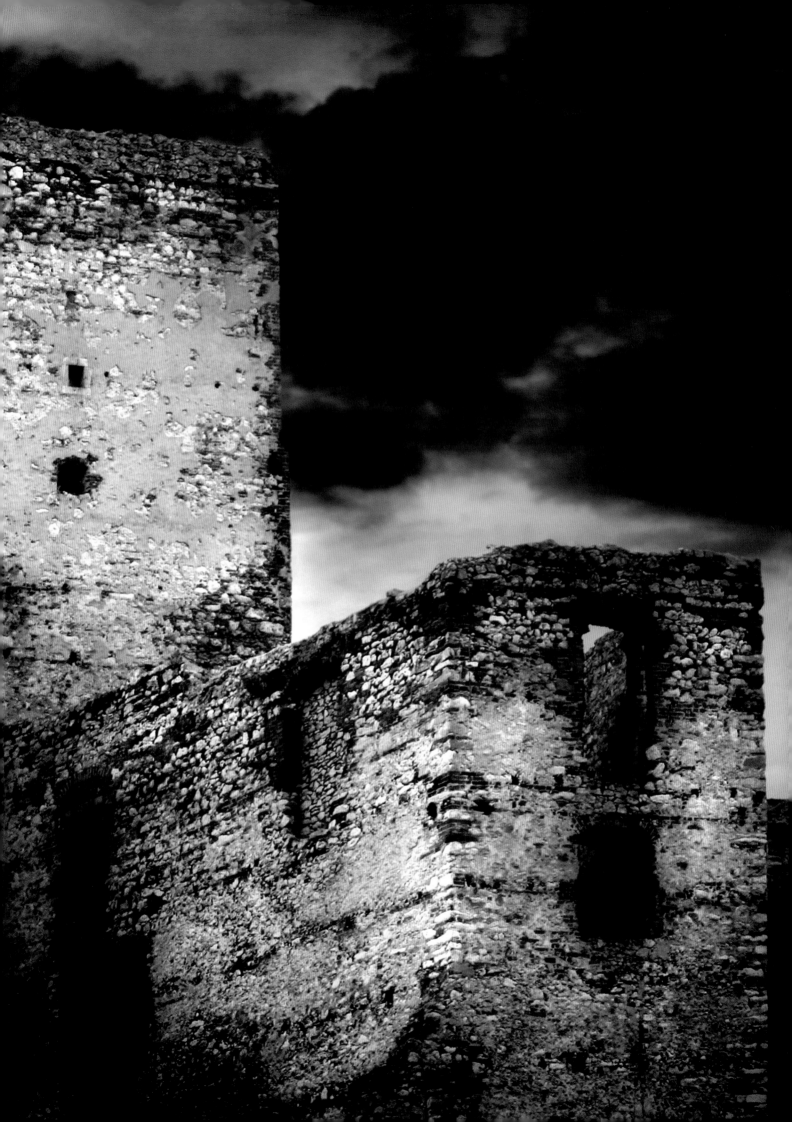

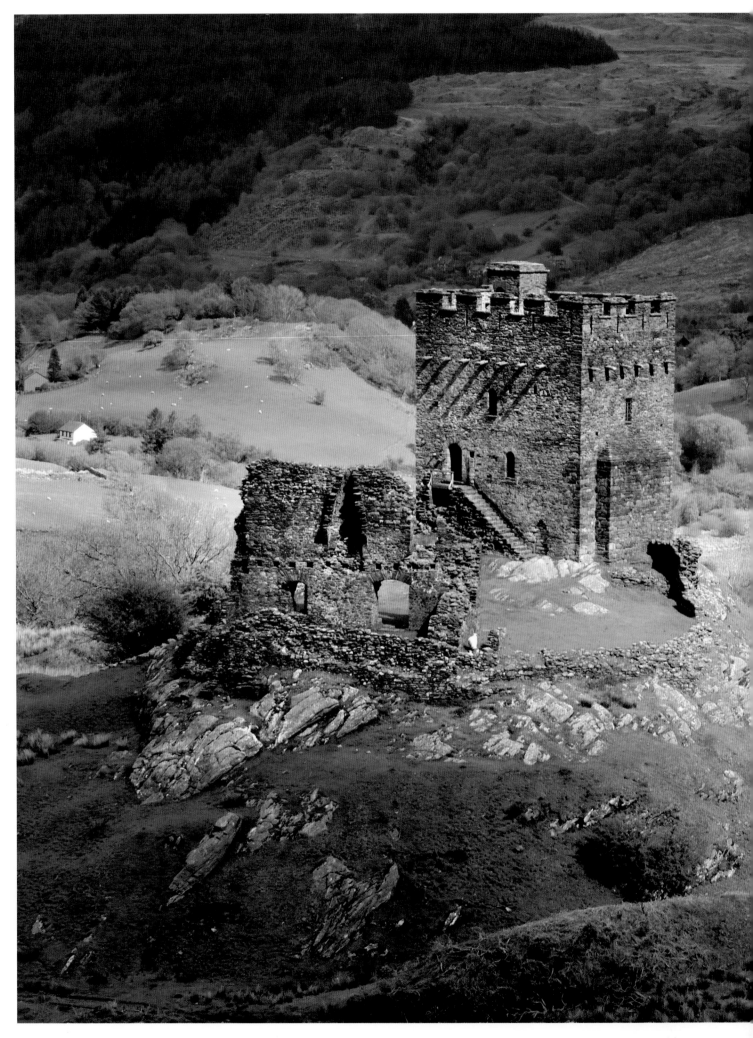

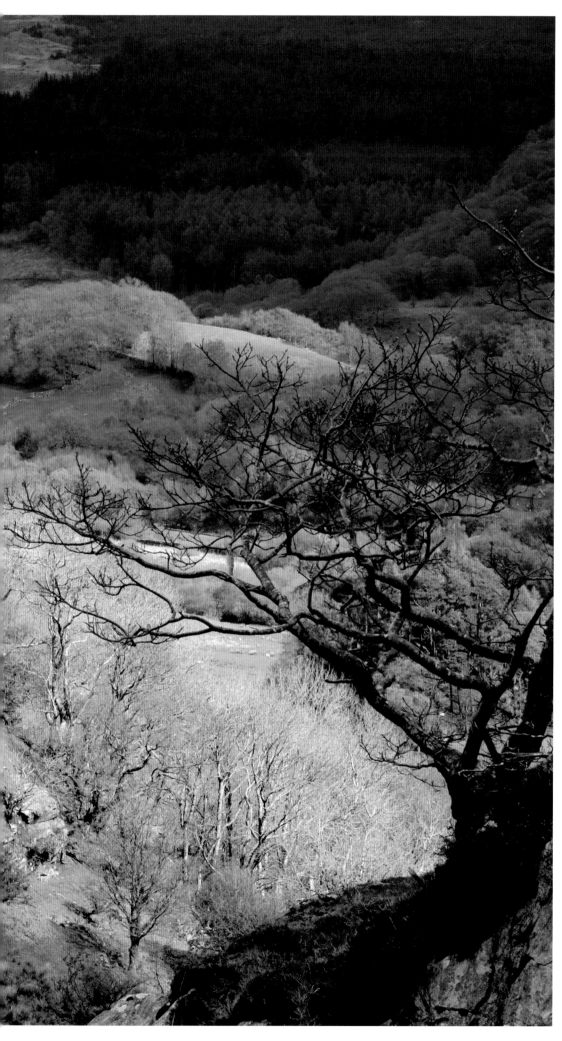

Dolwyddelan Castle, Conwy County Borough, Wales
Dolwyddelan Castle may date from the early 13th century, but the battlements are purely romantic decoration – they were added during restoration work in the 1800s. When, in the late 13th century, Edward I of England decided to control Wales through castles and administrative centres that were reachable by sea, inland castles like Dolwyddelan became obsolete.

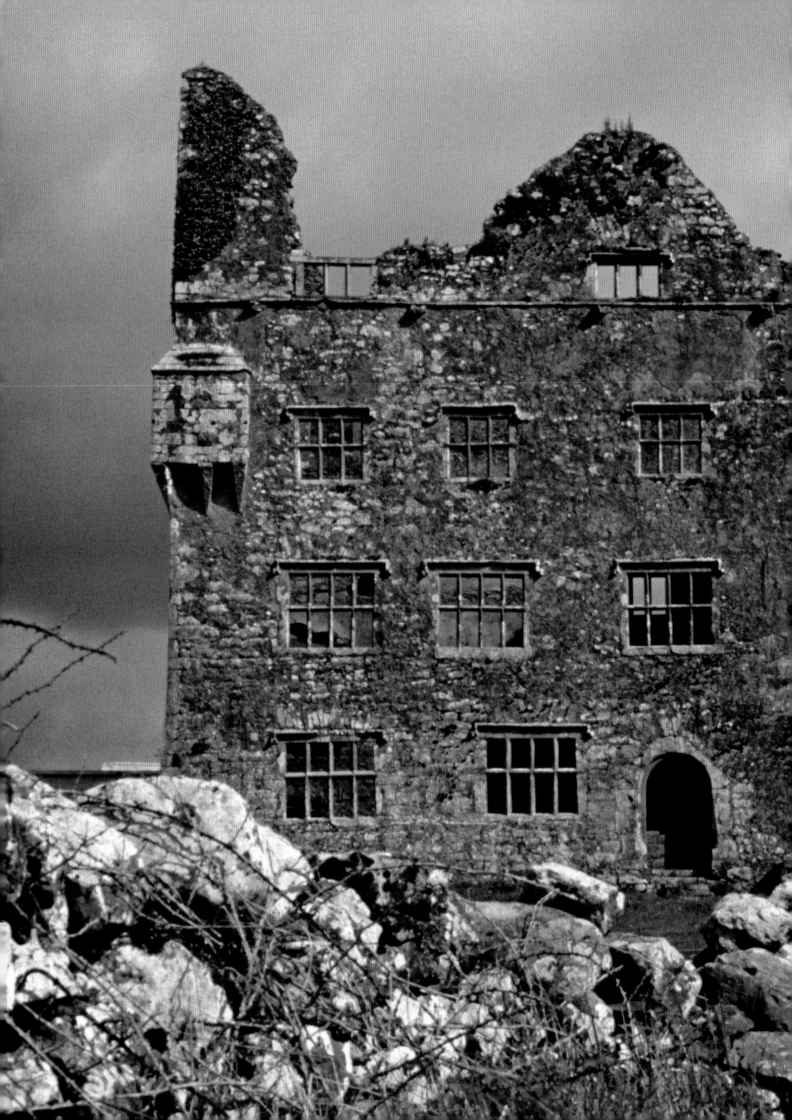

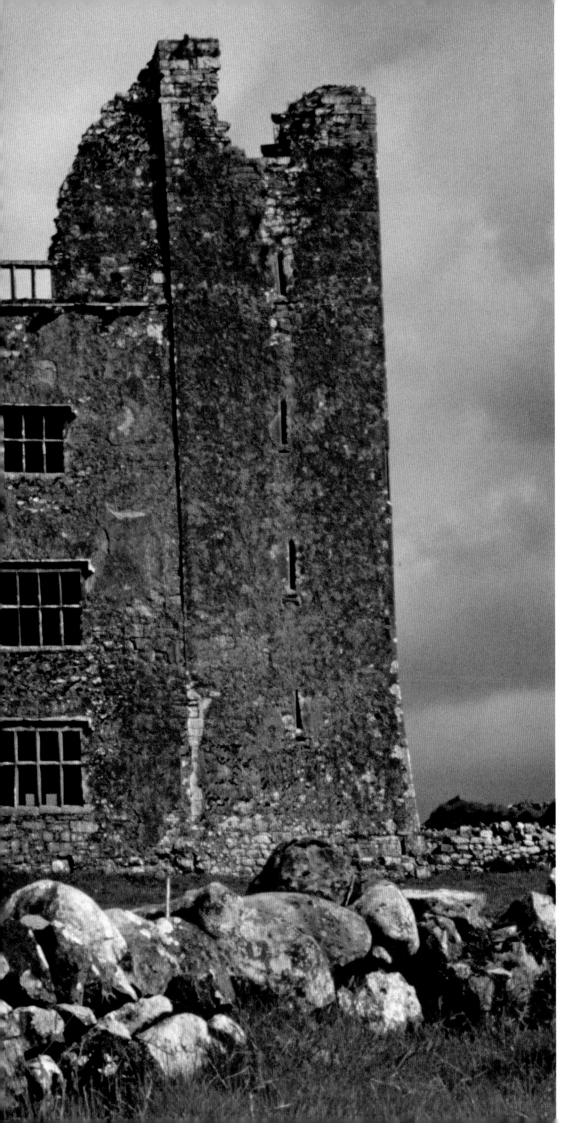

Leamaneh Castle, County Clare, Ireland
At Leamaneh you can clearly see the two separate building periods: the tower house with arrows slits on the right is from the late 15th century, while the manor house in the centre is from the mid-17th century. Its owners, Conor O'Brien and his wife Máire ní Mahon, sided with English Royalists when Oliver Cromwell's Parliamentarians invaded Ireland in 1649. O'Brien was killed in battle and ní Mahon later married one of Cromwell's soldiers. In around 1685, O'Brien and ní Mahon's heir moved the family out of Leamaneh.

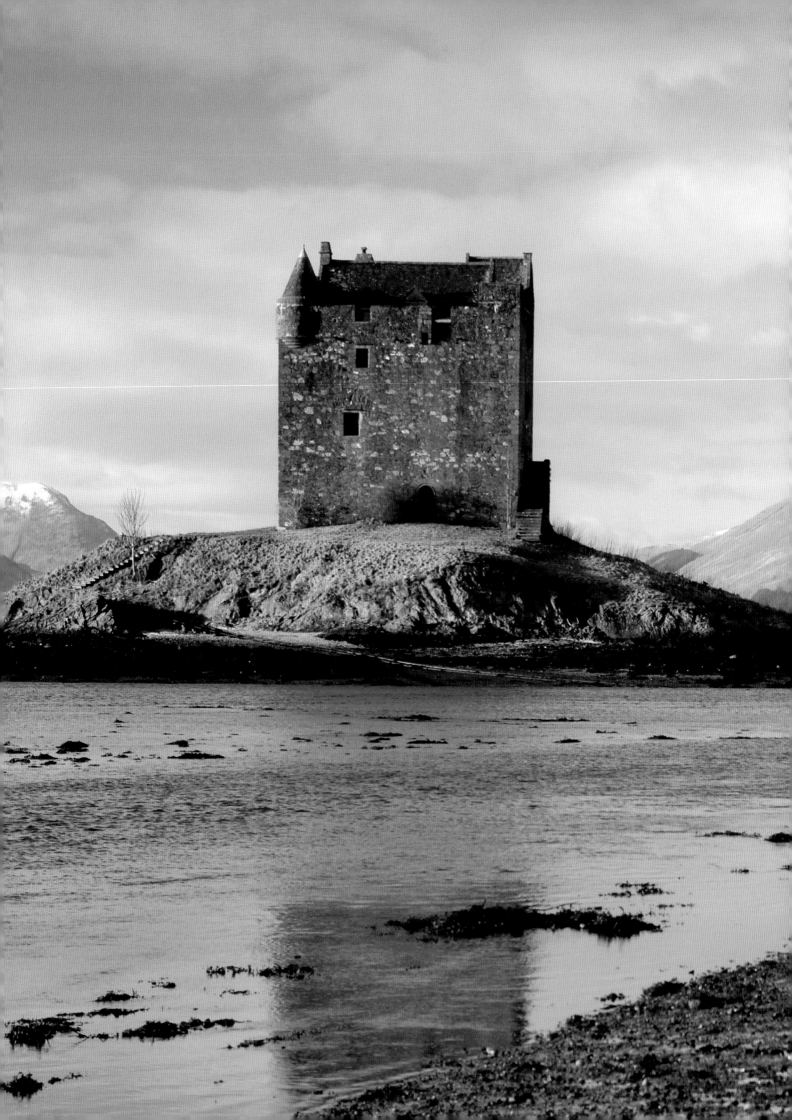

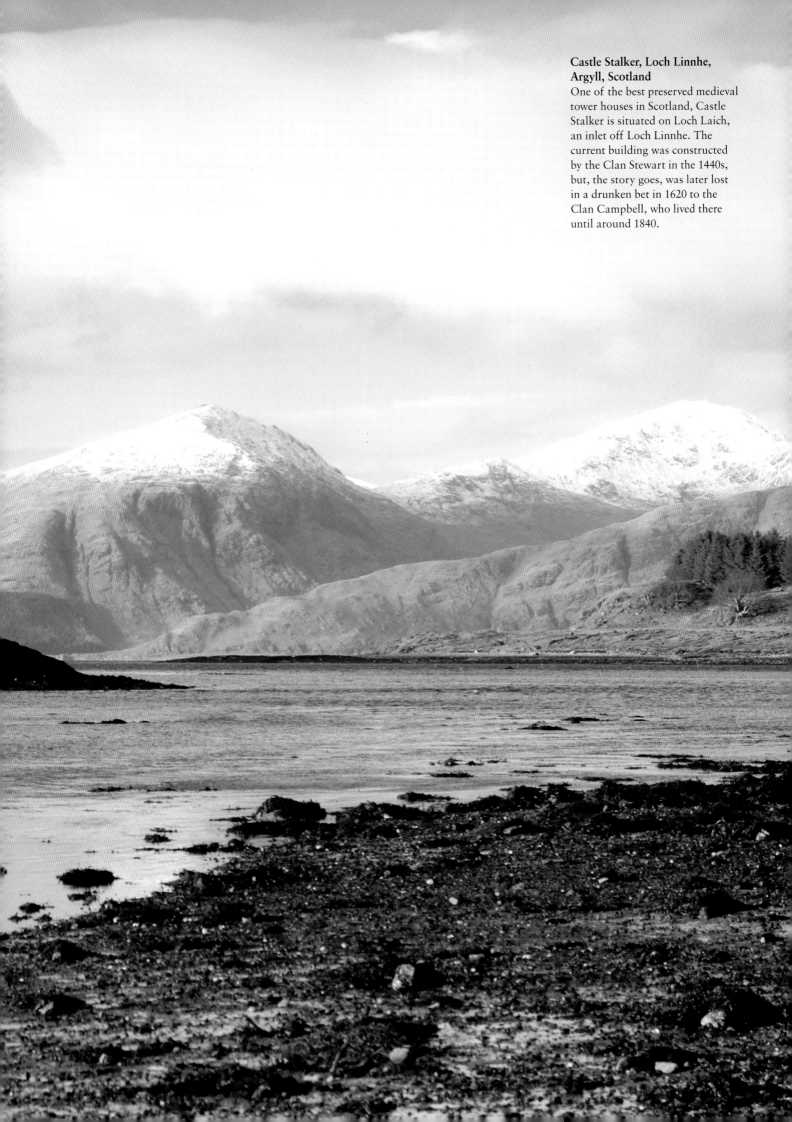

Castle Stalker, Loch Linnhe, Argyll, Scotland
One of the best preserved medieval tower houses in Scotland, Castle Stalker is situated on Loch Laich, an inlet off Loch Linnhe. The current building was constructed by the Clan Stewart in the 1440s, but, the story goes, was later lost in a drunken bet in 1620 to the Clan Campbell, who lived there until around 1840.

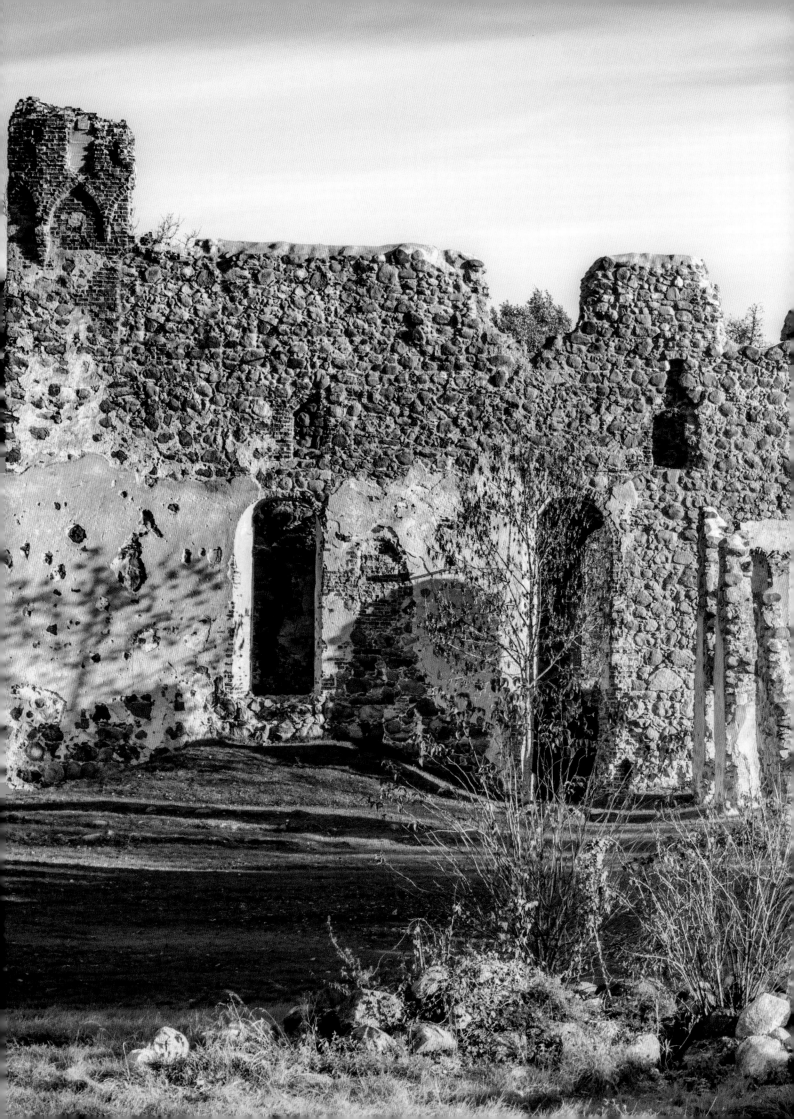

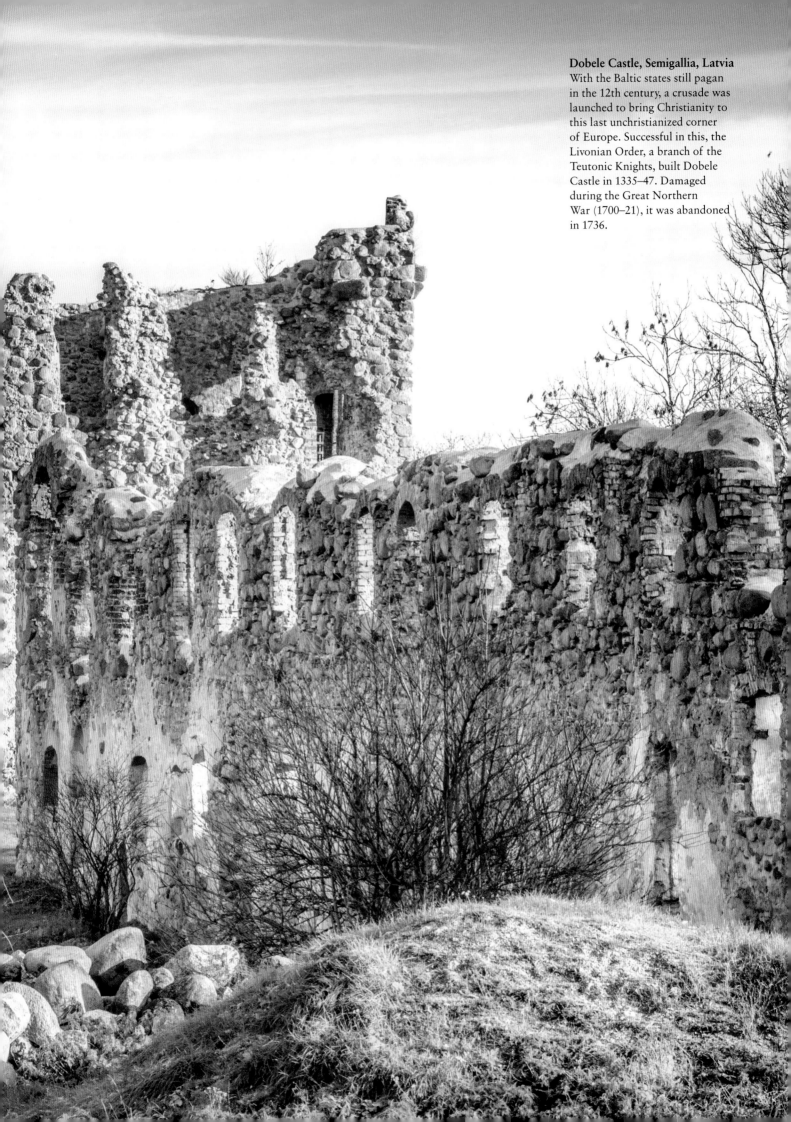

Dobele Castle, Semigallia, Latvia
With the Baltic states still pagan in the 12th century, a crusade was launched to bring Christianity to this last unchristianized corner of Europe. Successful in this, the Livonian Order, a branch of the Teutonic Knights, built Dobele Castle in 1335–47. Damaged during the Great Northern War (1700–21), it was abandoned in 1736.

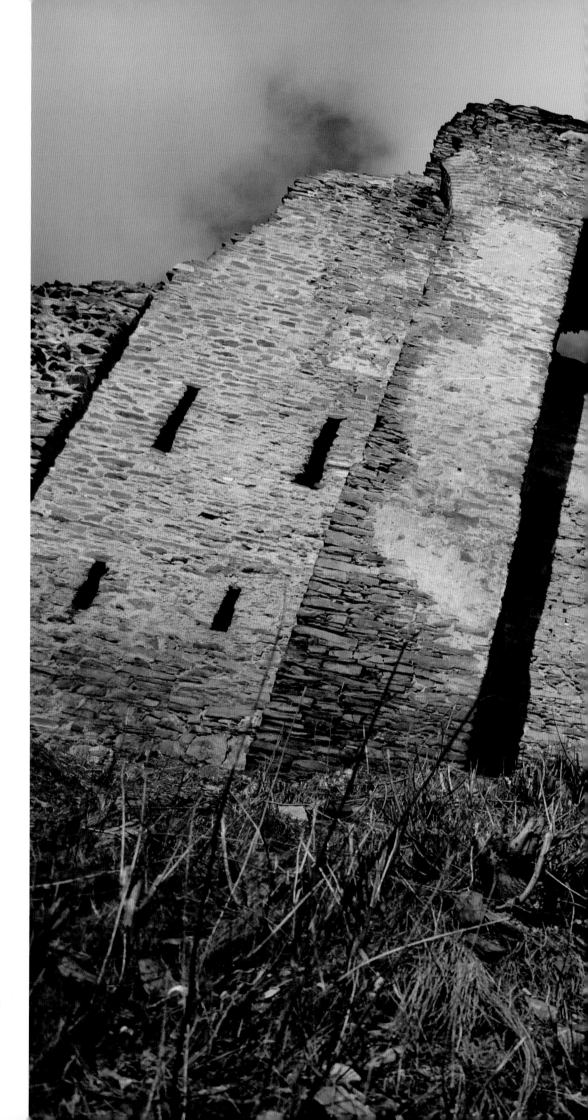

Okor Castle, Bohemia, Czech Republic
Standing on a rocky outcrop in a village 15 kilometres (9 miles) from the centre of Prague, Okor expanded from a 13th century stronghold to a 14th century Gothic castle to a 16th century Renaissance residence.

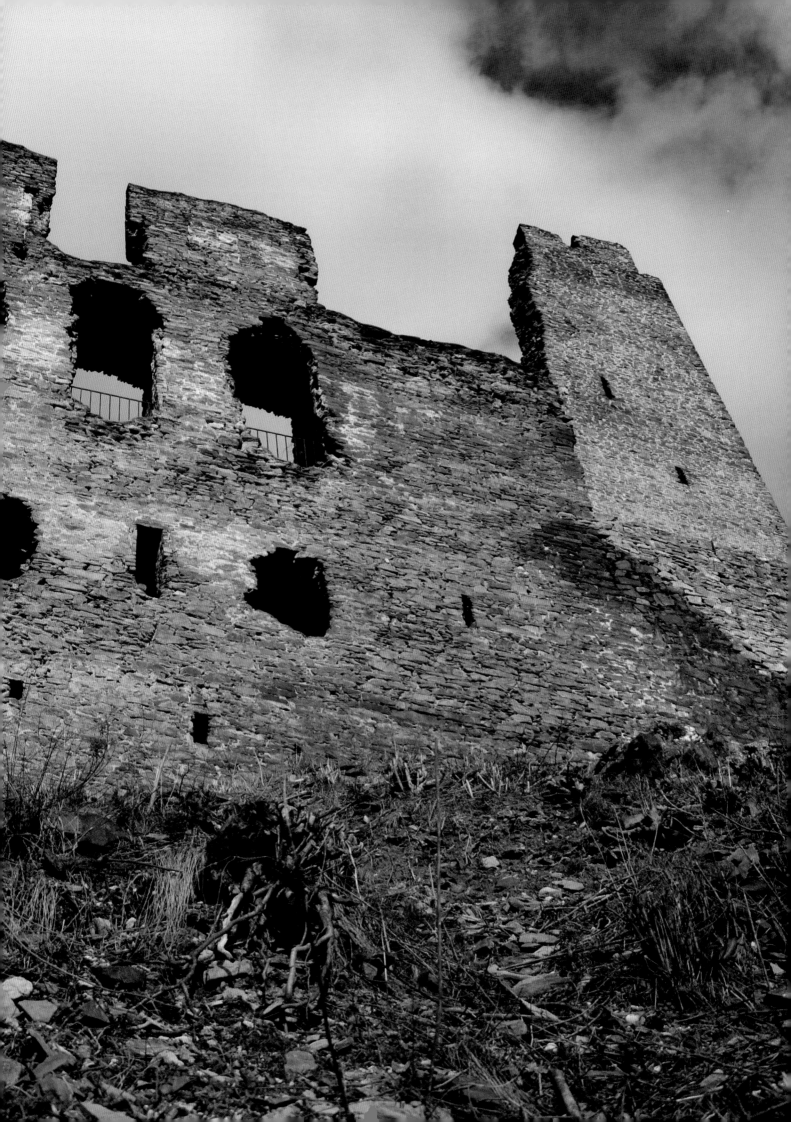

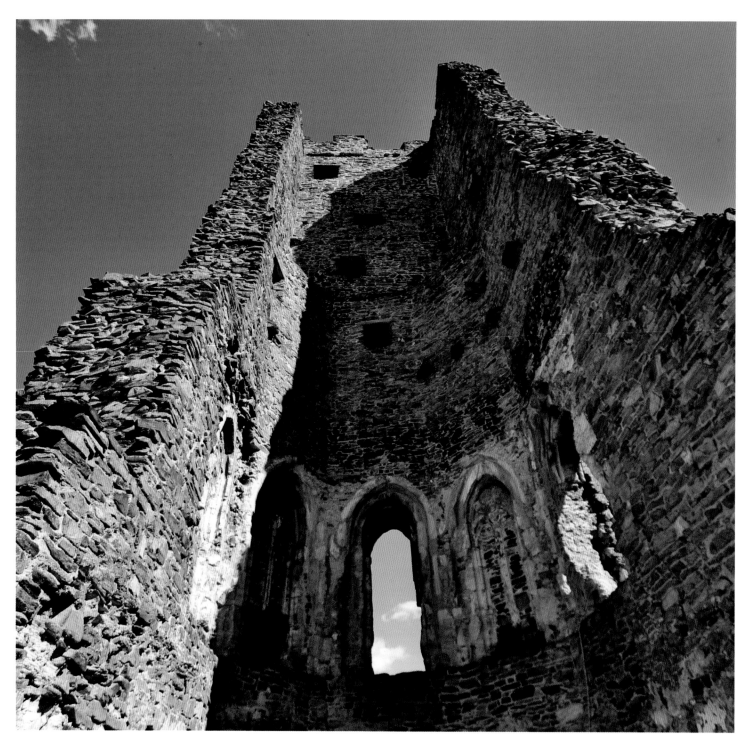

ABOVE:
Okor Castle, Okor, Bohemia, Czech Republic
Damaged during the Thirty Years' War (1618–48), Okor was restored in the Baroque style and later occupied by Jesuits, until their order was discontinued in Bohemia in the late 18th century.

OVERLEAF:
Hrusov Castle, Nitra, Slovakia
Built in the 13th century, the castle at Hrusov stands high on Mount Skalka and once guarded the road over the Tribec Mountains in western Slovakia. Severely damaged by the Habsburgs in 1708, it fell into ruin.

OPPOSITE TOP:
Fortress of Asklipio, Rhodes, Greece
Built in the late 15th century, the Fortress of Asklipio on the island of Rhodes was once a square castle with towers on each corner. Standing 250m (820ft) above the village of Asklipio, the castle commanded the surrounding countryside and a large section of coastline.

OPPOSITE BOTTOM:
Hovenweep Castle, Utah, USA
The towers at Hovenweep were built by the Puebloan people between 1200 and 1300. A farming community, the Puebloan settlement supported 2,500 people. By the end of the 13th century, probably mainly because of drought, the Puebloans moved south to areas in present-day New Mexico and Arizona.

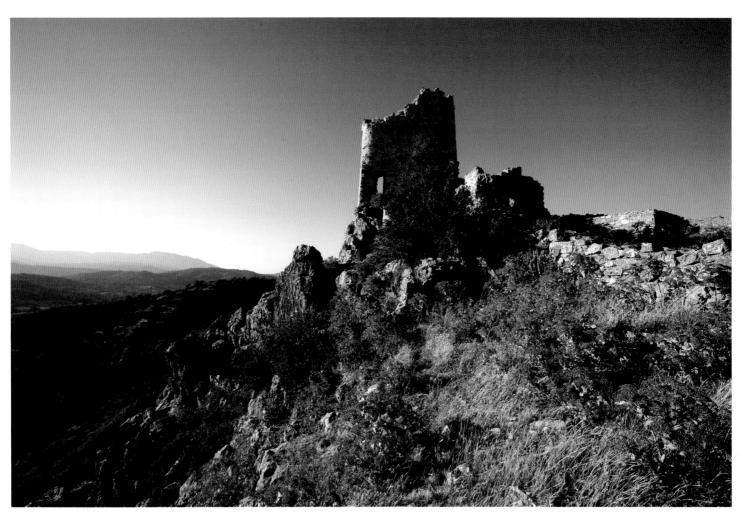

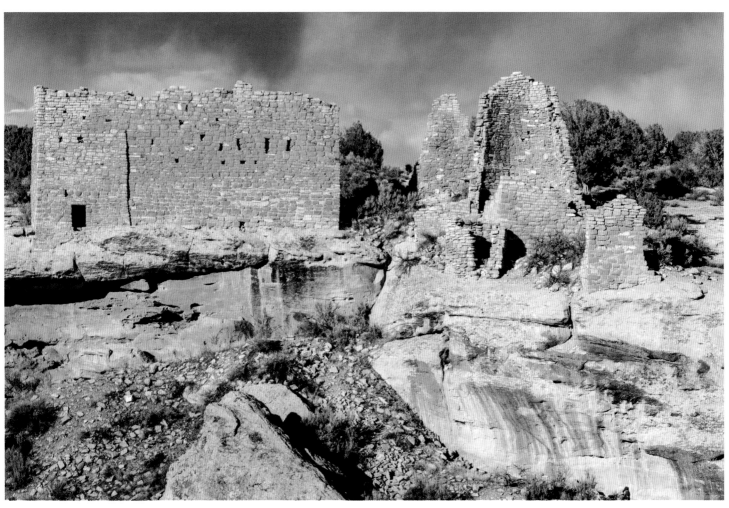

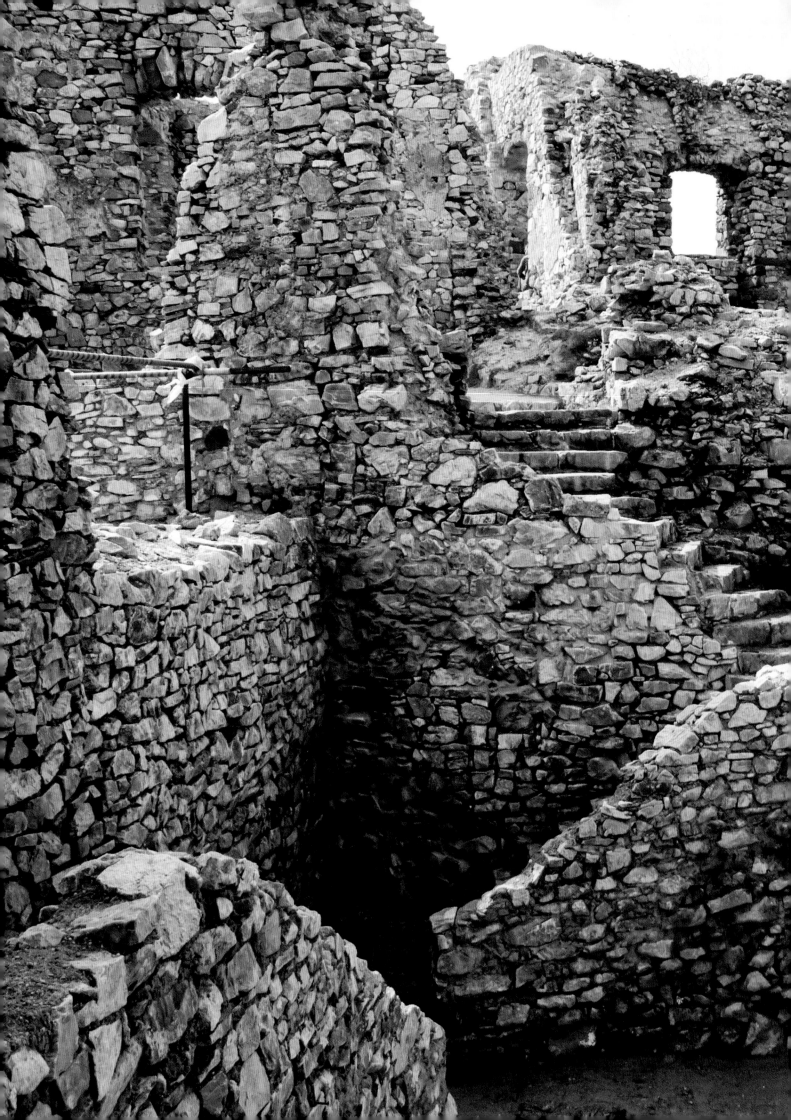

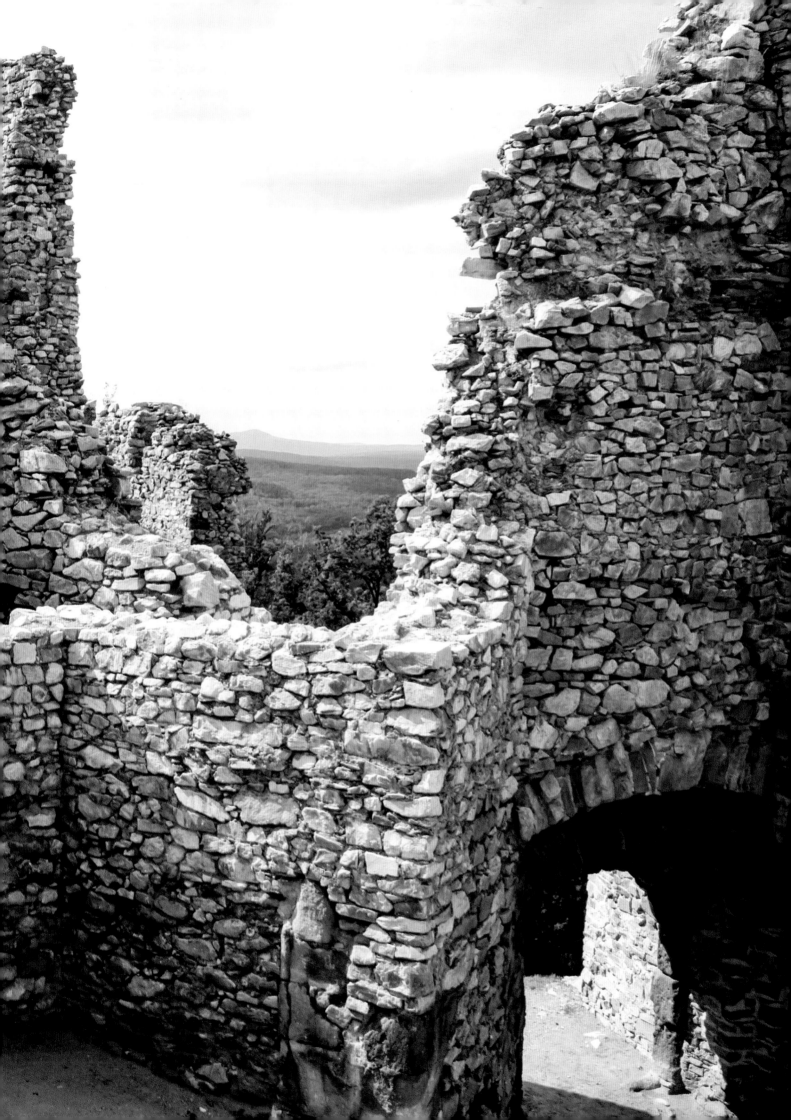

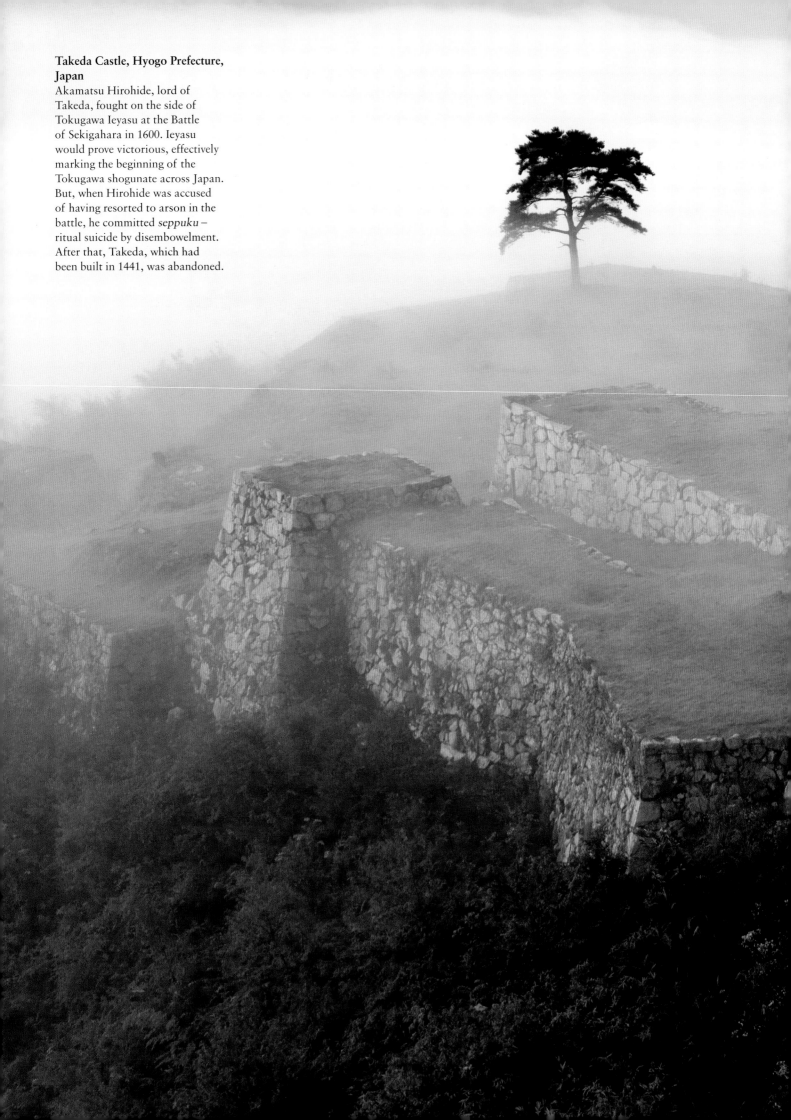

Takeda Castle, Hyogo Prefecture, Japan
Akamatsu Hirohide, lord of Takeda, fought on the side of Tokugawa Ieyasu at the Battle of Sekigahara in 1600. Ieyasu would prove victorious, effectively marking the beginning of the Tokugawa shogunate across Japan. But, when Hirohide was accused of having resorted to arson in the battle, he committed *seppuku* – ritual suicide by disembowelment. After that, Takeda, which had been built in 1441, was abandoned.

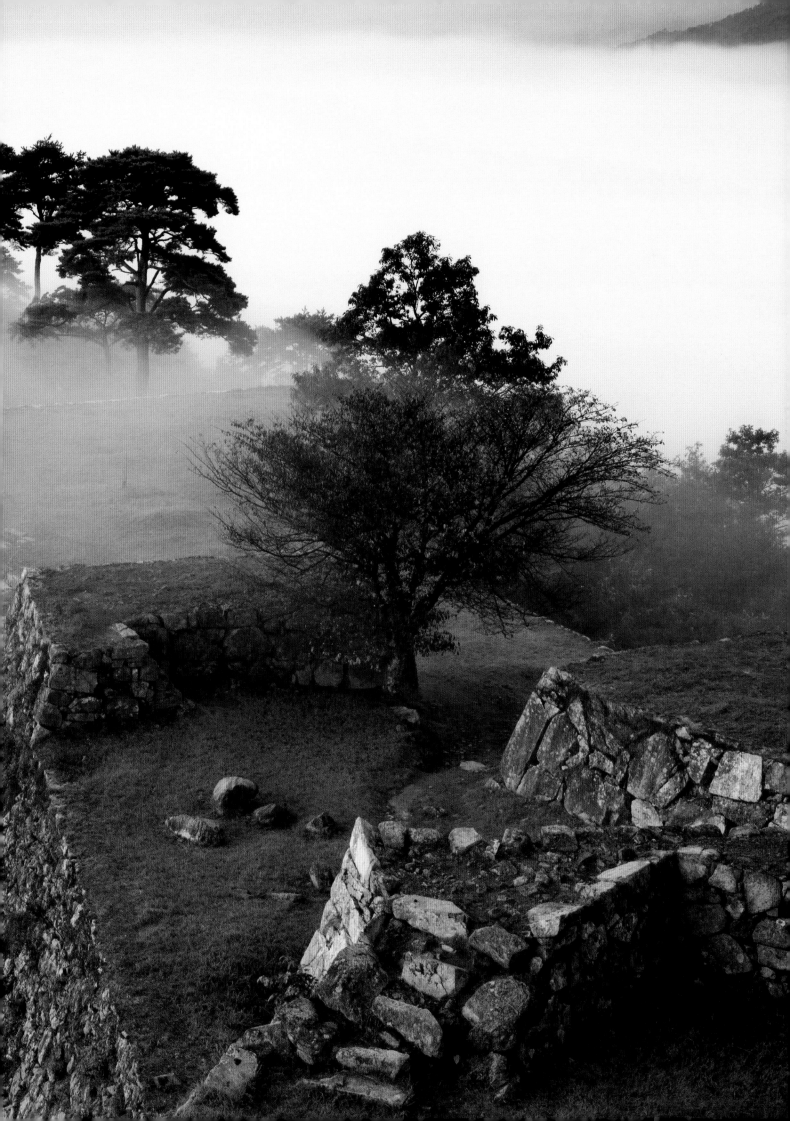

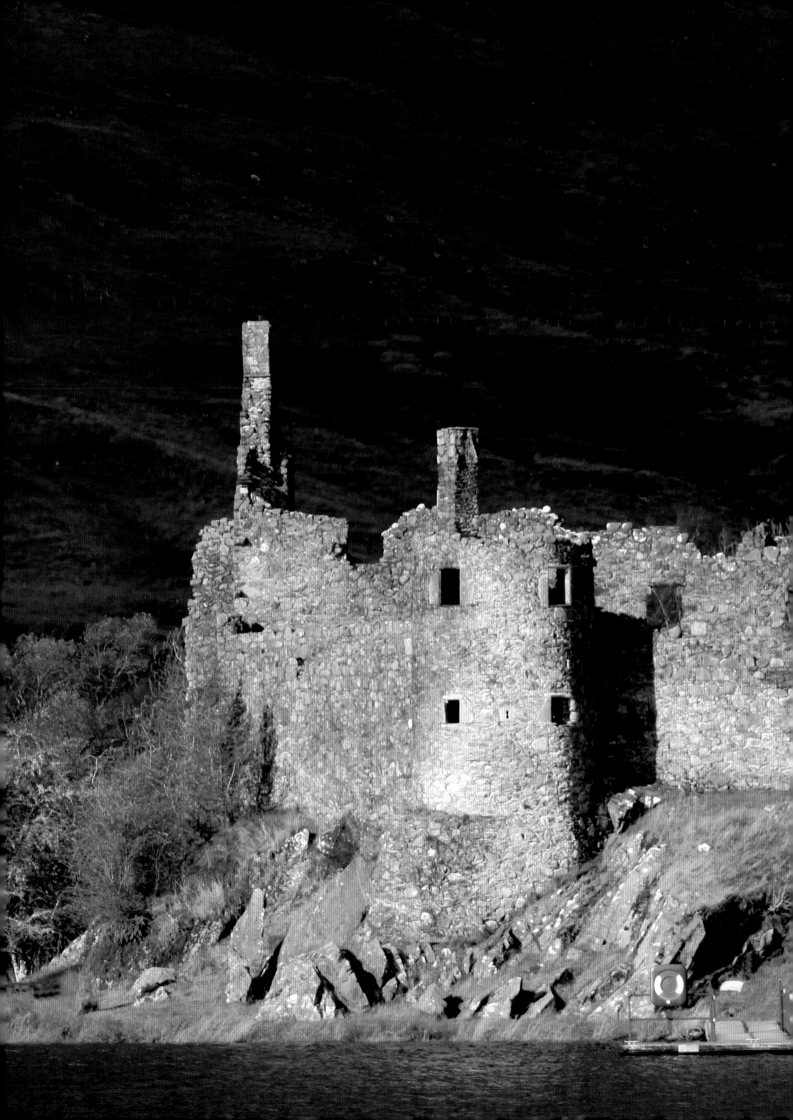

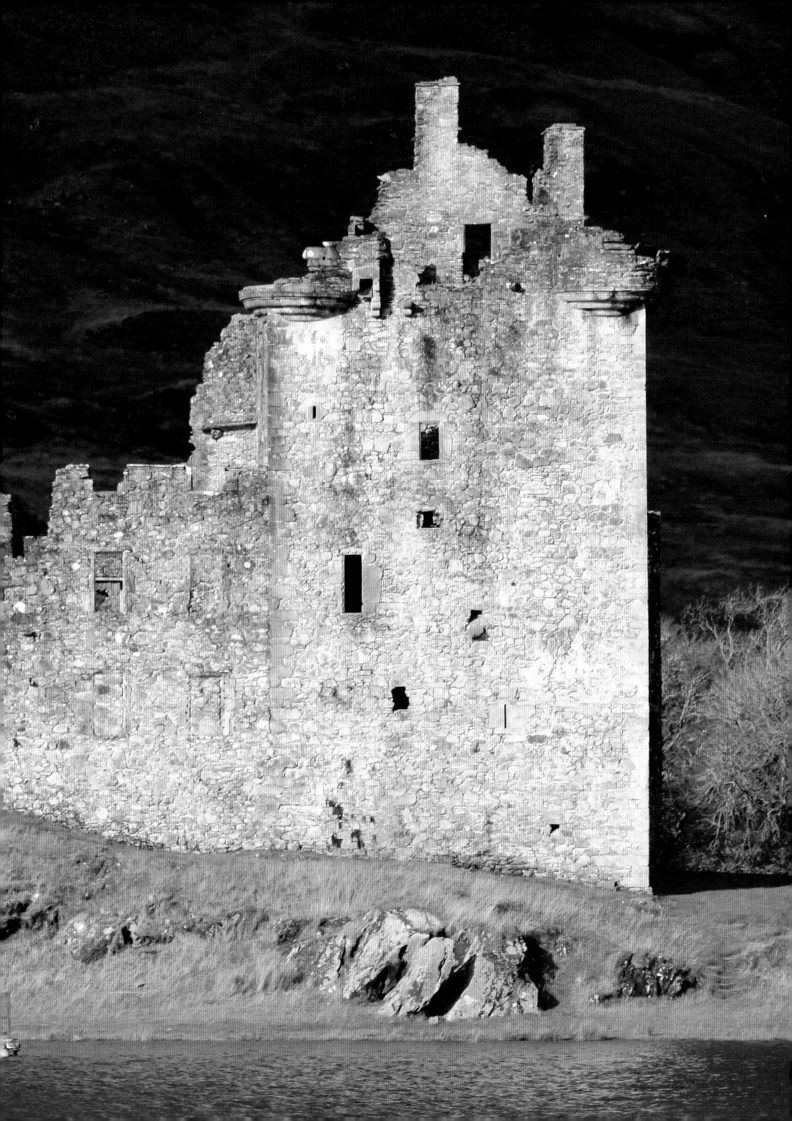

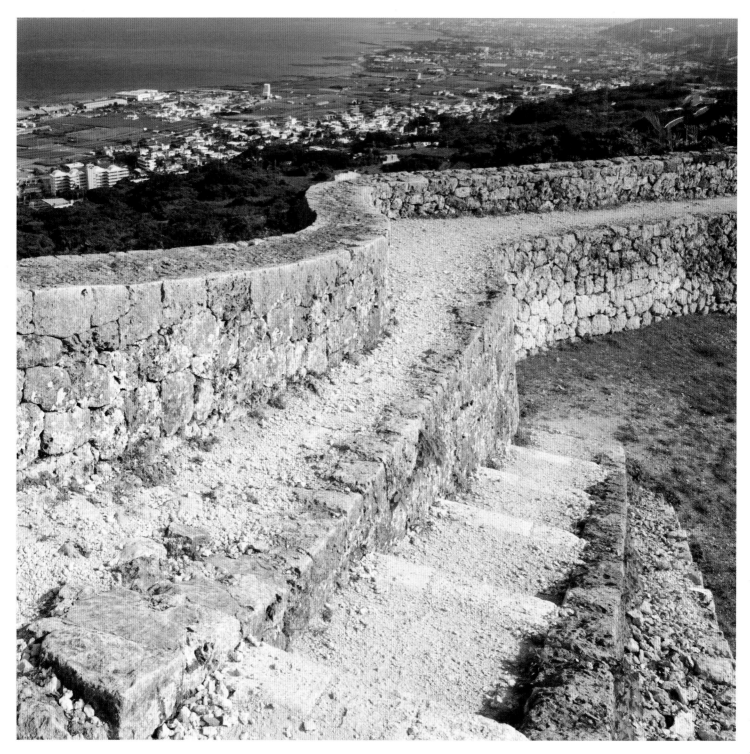

PREVIOUS PAGES:
Kilchurn Castle, Loch Awe, Argyll and Bute, Scotland
Standing on a tiny island, Kilchurn was built by Colin Campbell, first Lord of Glenorchy, around 1450. It was later occupied for almost a century by the Clan McGregor until the Campbells took violent repossession of it in the later 17th century. Badly damaged by a lightning strike in 1760, the castle was abandoned.

ABOVE AND OPPOSITE TOP:
Nakagusuku, Okinawa, Japan
Built in the early 15th century by the Ryukyu Kingdom, Nakagusuku had six courtyards. When the US re-established contact with Japan in 1853, Commodore Matthew Perry observed that its dense walls seemed to have been designed to withstand cannon fire.

OPPOSITE BOTTOM:
Zakimi Castle, Okinawa, Japan
Like Nakagusuku, Zakimi was also a 15th-century Ryukyuan *gusuku* (fortress). During World War II, it was used for gun emplacements. After the war, the US destroyed some of the castle walls to build a radar station. The castle has now been restored.

OVERLEAF:
Zakimi Castle, Okinawa, Japan
Zakimi has two inner courtyards, each with an arched gate. The courtyards of typical *gusuku* usually contained a residence, a well, an *utaki* (a sacred grove), and storage buildings.

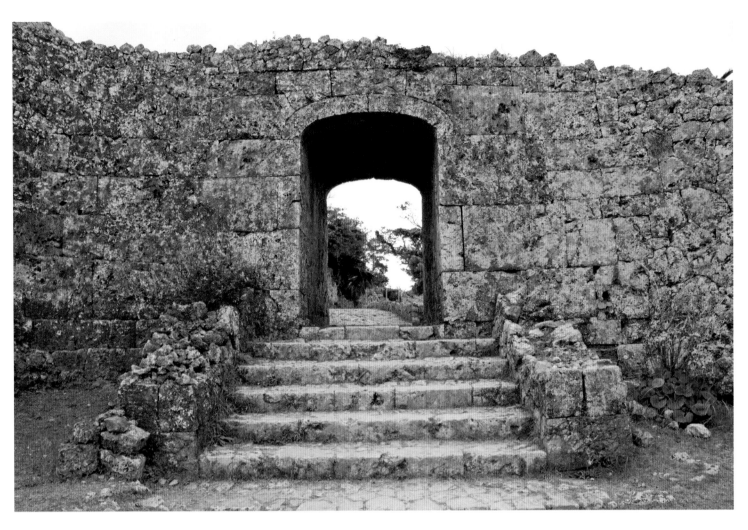

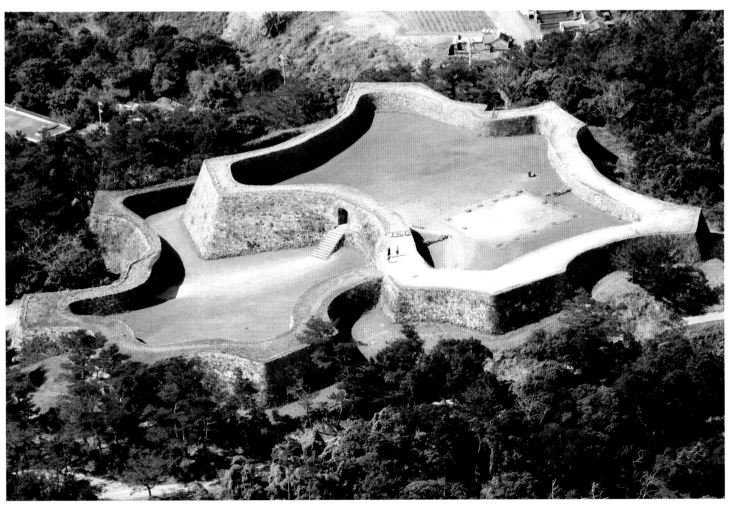

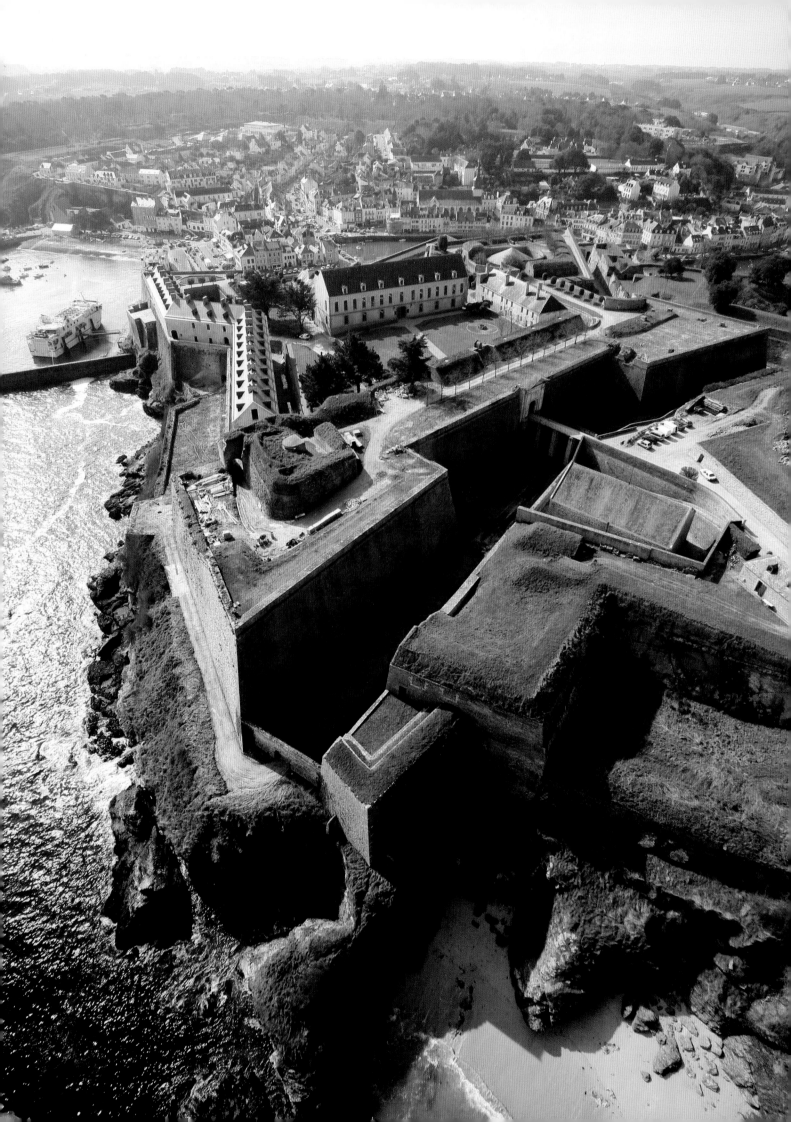

Early Modern Era

Although few new castles were being built by the 17th century, smaller forts and towers continued to be constructed around the world. Gone were the arrow slits, battlements and towers of medieval times, but other forms of fortifications survived. Where castles from the later medieval period were often multi-sided, we now find star-shaped citadels, and, in Palmanova in northern Italy, even a whole town designed in a star shape to aid defence.

The stories of the fortresses featured here also tell us about the history of the new age of exploration and colonization. Fort San Lorenzo in Panama was first built in the 16th century not to defend against an invading army, but to protect the transit of Peruvian gold to Spain. In 1739–40, the fort was attacked by the British but, although it remained in Spanish hands, its importance waned after the gold ceased to be shipped through Panama. It wasn't war that caused Fort San Lorenzo to be abandoned, but lack of trade.

In these pages, where the entries range from the 16th to the early 19th century, we find the last castles of Europe and Japan, coastal towers in the Mediterranean, as well as hill and sea forts ranging from France to India and on to the United States.

OPPOSITE:

Citadelle de Palais, Belle-Île-en-Mer, Brittany, France
In the late 17th century, Sébastien Le Prestre de Vauban was France's foremost military engineer, responsible for upgrading the defences of 300 cities and building 37 new fortresses. He transformed the existing citadel on the island of Belle-Île, off the south coast of Brittany, into the star-shaped enclosure that survives today.

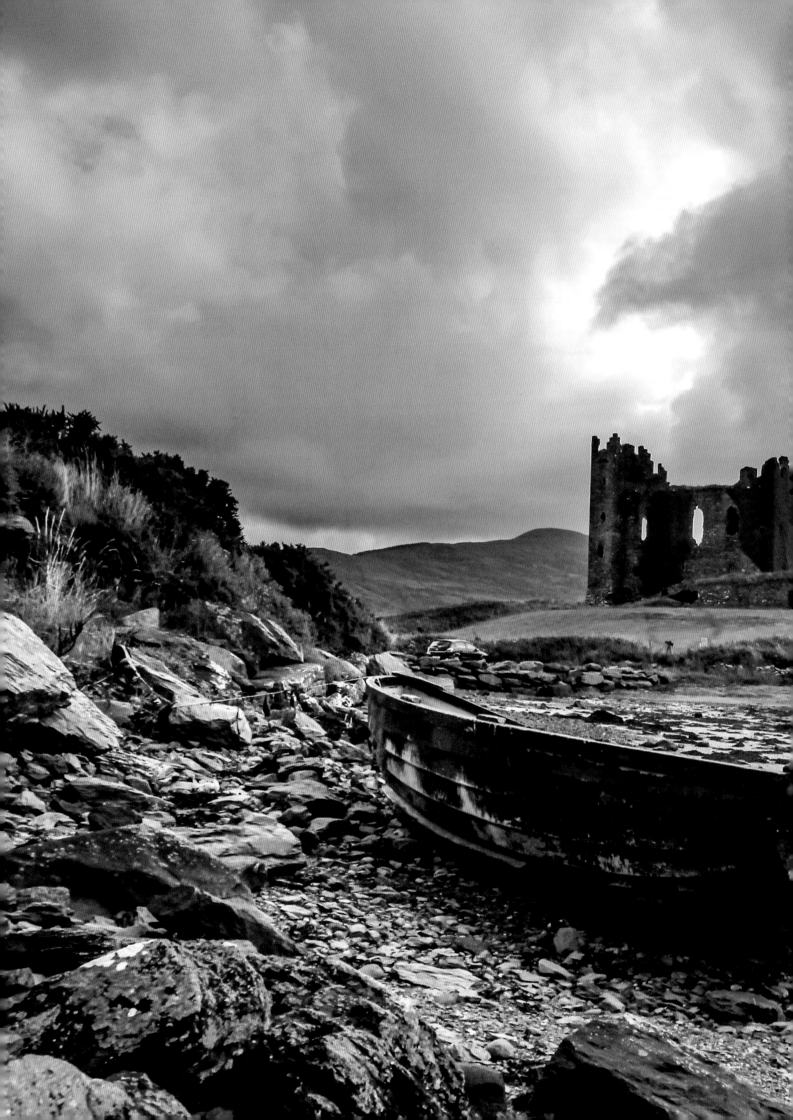

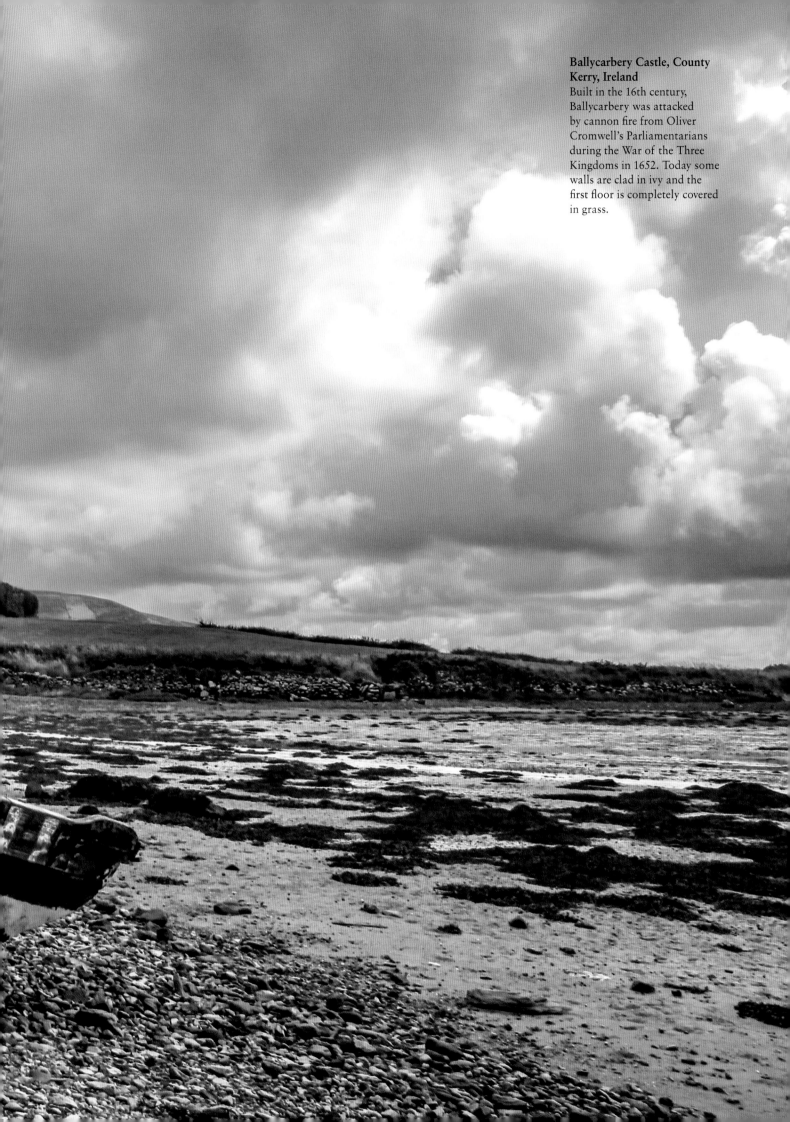

Ballycarbery Castle, County Kerry, Ireland
Built in the 16th century, Ballycarbery was attacked by cannon fire from Oliver Cromwell's Parliamentarians during the War of the Three Kingdoms in 1652. Today some walls are clad in ivy and the first floor is completely covered in grass.

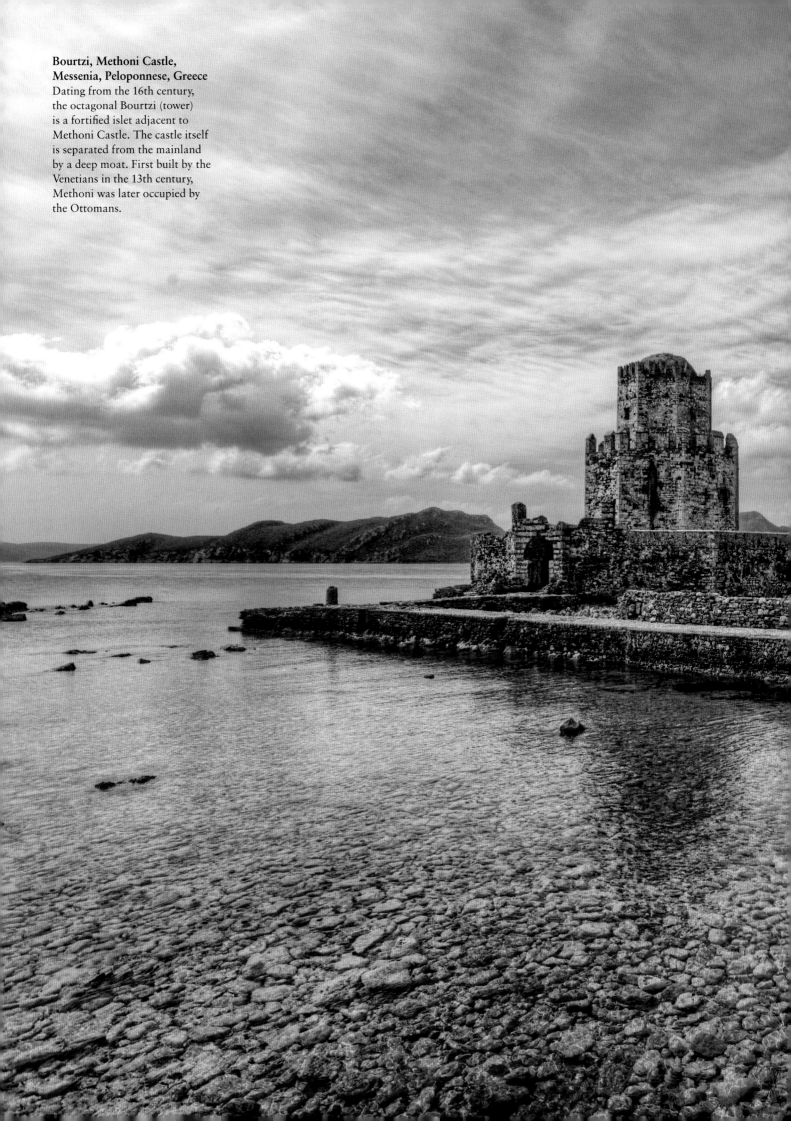

Bourtzi, Methoni Castle, Messenia, Peloponnese, Greece
Dating from the 16th century, the octagonal Bourtzi (tower) is a fortified islet adjacent to Methoni Castle. The castle itself is separated from the mainland by a deep moat. First built by the Venetians in the 13th century, Methoni was later occupied by the Ottomans.

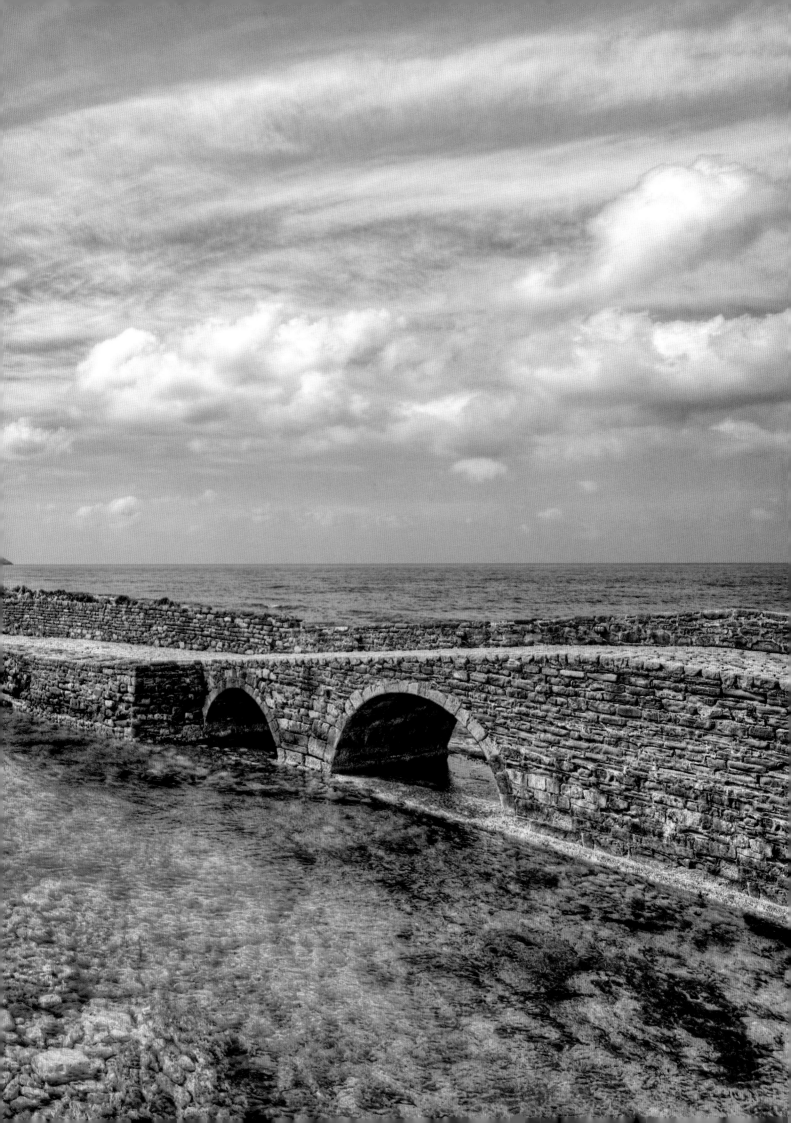

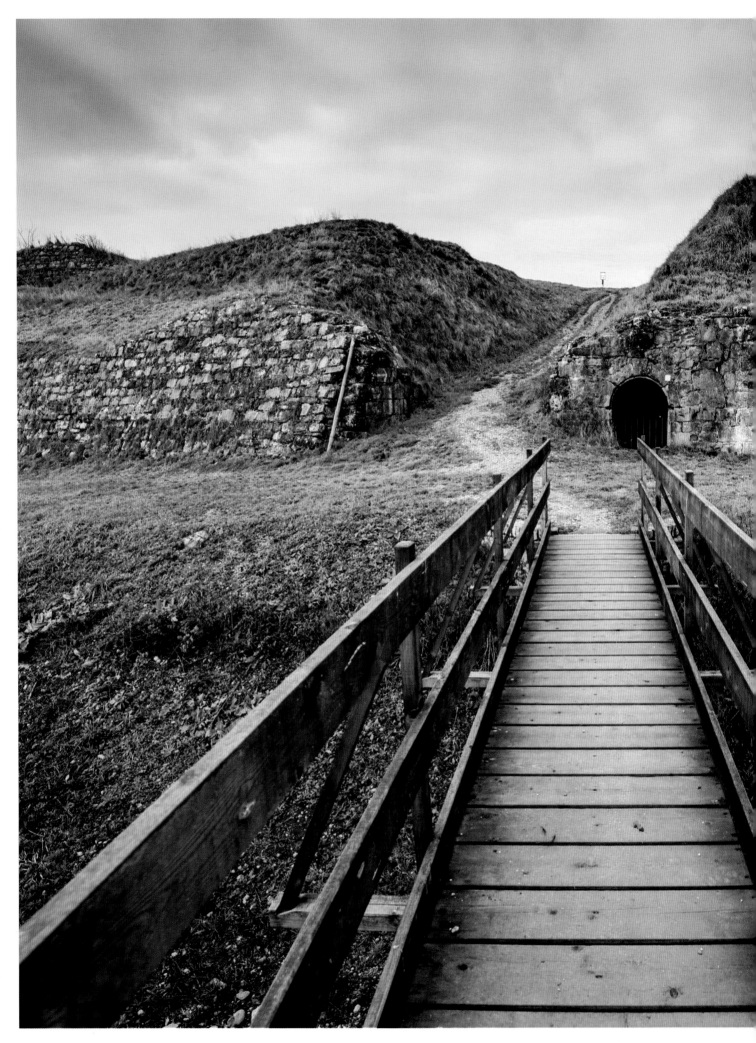

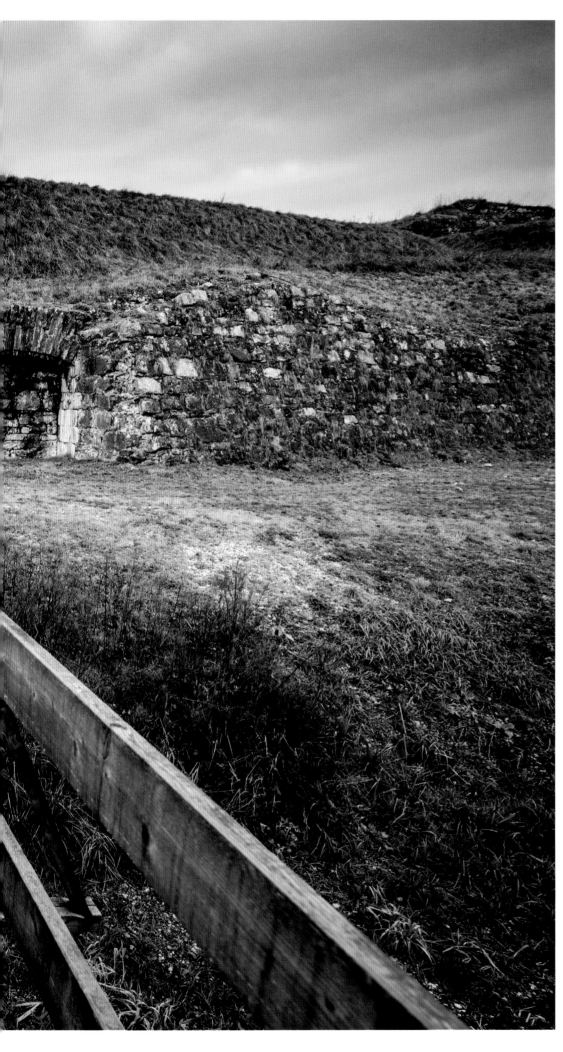

Palmanova, Udine, Friuli-Venezia Giulia, Italy
Planned by the Republic of Venice as both a utopian town and fort laid out on the mainland in the shape of a nine-pointed star, Palmanova struggled to find people who wanted to live there. By 1622 – 30 years after construction had begun – the Republic was offering pardoned criminals incentives to move to the new town. Beyond the streets were star-shaped fortifications – as seen here – but the town has never been the site of a siege or battle.

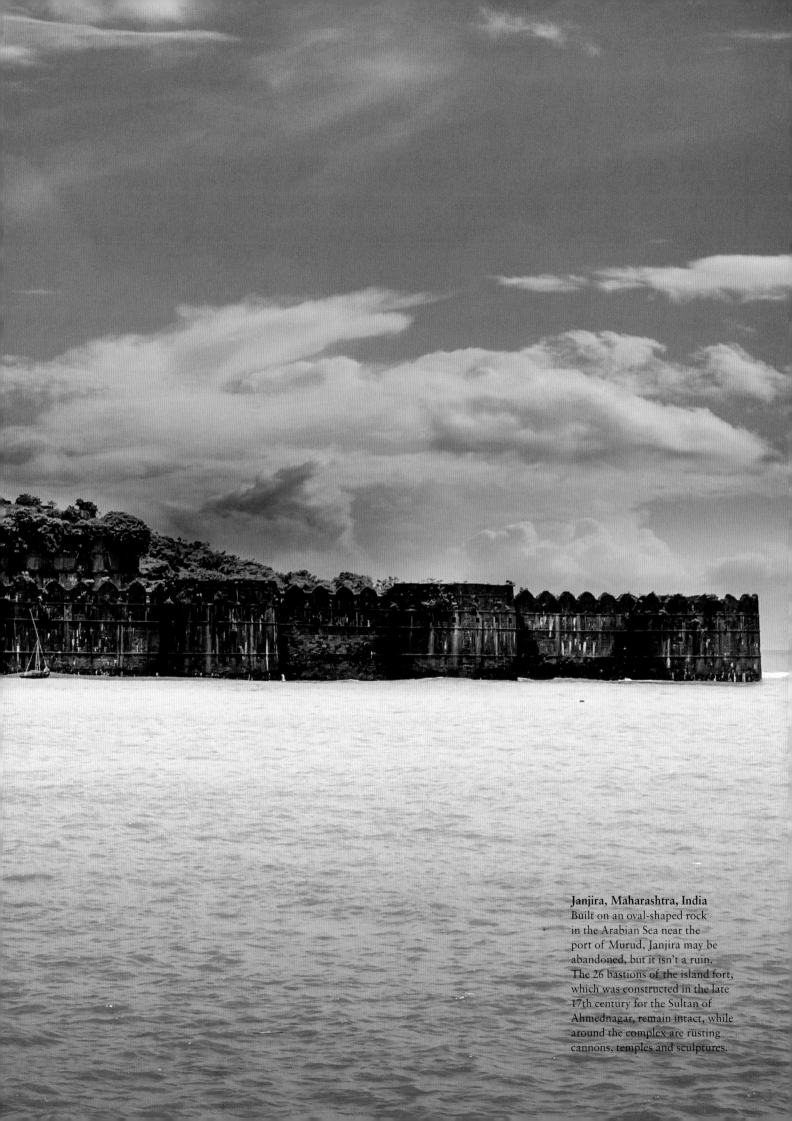

Janjira, Maharashtra, India
Built on an oval-shaped rock
in the Arabian Sea near the
port of Murud, Janjira may be
abandoned, but it isn't a ruin.
The 26 bastions of the island fort,
which was constructed in the late
17th century for the Sultan of
Ahmednagar, remain intact, while
around the complex are rusting
cannons, temples and sculptures.

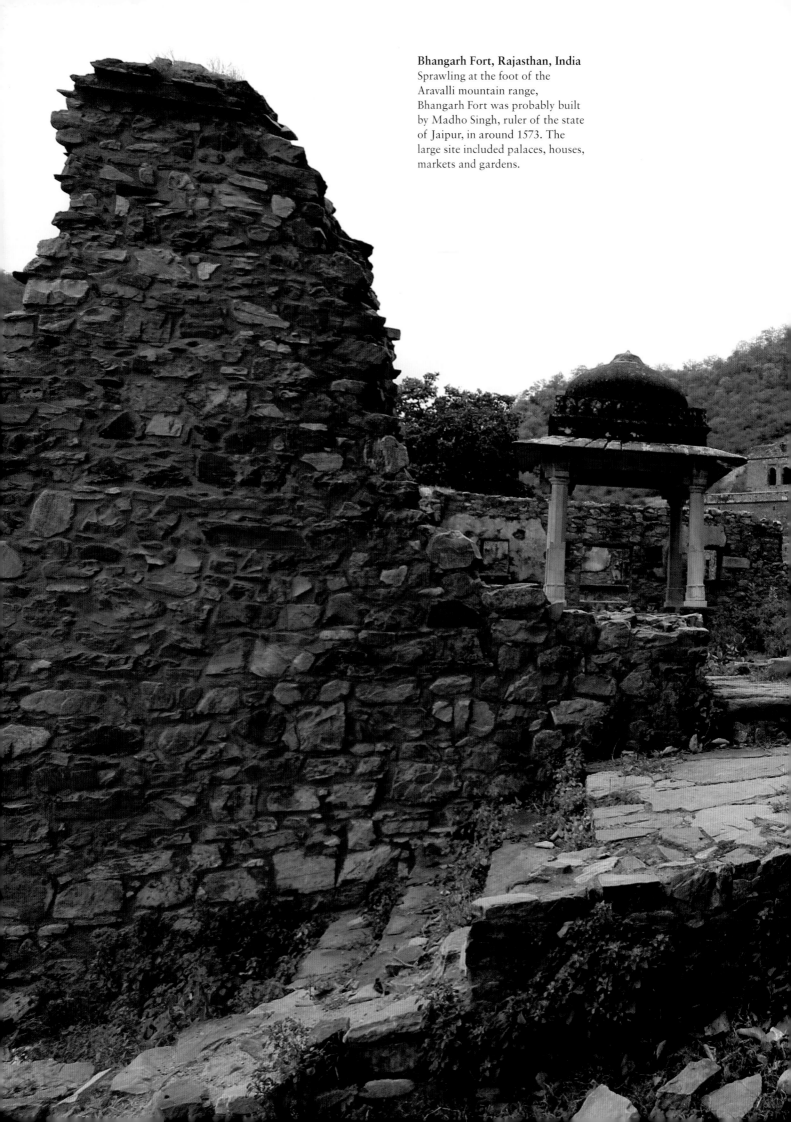

Bhangarh Fort, Rajasthan, India
Sprawling at the foot of the
Aravalli mountain range,
Bhangarh Fort was probably built
by Madho Singh, ruler of the state
of Jaipur, in around 1573. The
large site included palaces, houses,
markets and gardens.

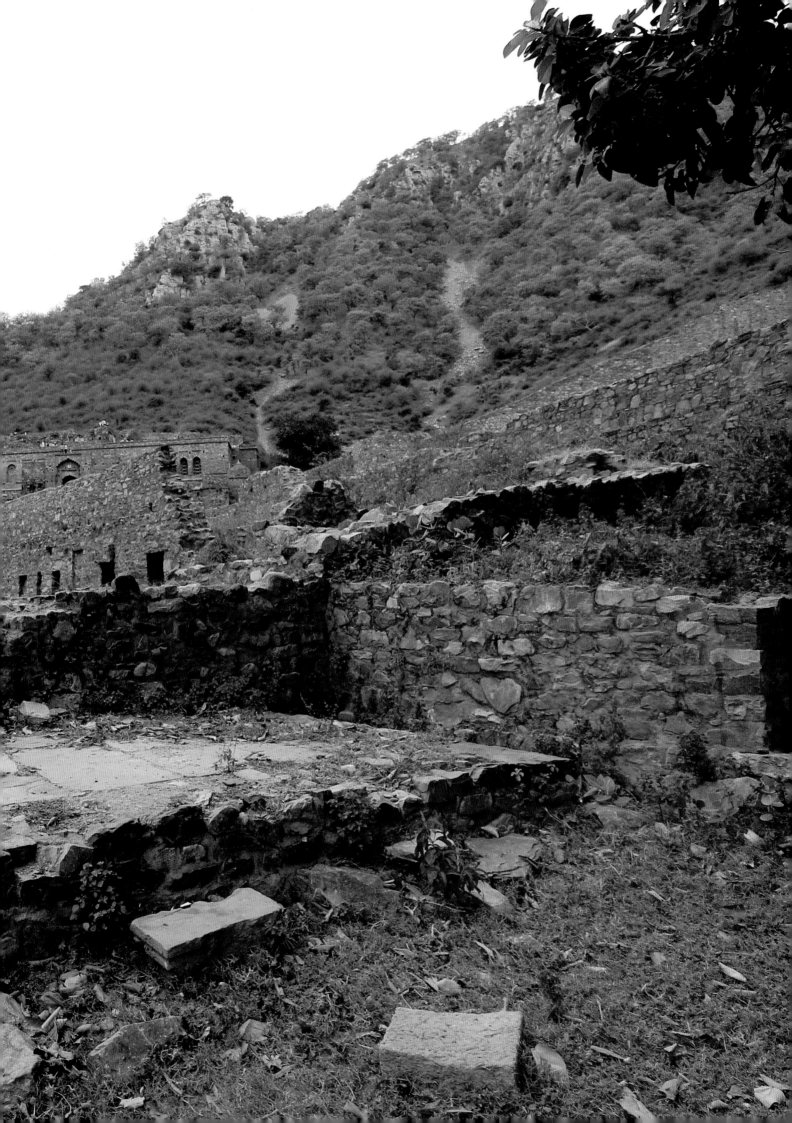

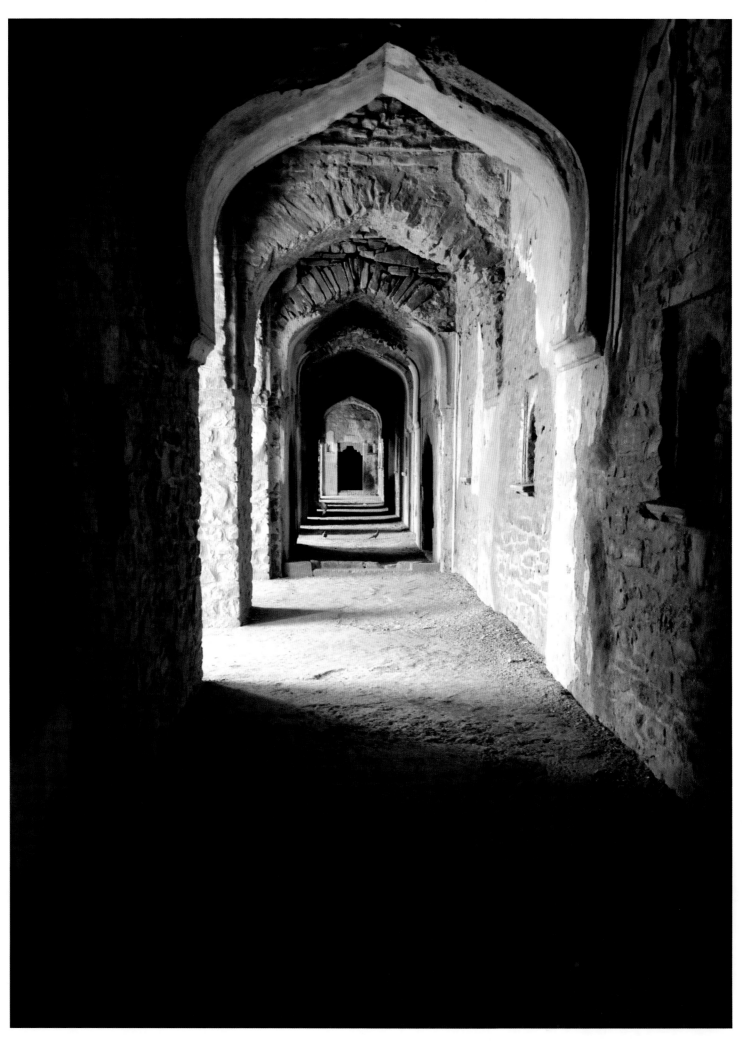

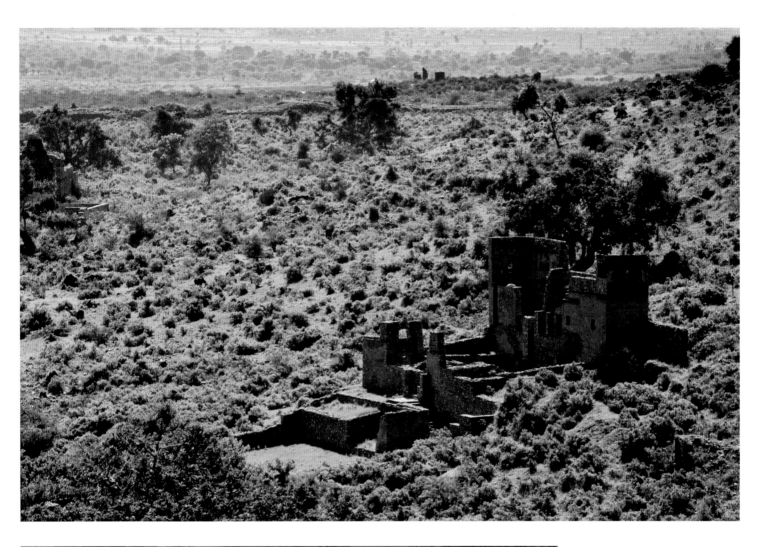

OPPOSITE, ABOVE AND LEFT:
Bhangarh Fort, Rajasthan, India
Although established by a Hindu, many of the inhabitants of Bhangarh Fort embraced Islam during the reign of Mughal Emperor Aurangzeb in the later 17th century. Consequently, there are both ruins of Hindu temples and mosques at the fort.

With the Mughal Empire weakening following the death of Aurangzeb, the fort was attacked in 1720 by Jai Singh II, before being abandoned after famine struck in 1783. Today some of the buildings have been restored.

151

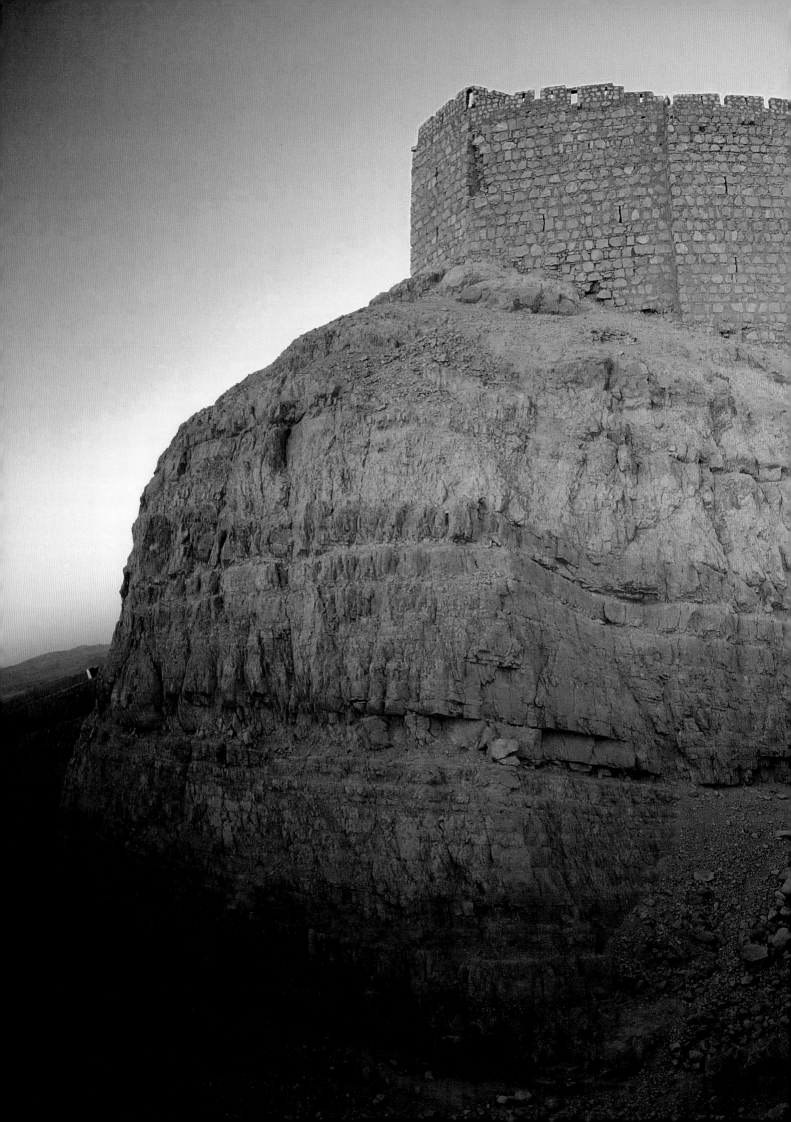

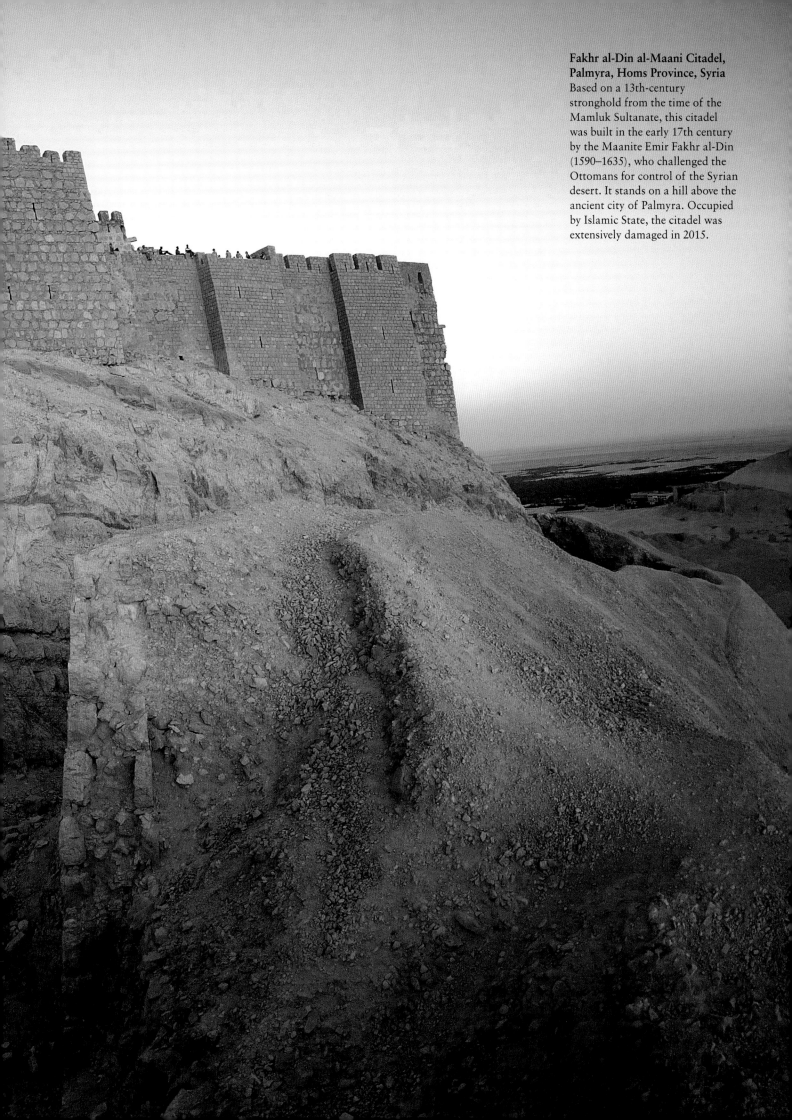

Fakhr al-Din al-Maani Citadel, Palmyra, Homs Province, Syria
Based on a 13th-century stronghold from the time of the Mamluk Sultanate, this citadel was built in the early 17th century by the Maanite Emir Fakhr al-Din (1590–1635), who challenged the Ottomans for control of the Syrian desert. It stands on a hill above the ancient city of Palmyra. Occupied by Islamic State, the citadel was extensively damaged in 2015.

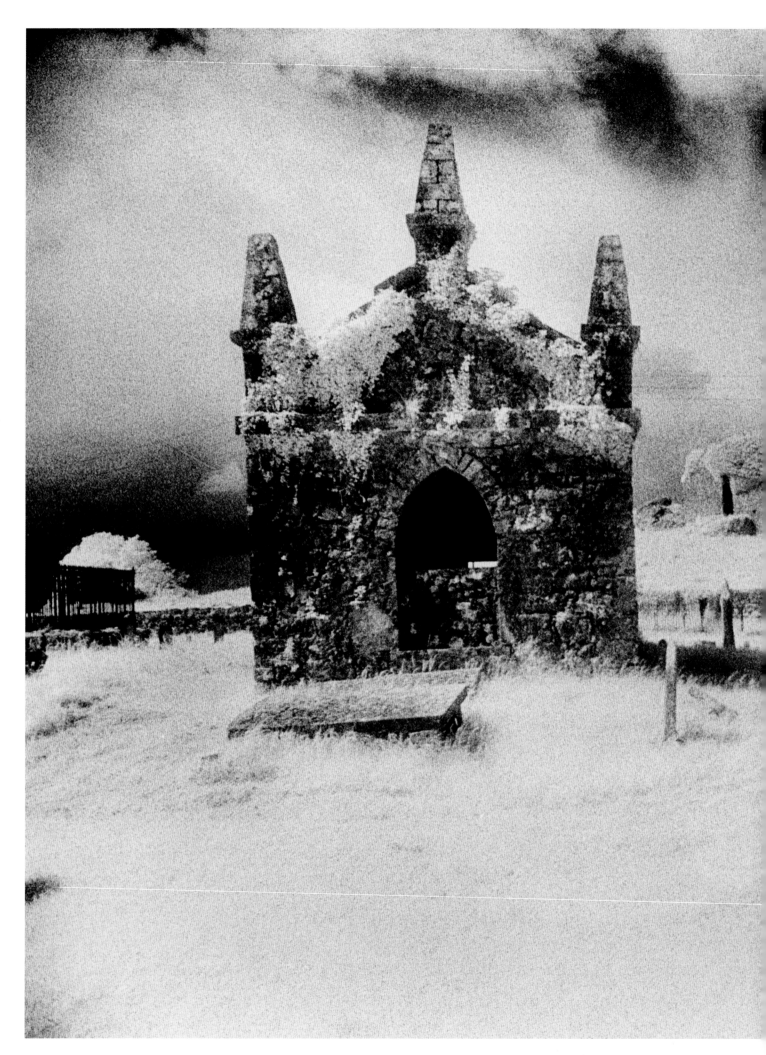

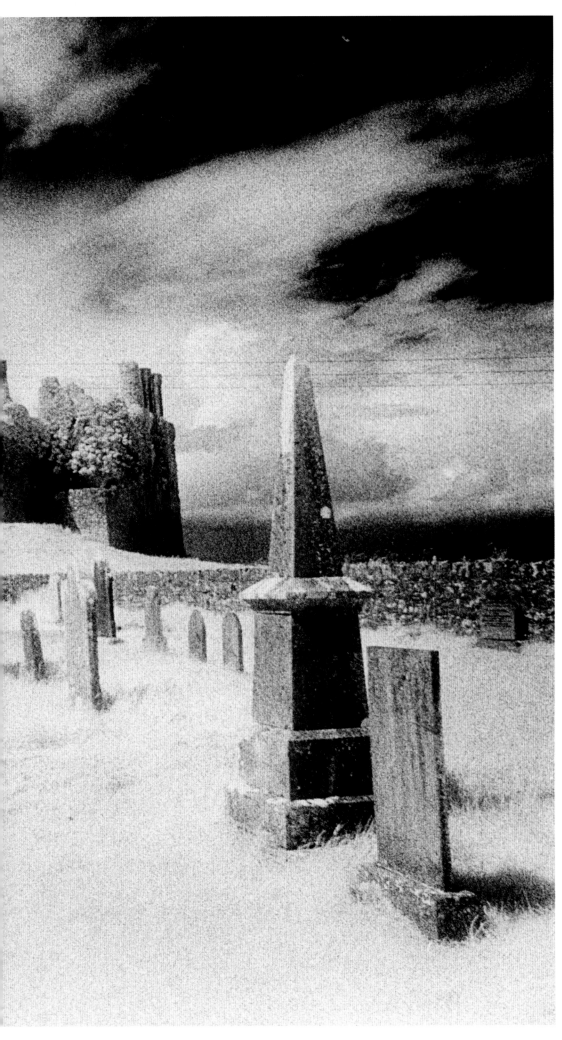

Carbury Castle, County Kildare, Ireland

In 1569, Elizabeth I of England granted the Manor of Carbury to Henry Colley. He remodelled the existing castle and his tall, ivy-clad Elizabethan chimneys can still be seen on the house in the background. On the left are the ruins of the Colley mortuary chapel.

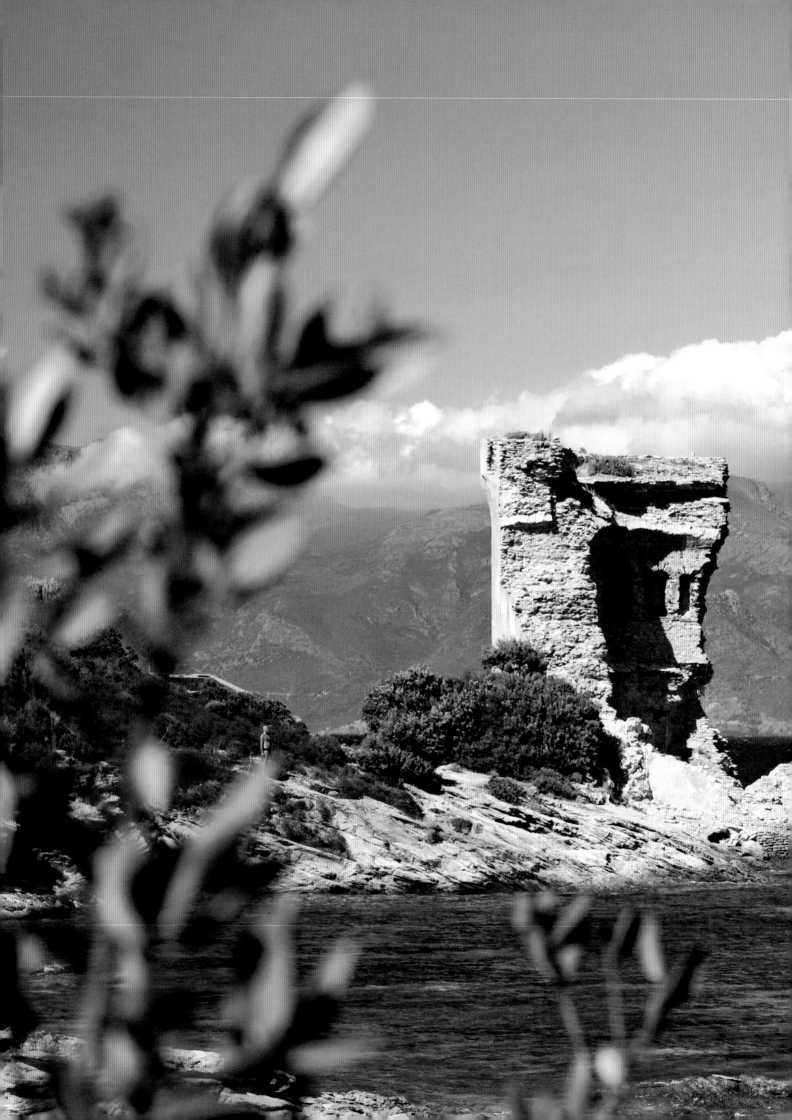

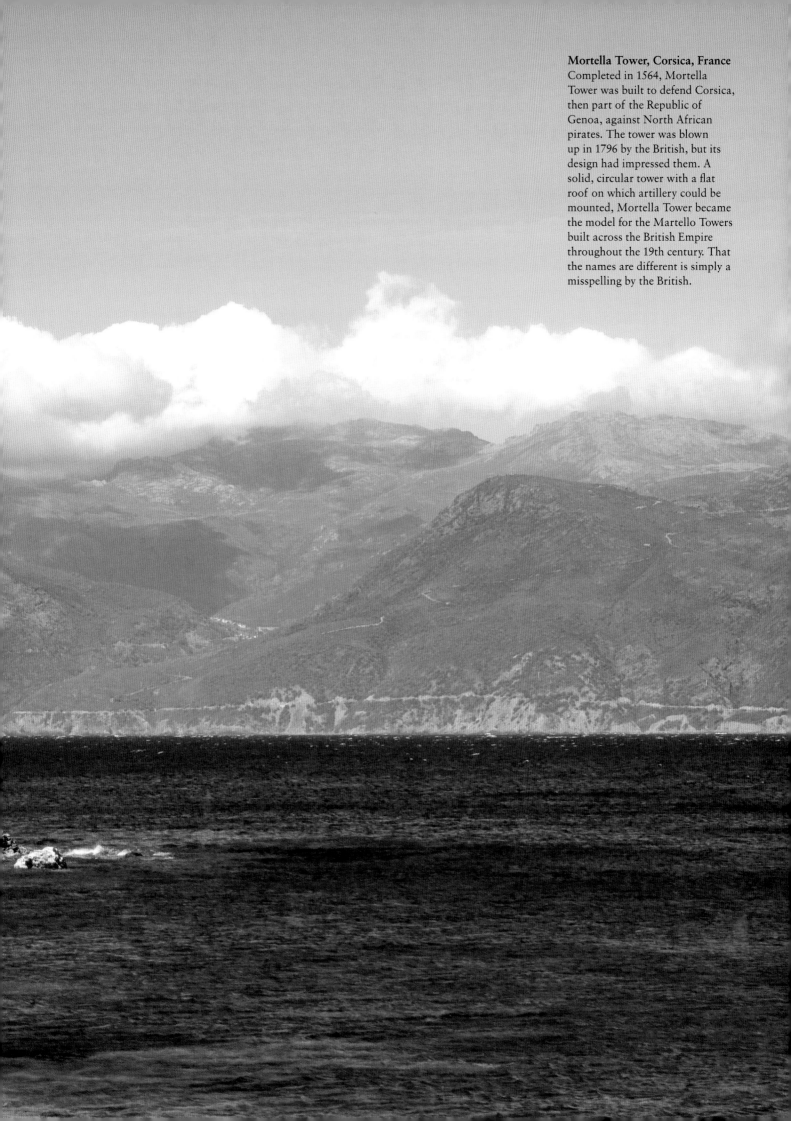

Mortella Tower, Corsica, France
Completed in 1564, Mortella Tower was built to defend Corsica, then part of the Republic of Genoa, against North African pirates. The tower was blown up in 1796 by the British, but its design had impressed them. A solid, circular tower with a flat roof on which artillery could be mounted, Mortella Tower became the model for the Martello Towers built across the British Empire throughout the 19th century. That the names are different is simply a misspelling by the British.

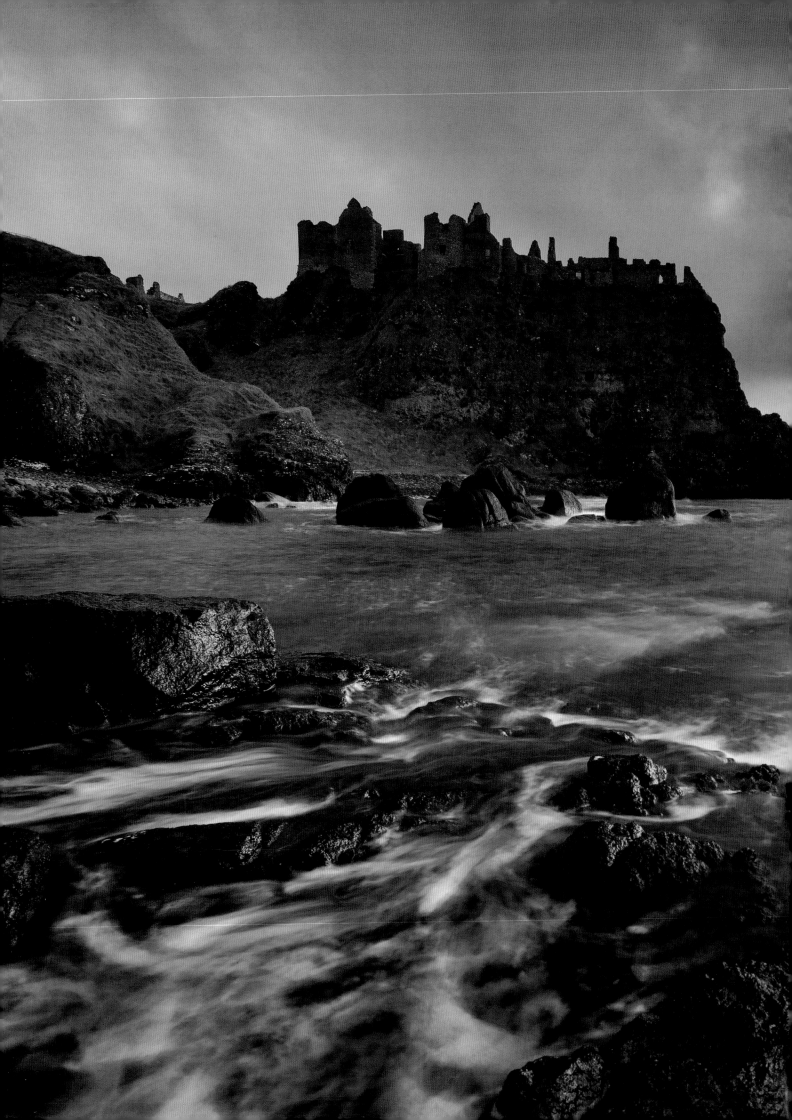

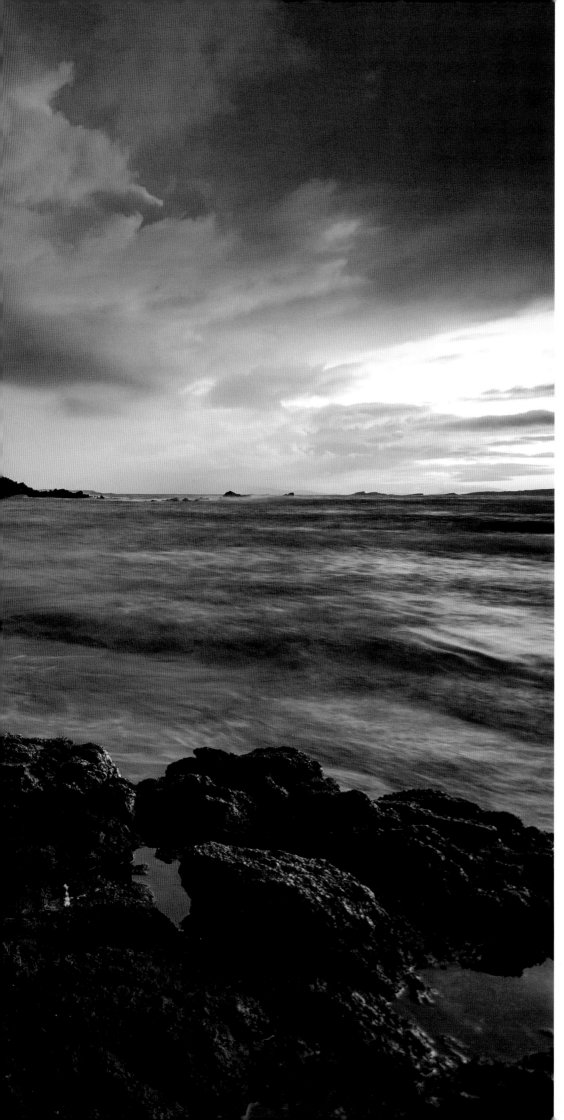

Dunluce Castle, County Antrim, Northern Ireland
A castle was built on this basalt outcropping in the far north of Ireland in the 13th century, but today it is only ruins from the late 16th century that we can see. Dunluce was the seat of the Earl of Antrim until he was defeated supporting the forces of the deposed Catholic King James II against the Protestant William III in the Battle of the Boyne in 1690, after which the castle began to fall into ruin.

159

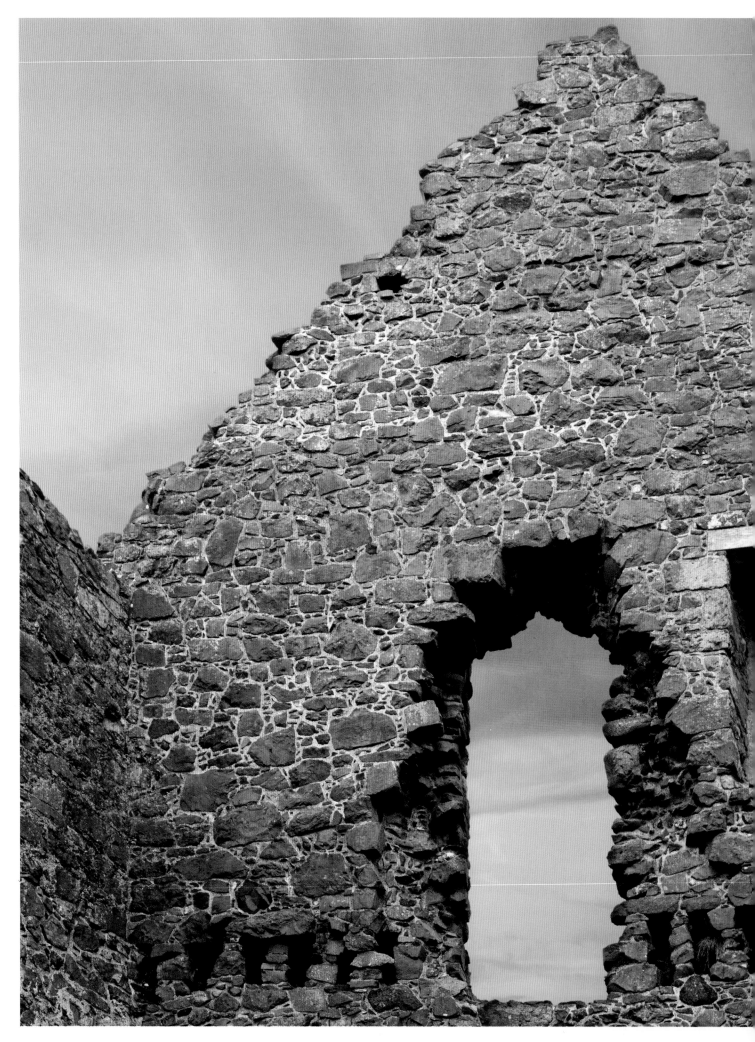

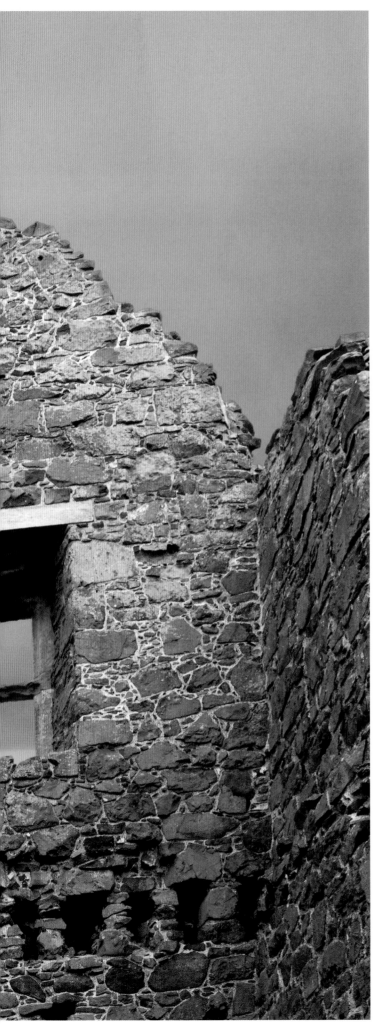

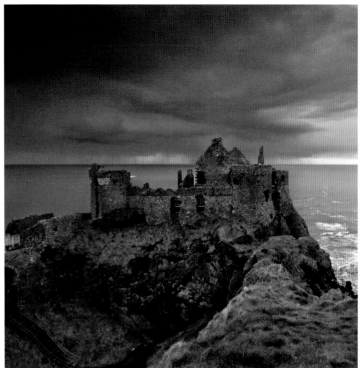

LEFT:

Dunluce Castle, County Antrim, Northern Ireland

After a ship from the Spanish Armada of 1588 was wrecked nearby, its cargo was sold and the money used to fund the restoration of Dunluce. Cannons from the ship were salvaged and positioned over the castle gatehouse.

ABOVE:

Dunluce Castle, County Antrim, Northern Ireland

Surrounded by steep drops on either side, Dunluce is reached by a bridge to the mainland. In the 18th century, the north wall of the castle collapsed into the sea, but the other exterior walls remain.

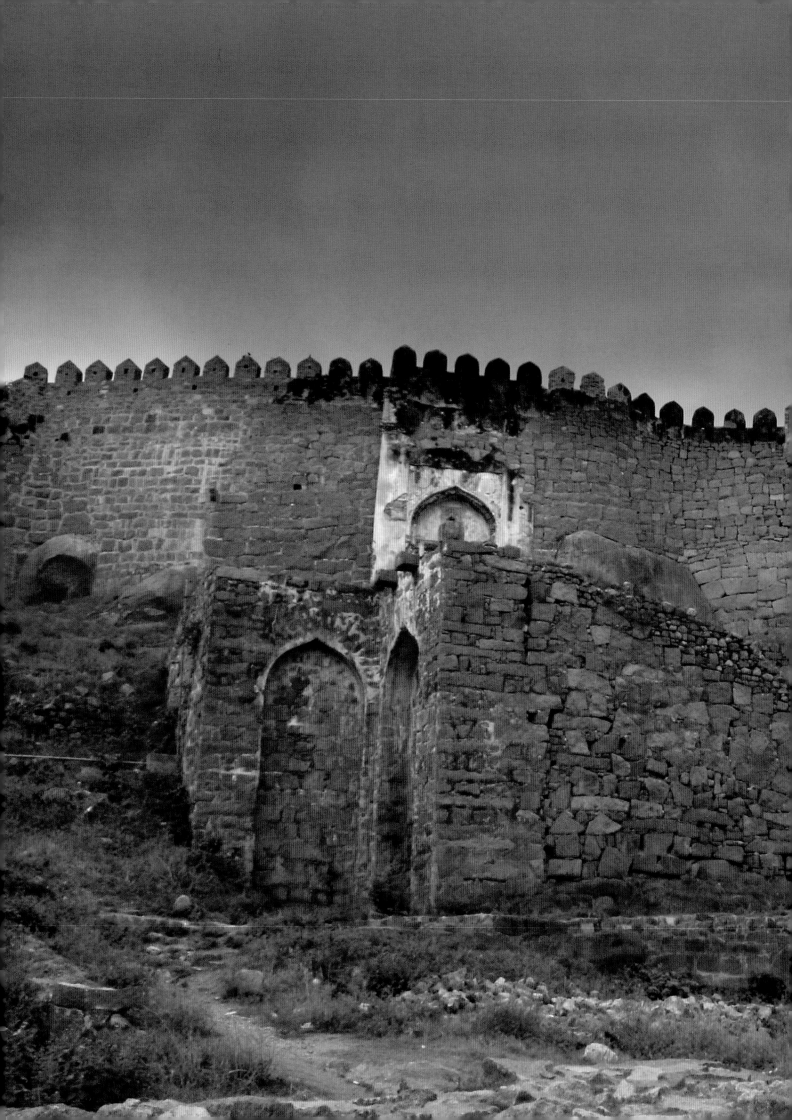

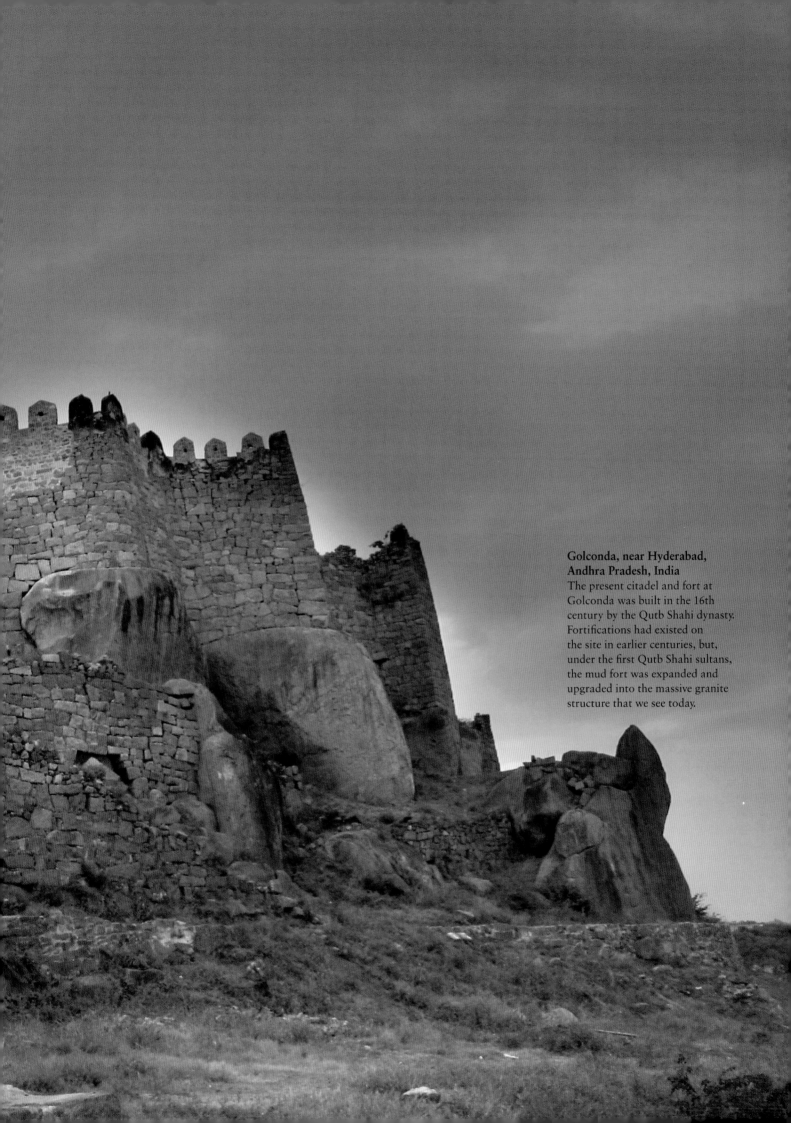

Golconda, near Hyderabad, Andhra Pradesh, India
The present citadel and fort at Golconda was built in the 16th century by the Qutb Shahi dynasty. Fortifications had existed on the site in earlier centuries, but, under the first Qutb Shahi sultans, the mud fort was expanded and upgraded into the massive granite structure that we see today.

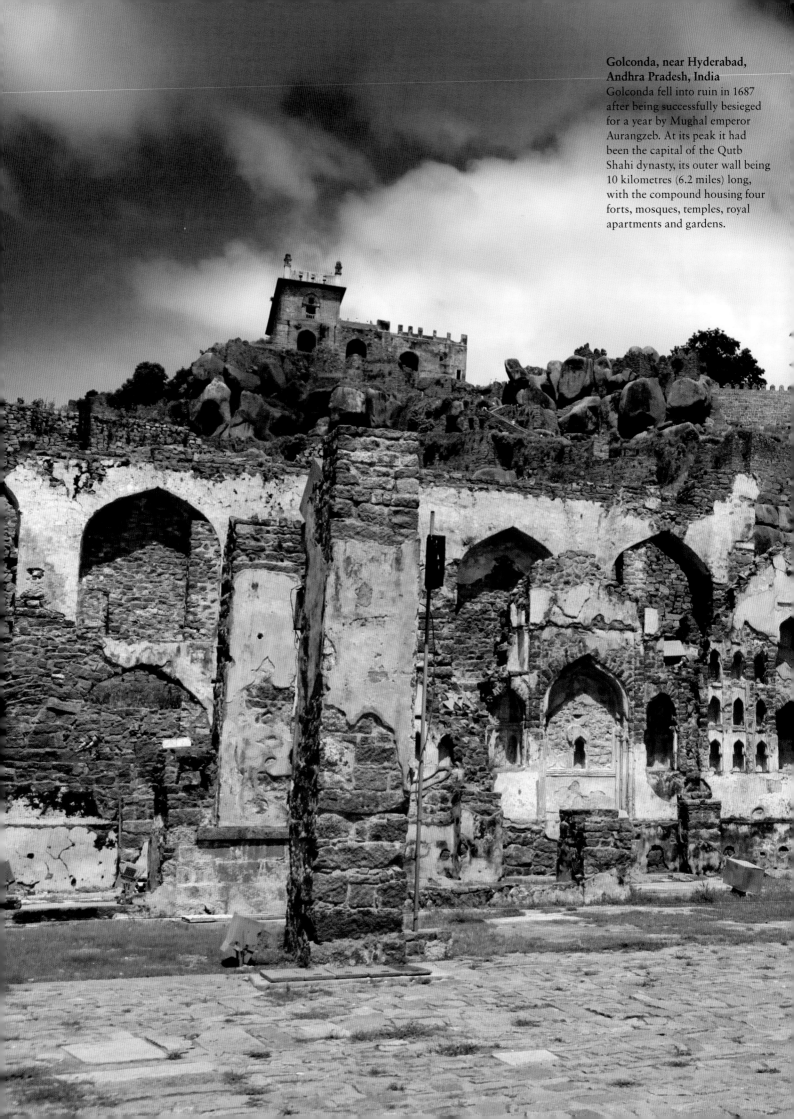

Golconda, near Hyderabad, Andhra Pradesh, India
Golconda fell into ruin in 1687 after being successfully besieged for a year by Mughal emperor Aurangzeb. At its peak it had been the capital of the Qutb Shahi dynasty, its outer wall being 10 kilometres (6.2 miles) long, with the compound housing four forts, mosques, temples, royal apartments and gardens.

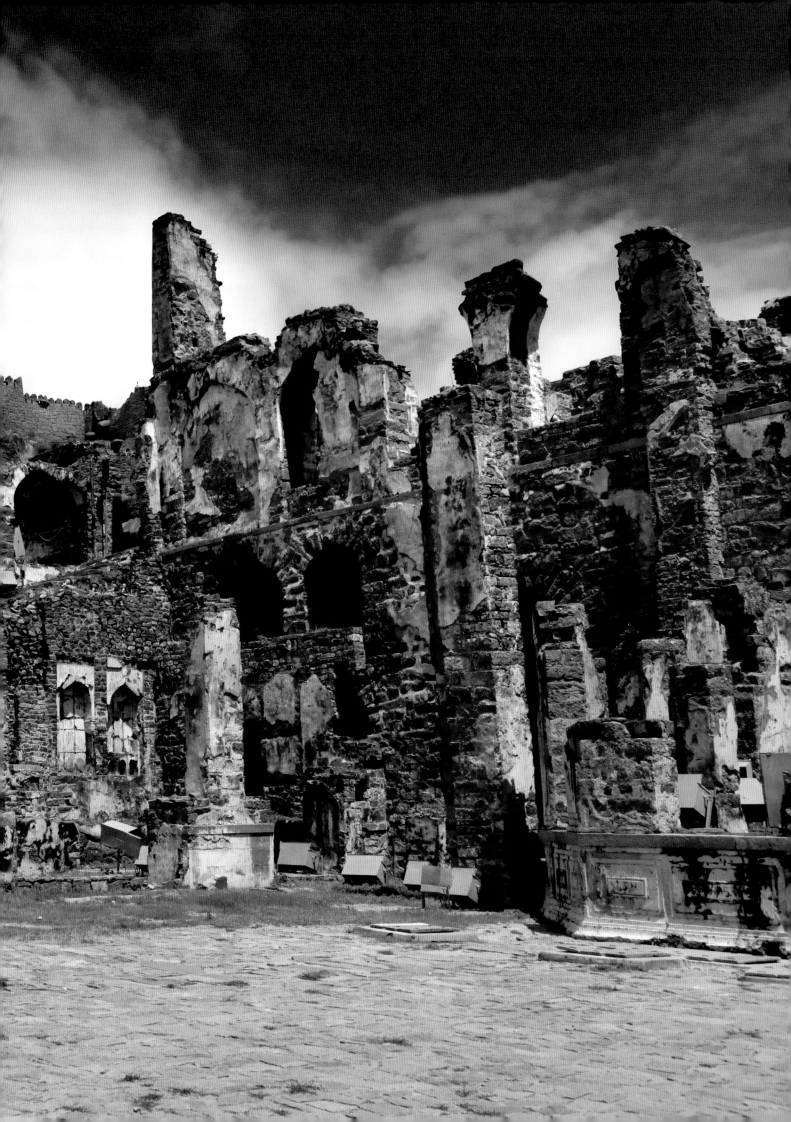

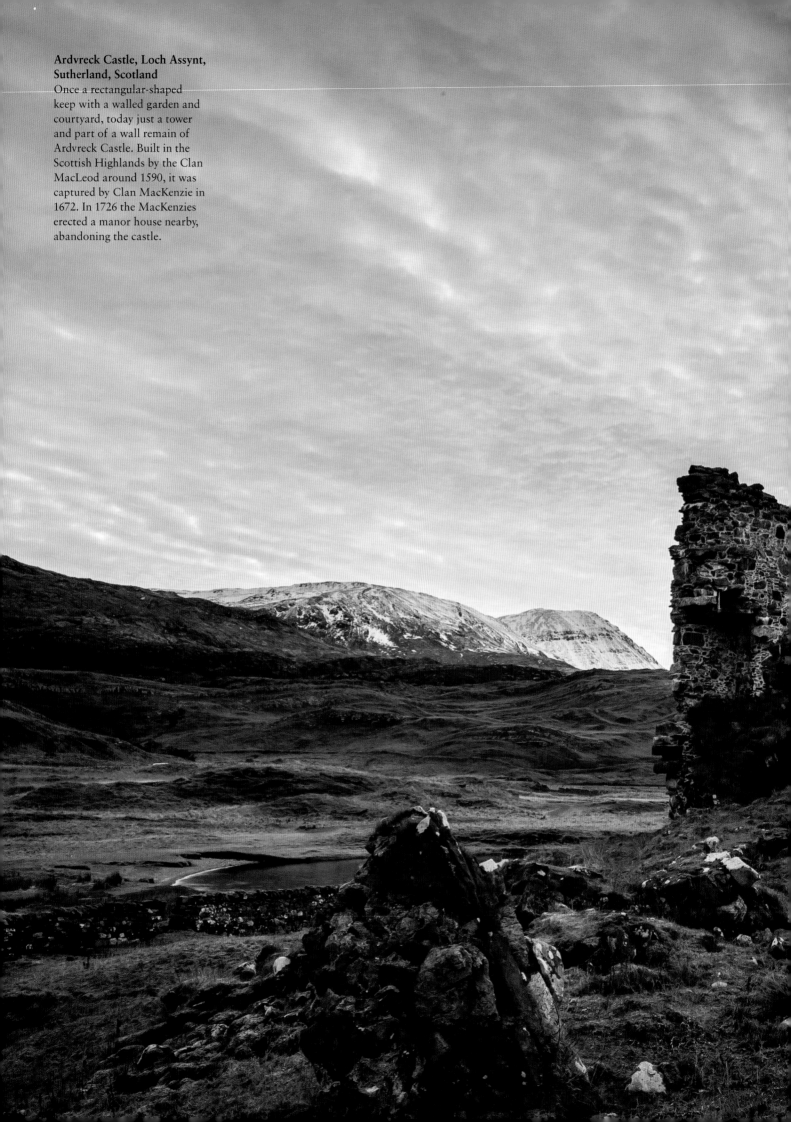

Ardvreck Castle, Loch Assynt, Sutherland, Scotland
Once a rectangular-shaped keep with a walled garden and courtyard, today just a tower and part of a wall remain of Ardvreck Castle. Built in the Scottish Highlands by the Clan MacLeod around 1590, it was captured by Clan MacKenzie in 1672. In 1726 the MacKenzies erected a manor house nearby, abandoning the castle.

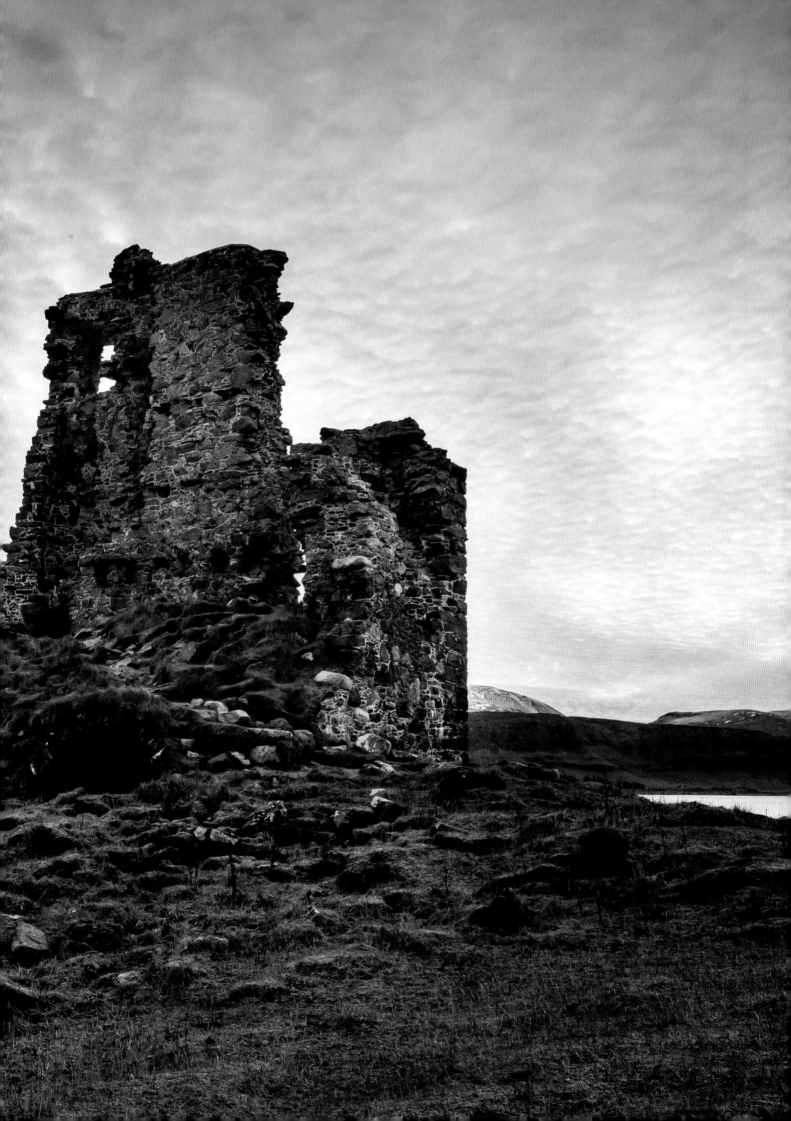

ABOVE AND RIGHT:
Fort San Lorenzo, Colón, Panama

By the 1530s, the Spanish were shipping Peruvian gold up the Pacific Coast to Panama, where it was carried to the Chagres River on the Atlantic Coast, and from there sent to Spain. With the shipments attracting the attention of pirates, the first Fort San Lorenzo was built around the Chagres river-mouth in the late 16th century.

Ruined by privateer Henry Morgan in 1670, San Lorenzo was rebuilt the following decade, while the town of Chagres developed around the fort. By the 18th century, however, gold had ceased to be transported through Panama and the importance of Chagres and Fort San Lorenzo waned.

By the early 20th century, San Lorenzo was no longer in use, and, when the construction of the Panama Canal left Chagres isolated from inland trade, the town's population was relocated elsewhere.

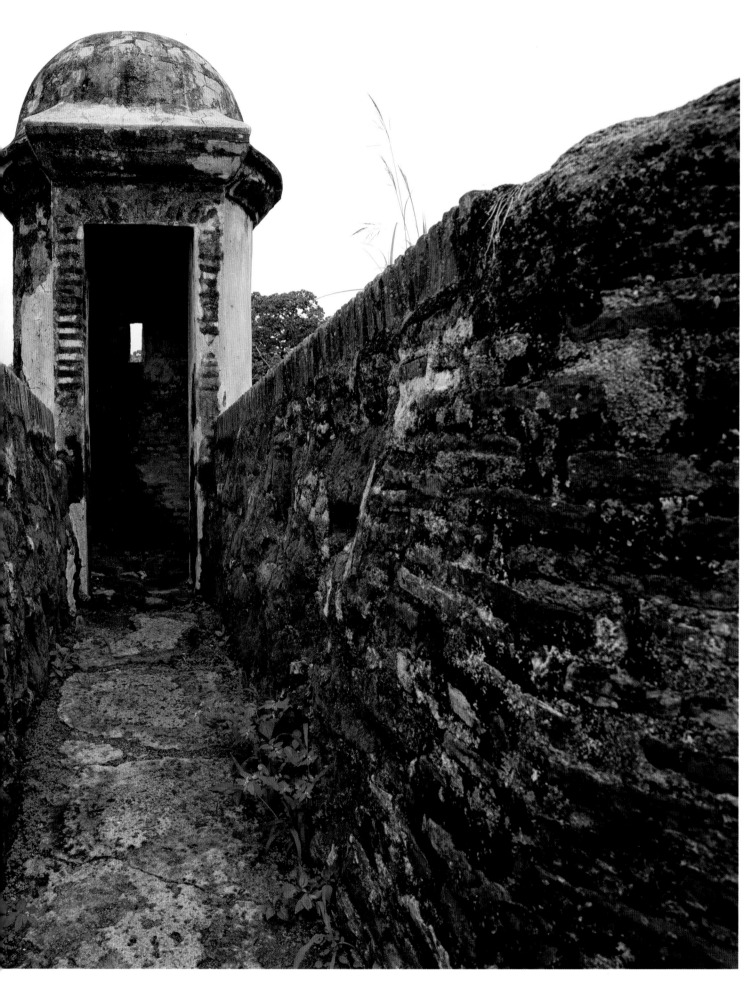

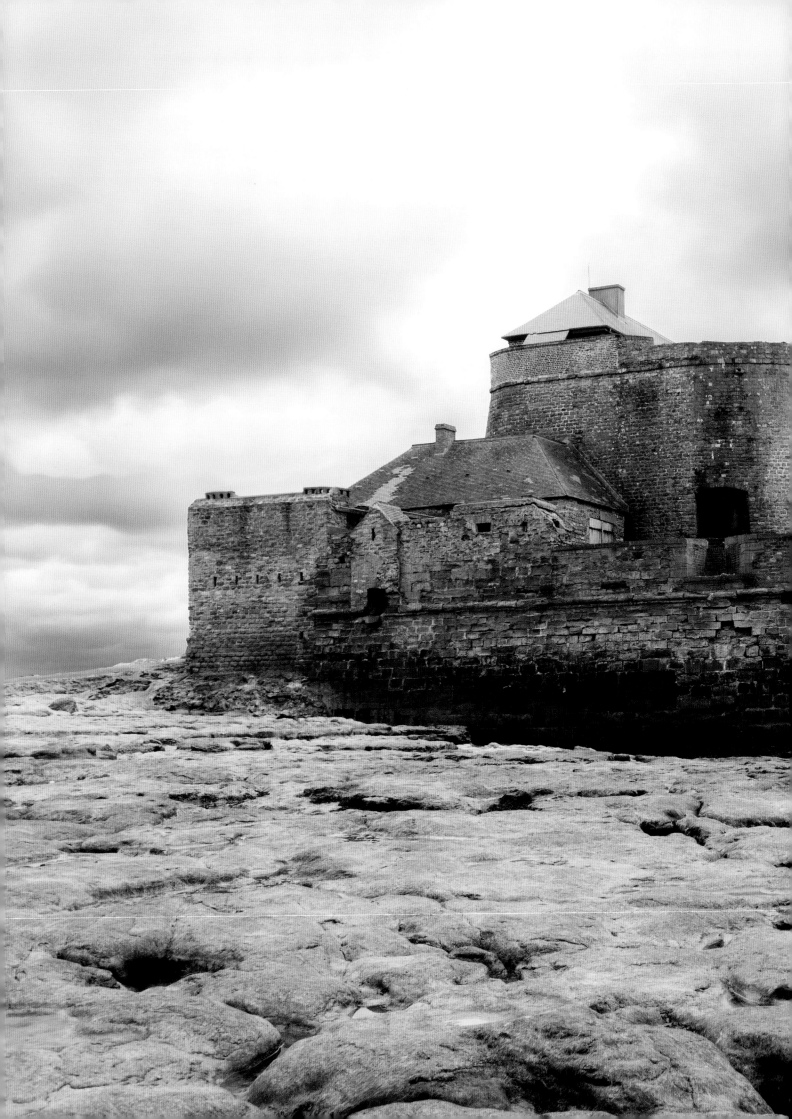

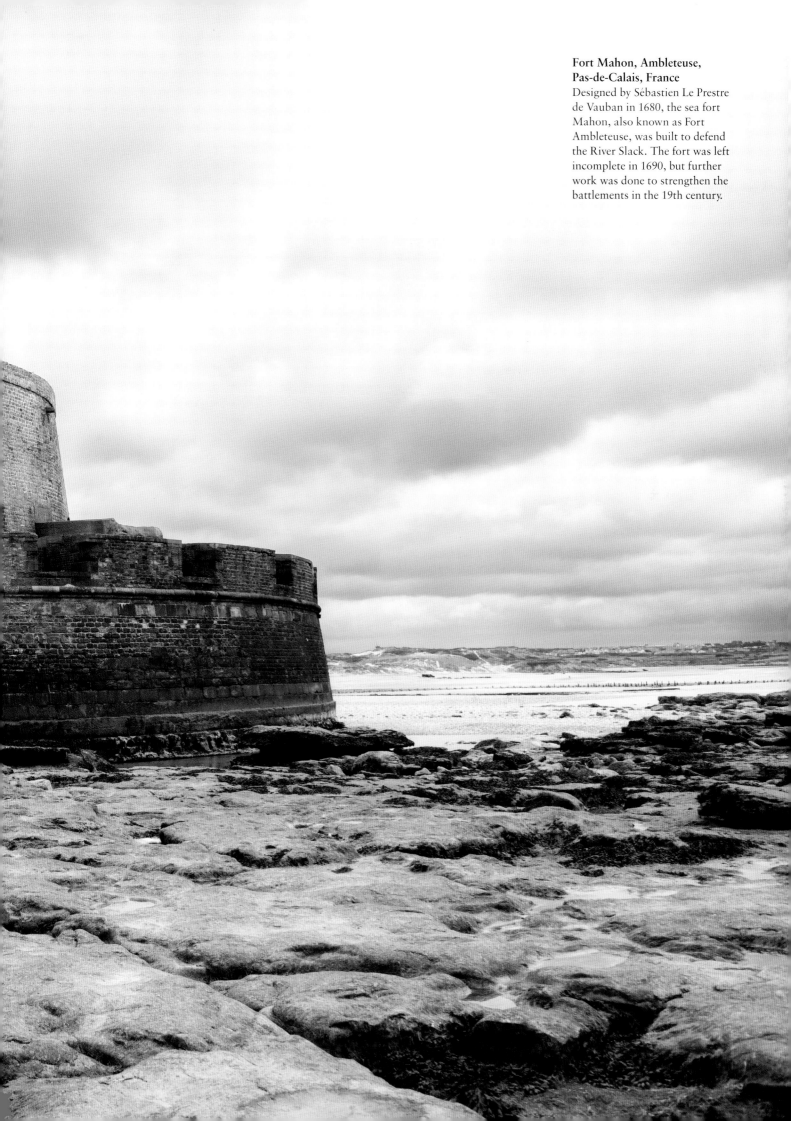

Fort Mahon, Ambleteuse, Pas-de-Calais, France
Designed by Sébastien Le Prestre de Vauban in 1680, the sea fort Mahon, also known as Fort Ambleteuse, was built to defend the River Slack. The fort was left incomplete in 1690, but further work was done to strengthen the battlements in the 19th century.

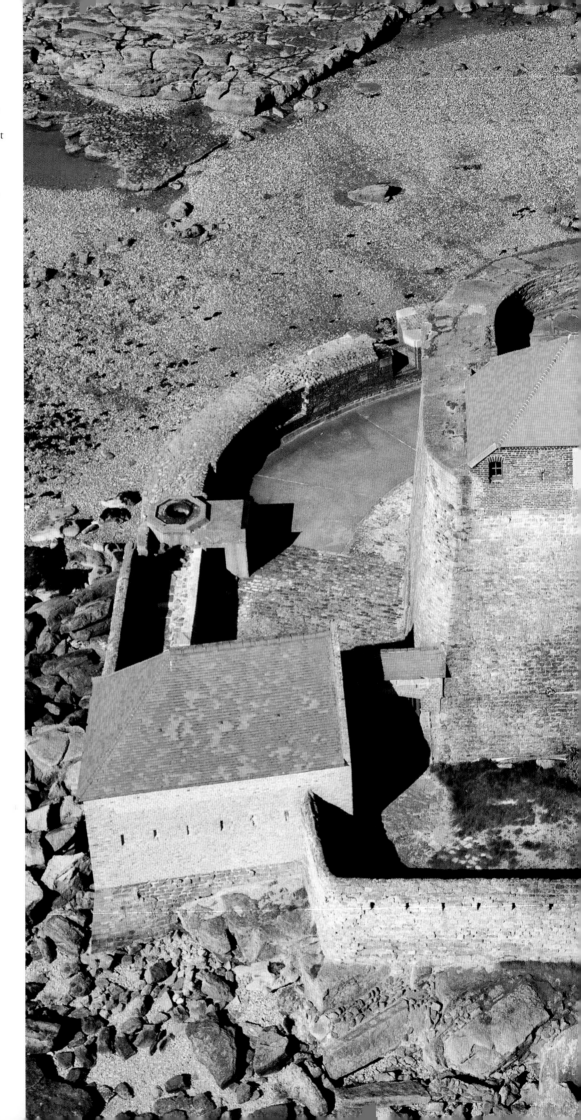

Fort Mahon, Ambleteuse, Pas-de-Calais, France
During World War II, German forces occupied Fort Mahon and, in 1945, two drifting sea mines destroyed its outer walls. In recent years, restoration work has been carried out and today it is the only preserved sea fort between Cherbourg in Normandy and the Belgian border.

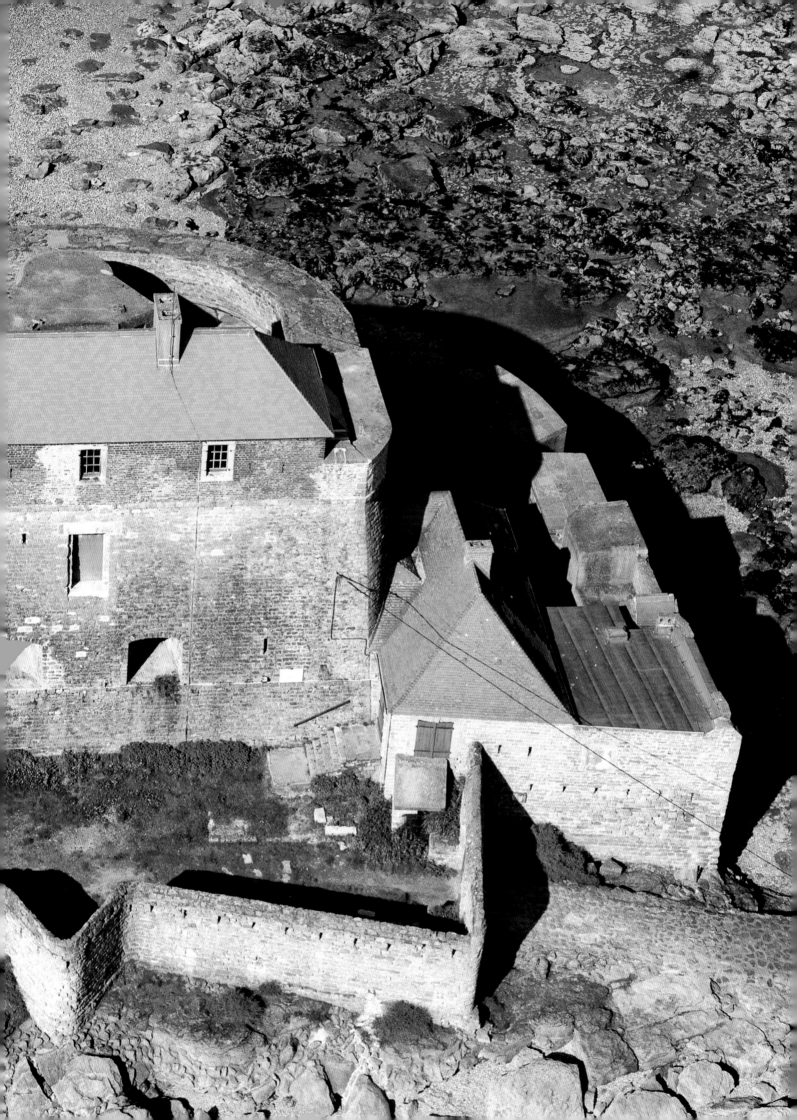

PREVIOUS PAGES:
**Krzyztopor Castle,
Swietokrzyskie Province, Poland**
Completed in 1644, Krzyztopor
was pillaged and sufficiently
damaged by invading Swedes 11
years later that only the western
wing was re-inhabited. Seized by
the Russians in 1770, the castle
was ransacked and, after 1787,
abandoned. In design it is a mix
of palace and fortress. Its curious
name means 'Cross Axe'.

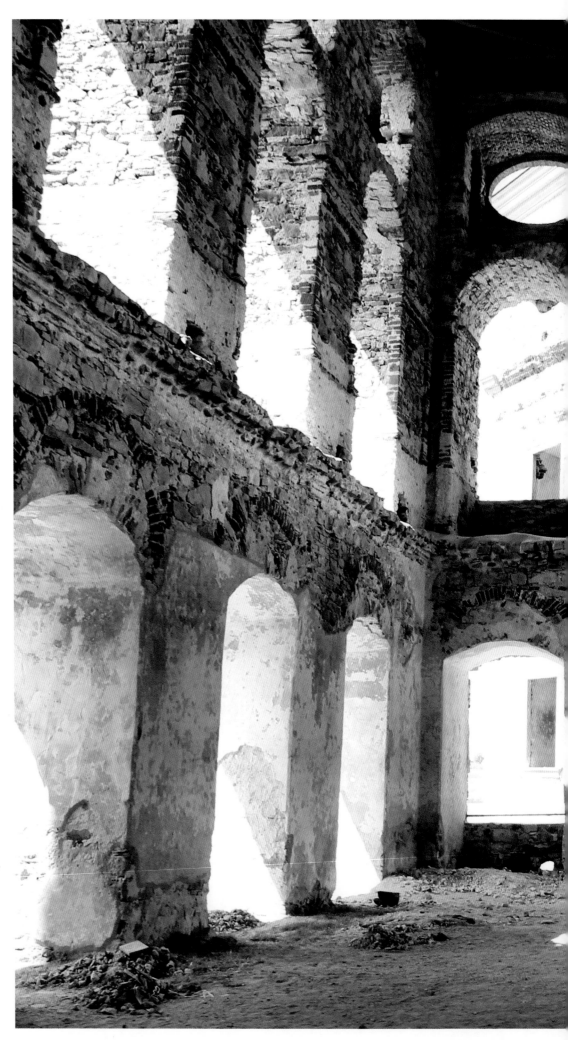

RIGHT:
**Krzyztopor Castle,
Swietokrzyskie Province, Poland**
The eccentric Krzysztof Ossolinski,
who commissioned the castle,
believed in black magic, which
perhaps explains the symmetry
throughout the castle – the
buildings forming a circle within a
square within a pentagon, as well
as a calendar theory. Designed to
match the days, weeks and months
of the year, the castle is believed to
have had 365 windows, 52 rooms
and 12 ballrooms.

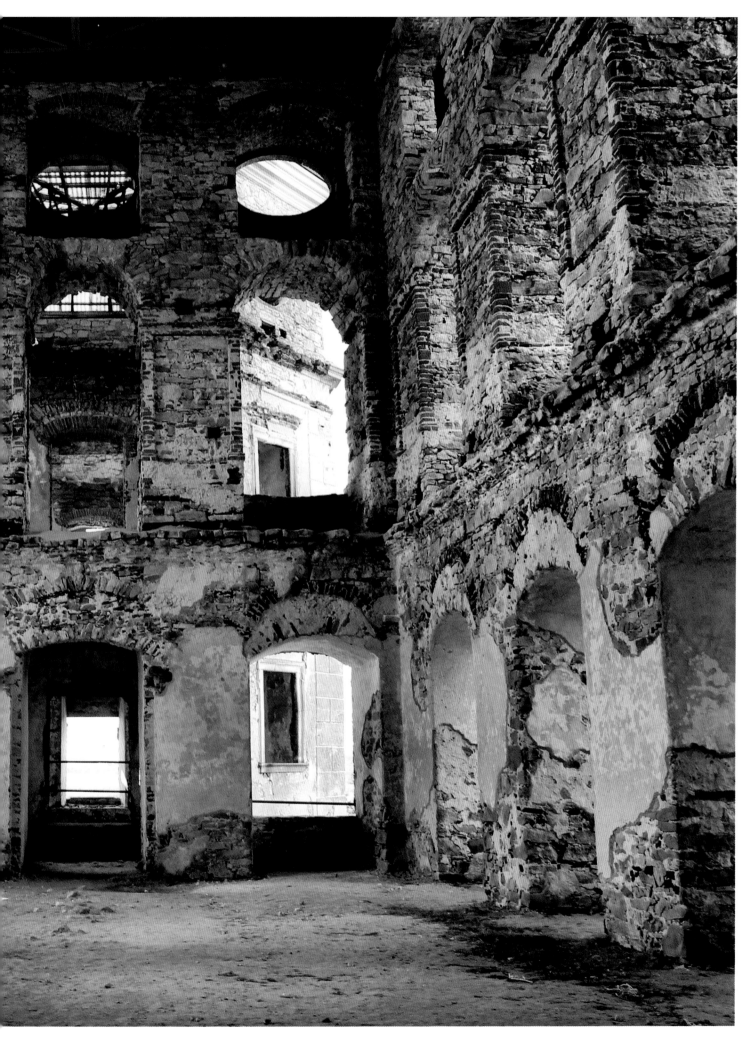

Fort Paté, Blaye, Gironde, Aquitaine, France
Situated on a sandbank in the estuary of the Gironde River, Fort Paté was part of a network of defences built in the late 17th century to protect the town of Bordeaux and its port. Oval-shaped and 12 metres (40ft) high, the fort had a complete view of the estuary and featured two artillery batteries: one at ground level and another on the roof.

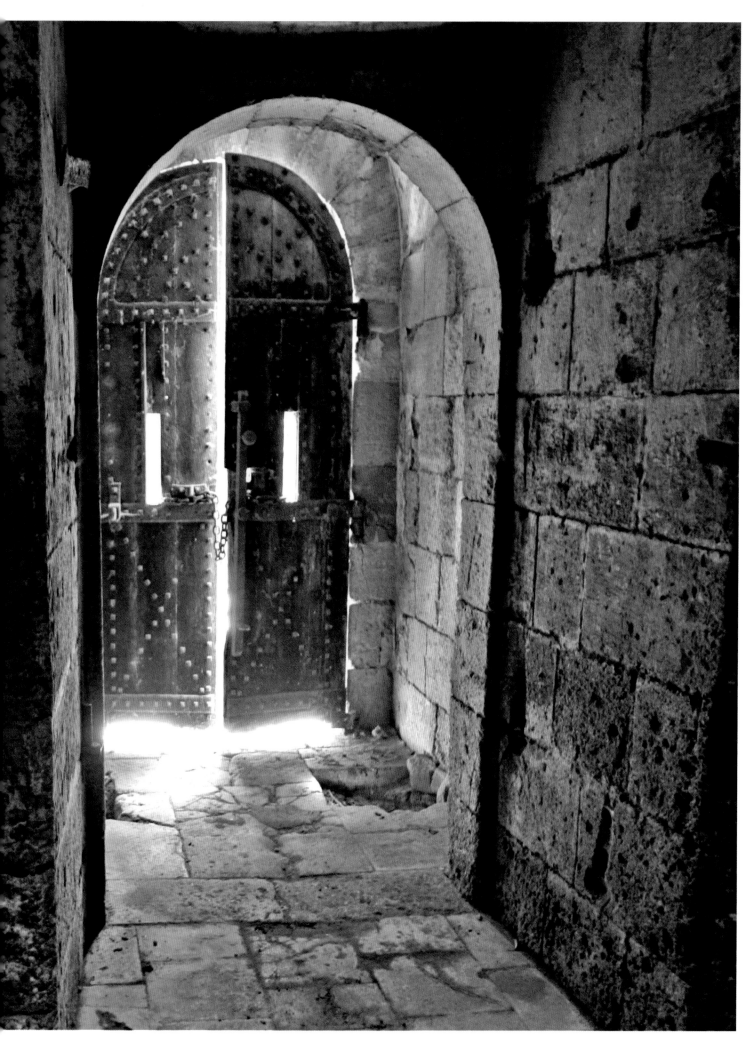

**Bitchu Matsuyama Castle,
Takahashi, Okayama Prefecture,
Japan**
At an elevation of 480 metres
(1,575ft), Bitchu Matsuyama is
the highest castle in Japan. The
current building was built by
Mizunoya Katsutaka in 1683, but
there had been an earlier castle on
the site since 1331. With the end of
the Tokugawa shogunate in 1868,
the castle was partly destroyed,
while the rest was abandoned and
slowly fell into disrepair.

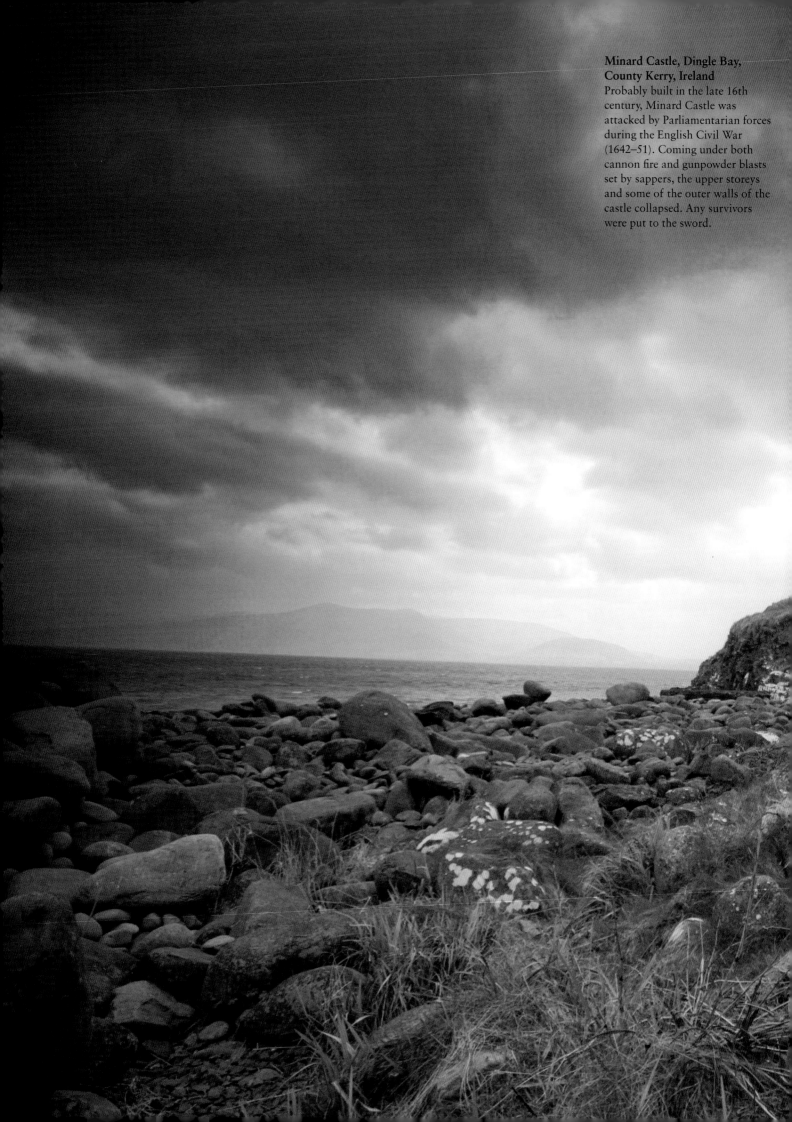

Minard Castle, Dingle Bay, County Kerry, Ireland
Probably built in the late 16th century, Minard Castle was attacked by Parliamentarian forces during the English Civil War (1642–51). Coming under both cannon fire and gunpowder blasts set by sappers, the upper storeys and some of the outer walls of the castle collapsed. Any survivors were put to the sword.

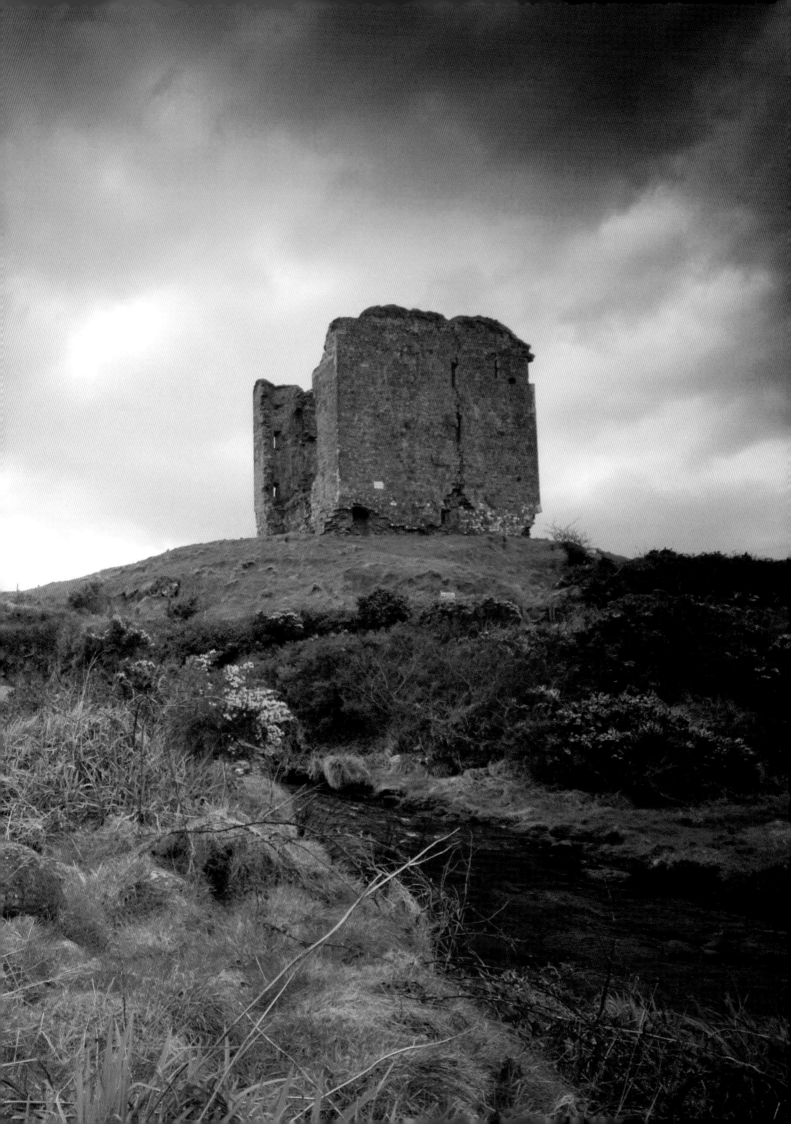

Twizell Castle, Northumberland, England

Built on the ruins of a medieval tower house, Twizell Castle was begun around 1770 as a mansion in the Gothic Revival style. The ambitious, five-storey project was the initiative of Sir Francis Blake, 1st Baronet of Twizell, but after 40 years of work, and long after Blake had died, the building work was abandoned uncompleted. When, in 1882, the Blake family began building a new mansion, much of the castle was demolished and the stone used in the new construction.

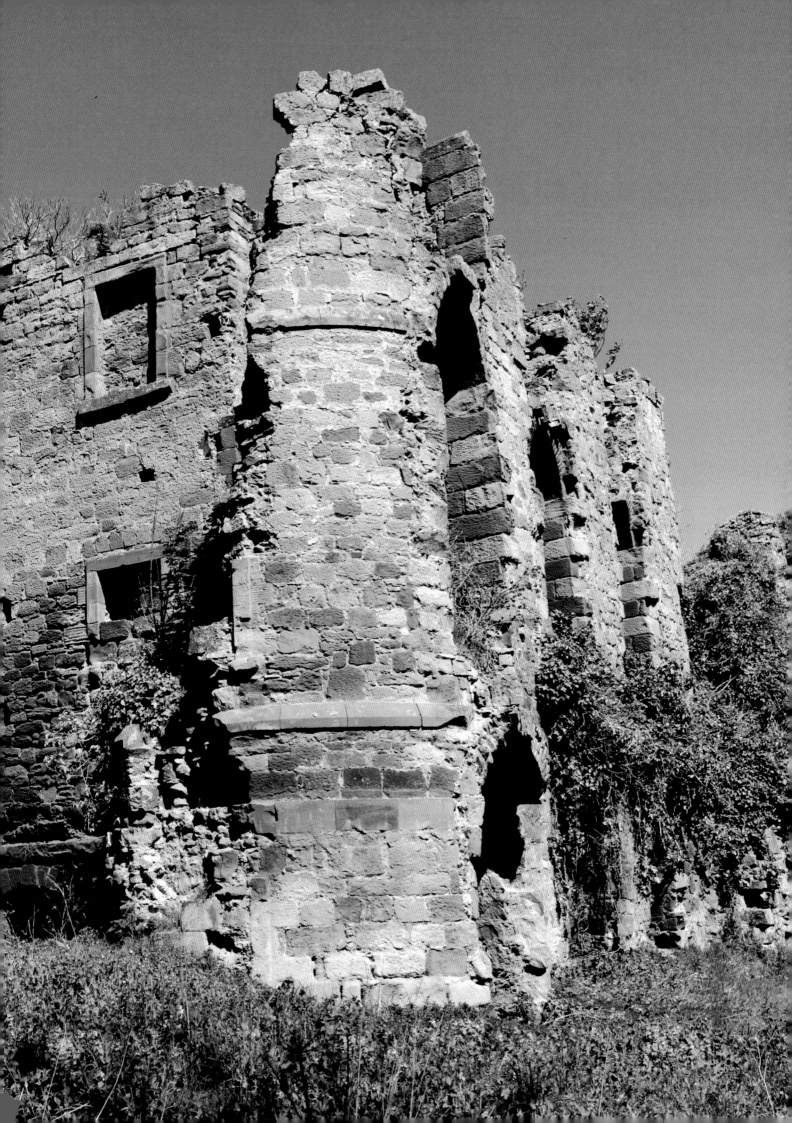

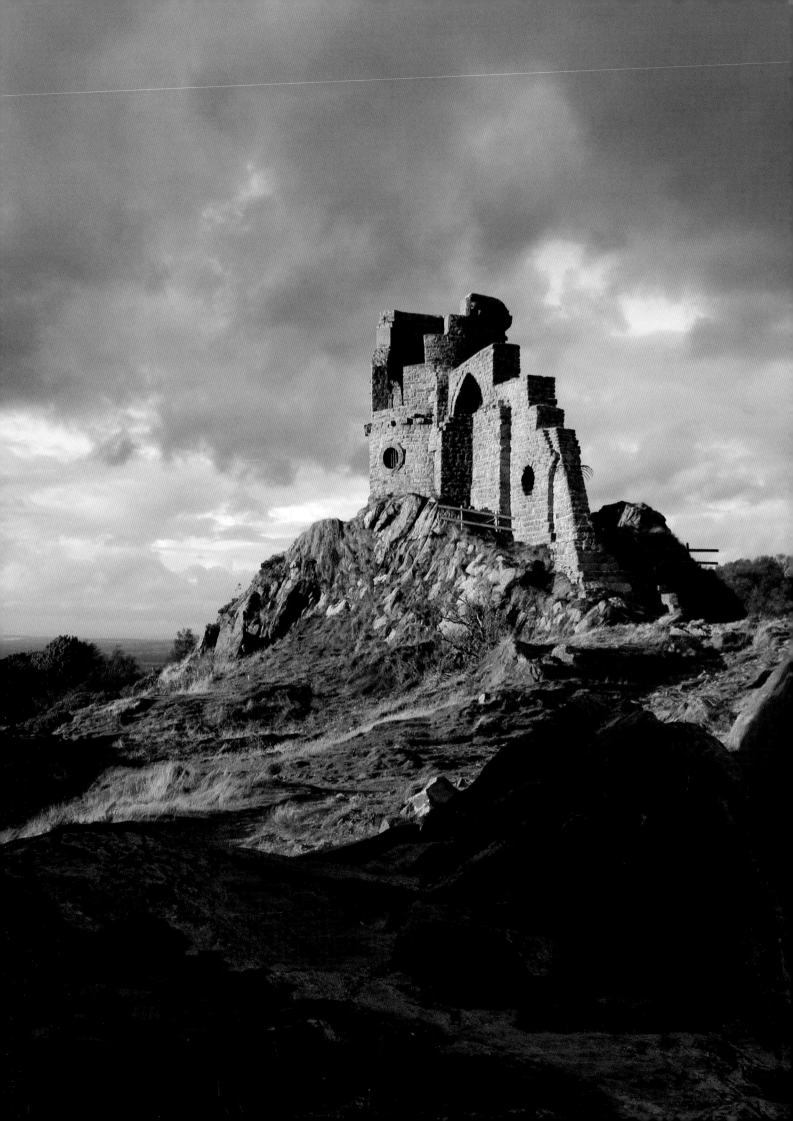

Imperial Era

The present stands on the shoulders of the past. In the 19th century, Martello Towers were built by the British from southern England to Canada and the Caribbean, and from South Africa to Sri Lanka. These round, defensive, coastal forts weren't, however, a British idea at all. Instead, they were a modification of Mortella Tower, constructed by the Republic of Genoa on the island of Corsica in the 16th century to defend against pirates. The British largely blew up Mortella Tower in the late 18th century, but they left impressed with its design and its successors survive right across the former British Empire.

Looking to the past for inspiration can be done for matters of style, too. Today if we often find castle ruins romantic, we are by no means the first to do so. From the 18th century, follies of medieval ruins were erected, and tumble-down fortresses from the Middle Ages were kept as decoration in stately gardens, while 13th century castles were adorned with battlements to make them look even more medieval.

Then, during the Gothic Revival period of architecture in the 19th century, palaces and country houses were constructed featuring medieval-style ornamental towers and turrets, even though these buildings now had no military function. Castles were no longer being built, but that didn't stop us liking the idea of them.

We still do.

OPPOSITE:
Mow Cop Castle, Mow Cop, Odd Rode, Cheshire, England
This is not what it might seem – Mow Cop Castle is a folly of a ruined castle built in 1754 by Randle Wilbraham.

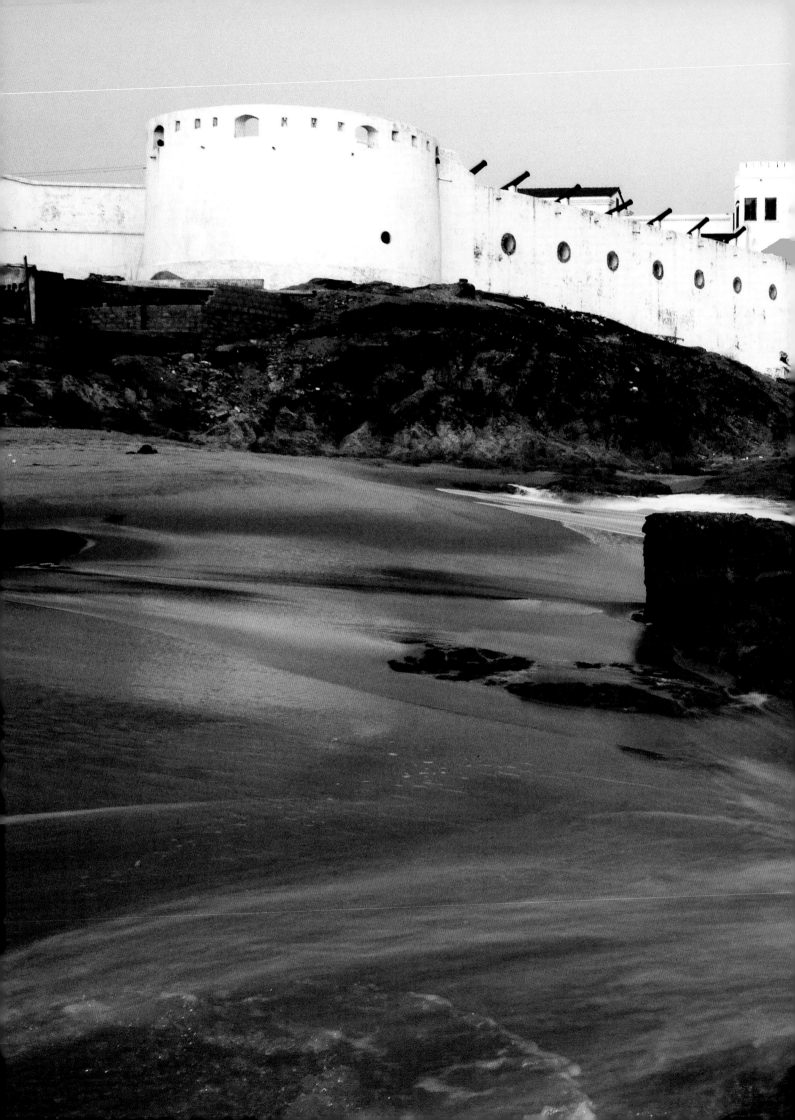

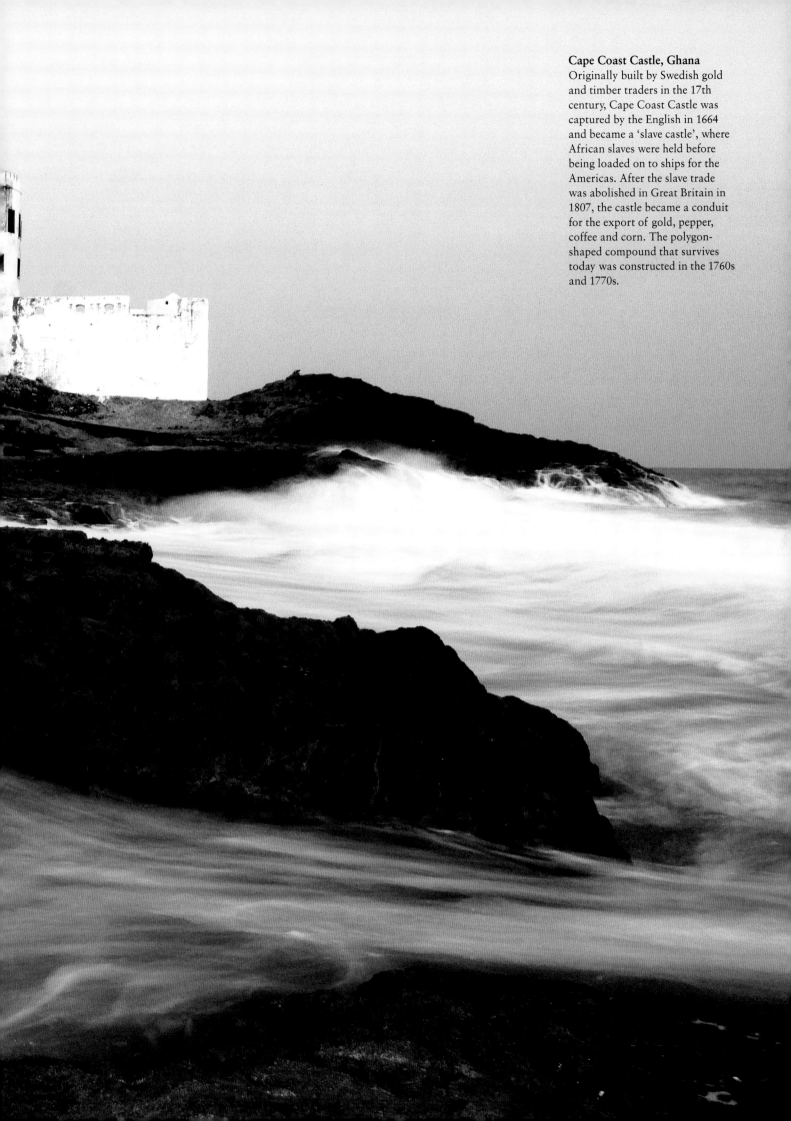

Cape Coast Castle, Ghana
Originally built by Swedish gold and timber traders in the 17th century, Cape Coast Castle was captured by the English in 1664 and became a 'slave castle', where African slaves were held before being loaded on to ships for the Americas. After the slave trade was abolished in Great Britain in 1807, the castle became a conduit for the export of gold, pepper, coffee and corn. The polygon-shaped compound that survives today was constructed in the 1760s and 1770s.

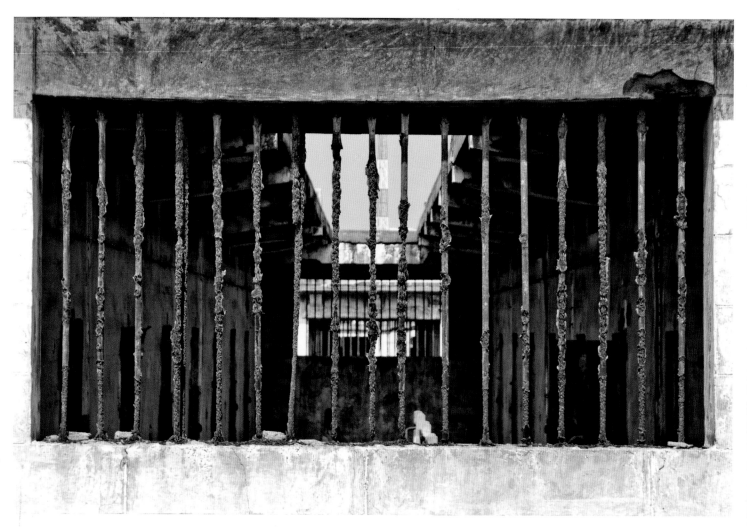

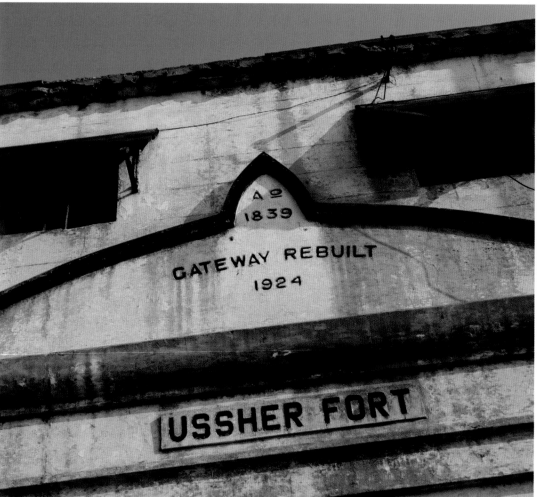

TOP, LEFT AND OPPOSITE:
Ussher Fort, Accra, Ghana
Ussher Fort stands on the site of
Fort Crèvecœur, which was built
by the Dutch West India Company
in the mid-17th century. Crèvecœur
was abandoned in 1816, before
being rebuilt and renamed Ussher
Fort by the British in 1868, after
which it was used as a prison
until 1993.

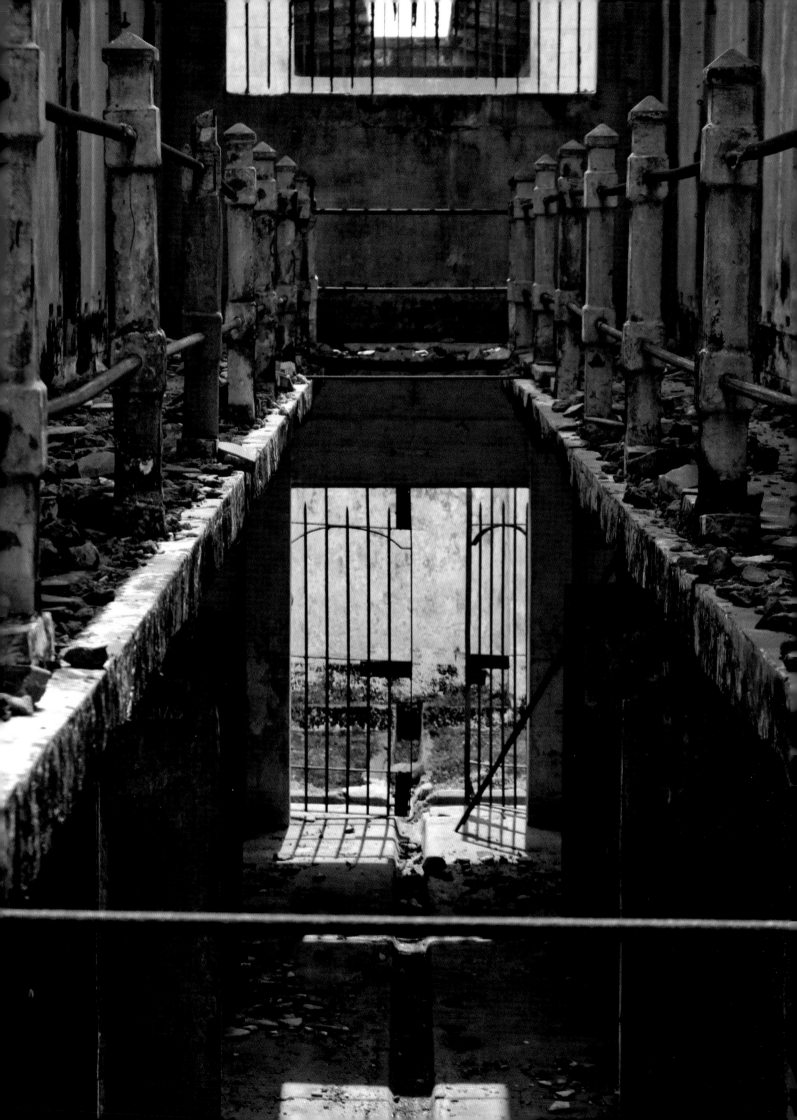

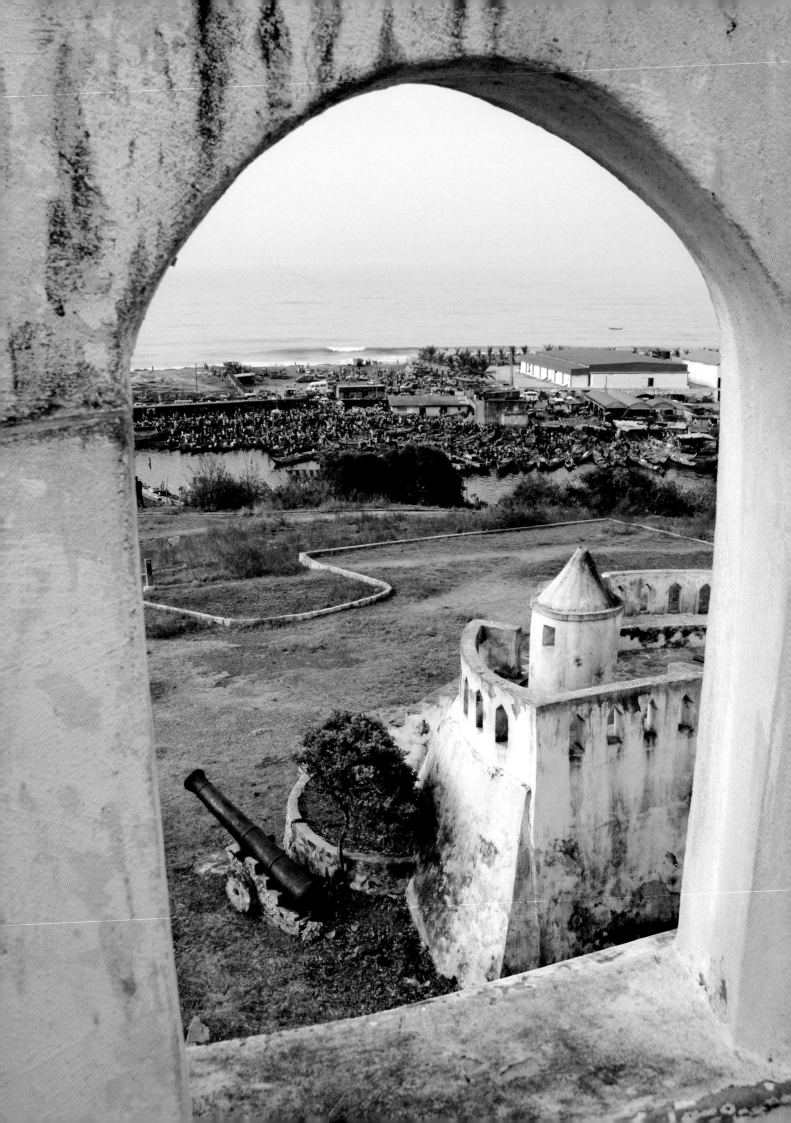

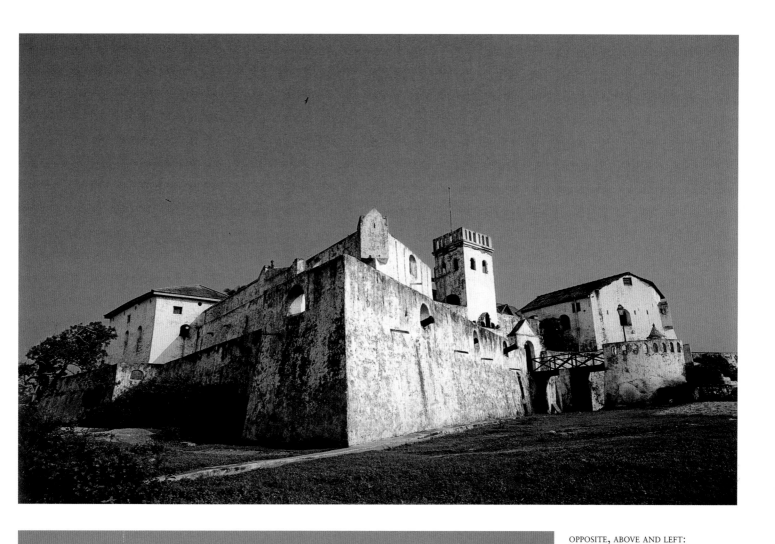

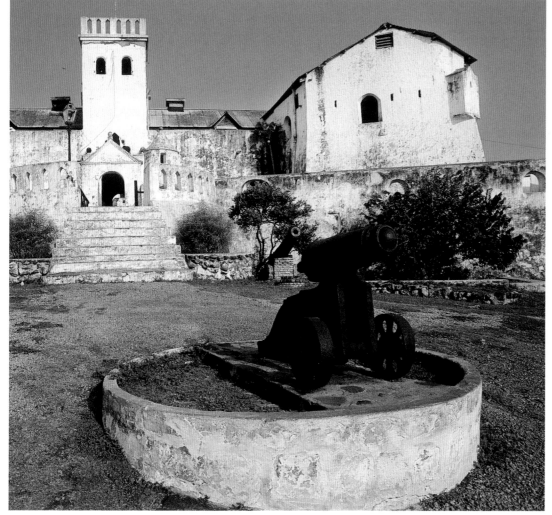

OPPOSITE, ABOVE AND LEFT:
Fort James, Accra, Ghana
Built as a British trading post in 1673, Fort James was originally star-shaped. Like other colonial forts on the Gold Coast, it was both a residence for military and commercial staff, and a store-house for goods brought from Europe and those traded locally. Where fortifications were originally built to defend against enemies who might approach from the interior, in time the real danger came from competing European naval powers. In recent years Fort James was used as a prison.

Palamidi, Nafplio, Peloponnese, Greece
The fortifications at Palamidi are named after ancient Greek heroes, but they were only given these names after the area was taken from the Ottoman Turks in 1822, who had taken it from the Venetians in 1715 – who had only completed its construction the previous year! Originally the fortifications were named after Venetian politicians.

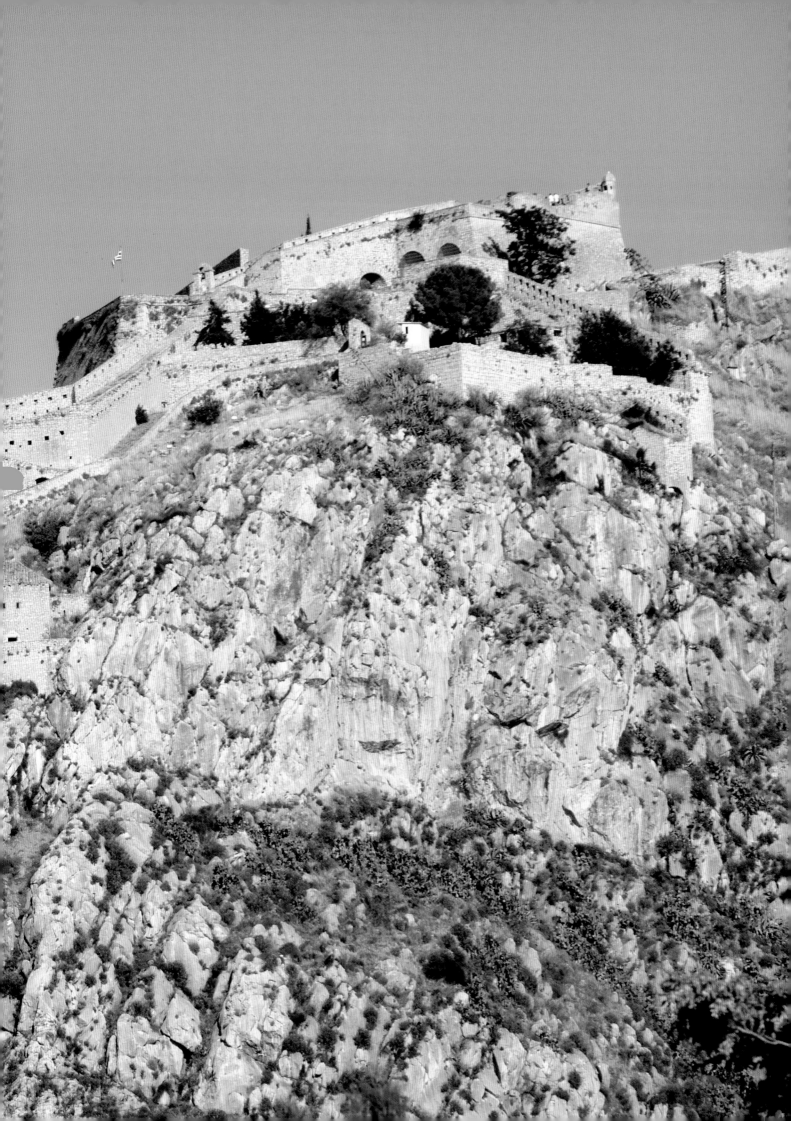

Kincasslagh, County Donegal, Ireland
Kincasslagh was an anti-invasion fort on the northwest coast of Ireland built by the British during the Napoleonic Wars (1803–15). The tower offers views out to sea in what is a very isolated location.

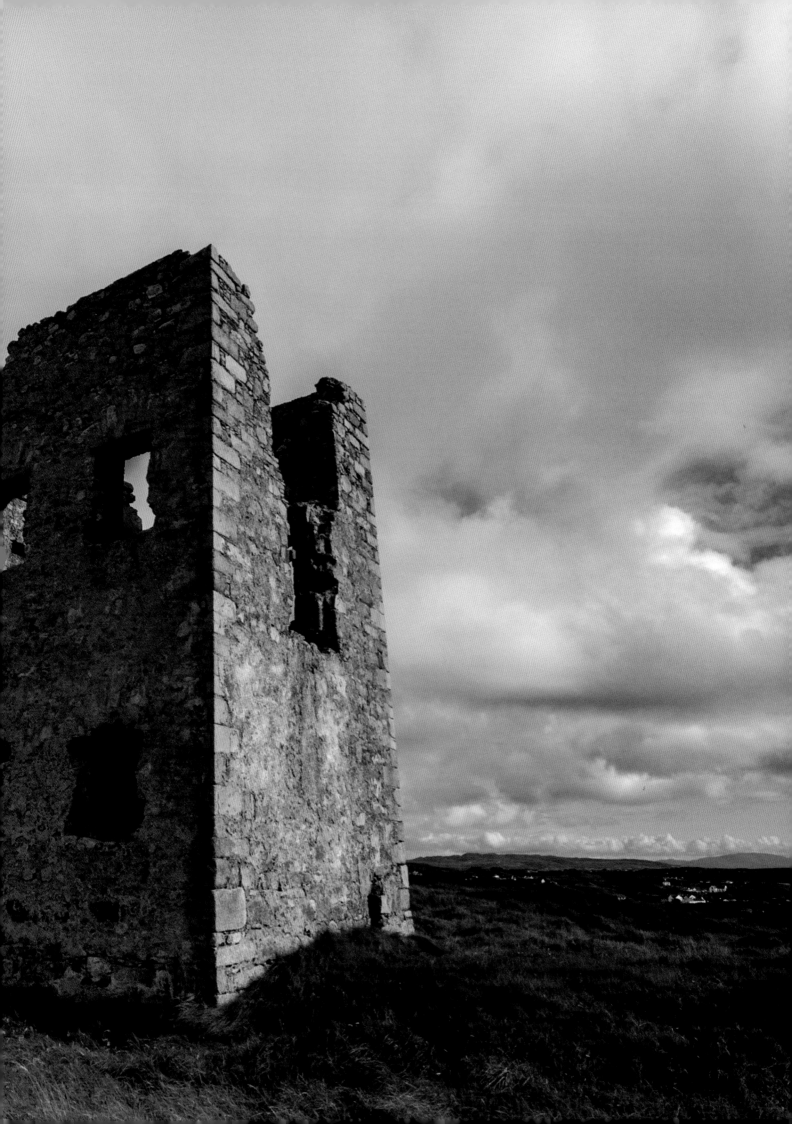

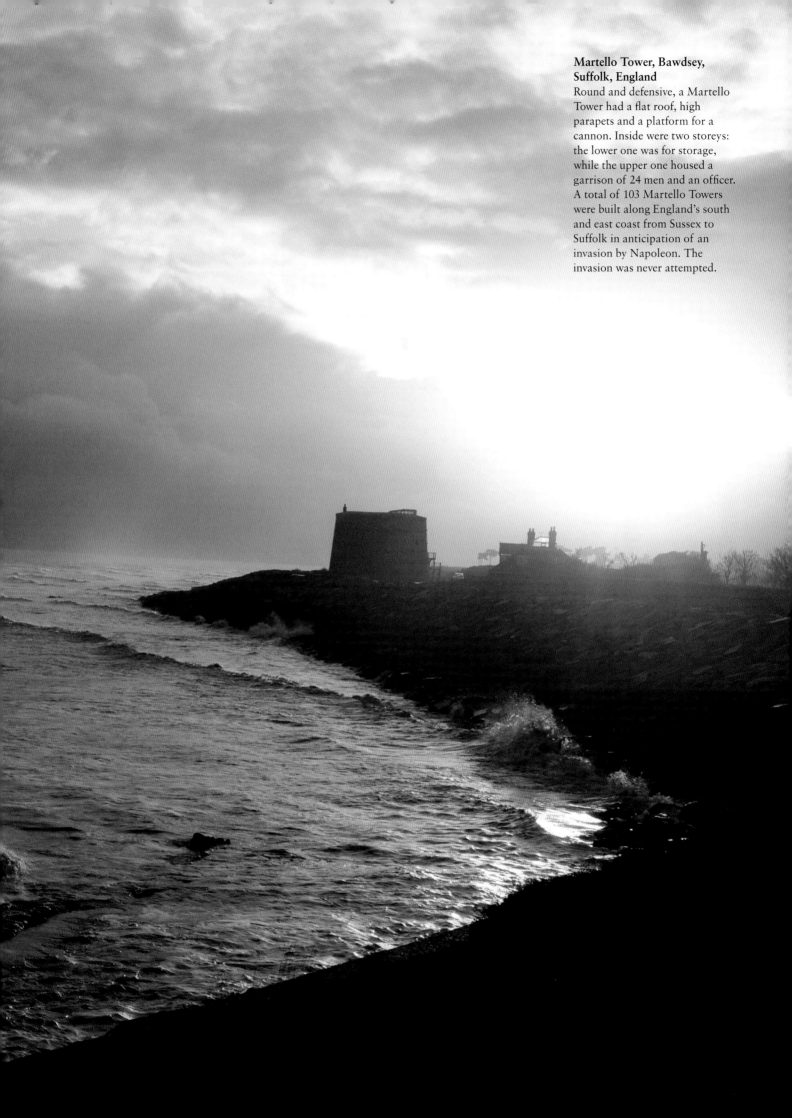

Martello Tower, Bawdsey, Suffolk, England
Round and defensive, a Martello Tower had a flat roof, high parapets and a platform for a cannon. Inside were two storeys: the lower one was for storage, while the upper one housed a garrison of 24 men and an officer. A total of 103 Martello Towers were built along England's south and east coast from Sussex to Suffolk in anticipation of an invasion by Napoleon. The invasion was never attempted.

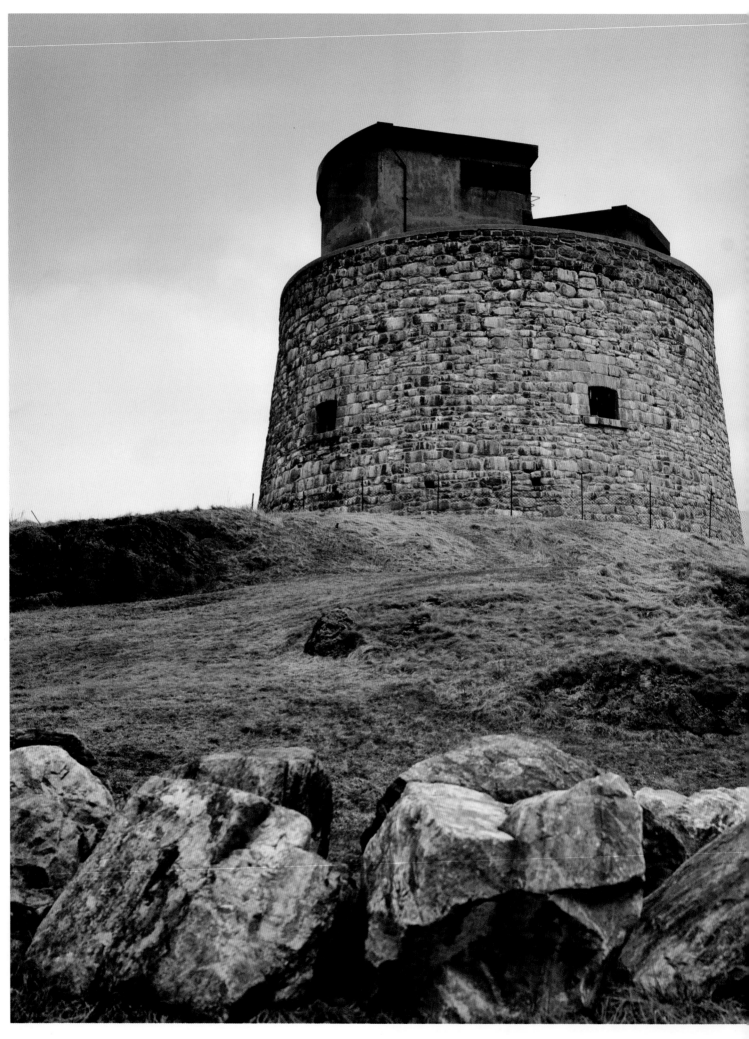

Carleton Martello Tower, Saint John, New Brunswick, Canada
The Carleton Martello Tower was designed to defend against an overland invasion from the United States during the War of 1812, but by the time the tower was completed in 1815 the hostilities were over. Half a century later it received two 32-pounder guns, intended to defend the city in the event of attacks from Irish nationalists. The concrete building on the roof was constructed during World War II, when the tower was used as a command post for harbour defence.

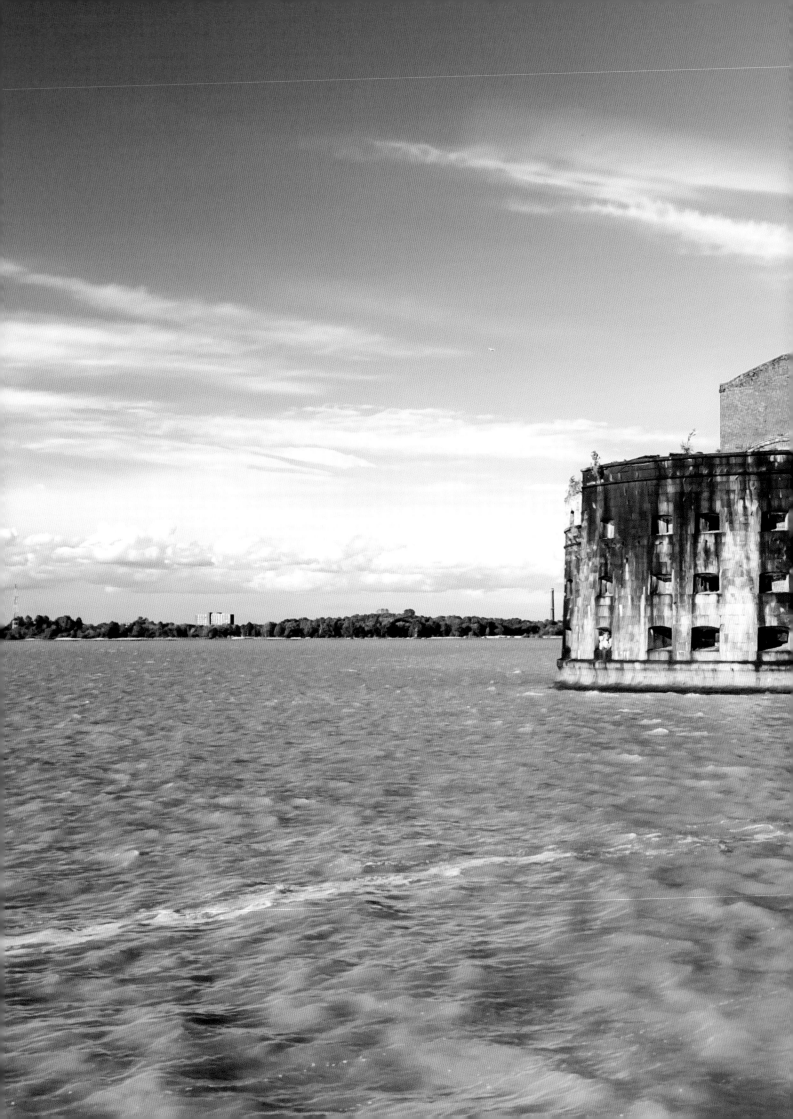

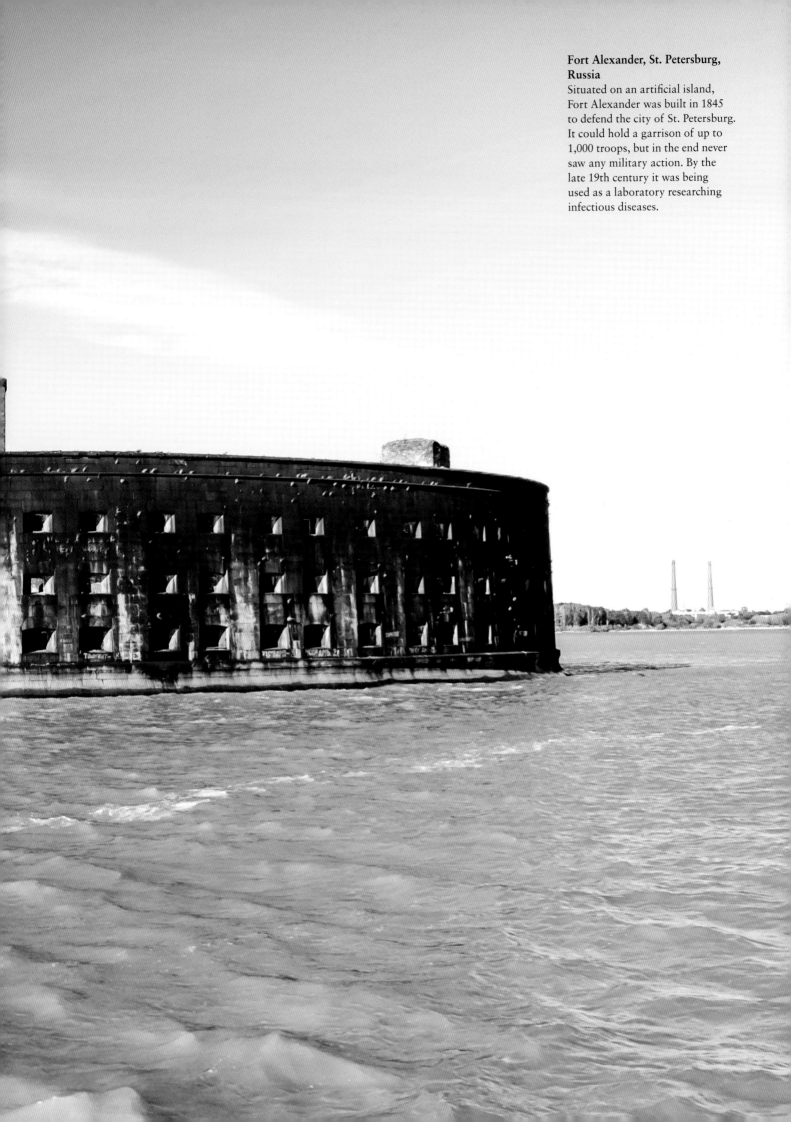

Fort Alexander, St. Petersburg, Russia
Situated on an artificial island, Fort Alexander was built in 1845 to defend the city of St. Petersburg. It could hold a garrison of up to 1,000 troops, but in the end never saw any military action. By the late 19th century it was being used as a laboratory researching infectious diseases.

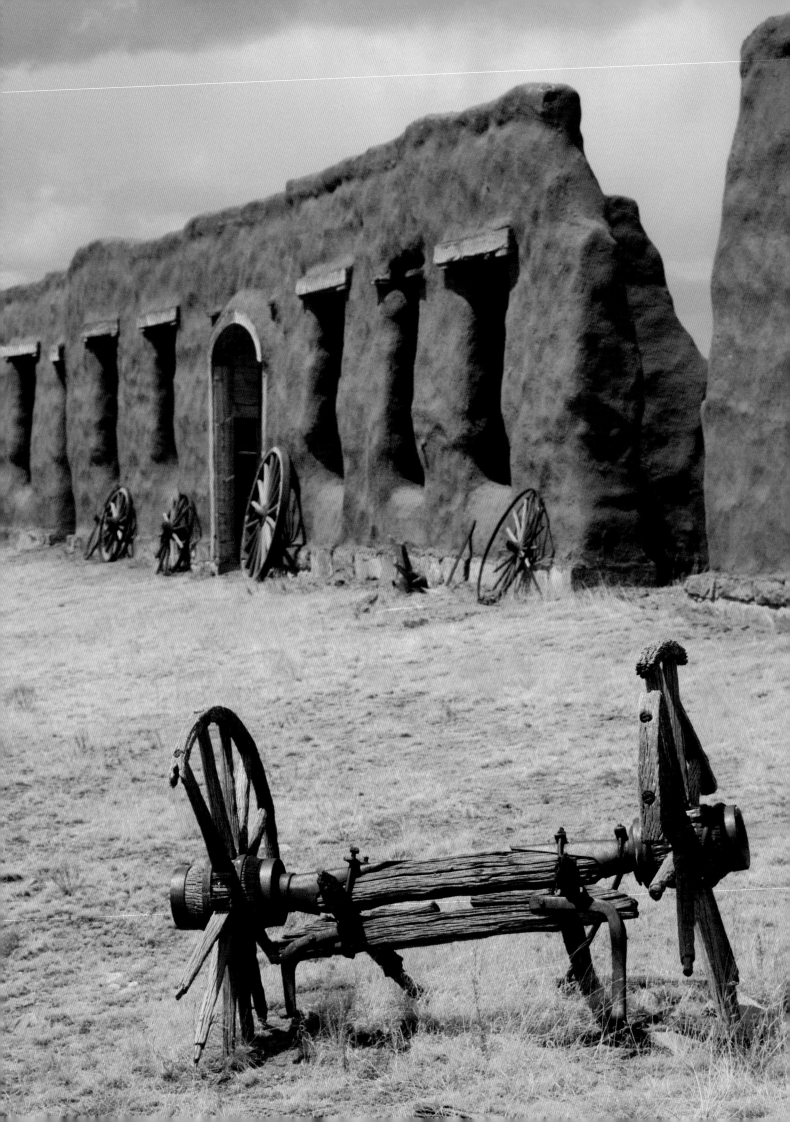

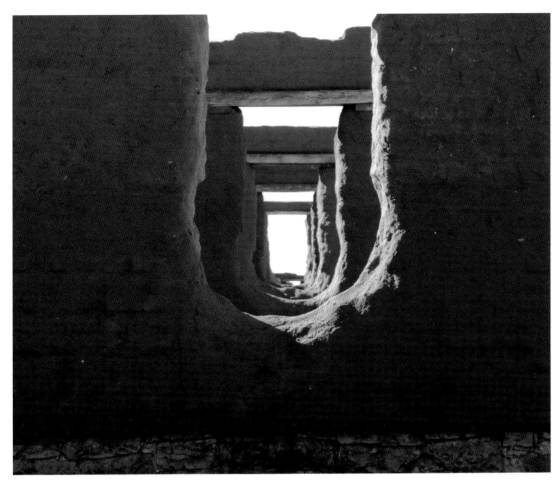

Fort Union, Mora Valley, New Mexico, USA

With New Mexico acquired by the US following the Mexican–American War (1846–48), the first Fort Union was established to protect US citizens and trade along the Santa Fe Trail.

The fort's garrison led campaigns into Native American homelands and protected caravans passing through Kiowa and Comanche territory. In addition, the troops at the fort, which included infantry and cavalry, played an important role in driving back Confederate forces that invaded New Mexico from Texas in 1862. The fort also had a civilian function as a stopping point for Missouri–Santa Fe mail coaches. The buildings that remain today are from the third Fort Union, begun in 1862.

The opening of the Atchison, Topeka, and Santa Fe Railroad in 1879 marked the beginning of the end for the Santa Fe Trail and Fort Union. In 1891 the fort was abandoned.

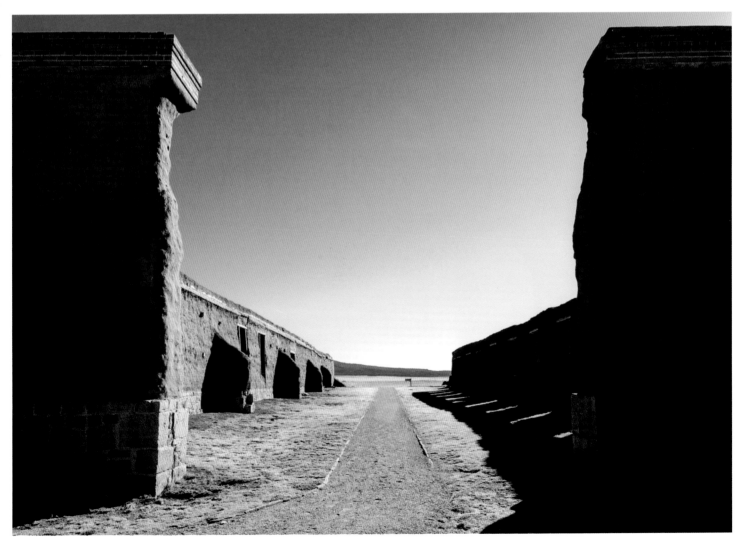

Buchanan Castle, Stirlingshire, Scotland

A castle only in name, Buchanan Castle is a neo-Gothic manor house with turrets and battlements built during the 1850s. Sold by the dukes of Montrose in 1925, the castle was later a hotel and, during World War II, a hospital. With the house no longer in use, the roof was removed in 1954. Both the interior and exterior are now overgrown with trees and plants.

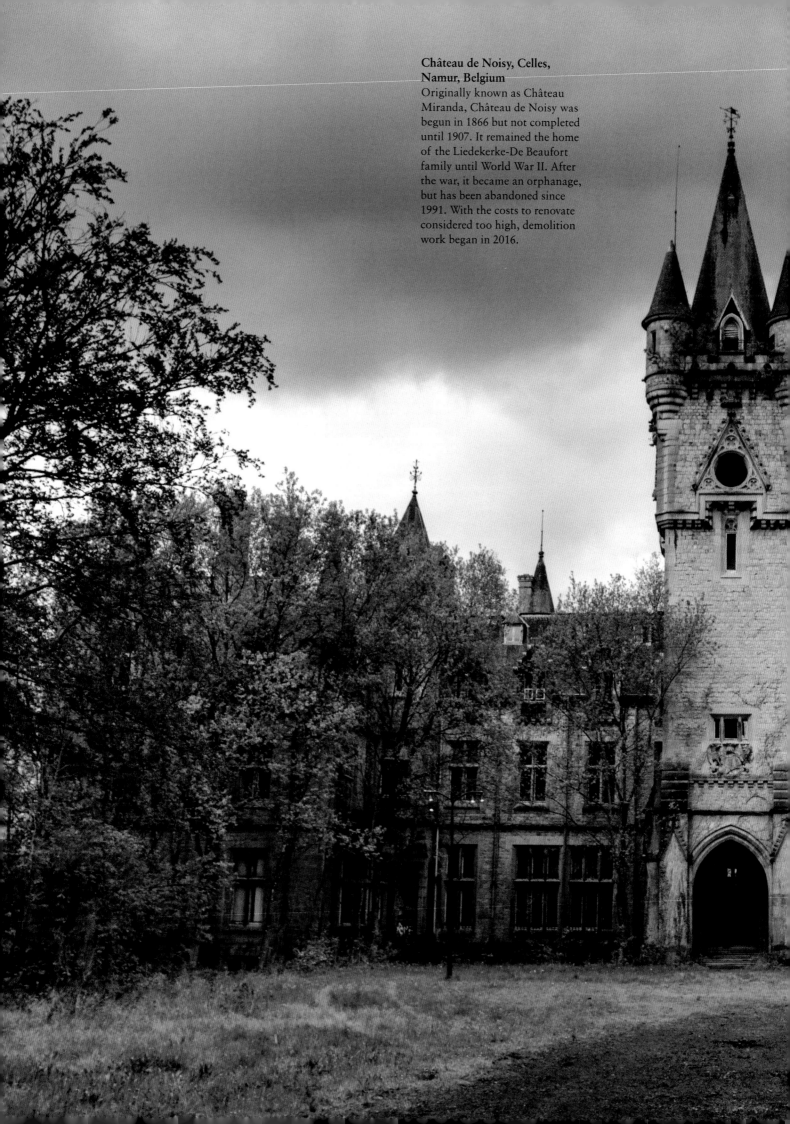

Château de Noisy, Celles, Namur, Belgium
Originally known as Château Miranda, Château de Noisy was begun in 1866 but not completed until 1907. It remained the home of the Liedekerke-De Beaufort family until World War II. After the war, it became an orphanage, but has been abandoned since 1991. With the costs to renovate considered too high, demolition work began in 2016.

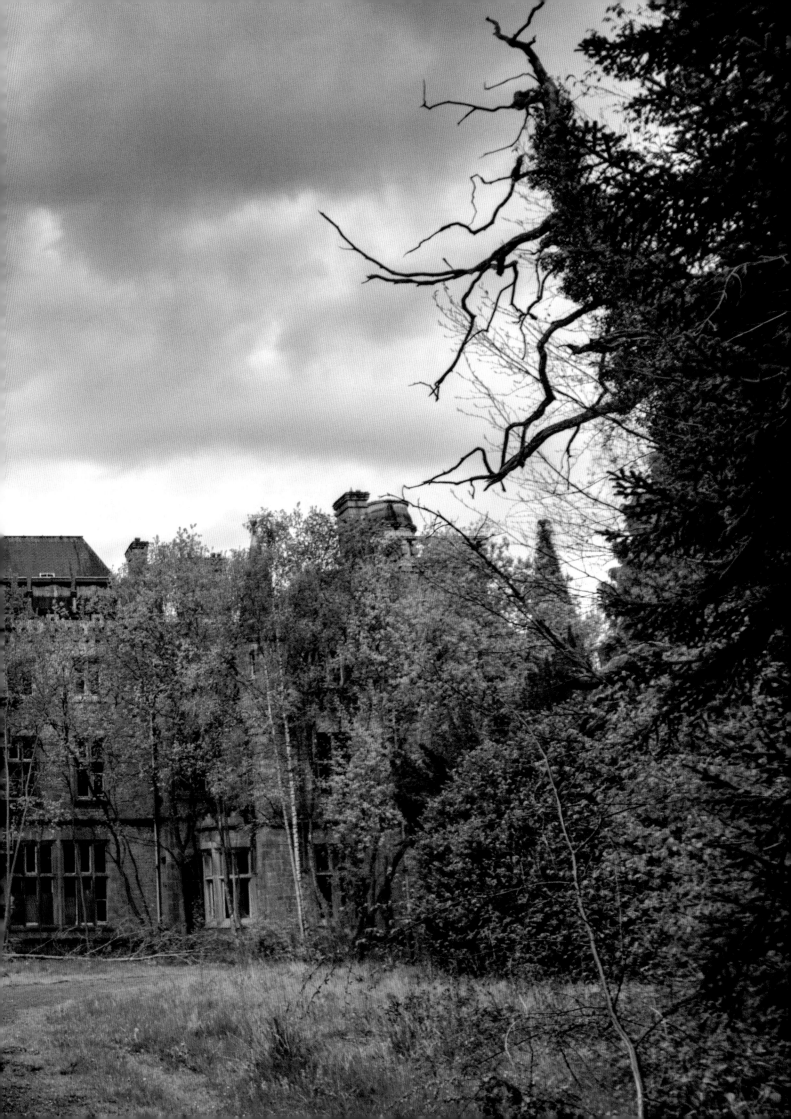

Fort Gilkicker, Gosport, Hampshire, England

With 22 gun emplacements arranged on its semi-circular wall, Fort Gilkicker was designed to defend the western approach to Portsmouth Harbour. Built in the 1860s, the fort was upgraded over the years – at the beginning of the 20th century, the granite exterior wall was buried beneath earthwork embankments as protection – but it never came under attack. In World War I it was armed with an early anti-aircraft gun, and during the D-Day landings in 1944 a signals unit was based at the fort. It was decommissioned in 1956.

Fort Zverev, Kronstadt, near St. Petersburg, Russia

Built on an artificial island in the Baltic Sea in the 1870s, Fort Zverev protected the approach to St. Petersburg. After World War II, it was used for military training and as an ammunition dump. A fire at the fort in 1970 ignited a stash of barrels containing a substance similar to napalm. The subsequent inferno tore through the fort, even melting the brickwork.

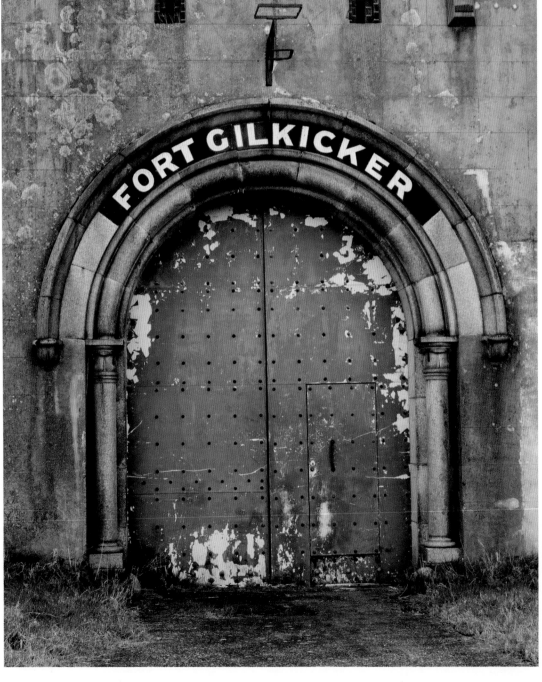

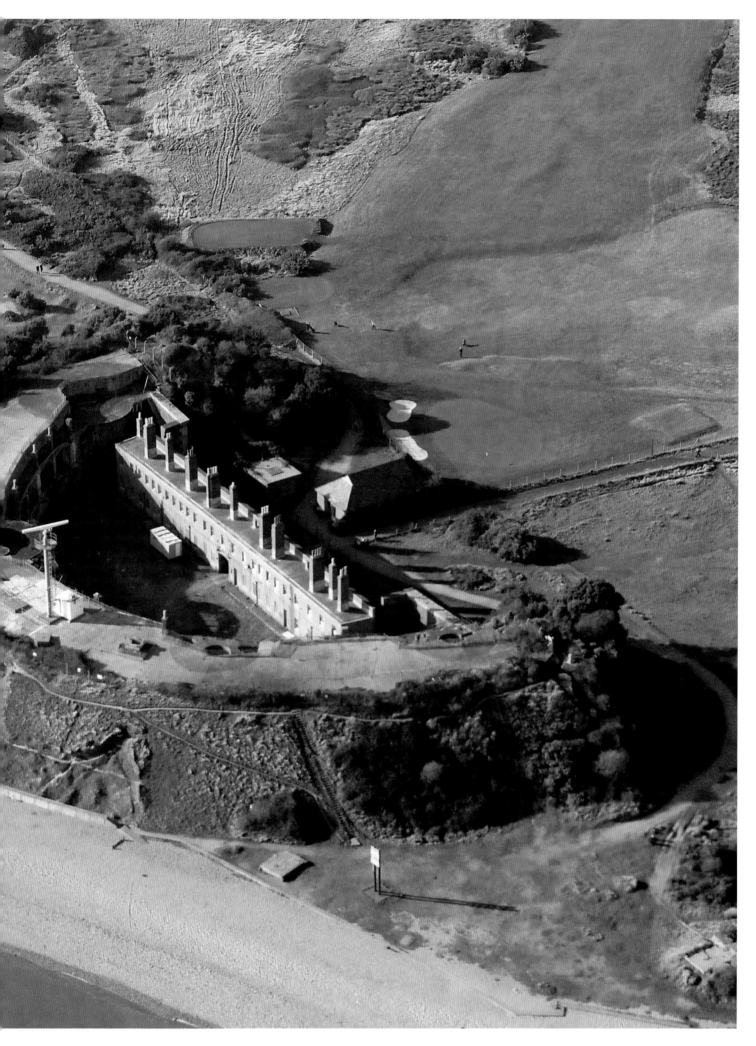

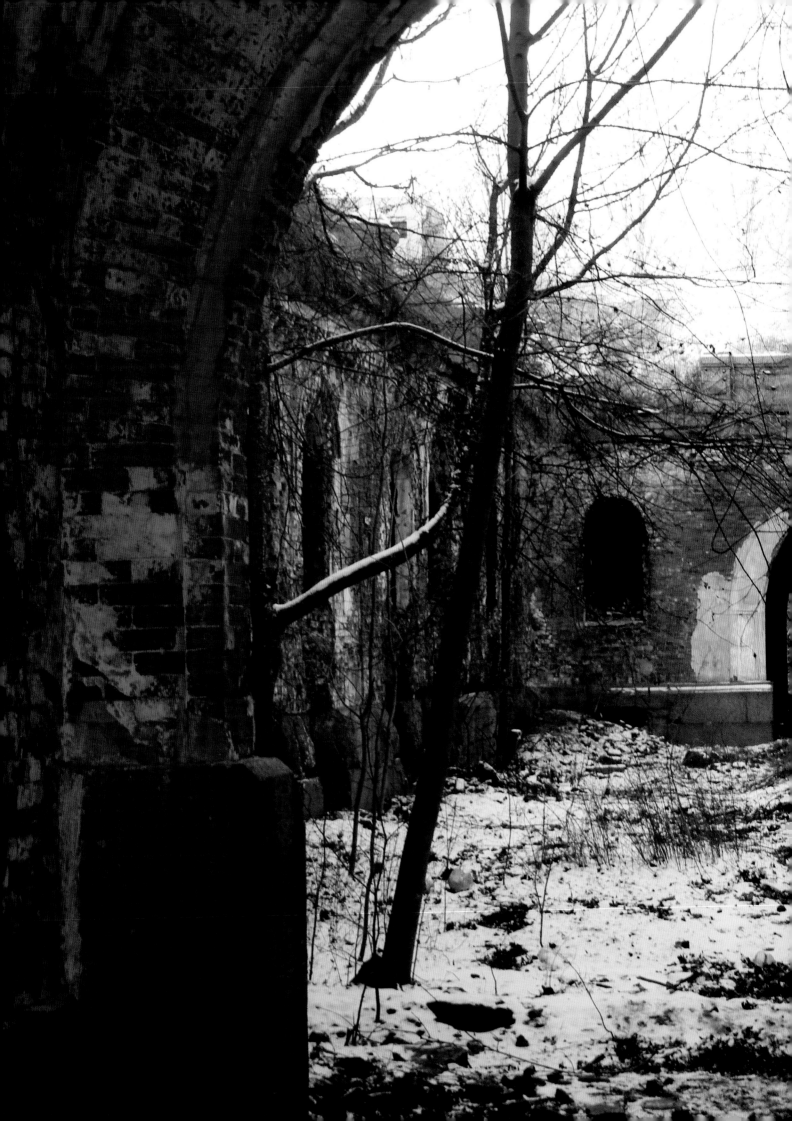

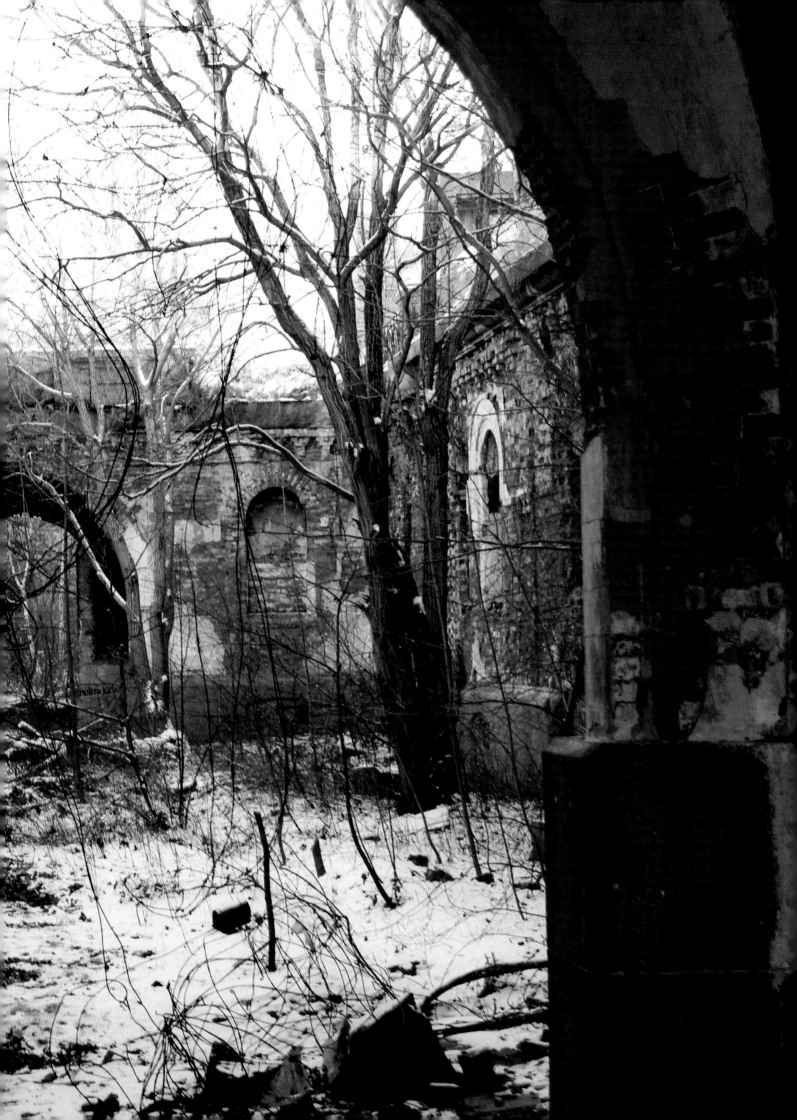

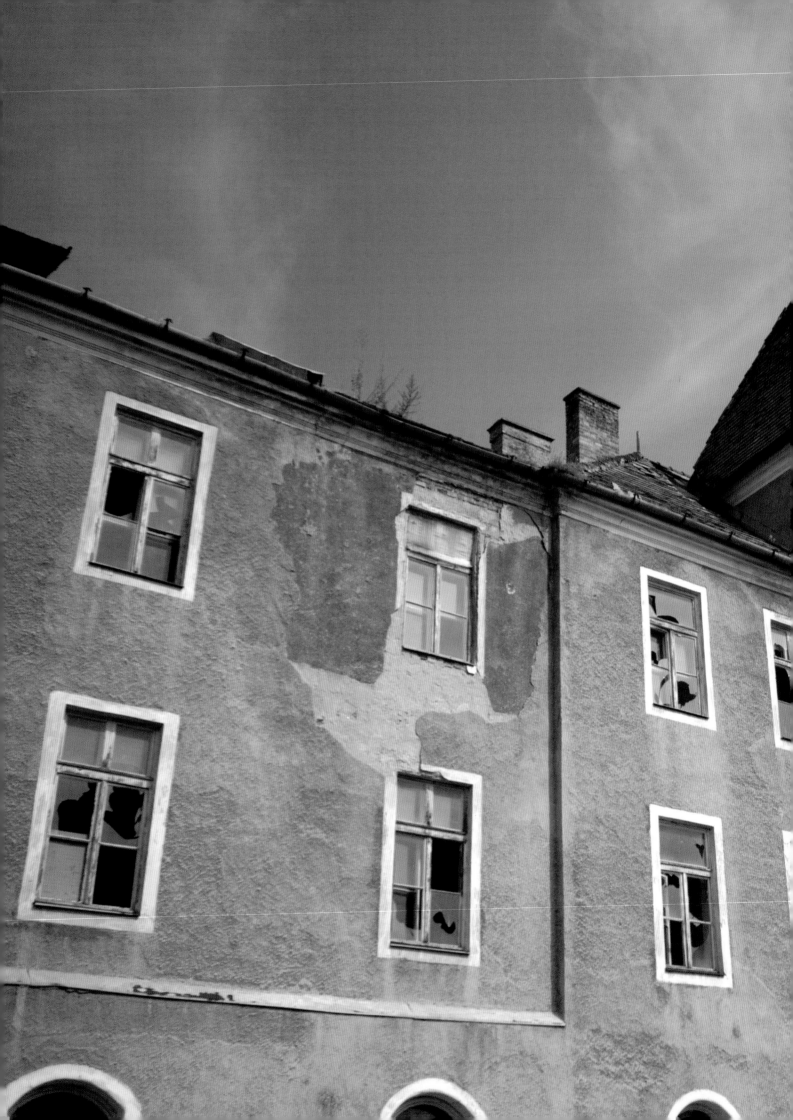

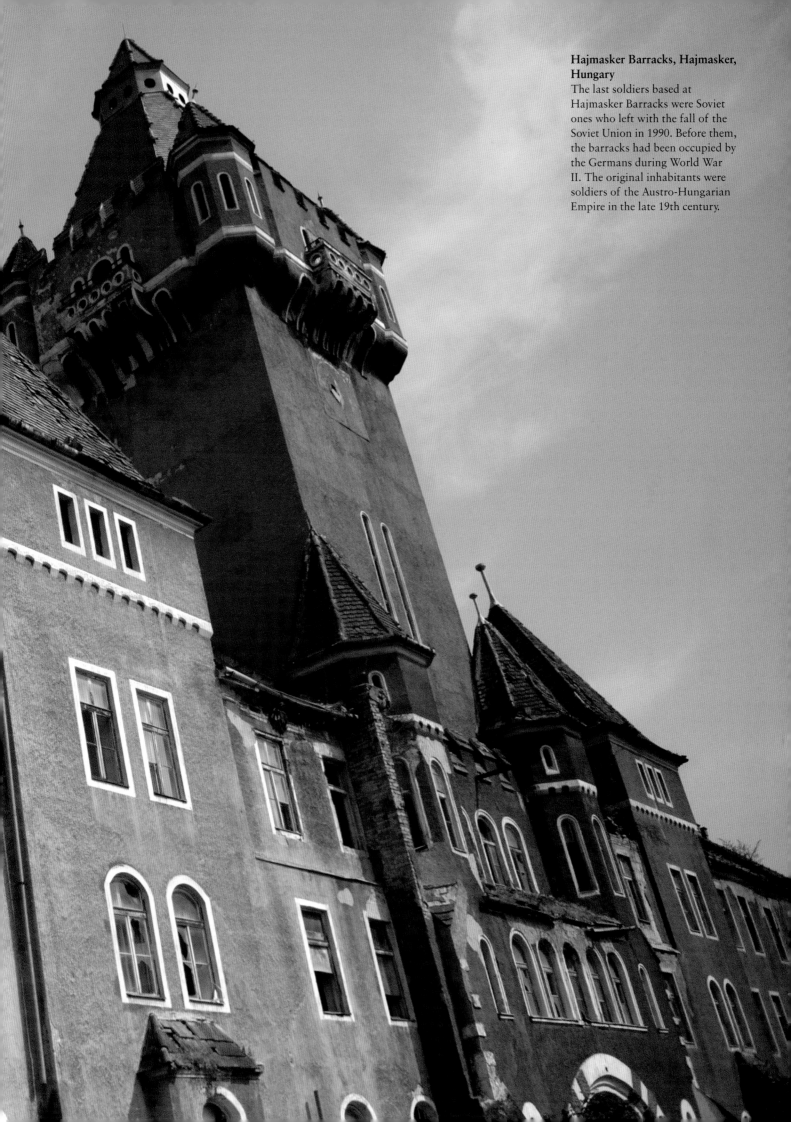

Hajmasker Barracks, Hajmasker, Hungary
The last soldiers based at Hajmasker Barracks were Soviet ones who left with the fall of the Soviet Union in 1990. Before them, the barracks had been occupied by the Germans during World War II. The original inhabitants were soldiers of the Austro-Hungarian Empire in the late 19th century.

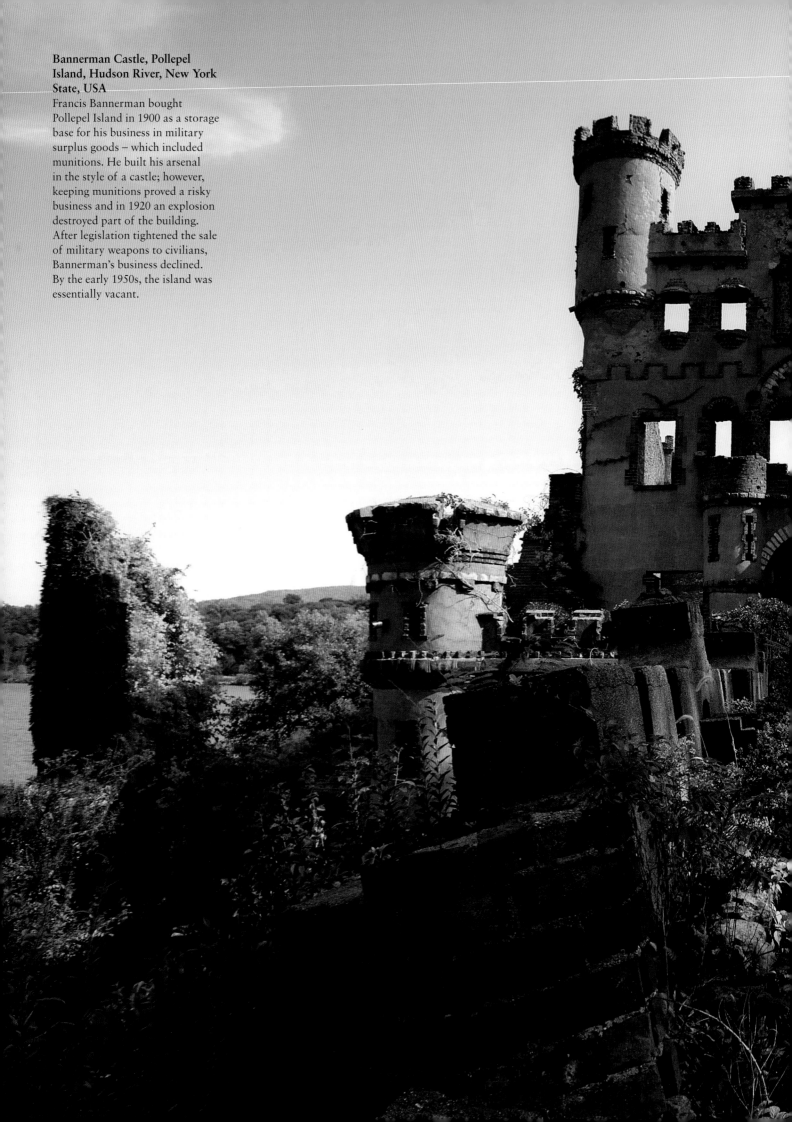

Bannerman Castle, Pollepel Island, Hudson River, New York State, USA

Francis Bannerman bought Pollepel Island in 1900 as a storage base for his business in military surplus goods – which included munitions. He built his arsenal in the style of a castle; however, keeping munitions proved a risky business and in 1920 an explosion destroyed part of the building. After legislation tightened the sale of military weapons to civilians, Bannerman's business declined. By the early 1950s, the island was essentially vacant.

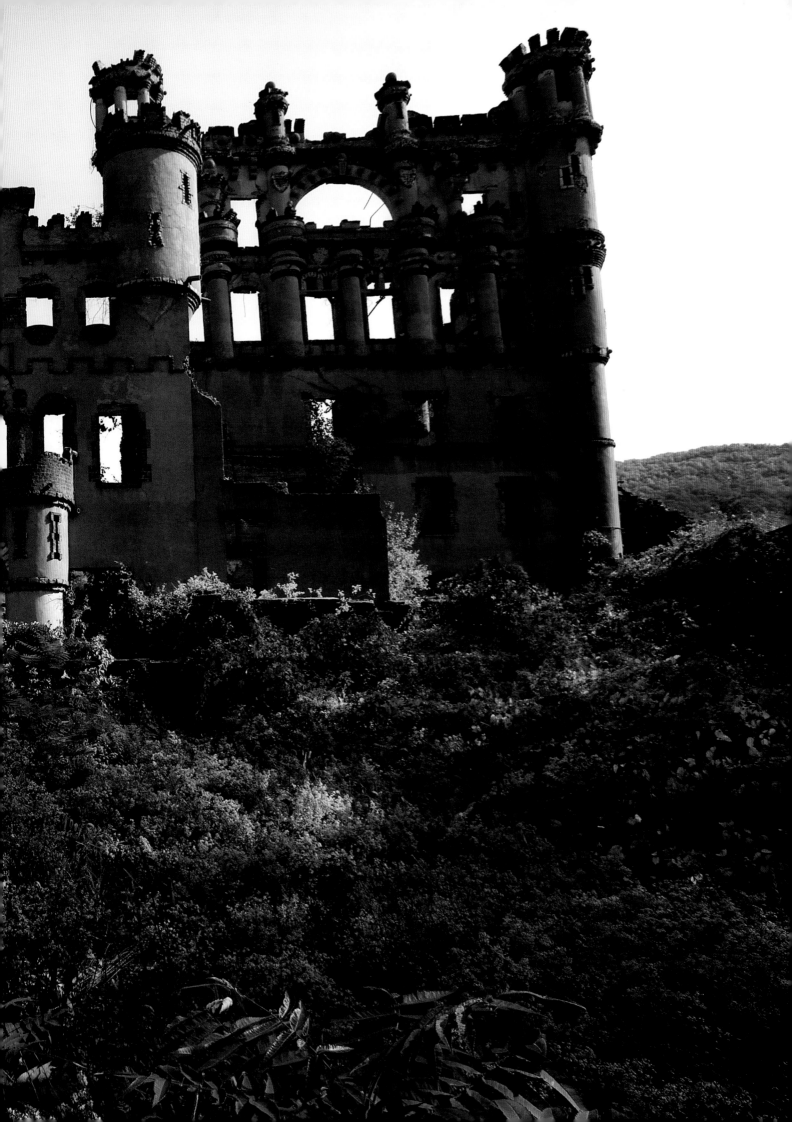

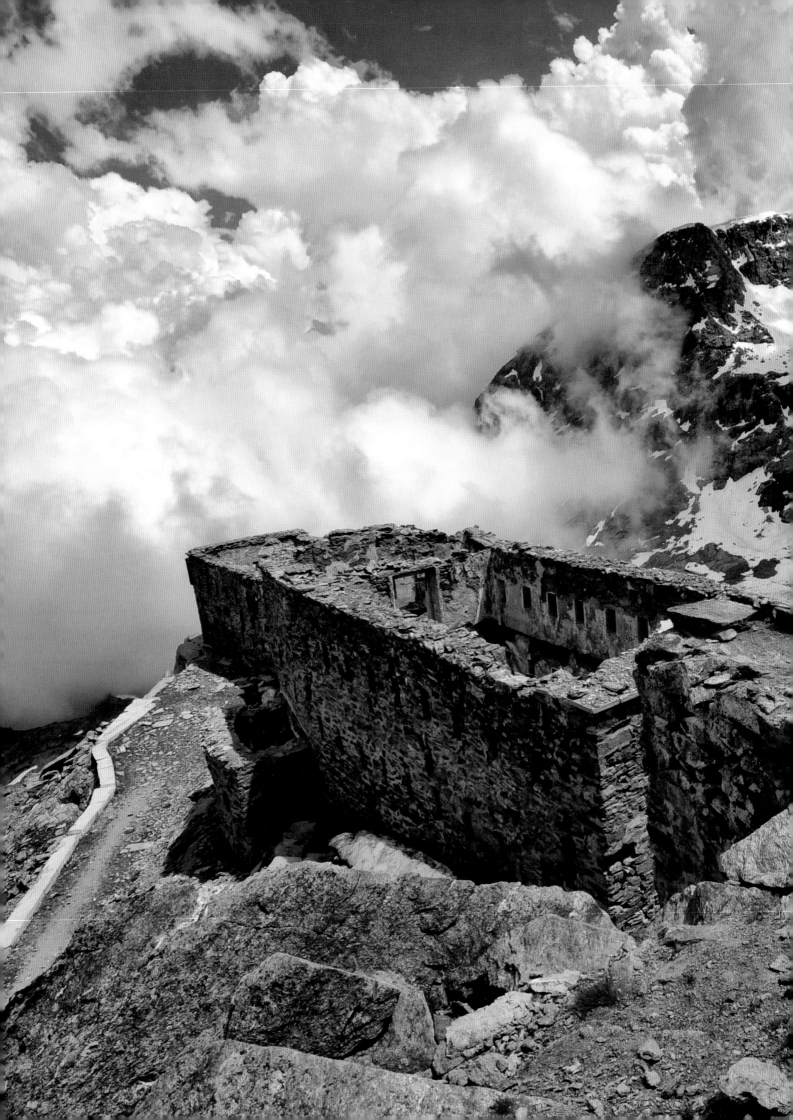

Fort de Malamot, Mont Malamot, Savoy, France
At an altitude of 2,850m (9,350ft), Fort de Malamot was built in 1889 by the Italians to monitor the Mont Cenis Alpine pass to France. When the area was ceded to France in the 1947 Paris Peace Treaties, the fort was no longer of use.

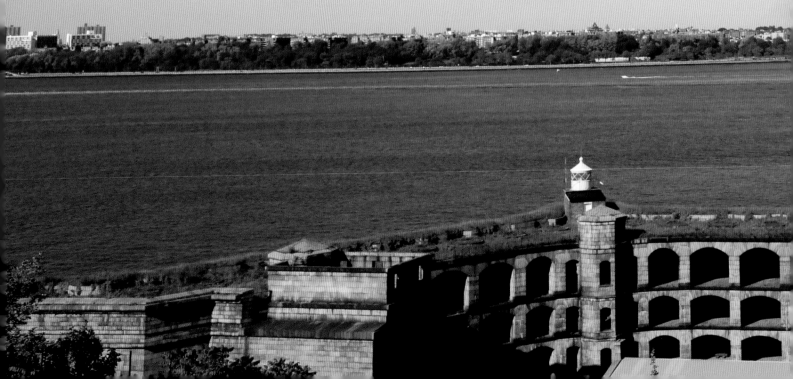

Fort Richmond, New York City, USA
An earlier Fort Richmond had existed on this site in the first decade of the 19th century, but it is the mid-century reconstruction that we can see today. Guarding the entrance to New York Harbor, it had three seaward fronts with four tiers of cannon boasting 116 guns. In 1902 it was renamed Battery Weed, in honour of Civil War soldier Stephen H. Weed. Today the Verrazano–Narrows Bridge towers over the fort.

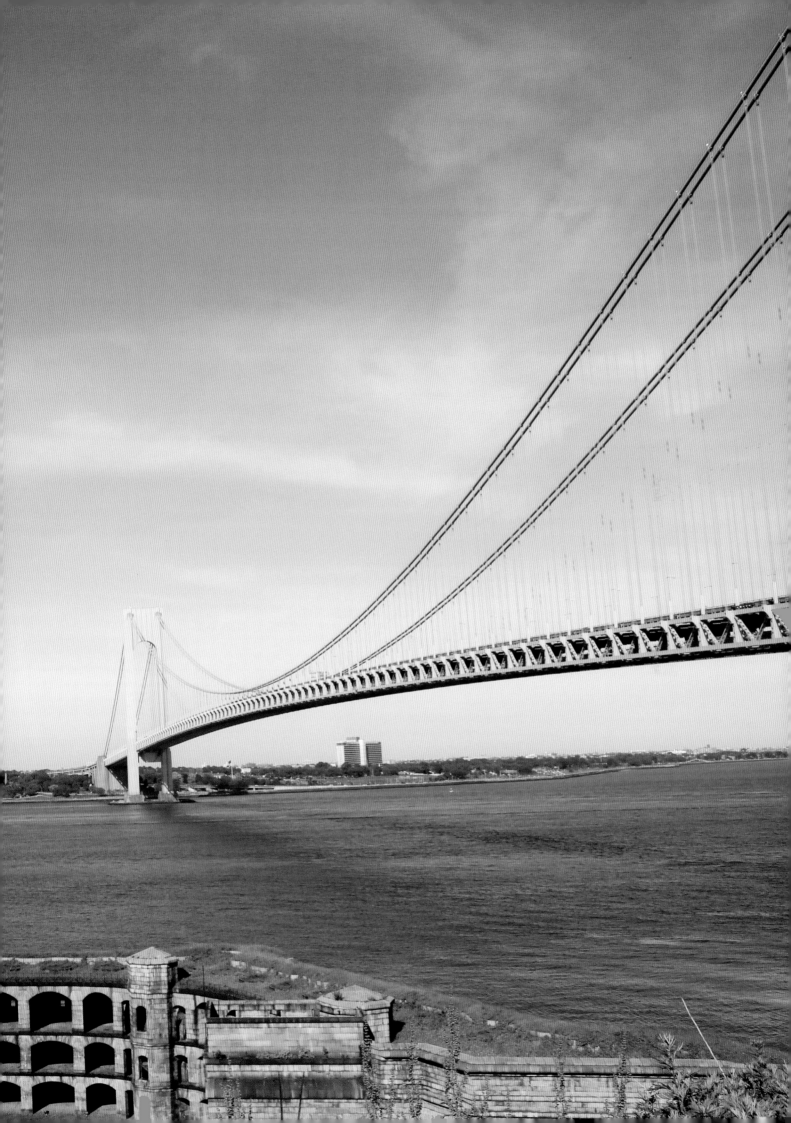

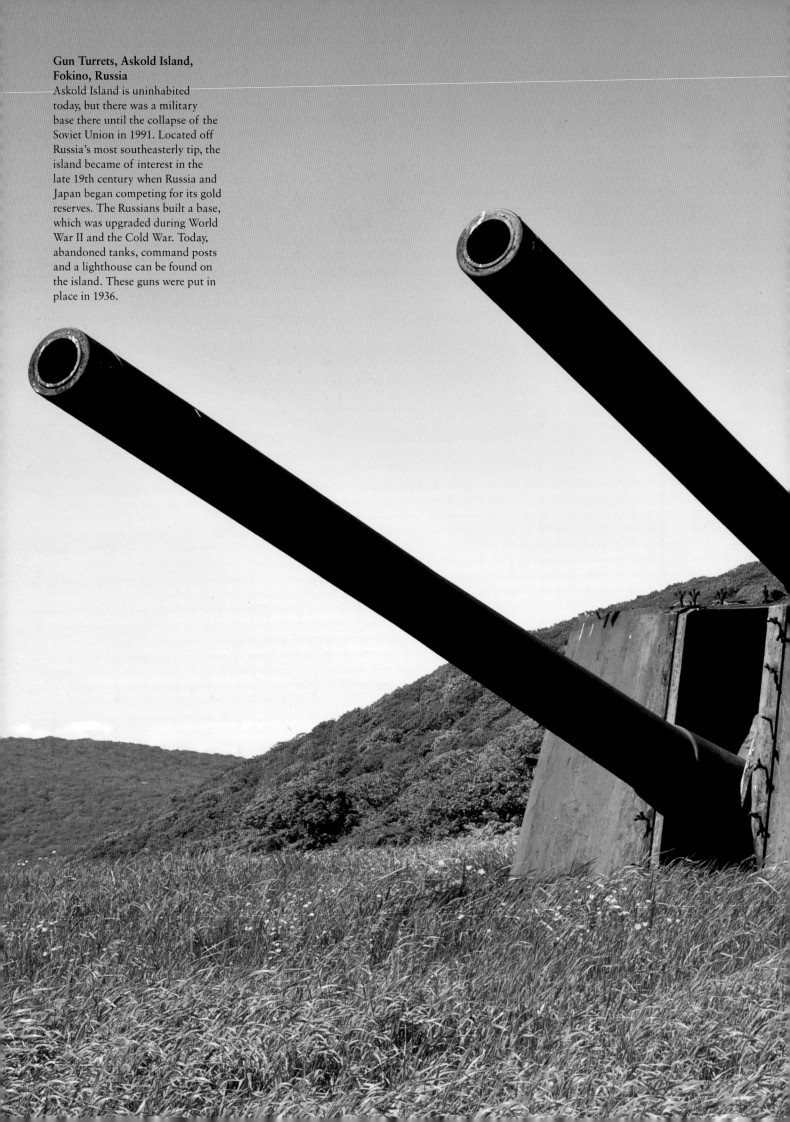

Gun Turrets, Askold Island, Fokino, Russia

Askold Island is uninhabited today, but there was a military base there until the collapse of the Soviet Union in 1991. Located off Russia's most southeasterly tip, the island became of interest in the late 19th century when Russia and Japan began competing for its gold reserves. The Russians built a base, which was upgraded during World War II and the Cold War. Today, abandoned tanks, command posts and a lighthouse can be found on the island. These guns were put in place in 1936.